SHELBURNE AND REFORM

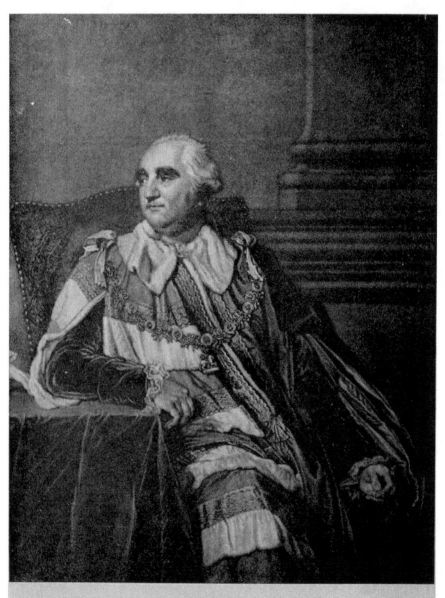

WILLIAM, EARL OF SHELBURNE, MARQUESS OF
LANSDOWNE, K.G.

SHELBURNE AND REFORM

BY

JOHN NORRIS

ASSOCIATE PROFESSOR OF HISTORY
UNIVERSITY OF BRITISH COLUMBIA

LONDON
MACMILLAN & CO LTD
NEW YORK · ST MARTIN'S PRESS
1963

To My Wife

14097

PREFACE

DURING the years in which I have been writing this book, I have contracted debts of gratitude in three countries. In Great Britain, I have to thank the Most Honourable the Marquess of Lansdowne for allowing me to use the Shelburne Papers in his possession; His Grace the Duke of Grafton for permission to use the papers of the Third Duke of Grafton, at present deposited in the West Suffolk County Record Office at Bury St. Edmunds; Earl Fitzwilliam and his Trustees of the Wentworth Woodhouse Settled Estates for permission to use material from the Wentworth Woodhouse Muniments deposited in the Central Library, Sheffield; Professor Thomas Copeland for permission to quote from letters of Edmund Burke which are soon to appear in volumes of the definitive edition of the *Correspondence of Edmund Burke* under his editorship; University College London for permission to use the Bentham Papers in their possession; the Trustees of the National Library of Scotland for the use of the Melville Papers in their custody; the Controller of H.M. Stationery Office for permission to use unpublished Crown Copyright material in the Public Record Office; the Bodleian Library, Oxford, for permission to use material from the North and Price Papers; and Dr. R. W. Greaves, the Right Honourable the Lord Tweedsmuir and Mr. C. I. Casey for their help and encouragement.

In the United States I must thank Dr. Howard Peckham, Librarian of the William L. Clements Library, Ann Arbor, Michigan, and his staff for their help in securing me access to, and permission to use the magnificent eighteenth-century collections in their care; the American Council of Learned Societies for a Pre-Doctoral Fellowship to enable me to gather the material for this book; and Dr. G. C. Boyce and members of the History Department of Northwestern University for their encouragement.

In my own country, I am grateful to the Canada Council and the University of British Columbia for money and time to enable me to write, and to my departmental colleagues, Dean F. H. Soward

and Drs. Margaret Ormsby, Peter Harnetty and John Bosher for encouragement and criticism.

In all countries and in all circumstances I have had the support and encouragement of my wife, to whom this book is gratefully and affectionately dedicated.

J.M.N.

CONTENTS

FRONTISPIECE

William, Earl of Shelburne, Marquess of Lansdowne, K.G.
[*From a mezzotint of a group with Lord Ashburton and Colonel Barré, painted by Sir Joshua Reynolds, 1787.*]

INTRODUCTION

IN the last third of the eighteenth century one generation in England saw the rise of modern party politics and a revolution in administration that produced, at a stage or so removed, modern executive government in the parliamentary setting and a re-fashioning of economic policy along classical liberal lines. In that generation, the second Earl of Shelburne was one of the most important of the architects of change. More than most, his career demands explanation.

Two questions in particular must be answered: to what extent was Shelburne responsible for the liberal reforms that emerged in England at the end of the American War? and why was he, the patron of almost all the precursors of nineteenth-century radicalism, the politician most disliked and distrusted by the libertarian opponents of the American War? No single or simple answer can be given to either question. As Shelburne himself wrote, almost in anticipation of the difficulties his biographers would encounter:

> It is common with most men to attribute all events to some one cause. It suits the pedantry of the historians, who are for making every thing into a system, and it saves others the great trouble of combining and thinking. But no great river arises from one source, but on examination will be found to come from the accidental junction of a number of small streams. Besides I am convinced that there are two classes of causes, one ostensible and plausible, calculated to meet the publick eye and mind. The other from private and bye motives, which men scarcely dare to own themselves.[1]

Lord Fitzmaurice, his descendant, tried to explain the divergence between Shelburne's genius and his legend in one of the finest of Victorian biographies. Fortunately Lord Fitzmaurice believed in letting his subject speak for himself whenever possible, and printed Shelburne's fascinating autobiographical fragment and his comments on men and manners of the time. From these it is possible to

[1] Lord Fitzmaurice, *Life of William Earl of Shelburne* (2d. ed.; London, 1912), I, 79.

understand a good deal, though not everything, of why Shelburne
was so disliked. His comments reveal a bitingly perceptive intel-
ligence, all too aware of the shortcomings of his contemporaries
and filled with distrust of the world. The early passages of his
autobiography shed a good deal of light on how he got that way.
But these were the reflections of his old age, and they did not
explain the career of the mature Shelburne. As the recollections of
one who liked to surround himself with equivocation and mystery
— even where no reason for them existed — they were not
infrequently unreliable.

Lord Fitzmaurice did not, however, explain Shelburne's part in
the reform movement of the eighteenth century, nor his relations
with the opposition to the American War. He emphasised his own
interests, which were in parliamentary and diplomatic history.
He was also much influenced by the historical values of his age,
which were unashamedly whiggish. Though he did his best to
rescue Shelburne's reputation from the strictures of Adolphus,
Lord Holland, Macaulay, Lord John Russell and Lecky, he himself
wrote from an unshakeable conviction that the opponents of the
North régime and the American War were defenders of the cause
of liberty, pure and simple. Hence it was difficult for him to defend
Shelburne's falling out with the Rockingham party in 1782 in
alliance with the King. He admitted that part of the blame lay in
Shelburne's unfortunately oily manner and love of intrigue. But he
explained the episode in Disraelian terms as the Venetian oligarchy
pouring out the vials of their wrath on one who, as a King's
minister, had courageously defended the prerogative from their
encroachments, and united King and people in a patriotic bond
against them.

But Shelburne's public personality was not especially more
objectionable than those of Burke, Chatham or Grafton; nor were
his opponents all, or even mostly, selfish oligarchs. The answers to
the problems of his reforming career and his unpopularity do not
lie simply in ideological or personal considerations, important as
these were. I think they do lie in a consideration of these factors
with the peculiar juxtaposition of the circumstances of his career.
The structure of politics of his generation was particularly un-
favourable to his ambitions and to the ideas of reform toward
which he was groping. The latter developed particularly quickly
during his short administration, when he came to grips with the

real details of government. Unfortunately his ministry was doomed
from the outset, and only the accident of a parliamentary recess
prolonged its life to eight months. In spite of his defeat he might
have restored his reputation and come back to power at the over-
throw of the Coalition had he been able to go a little farther with
his reforms and go out of office with concrete accomplishments
other than the controversial peace of 1783. But there was no time
to achieve these. In most cases he left only schemes in embryo,
to be taken up and instituted or ignored by the Younger Pitt, who
made no acknowledgements to his old leader for the inspiration.
Only a few civil servants and a few of Shelburne's friends, to whom
he poured out his anguish for twenty years thereafter, realised the
truth. The brilliant reputation for reform on which Shelburne had
relied to rescue himself from the calumnies of the age, to justify his
snatching power from Fox, and obliterate the memory of the
'Jesuit in Berkeley Square', remained still-born in the huge mass
of his papers.

This book is not intended to be the new 'definitive' biography of
Shelburne. Too many questions about Shelburne's personality
remain to be answered for that, and in discussing his part in the
reform movement, I have not been at great pains to answer them.
On the other hand, I could not discuss his part in reform without
making as extended a study of his career as relevance to the topic
of reform, the extent of the evidence, and my own limitations
would allow.

LIST OF ABBREVIATIONS

Add. MSS	British Museum, Additional Manuscripts.
A.H.R.	*American Historical Review.*
Bowood MSS	Shelburne Papers in the Possession of the Most Honourable the Marquess of Lansdowne at Bowood Park.
B.T.	Public Record Office, Board of Trade Papers.
Burke Corr.	*Correspondence of Edmund Burke*, under the general editorship of Professor Thomas Copeland, Vol. I, ed. Thomas Copeland, Vol. II, ed. Lucy S. Sutherland, vol. III, ed. G. C. Gutteridge (Cambridge and Chicago, 1957–60).
Chatham Corr.	*The Correspondence of William Pitt, Earl of Chatham*, ed. W. Taylor and J. H. Pringle (London, 1838–40), 4 vols.
Chatham Papers	Public Record Office 30/8, Papers of William Pitt, Earl of Chatham, and of William Pitt the Younger.
C.O.	Public Record Office, Colonial Office Papers.
E.H.R.	*English Historical Review.*
Fitzwilliam MSS	Central Library, Sheffield, Wentworth Woodhouse Muniments, Rockingham and Burke Papers.
Fortescue	Sir John Fortescue, ed., *The Correspondence of King George the Third from 1760 to December 1783* (London, 1927–8), 6 vols.
Grafton MSS	West Suffolk County Record Office, Bury St. Edmunds, Papers of the Third Duke of Grafton.
H.M.C.	Historical Manuscripts Commission Reports.
H.O.	Public Record Office, Home Office Papers.
Proc. Mass. Hist. Soc.	*Proceedings of the Massachusetts Historical Society.*
Rock. Mem.	*Memoirs of the Marquis of Rockingham*, ed. Earl of Albemarle (London, 1852), 2 vols.
Shelburne Papers	William L. Clements Library, Ann Arbor, Michigan, U.S.A., Shelburne Papers.
S.P.	Public Record Office, State Papers.
T.	Public Record Office, Treasury Papers.
U.C.L.	University College London, Library.

Apprenticeship, 1737–1763

Villiam Petty, second Earl of Shelburne — to give him the style and title by which he was known throughout his active career[1] — was born in Dublin on May 13, 1737, the son of the Honourable John Fitzmaurice, second son of the first Earl of Kerry. Both his family and their circumstances in the Ireland of his youth had an important influence on the future Lord Shelburne's career. The Fitzmaurices were part of that great adventuring family, descended from the marriage of Gerald of Windsor with Nest of Wales, which gave to Irish history the houses of Carew, Desmond, Kildare and Fitzmaurice. Since the end of the twelfth century the Fitzmaurices had been ruling and civilising *ultima Europa*, the county of Kerry. By the early eighteenth century, having learned the art of keeping on the winning side in the Irish wars, they attained, in the person of the twentieth Lord of Kerry, to the dignity of an Irish earldom. According to his grandson, it was not the first Earl of Kerry's ability to secure promotion in the peerage which made the family's fortunes, but his marriage to Anne Petty, 'a very ugly woman who brought into his family whatever degree of sense may have appeared in it, or whatever wealth is likely to remain in it.' She was the daughter of Sir William Petty of the Down Survey and modern economics, and she was the prospective heir, after her brothers, to Petty's extensive lands in Ireland, Wiltshire and Buckinghamshire. Inheriting most of her father's enterprising qualities, she devoted herself to the difficult task of civilising her husband. He 'did not want the manners of the country, nor the habits of his family to make him a tyrant. He was so by nature.' He was only drawn away from the congenial exercise of this quality in the confined circle of his family and estate by the ambitions of his wife, who,

[1] The family name of the Earl of Kerry was Fitzmaurice, but in 1752 Shelburne's father, John Fitzmaurice, assumed the name of Petty on succeeding to the estates of his uncle, Henry Petty, Lord Shelburne. Our subject's son, the third Marquess of Lansdowne, on succeeding to the earldom of Kerry in 1818, combined the two family names as Petty-Fitzmaurice.

... by a conduct which was a perfect model of sense, prudence, and spirit, educated her children well, gained her family consideration at home and abroad, furnished several houses, supported a style of living superior to any family whatever in Ireland, and with all this improved his fortune.[1]

Shelburne's claims to the contrary, his family's distinction was pretty much confined to Kerry and the society of Dublin, just then emerging from the decline into which it had fallen when the city had ceased to be a national capital at the Williamite settlement. Lady Kerry's children, circulating between the provincial world of their mother's ambitions and the feudal tyranny of their father, missed a regular education and also missed establishing themselves in any circle of society. After her death, Dublin was lost to them. Her husband retired to Kerry, there to brood over and instruct his family in his supposed grievances against a neglectful government. His second son John, in spite of Westminster School and the Grand Tour, was certainly unfitted for a career in the world, and was still dependent at forty-five on his father's uncertain bounty. By the time he secured independence and a position by inheriting the Petty fortune and title in 1751, he had lost the ability to make decisions and was an awkward country bumpkin. Horace Walpole was diverted by:

... a speech by Lord Shelburne, one of those second-rate fortunes who have not above five-and-thirty thousand pounds a year. He says everybody may attain one point if they give their attention to it; for his part, he knows he has no great capacity, he could not make a figure by his parts; he shall content himself with being one of the richest men in England.[2]

Much should be forgiven the new peer, pitched suddenly into high society. His son claimed that he 'had an uncommon good plain understanding, great firmness, and a love of justice, saw things public and private *en grand*',[3] and he apparently had considerable shrewdness, for he improved the value of his inheritance and, according to Adam Smith, he was a conscientious and capable landlord.[4]

[1] Fitzmaurice, *op. cit.*, I, 2–4.
[2] To H. S. Conway, April 16, 1756, *Letters of Horace Walpole*, ed. Mrs. Paget Toynbee (London, 1912), III, 413–14.
[3] Fitzmaurice, *op. cit.*, I, 6.
[4] Adam Smith to John, Earl of Shelburne, April 4, 1759. Papers in the possession of the Most Honourable the Marquess of Lansdowne at Bowood Park, Wiltshire.

Certainly he had sufficient judgment in politics to attract the friendship of Henry Fox. Moreover he was careful to introduce his son into public life as early as possible by taking him on a round of visits to the *salons* in the spring of 1753.

Shelburne's mother, according to her son, was a foolish woman,

> ... one of the most passionate characters I have ever met with, but good-natured and forgiving when it was over — with a boundless love of power, economical to excess in the most minute particulars, and persevering, by which means she was always sure to gain her ends of my father.... If it had not been for her continued energy my father would have passed the remainder of his life in Ireland, and I might at this time be the chief of some little provincial faction.[1]

But Shelburne had a very imperfect preparation even for this, since his parents neglected everything else in order to shine in the society from which they had been isolated for years.

> I had no great chance of a liberal education [he wrote in later life]; no great example before me, no information in my way, except what I might be able to acquire by my own observation or by chance....[2]

A poor school, the intermittent attentions of a cheap French Huguenot tutor, and a year of penurious idleness in London at the age of fifteen were almost the sum of his early formal education. Apparently his first schoolmaster found that he had a natural bent for logic and mathematics and gave him some encouragement. The only other bright exception to this tale of neglect was his aunt, Lady Arabella Denny, who surrounded him with the affection that was lacking in his own family. Shelburne believed that it was due to her that he was able to read, write and speak, and attributed his later success to her. To overcome the disorder of his family and training, she instilled in him an exaggerated respect for methodical habits (though he lacked these himself) and a strong sense of duty.

At sixteen he went up to Christ Church, then a Hanoverian enclave in Tory and Jacobite Oxford. His studies, as he remembered them, consisted of 'natural law and the law of nations, some history, part of Livy, and translations of Demosthenes'; a mixture enlightened by Blackstone's early lectures and a good deal of indiscriminate reading in religion. Such interests might be explained by the general interest of his generation in moral philosophy and jurisprudence. But in Shelburne's case they struck deeper

[1] Fitzmaurice, *op. cit.*, I, 6. [2] *Ibid.*, 7.

roots. His later comments on his religious interests are reveal ing:

> Surely it is natural for a person of the least reflection, if they (*sic*) are taught to believe in the Bible &c., to be restless till they know the sum of what it contains, and come to some decisive judgment upon a subject so interesting as their future existence and eternal welfare. The certainty of ninety-nine out of a hundred never bestowing a thought upon the subject tells a very extraordinary view of the world, accounting for a great deal of otherwise unaccountable matter.[1]

The afternoon sermon readings with which he entertained his family circle in the 1760's, led on to the enquiries directed to Priestley, Price, Morellet and a succession of Dissenting clerical protégées at Bowood concerning the immortality of the soul, and to a serious personal struggle to reconcile the demands of revealed and natural religion. In later years he held to an austere Deism, strongly coloured by dislike for the Anglican clergy.[2]

His interest in the law was also greater than that of most men of his age and rank. Blackstone reinforced in him the contractual libertarian beliefs of his generation, and armed him with a suspicion of Mansfield's apparent tampering with the common law which he would express frequently in later years. In the 1770's and 1780's he was to emerge into the larger world of legal theory, corresponding with Beccaria and Morellet, and giving his patronage to Bentham, Dumont, Madan and Romilly.

His undergraduate career was no more satisfying than his childhood had been. Under the influence of a tendentious tutor he found himself cut off from the fashionable group that had come up to Christ Church from Westminster School in the wake of Mansfield, the Pelhams and the Stones. In later life he remarked of this association: 'It has by one or other accident, been my fate through life to fall in with clever but unpopular connections.' But from the bleak round which he catalogued as: 'home detestible, no prospect of a decent allowance to go abroad, neither happiness nor quiet,'[3] he was rescued by war. In 1757 the young man determined to go into the Army, and the elder Shelburne was persuaded by Henry Fox to purchase a commission for his son in the 20th Regiment, then commanded by Colonel James Wolfe.

<p align="center">★ ★ ★ ★</p>

[1] *Ibid.*, 14–15. [2] Cf. *ibid.*, II, 347–8. [3] *Ibid.*, I, 13–14, 70–1.

His formal education was over, but the effects of it were obvious for the rest of his life. He would always have exaggerated doubts about his own knowledge in the presence of people whom he thought better grounded than himself, and these uncertainties would drive him on to the omniverous study that made him perhaps the best-informed public figure of his generation. Like most self-educated people, he lacked order in his studies and took them up with the immoderate enthusiasm and earnestness attaching to new discoveries. 'He caught hold of the most imperfect scrap of an idea [wrote Bentham later], and filled it up in his own mind — sometimes correctly — sometimes erroneously.'[1] And Lord Loughborough remarked that 'his art had a strong twang of the boarding school education about it'.

His confidence in his own considerable talents was undermined and made him exceptionally sensitive to criticism. This was unfortunately combined with something of his grandfather's imperious temper. He admitted that any moderation that he had introduced into it had arisen 'more from self-discipline, good company, and observation of the world, than from my own nature'. To his intimates he was always generous and often considerate; he had warm friendships with a variety of people who were good judges of character. When he did not feel threatened he was equally open to the world in general. But more frequently his public conduct was an unattractive mixture of the obsequious and the harshly domineering.

> Since I can remember [he wrote in a revealing passage of his autobiography] I have never forgot a kindness, nor an injury, though I have forgiven many of the latter, having, thank God, by reading, reflection and observation, rooted whatever degree of revenge I had by nature out of my character, of which I could give many proofs.[2]

In the midst of the bear-garden of eighteenth-century politics, his uncertainties of mind drove him to shifts and dodges, to abrupt changes of front and mysterious silences. Contemporary opinion generally regarded him as treacherous. But Burke, who was no friend of his, came nearer the mark when he wrote:

> He wants what *I* call principles, not in the vulgar sense of a deficiency

[1] Bentham, *Works*, ed. Sir John Bowring (London, 1838-43), X, 116.
[2] Fitzmaurice, *op. cit.*, I, 4.

of honour, or conscience — but he totally wants a uniform rule and scheme of life.[1]

The later personal influences in his life did relatively little to change the pattern already set. His first wife, whom he married in 1765, was Lady Sophia Carteret, daughter of that Lord Granville who had so nearly carried off the prize in the struggle for power following Walpole's eclipse. Disraeli was later to imagine that this connection influenced Shelburne's ideas, but in fact Shelburne met Granville only once, in 1753. Lady Shelburne's diary shows her to have been amiable and intelligently observant of the world of affairs. She was apparently devoted to her husband, tolerating his restlessness and conforming to his odd evangelical enthusiasms. His letters to her are surprisingly cold in tone, but when she died at the beginning of 1771, he sank into a depression and had to go abroad for a season to recover.

For nearly a decade after her death Shelburne was content with a bachelor life. In 1778 his engagement to a Miss Molesworth was broken off, but in 1779 he married Lady Louisa Fitzpatrick, sister of the Earl of Upper Ossory and Richard Fitzpatrick, the close friends of Charles James Fox. Unlike his first marriage, this one had some political significance — for a time in 1779 it strengthened his alliance with Fox. In the following years, however, family relationships were severely strained by the intense antipathy to Shelburne manifested by his brothers-in-law. Through her Fitzpatrick, Vernon and Bedford connections, the second Lady Shelburne figures in the correspondence of Horace Walpole. Jeremy Bentham paid tribute to her beauty, her reserve and her kindness. She left no such impression as her diarist predecessor did, but for all that Shelburne felt her death in 1789 perhaps more than he had done that of his first wife. It left him alone in the world in his later middle age, when he was in the political wilderness without the distraction of public affairs.

As might have been expected, Shelburne showed himself an indulgent and extremely anxious parent. In his eagerness to make sure that his own neglected childhood should not be repeated, he subjected his children to the latest educational advantages. His eldest son, John, was educated under the supervision of a succession of Dissenting clergymen, including Joseph Priestley. In this

[1] Quoted in Sir Philip Magnus's *Edmund Burke, A Life* (London, 1939), 317, note 15.

young man, whose feeble and erratic intelligence reflected the worst characteristics of the Fitzmaurices, Shelburne unfortunately centred all the hopes of his disappointed old age. But it was his son by his second marriage, Henry, who was to carry on his father's distinction. His education, under the supervision of Bentham and Dugald Stewart, and his career in successive nineteenth-century governments, were almost the quintessence of Victorian whiggery.

*　　*　　*　　*

The Seven Years War gave the young Lord Fitzmaurice (as he then was) some experience of the world, even if it was the rather limited world of the subaltern, and his instruction was unorthodox. Wolfe took an interest in him — as Shelburne confessed 'more from principle and elevation of mind than any particular liking' — encouraged him to indulge in private study of philosophy as well as military subjects, and taught him the art of being popular in the regiment. When Wolfe left for Canada, Fitzmaurice took part in the Rochefort expedition and other raids on the French coast which upheld the best amateur traditions of an army that had Laufeldt and Hastenbeck among its recent battle honours, and Lord George Sackville and Henry Seymour Conway as its field commanders. But after two seasons of disastrous expeditions, the theatre of operations changed. Pitt had discovered that America was to be won on the plains of Germany, and Fitzmaurice followed his regiment — the 3rd (now Scots) Guards — to distinction at Minden and Kloster Kampen. At the end of 1760 Lord Granby recommended his promotion to the rank of colonel and his appointment as aide-de-camp to the new king.

Returned from the wars, Fitzmaurice found his military career merging into a political one. He had been an absentee Member of Parliament for the family borough of Chipping Wycombe since the previous June, having succeeded his father who had just crowned a successful siege of government with promotion to an English barony. In the new reign the elder Shelburne was even more successful. His friendship with Henry Fox, Lord Bute and the Duke of Rutland made him a useful political agent in the negotiations then being made to gather a party to support Bute. His son, though he had not so far engaged in politics, landed in England in December 1760 to find himself the centre of a political controversy. His promotion had been made over the head of Lord George

Lennox, the Duke of Richmond's brother, and Richmond resigned his court appointments in protest. Senior officers in the home army were inclined to sympathise with Richmond and regard Fitzmaurice's promotion as a political job — a suspicion that would have been confirmed had they known that the elder Shelburne was at that time negotiating with Granby's father, the Duke of Rutland, to secure the family's support for Bute.[1] They would have been wrong in supposing this, since the promotion originated with Granby for service in the field. But these circumstances of Fitzmaurice's entry into politics were particularly unfortunate, because they helped to establish his unpopularity with a most influential political interest. Richmond took his grievance with him out of the orbit of the Court and of his brother-in-law Henry Fox, and into that of the group of younger supporters of the Duke of Newcastle, led by the Duke of Devonshire and the Marquess of Rockingham. Fitzmaurice took Richmond's place as Fox's political pupil. As a result, among the rising generation of political leaders where one's attitude to Bute was the paramount test determining party allegiance, Richmond and Rockingham, and somewhat later the young Duke of Grafton, established themselves as enemies of Bute; but Fitzmaurice was an ally and protégé of Bute in the operations which drove the Duke of Newcastle's party from office in 1761-2. No matter how strenuously Shelburne might strive against the Court in later years, he was never quite forgiven this beginning by the Rockinghams.

In the spring of 1761 his father died and he succeeded to the peerages. The elder Shelburne had come near to realising the ambition which had so excited Horace Walpole's ridicule, and his son had a rich inheritance, with two great houses — Bowood and Wycombe, the patronage of one parliamentary seat and the means of securing two more. He also inherited his father's position as lieutenant to Bute and interlocutor between Bute and Fox.

The choice of the young peer for such a role requires some explanation. It was the King's dislike of Fox which obliged Bute to approach him in this indirect way. If it was going to be necessary to rely on Fox to create a party for Bute, then the relationship must

[1] *Letters of Horace Walpole*, V, 1, 8, 10; *The Diary of the Late George Bubb Doddington, Baron of Melcombe Regis* (3rd ed.; London, 1785), 417-19, 500-4; *Letters of George III to Lord Bute*, ed. R. Sedgewick (London, 1939), 50-2; Charles Jenkinson to George Grenville, November 1760, *The Grenville Papers* (London, 1852), I, 356-7.

be kept as quiet as possible. It was typical of Bute's amateurishness
that he should have supposed that the association could be kept
quiet, and typical also that he should have chosen such instruments
as the Shelburnes. The elder Shelburne, lobbying for an English
peerage at Leicester House just before the new reign opened, had
no independent influence that might have threatened Bute, but
also none that could have helped him much. The younger Shel-
burne, though he had a minor place at Court and was eager to help
in clearing out the 'old gang', was young and inexperienced. Fox
had other reasons for finding Shelburne congenial: his impression-
ableness would be useful in urging Fox's case for the peerage and
other rewards which he was demanding in return for helping Bute.

Neither Bute nor Fox was a suitable connection for a young
politician with his way to make. They were intimately associated
with the adjustments just then being made in the management of
politics; that is to say, both were in the process of becoming
victims, and in part creators, of the most influential political legend
of the eighteenth century — the legend that George III with the
aid of unscrupulous advisers changed the course of constitutional
development away from a gradual evolution toward responsible
parliamentary government. Actually the political changes of the
first few years of George III's reign were unusual not because the
King demonstrated an interest in politics, nor because the control
of the political machine changed hands, but because the new
directors of the system, Bute and Fox, were not really suited to
their task. Neither had the skill nor the respect of the political
classes necessary to convert the change of administration into a
new stable régime by encompassing most of their opponents in a
broad-bottom administration such as had been formed after the
changes of 1742 and 1757.[1] Shelburne described Bute in later
years as:

> ... proud, aristocratical, pompous, imposing ... rash and timid,
> accustomed to ask advice of different persons, but had not the sense
> and sagacity to distinguish and digest, with a perpetual apprehension
> of being governed, which made him, when he followed any advice,
> always add something of his own in point of matter or manner, which
> sometimes took away the little good which was in it or changed the
> whole nature of it. He was always upon stilts, and never natural. ...[2]

[1] J. B. Owen, *The Rise of the Pelhams* (London, 1955), *passim*.
[2] Fitzmaurice, *op. cit.*, I, 110–11.

When Bute's cautious intrigue failed to rally parliamentary support, Henry Fox was hired to rally it. But though Fox was the opposite of Bute in almost every way — he had, for example, the professional politician's understanding and broad tolerance of human weakness — he was handicapped by his desperate anxiety to secure a peerage as the mark of his social acceptance. This made him perpetually anxious in his relations with the great, and inspired in him a form of inverted snobbishness, a resentful deference which usually kept him from taking a lead or an independent line in any of the many political crises of his times. If anyone understood the structure of politics at the accession of George III it was Fox, but he was someone else's 'man of business' long after experience and length of service had earned him men of business of his own. Preoccupied with the mechanics of politics, he had little appreciation or understanding of political opinion, and that opinion was usually hostile to him.

Shelburne learned a good deal from Bute and Fox: from Bute, by example, the fatality of indecision in high places; from Fox, the detailed mechanics of the political system. But he was too young to assess correctly the values of the world of backstairs intrigue into which he had been plunged. His notions of good politics at this early period varied from reckless stands on matters of principle to the sort of exaggerated deviousness which often passes among young politicians for *realpolitik*. With great industry he prepared lists of Members of Parliament who might be brought to support Bute, and this was matched by his violence in attacking the Duke of Newcastle's government and the German War. As the patron of a small parliamentary interest he could command some attention, and as the friend and connection of other magnates such as the Duke of Rutland, considerably more. His followers had some distinction: Colonel Isaac Barré, professional patriot and one of the most vigorous of the Commons demagogues, was his Member for Chipping Wycombe, and John Calcraft was his man of business.

He had dreams of high-minded statesmanship.

Men of independent fortune [he wrote to Fox in explaining why he refused a court appointment from Bute's government in the spring of 1762] should be trustees between King and people, and continue to think in whatever they do to be occupied in actions of service to both without being slaves to either.[1]

[1] *Ibid.*, I, 112-13, 117-18.

Fox told him to get rid of these puerile notions and sink himself into the ranks of the placeholders — 'it is the placeman, not the independent Lord, that can do his country good' — and this was the road to higher office in any case.

For the time being he was satisfied to play a minor role in the political manoeuvring of Bute's rise to power. Apparently he had something to do with the obscure negotiations between Bute and the Sardinian Ambassador, Count Viri, which were designed to speed up the negotiations for peace with France.[1] His chief duties concerned the bargaining between Bute and Fox for the management of Parliament. In this last he ran into trouble. Fox knew perfectly well that the government needed him and held out for the highest possible price. Having frightened Bute by threatening to displace him at the Treasury, he agreed to lead the Commons for the government in return for a peerage when the peace was safely ratified. He was in no hurry to resign his place as Paymaster-General of the Forces, nor his income on the Irish establishment, though undoubtedly Shelburne and Bute, as well as Fox's former followers Richard Rigby and John Calcraft, assumed that Fox would retire from the Ministry as soon as he got the peerage.[2] Had he not frequently said that he wanted to retire to enjoy the maritime delights of Kingsgate? But no one thought to get Fox's promise in writing.

The question was not thought of again until after Parliament had been mobilised and the peace safely passed. Then the administration ran into heavy weather over Sir Francis Dashwood's Cider Tax and a proposal by Sir John Phillips for an enquiry into wartime expenditure. No doubt the threat hastened Bute's retirement. It also decided Fox not to accept the succession, since his accounts at the Pay Office were to be the principal object of Phillips's proposed investigation. But when the time came for him to go, he refused to leave the Pay Office. Shelburne, Rigby and Calcraft agreed that no administration could expect to be popular that gave Fox a peerage and at the same time allowed him to hold

[1] Shelburne's Memorandum of Events of 1762, Bowood MSS; British Museum, Additional Manuscripts 29,918, fo. 20. Many of the papers relevant to the Bute–Viri negotiations are among Shelburne's papers, but there is no direct evidence for Lord Fitzmaurice's assertion that Shelburne played an important part in the discussions.
[2] Bute to Shelburne, October 11, 1762, William L. Clements Library, Ann Arbor, Michigan, Shelburne–Lacaita Papers, vol. I; Sir Lewis Namier, *England in the Age of the American Revolution* (London, 1930), 241–2, 410–11.

the most lucrative office in government *and* sinecures worth
£4,000 a year. But Fox's threat to stay in the Commons and
perhaps join the Opposition had its intended effect. The King
agreed to make the resignation of the Pay Office 'optional' and Fox,
after some further bluster, chose to stay.[1]

It remained to present the best case for his apparent double-
dealing. To Bute and his colleages he explained it as the result of a
misunderstanding on Shelburne's part; but to the public, very
shortly, he was attributing it to Shelburne's treachery in deceiving
Bute and the King as to his real intentions. Shelburne may have
been guilty of ambiguity and an excessive desire to please in pass-
ing on the message (a 'pious fraud', as Bute was supposed to have
described it), but there is no evidence of outright treachery. Rigby
and Calcraft also had the impression that Fox intended to retire.
But Fox's description of 'perfidious and infamous liar' stuck to
Shelburne for life.[2]

It is remarkable that at such an early age he had such a reputa-
tion, and the 'pious fraud' did not originate it. His difficult
position between Bute and Fox had a good deal to do with it.
The King and Bute tried to avoid specifically agreeing to pay even
the peerage part of the price for Fox's services, but at the same
time encouraged him with vague promises; Fox was determined to
push the price up as high as possible, but hid his intention of
keeping the Pay Office and his Irish perquisites lest his peerage be
withheld. Each party tried to cheat the other. Shelburne, as go-
between, was bound to be distrusted by both, and his manners
heightened the distrust. The King looked on him as the agent of
Fox, and his eagerness to advise on policy, especially that con-
nected with the peace treaty, was interpreted as part of Fox's
scheme to take over the government. As early as the summer of
1762, when Shelburne interfered with a minor piece of army
patronage, the King described him as one who 'once dissatisfied
will go any lengths',[3] and linked him with Fox and Charles
Townshend as one of the chief objects of his aversion in politics.
In Court circles at least, Fox had no difficulty in making his
accusations against Shelburne stick. To them it was simply a case

[1] Fitzmaurice, *op. cit.*, I, 146–7, 150–1, 162–4; Bute to Fox, March 2, 1763,
Letters of Henry Fox, Lord Holland, ed. Earl of Ilchester, Roxburghe Club
(London, 1915), 172; *The Jenkinson Papers, 1760–1766*, ed. N. S. Jucker
(London, 1949), xiii.
[2] Fitzmaurice, *op. cit.*, I, 156, 162–7.
[3] George III to Bute, June 18, 1762, *Letters of George III to Lord Bute*, 117–18.

of thieves falling out. So it was, too, to the Newcastle-Rockingham party in Opposition.

Bute at least believed in Shelburne's innocence and was ready to use him as his representative in the new Grenville administration. He tried to persuade George Grenville to appoint Shelburne as Secretary of State for the Southern Department. But this would have meant displacing Grenville's brother-in-law, the Earl of Egremont, an experienced politician. The King refused to consider it and Grenville, under no illusion but that it was intended to use Shelburne as Bute's agent and spy in the new government, compromised by offering the Board of Trade. Shelburne's first reaction was to refuse, but Calcraft persuaded him to accept. Perhaps it was also on Calcraft's urging that he demanded the full powers of policy and patronage which had been enjoyed by the Earl of Halifax at the Board of Trade between 1752 and 1761. Egremont objected to this, and as a compromise Shelburne was allowed cabinet rank.[1] But when Shelburne kissed hands for his first office on April 20, 1763, it was as the subordinate of the Secretary of State. Far from ruling the cabinet for Bute, Shelburne was only a hostage in the Grenville camp.

He was certainly an active, and often a troublesome one. Of the twenty-one meetings of his Board during his short term in office, he attended seventeen,[2] and his energy in the performance of office routine rather palled on some of his colleagues. His activity also went far beyond the limits of his office. Within a few weeks the leaders of the Opposition were regarding him as the secret influence in the cabinet used by Lords Bute and Mansfield or, alternatively, by the Bedford party, to limit the power of the triumvirate of Grenville, Halifax and Egremont.[3] Whatever the truth of these rumours, there was no doubt about the rivalry existing between Shelburne and Egremont. Since 1756 the Board of Trade had exercised no more than nominal control over colonial policy. The Secretary of State was paramount. In demanding full powers for himself, Shelburne was doing no more than almost every other

[1] George III to Bute, March 11, 17, 24, 25, April 14, 1763, *Letters of George III to Lord Bute*, 199, 203–6, 210; Bute to Grenville, March 25, April 1, Grenville to Bute, March 25, 1763, *Grenville Papers*, II, 32–41; Fitzmaurice, *op. cit.*, I, 142–6, 148–9, 174–7.
[2] *Journal of the Commissioners of Trade and Plantations from January 1759 to December 1763* (London, 1935), 354–81.
[3] Duke of Newcastle to Lord Hardwicke, June 2, 1763, to Duke of Devonshire, June 23, 1763, Add. MSS 32,949, fos. 8, 192.

President did until the third secretaryship of state was created in
1768.[1] But in his case the rivalry of offices was given an edge by his
intense personal jealousy of Egremont. Shortly after he was
appointed he asked to have the full responsibility for colonial
correspondence assigned to his office. On June 8 he requested that
the Commander-in-chief in North America be instructed to corre-
spond directly with the Board on all matters concerning the
administration of the newly-acquired Western Lands in America.
Egremont refused to surrender such a large share of policy making.
As the arrangements for settling the empire after the peace took
shape in the summer of 1763, the bickering increased. Egremont
had done most of the work in preparing the plans for the new
territories and resented Shelburne's attempts to create the impres-
sion that he was directing policy. By the first week in August Lord
Hardwicke reported that Egremont was 'very jealous and uneasy
with my Lord Shelburne; and some of Lord Egremont's friends
seem to think that will have some serious consequences'.[2] But as it
turned out these were averted by a quite unexpected turn of events.

Throughout the summer almost everyone except the Trium-
virate had been expecting the Ministry to collapse. But negotiations
undertaken by the Triumvirate to include a few of the Opposition
in the Ministry, and by Bute to replace the Ministry by one under
his patronage, had all broken down on the reluctance of the
particular leaders — Newcastle, Hardwicke, Bedford and Pitt —
to come in separately.[3] By early August this united front appeared
to be crumbling. The Yorkes were at outs with Pitt for his apparent
sympathy with John Wilkes and the City in the case of *North
Briton No. 45*, and for his refusal to support Charles Yorke's
pretensions to the Great Seal. For his part, Pitt replied to overtures
made to him by Bute and the King through Shelburne and
Calcraft that he would not take office with any of the peacemakers
of 1763.[4] Neither Bute nor Bedford could afford to agree to this
and negotiations came to an end.

[1] Clements Library, Shelburne Papers, vol 134, fos. 1–7, 25–31, 33–6, 39–40,
43–4, 47–8.
[2] Philip Yorke, *The Life and Correspondence of Philip Yorke, Earl of Hardwicke*
(Cambridge, 1913), III, 514.
[3] *Correspondence of John, Fourth Duke of Bedford*, ed. Lord John Russell
(London, 1842–6), III, 223–30; Yorke, *op. cit.*, III, 495–7, 503, 509; *Memoirs of
the Marquis of Rockingham*, ed. Earl of Albemarle (London, 1852), I, 169; Earl
Gower to Shelburne, June 20, 1763, Bowood MSS.
[4] Yorke, *op. cit.*, III, 499–521; *Bedford Corr.*, III, 236–7; *Grenville Papers*,
II, 83–91; Fitzmaurice, *op. cit.*, I, 201–4.

It was only a pause. On August 21 Lord Egremont died, and the scramble for places began again. But this time it was more urgent that the fate of the Ministry be settled, since the new session of Parliament was approaching. Once more Pitt was called in, once more — this time in audience with the King on August 27 — he demanded a sweeping proscription of his enemies. The King was apparently receptive to his proposals and Pitt went away convinced that a new ministry would soon be formed. But either Bute or the King, or both, may have reflected that a ministry which included Pitt in high office was Pitt's ministry. On the evening of August 28 the King informed Grenville that Pitt's terms were too hard, authorised him to strengthen the Ministry where and how he could, and next day closed the discussions with Pitt.[1]

The collapse of the negotiations forced Shelburne to decide his future. He could not stay much longer in the Ministry, since the two conditions on which he had held office — Grenville's willingness to tolerate his quarrels with Egremont in return for the expectation of Bute's support for the Ministry, and Shelburne's willingness to support the Ministry and not co-operate with the Opposition — no longer applied. The negotiations with Pitt and their collapse led Grenville to break decisively with Bute, and to redouble his distrust of Shelburne. More important, Shelburne had fallen under Pitt's spell, and Calcraft, whose income from regimental agencies depended on his making the right political choices, thought Pitt had the best future of any of the party leaders. Shelburne had already taken the first step in that direction with a letter on August 30 congratulating Pitt on the end of the negotiations 'which carried through the whole such shocking marks of insincerity'. On September 2, with the usual profession of retiring politicians that he would support the King's Ministers as long as they showed themselves capable of governing, and with 'marks of goodness and favour' from the King, he resigned office.[2]

His position was not immediately clear. He continued to correspond with Bute, though less frequently, and he was not yet a Pittite. The preparations for the debate on general warrants in the

[1] [John Almon] *History of the Late Minority . . . during the Years 1762, 1763, 1764 and 1765* (London, 1766), 218 et seq.; *The Correspondence of William Pitt, Earl of Chatham*, ed. W. Taylor and J. H. Pringle (London, 1838–40), II, 235–41; *Rockingham Mem.*, I, 171; *Grenville Papers*, II, 93–8; Yorke, *op. cit.*, III, 525–9.
[2] *Chatham Corr.*, II, 241–3, 245–6; Fitzmaurice, *op. cit.*, I, 207–10.

new session of Parliament decided him.[1] He must have a party
when Parliament met. On November 18 he was summoned by Pitt
and came to an agreement with him. It was less a marriage of
principles than a union of outcasts. On November 24 Barré,
Calcraft and Shelburne's brother, Thomas Fitzmaurice, voted
against the Ministry's resolution 'that the privilege of Parliament
does not extend to seditious libels'. On the 29th Shelburne spoke
in the same cause. Punishment came swiftly. Shelburne was
dismissed as royal aide-de-camp, Barré as Governor of Stirling
Castle and Calcraft lost his agencies. A new career opened for all
of them as followers of a prophet and martyrs in a cause.

[1] Fitzmaurice (*op. cit.*, I, 195) cites an undated, unsigned memorandum in the
Bowood Manuscripts giving a legal opinion unfavourable to general warrants as
proof that Shelburne was opposed to the prosecution of Wilkes from April 1763
on. Actually the legality of general warrants, as distinct from the question of
privilege of Parliament, did not become a central feature of the Wilkes case until
the late summer and early autumn of 1763. There is no mention in the memo-
randum of privilege of Parliament, which was the main issue in April and May of
1763. In the absence of any date for the memorandum and of any mention of
Wilkes in Shelburne's correspondence during the summer of 1763, it may be
regarded as at least doubtful that Shelburne while in office was any less indifferent
to the case than were the other lesser figures in the Ministry. The prosecution of
Wilkes was largely the responsibility of the Triumvirate and Charles Yorke.

Measures not Men

Between 1763 and 1767 Pitt's dominating personality determined Shelburne's position in the party system. This was not because Shelburne wanted to have his fate decided in this way, but because any follower of Pitt necessarily committed himself to Pitt's aims, and Pitt was the most self-centred and independent of politicians. Even forty years on, in the recollections of his old age, this enforced subordination rankled with Shelburne.

> I was in the most intimate political habits with him for ten years [he wrote] the time that I was Secretary of State included, he Minister, and necessarily was with him at all hours in town and country, without drinking a glass of water in his house or company, or five minutes conversation out of the way of business.

Pitt's attitude to his followers, as Shelburne remembered it, was

> ...insolent and overbearing, at the same time so versatile that he could bend to anything. What took much from his character was that he was always acting, always made up, and never natural, in a perpetual state of exertion, and constantly upon the watch and never unbent.[1]

Under the circumstances, Pitt's following was more a discipleship than a party, devoted willy-nilly to the peculiarly personal aims of Pitt's politics. In the early 1760's his career was centred on the hope that he could revive that unity of opinion in his favour which had existed in 1757. For all that a great deal of politics was run by the machinery of patronage and connection, eighteenth-century politicians found it necessary to appeal to opinion 'out of doors', to the independents of the country party and the City of London's political interest. ' "We must have a cry," said Taper'; and all the eighteenth-century Tadpoles and Tapers were constantly searching for it. Pitt found the search particularly necessary

[1] Fitzmaurice, *op. cit.*, I, 60.

because he lacked both the Ministry's resources of patronage and the only less developed facilities for party management at the command of the Newcastle-Rockingham party.

The most important group to which he appealed were the country party. Shelburne described them perceptively as:

> ... the landed interest of England who desired to see an honourable, dignified government, conducted with order and economy and due subordination, in opposition to the Whigs, who courted the mob in the first instance, and in the next the commercial interest. The Tories, being men of property, and precluded from all court favour since Queen Anne's time, lived upon their estates, never went to London but to attend Parliament, and that for a short time.[1]

In the seventeenth and eighteenth centuries they regarded themselves as the representatives of the neighbourhoods of England resisting national tyranny, and only reluctantly came to admit that the national administration was no longer tyrannical. Local issues and patronage were their preoccupation, and it is a measure of the importance which they attached to these affairs that the country Members of Parliament regarded themselves as the true 'national interest', in contrast to the 'private' interests of Court, party and faction. They were usually suspicious and always independent of, but not necessarily opposed to the government. The degree of their suspicion or opposition varied with the degree to which the government appeared to promote excises, direct taxes and standing armies — all of which the country party abhorred. They also demanded that the dignity of the Crown and monarch and their own control over local patronage and administration be respected; and that the administration of the national government be cheap, competent and unobtrusive. Ordinarily their attitudes affected the security of governments very little, since the country party in Parliament lacked political sophistication and their ordinary methods of applying pressure out of doors — through addresses from justices of the peace, grand juries and, occasionally, country meetings of freeholders — were cumbersome. But in times of national crisis or when their own interests were obviously threatened, the country gentry might ally themselves with whatever organised opinion might be found among the commercial

[1] *Ibid.*, 38; cf. Sir Lewis Namier, *Structure of Politics at the Accession of George III* (2d. ed.; London, 1957), 7–8; Namier, *Personalities and Powers* (London, 1955), 59–77.

classes to present a force of opinion capable of toppling administrations. In 1757 Pitt had appealed to them in denouncing the current mismanagement of the war and wasteful expenditure. His Militia Act of 1757 was designed to strengthen his standing with the country party by drawing the gentry into participation in the war as officers of a militia which might replace the regular army for home defence. Newcastle, Hardwicke and other leaders of the orthodox political groups loathed the militia and suspected any measure which might appear to strengthen this usually inchoate, but potentially dangerous opposition.[1] Pitt, on the other hand, courted them assiduously. In the session of 1765–6, even though ill-health kept him away from the House for most of the Stamp Act debates, he took care to speak on the repeal of the Cider Tax and in defence of the Militia Act.[2]

Pitt was also bound to behave well toward the radicals of the City of London's political interest, with whom until 1763 he had had a close connection. As the City became more and more politically conscious, it became to an increasing degree a battleground for professional politicians from outside, whose leadership the City needed, but whom the City regarded with dislike as representing the aristocracy and wealth of the nation. Like other national leaders who sought the City's support, Pitt was forced to work through a representative, in this case Alderman William Beckford. But after he accepted a pension on leaving office in 1761, Pitt was never again trusted as wholeheartedly by the City as in the days of his glory; and in the later 1760's Beckford found himself run hard for the leadership in the City by John Wilkes, who seemed just what the 'middling' class of people in the City wanted, a political force of national significance personifying the defence of the rights of the small man in defiance of the 'establishment'. Neither Pitt nor Beckford could compete with this luminary, and only Wilkes's exile enabled Beckford to recover some of his influence between 1764 and 1767.

Canvassing the support of the independents meant engaging in formed opposition, which was still officially anathema to all right-thinking politicians, who were supposed to regard opposition to the

[1] In March 1765, for example, Newcastle urged that Thomas Gilbert's bill for grouping parishes for Poor Law purposes be opposed on the ground that it would increase the power of the justices of the peace (to Rockingham, March 26, 1765, Add. MSS 32,966, fo. 110).

[2] *Chatham Corr.*, II, 281–3, 383, 402–3, 413; *Rockingham Mem.*, I, 318.

King's government as disrespectful to the Crown, if not actually disloyal. The success of such opposition depended upon the degree to which it could be disguised as something else — as a patriotic rally to rescue the Crown from the unconstitutionality of a particular Minister, or as protecting the reversionary interest of the heir to the throne. The first — the legend of evil — explanation played a part in all the formed oppositions of the century, but it was never so influential as in the early 1760's when there was no adult heir to the throne and when the accidents of the character and Scottish nationality of the Earl of Bute made it possible for a great many reasonably intelligent politicians to believe in Bute's unconstitutional, authoritarian and — it might be — Jacobite, influence over the King. A later variant of this legend, Burke's story of a 'backstairs cabal', was harder to support because of its vagueness and its lack of such a convenient central figure. Pitt gave tacit support to the Bute legend, but not wholeheartedly; Bute had once been his ally, and in any case he had no intention of making the legend the *raison d'être* of his party. His career served that function. Shelburne wrote of him:

> He relied on quick turns which was his forte. He did not cultivate men because he felt it an incumbrance, and thought that he could act to more advantage without the incumbrance of party.[1]

At bottom this is what he meant by 'measures not men'. He refused to co-operate for very long with any faction, waiting for the moment when the King should call on him to form a government,

> ... and that in so ample and full an extent as shall leave nothing to the eyes of men equivocal on the outside of it, nor any dark creeping factions, scattering doubts and wooing discords within.[2]

Pitt's influence was still enormous in a negative and, for him, unsatisfactory way. In the memory of politicians and public alike, he was still the great war minister who had been called to supreme power by the voice of the people; and the most important factor governing political decisions between 1761 and 1766 was the apprehension of what he might do to marshal opinion out of doors.

In the shadow of this overwhelming personality, Shelburne made no attempt to mark out an independent line for himself.

[1] Fitzmaurice, *op. cit.*, I, 59.
[2] Pitt to Shelburne, December 1765, *Chatham Corr.*, II, 360.

Though his ideas were developing and he suggested general lines of policy — as, for example, supporting Rockingham's Declaratory Act in December 1765[1] — he bowed to Pitt's dictation of party strategy.

> You believe me, I hope, incapable of imagining that Mr. Pitt needs my assistance to discuss any part of what is right [he wrote concerning his proposal to support the North American merchants against the West Indian merchants in the controversy over the repeal of the Sugar Act in the spring of 1766]; I shall certainly on all occasions be very proud to receive any communications you judge proper to confide to me, and that the situation of the times makes fitting and convenient.[2]

His flattery of Pitt went the ridiculous length of assuring him that the use of Pitt's name was necessary to get Calcraft returned in his own pocket borough of Calne.[3]

Yet Shelburne was by no means Pitt's dependent in the ordinary political sense. He made a significant contribution to Pitt's small forces. In the country, his interest at Chipping Wycombe and Calne gave him sally-ports into county politics, strengthening the anti-Grenville forces in Buckinghamshire and the anti-Court and anti-Herbert interest in Wiltshire. Shelburne's supporters, too, provided the largest part of the debating talent in Pitt's small following. During Pitt's frequent illnesses, Colonel Barré carried the main burden of the party's attacks on the Ministry; Calcraft was a competent speaker and a skilful manager of business. Shelburne's East India connections brought him the acquaintance of John Dunning — a common laywer in the tradition of Coke and Maynard with a high reputation at the Bar and a clientele among the radicals in the City that included John Wilkes and Beckford. He was far more capable than Pitt's favourite lawyer, Lord Camden, and his advice enabled Shelburne to argue the libertarian constitutional case with Mansfield without lapsing into the absurdities which characterised Pitt and Camden in such circumstances.[4]

Shelburne's association with the East India Company was also a

[1] Shelburne to Pitt, December 30, 1765, Public Record Office, Chatham Papers, vol. 56, fo. 45.
[2] Same to same [April] 1766, ibid., fo. 64.
[3] Same to same, April 16, 1766, ibid., fos. 66–7.
[4] Cf. Shelburne's comments on Dunning's resistance to Mansfield (Fitzmaurice, op. cit., II, 319), and on Mansfield (ibid., I, 67–9).

significant auxiliary to the party's strength at a time when the
Company's politics were an adjunct to the politics of the nation.
Shelburne had bought himself voting rights in the Company in
1762 and had begun to build up a following there in partnership
with Henry Fox. Fox was no longer his ally, but the friendships
and associations which he made then continued. His principal ally
in the Company, Lawrence Sulivan, brought him other friendships,
notably with John Dunning and Lawrence Palk. Through Fox's
amanuensis and pamphleteer, the elder Philip Francis, Shelburne
also came to be on friendly terms with John Glynn and John
Horne, allies of Wilkes and champions of radicalism in the City,
though his association with the City did not become important
until 1768.

Shelburne's part in the parliamentary politics of the party was
undistinguished at first. In the spring of 1764 he spoke in the debate
on the dismissal of Conway, Barré and himself from their army
commands as a punishment for voting against the Ministry on the
Wilkes issue. In his argument he made the most of the fact that the
dismissals violated the property rights of the officers and their
freedom of parliamentary debate, both cardinal articles of whiggish
faith.[1] He apparently made no noteworthy contribution to the
debate on general warrants and did not oppose the initial passage
of the Stamp Act, though Barré offered the principal opposition to
it in the Commons. But Shelburne took a leading part in the debate
on the Regency Bill in the spring of 1765. The Bill presented an
excellent opportunity for Pitt to indulge in Opposition dialectics,
since it concerned the disposition for the future of the Crown's
power and patronage, and was put forward and mishandled by a
government which had already attacked liberty and property rights
in the cases of Wilkes and the dismissed officers. But Pitt was not
sure how the question would help his fortunes, and left it to
Shelburne and Beckford to lead the attack. They demanded a
strong parliamentary supervision over the Regency, and Shelburne
proposed that the regent be given greater latitude than was
provided in the Bill for calling on the Opposition for its advice.[2]
The idea of such direct parliamentary participation in the function
of the monarchy had no support from the big battalions in

[1] Shelburne Papers, vol. 165, fos. 329–46.
[2] *Ibid.*, fos. 329–46, 353–62; *Grenville Papers*, III, 21–2; Sir John Fortescue,
ed., *The Correspondence of King George the Third from 1760 to December 1783*
(London, 1927–8), I, no. 50.

Opposition. The Rockingham party, who were to attack Shelburne seventeen years later for having a sneaking kindness for royal independence, at this point were shy of becoming involved in the issue.

The Rockinghams, like Pitt, were anxious not to antagonise the King and the Court party when they might be about to take office. They were also anxious to please Pitt. When they did take office in June 1765 these two anxieties conflicted to frustrate their efforts to find a policy. The Court party, as well as being annoyed by the large displacement of officeholders at the accession of the Rockinghams to power,[1] were bitterly opposed to the canvassing of support for the repeal of the Stamp Act by the activists among the Rockingham party. But at the same time these efforts to secure repeal, went largely unappreciated by Pitt, whom they were designed to please. The Ministry came as near as any set of men so situated could do to carrying out the policies to which Pitt had declared himself attached. But Pitt never lost an opportunity to disclaim responsibility for the Ministry's existence and equivocate about its measures. They could not please him because he did not want to be pleased; he wanted power.

As part of the price to gain Pitt, Rockingham offered places in the Ministry to Shelburne and Barré. Shelburne refused the offer of the Board of Trade — he had already served his apprenticeship there, and he was not, in any case, going to be swallowed up in the Rockingham party. But he based his refusal on the customary excuse that he did not know what measures the Ministry intended to pursue, and that for himself he intended to be guided by the formula of 'measures not men'. He could undertake to support the King at all times, and 'whomever was his Minister if he proposed right measures'.[2] But the Pittites were not going to commit themselves to support Rockingham while they saw a chance of forming their own administration.

The prospects for them steadily improved that autumn and winter. The outcries of the British merchants trading to America against the interruption of their trade resulting from the Stamp Act difficulties swelled to a roar, and the Rockinghams hesitated unhappily between the Court party who demanded a firm assertion

[1] *Correspondence of Edmund Burke*, ed. Thos. Copeland (Cambridge, 1958), I, 214–15; *Chatham Corr.*, II, 315–16.
[2] Rockingham to Shelburne, Shelburne to Rockingham, July 11, 1765, Shelburne-Lacaita Papers, I.

of Parliament's authority over the colonies, and Pitt who demanded repeal of the Stamp Act. They eventually decided to satisfy both. The debates on the repeal and the Declaratory Bill, though they gave Shelburne the opportunity to bear witness to his economic liberalism, did nothing directly toward bringing Pitt back to office. But indirectly they did a great deal by creating sharp divisions among the supporters of the Ministry. The Court party were ready to desert after what they regarded as concession to mob violence in the repeal of the Stamp Act; the merchants were divided over the proposal to amend or repeal the Sugar Act and change the regulations governing trade in the West Indies.[1] Inside the Ministry Lords Egmont and Northington wanted Rockingham to ally himself with Bute; the Earl of Albemarle and the Yorkes favoured an approach to the Bedford party; Conway and Grafton wanted to see Pitt in the Ministry; and Rockingham, who was equally unwilling to share power with Bute or Bedford or surrender it to Pitt, sat tight. At the end of April the Duke of Grafton resigned as Secretary of State, and negotiations were opened between the King and Pitt. To hasten them, on July 6 Northington resigned the Great Seal with the King's approval, and the Ministry fell. On this occasion the King's appeals and commands were all that Pitt could desire, and at the end of July he stood triumphant at the head of a Ministry of his own choosing.

It was not anything which they had done in Opposition, but the impression which Pitt's personality made on all parties, which had brought the Pittites back to office. For Shelburne, who at the age of twenty-nine took office as Secretary of State for the Southern Department, the lesson to be learned from this success was that a single forceful individual in a moment of crisis could triumph over the political mediocrities, however numerous they might be.[2] The Rockinghams's collapse in 1766 influenced Shelburne's political judgment for the next two decades. Just so had his father-in-law Granville been deluded by the near-collapse of Walpole at the death of George I into believing that with the Crown on his side a man could defy all the other powers of politics.

* * * *

[1] Lucy S. Sutherland, 'Edmund Burke and the First Rockingham Ministry', *English Historical Review*, XLVII, 46–72.

[2] Cf. his admiration of Strafford, Richelieu and all enterprising ministers, whom he regarded as the real power behind great princes (Fitzmaurice, *op. cit.*, II, 355).

The Ministry of 1766 [wrote Shelburne in his old age] was formed of those who recognised that the Hanover family was become English, and the old mode of false government worn out and seen through. It was proposed no longer to sacrifice all merit and worth in Army, Navy, Church and State, to the miserable purpose of corrupting a majority of the House of Commons, but that the Crown should trust to the rectitude of its own measures, taking care by a scrupulous regard to merit, and a just distribution of honours, to secure a general conviction of its good intentions, and under that conviction to restore the constitution.[1]

It is doubtful if Chatham had such clear ideas of the Ministry's aims in 1766; and certainly the description owes a good deal to Shelburne's interpretation of those aims during the eighteen months when he was the lone and unappreciated defender of them in the Ministry. But there is still a good deal of truth in it. It has been customary to discover fundamental weaknesses in the Ministry's beginnings by arguing from the fact of its later collapse, to emphasise that Chatham was difficult to work with, that he chose an impossible mixture of colleagues, and that he had no clear ideas of what he was going to do. But the Ministry was no more mixed than most in the century, and in office, as distinct from Opposition, Chatham had definite ideas on which he intended to found his administration. For years he had had a vision of the monarchy and the minister acting in partnership to unite the nation and bury the divisive heritage of Jacobitism. 'Measures not men' had been his catch-phrase in Opposition to distinguish his party from the Rockinghams; but it should not be supposed that he did not intend that the idea should have some substance when he came to office. His measures, so far as they emerged in the short interlude before he retired into ill-health in the spring of 1767, included a radically new policy of government management for the East India Company, a new foreign policy based on a northern alliance, and a policy, so far as it could be applied, of practical *laissez-faire* toward America. Accidents, rather than personalities or intentions, made the Ministry the tessellated pavement of Burke's famous image. Chatham had planned his Ministry so that the personality which had created it should be its essential force in every department. When he was removed, the competing talents of Shelburne and Charles Townshend contested the succession until

[1] *Ibid.*, I, 402.

the Court and the other parties took advantage of the division and recovered power.

Shelburne's appointment to the Southern Department demonstrated at the outset the difficulties of such a personal administration. On the political side, the Rockinghams had shared the general impression that the new Ministry would be formed largely from their own ranks,[1] and the appointment of the young Shelburne instead of their candidate, General Conway, to the Southern Department was one of the earliest and heaviest of their disillusionments.[2] Shelburne's bad reputation with them grew worse, and they were convinced that Chatham was in league with Bute.

The administrative arrangements caused more serious trouble. Chatham intended to keep the Southern Department, which was his old department and concerned with the Bourbon powers and the colonies, particularly under his eye, and Shelburne was required to make meticulous and frequent referrals of papers to him.[3] During the period of Chatham's active direction of the Ministry there were very few important matters at issue with the Southern powers. An unsuccessful wrangle with Spain to secure the Manilla Ransom and a suspicious surveillance of Choiseul's activities on the Continent were about the sum of Shelburne's activities in foreign affairs, while to Conway, as Secretary for the Northern Department, fell the duty of directing those Jovian thunderbolts by which Chatham hoped to fuse together a northern alliance of Britain, Prussia and Russia.

In colonial affairs, however, Chatham directed Shelburne more closely. In these early months he was intent on reconcentrating the control of colonial policy in the hands of the Southern Secretary in preparation for reshaping that policy. The organisation and management of the Southern Department should be as much as possible as they had been during his 'finest hour'. Then he had firmly resisted the attempts by Lord Halifax and others to remove colonial affairs from the Southern Department; now he insisted that not only should the Earl of Dartmouth's recent proposal for a

[1] Rockingham to Conway, July 26, 1766, Central Library Sheffield, Fitzwilliam MSS, Rockingham 1–411; Rockingham to Newcastle, Newcastle to Rockingham, July 26, 1766, Add. MSS 32,976, fos. 254, 255; cf. Copeland, *Burke Corr.*, I, 261, 262–3; John Brooke, *The Chatham Administration, 1766–68* (London, 1956), 1–116.

[2] Lauchlin Macleane, soon to be Shelburne's undersecretary, reported to his friend John Wilkes on July 22: 'It is imagined a very few changes, and those only in the upper Departments, will take place' (Add. MSS 30,869, fo. 62).

[3] Cf. Chatham Papers, vol. 56, fos. 52, 56, 60–1, 70, 186, 188.

third secretaryship of state be dropped, but that the Board of Trade should be reduced to the status it had had before 1752, and all executive as well as policy-making powers be transferred to the Secretary of State.

The Earl of Hillsborough, President of the Board of Trade, facilitated the arrangement by refusing to bear the burdens of what would be a meaningless office, and insisted that the routine duties of reading colonial correspondence and preparing colonial instructions be taken away from him. But when Shelburne suggested that Hillsborough would be more usefully employed in filling the vacant Spanish Embassy, Chatham replied querulously that this was a 'desultory step, unfixing the most critical office in the kingdom, so happily fixed, through and by my channel . . .'.[1] In an effort to relieve himself of at least a small part of his work, Shelburne then gave orders that the preparation of estimates and the directions and applications for money granted thereon 'should be resumed into the proper channel', namely the Treasury. The Treasury, however, demonstrated with a wealth of historical detail that they were not and never had been the proper channel.[2] The result was that the Board of Trade was reduced to the status of a board of reference, and an impossibly heavy burden was thrown on the Secretary of State as Hillsborough, who did not like Shelburne, probably foresaw. All might still have been well had the Prime Minister been available to set policy and confine Shelburne's labours to executing it. But by the New Year Shelburne found himself having to shape policy as he imagined Chatham would have wanted it shaped, and in the face of the growing hostility of most of the Cabinet, who were more concerned to secure stability for the Ministry and savings to the Treasury, than harmony with the Americans.

The reorganisation of his office made necessary by this new work introduced Shelburne to a theme that was to preoccupy him later — the reform of the fee system. With the appointment of three new undersecretaries and five new clerks to take care of the business, the senior clerks, anxious to have the full benefits of their seniority, petitioned Shelburne to restore their franking privileges

[1] To Shelburne, October 19, 1766, *Chatham Corr.*, III, 116.
[2] Charles Lowndes to John Pownall, September 23, 1766, Shelburne Papers, vol. 134, fos. 85–6; cf. *ibid.*, fos. 13–14; Margaret Spector, *The American Department of the British Government, 1768–1782* (New York, 1940), 17–19. Hillsborough left the Board of Trade at the first opportunity in December 1766 (*Chatham Corr.*, III, 138–9).

which had been abolished by the Franking Act of 1764. This perquisite, which had been permitted as a compensation for low salaries, had come to be regarded by its holders as their private property, and it was the substance of their case that Parliament ought to compensate them as it did others who suffered property loss by its Acts.[1] Shelburne had defended property rights in the past, but now they seemed to be standing in the way of the public interest. He would not admit the case for compensation, but ordered an investigation of the establishment of the clerks and their salaries. This introduced him to the fee system.

Fees were the life blood of office. The Secretary of State himself had to pay on coming into office a total of £111 12s. 10d. to such assorted functionaries as the Lord Privy Seal, the Attorney-General, the Auditors of the Imprest, the Clerk of the Pells, the Serjeant Trumpeter, the Lord Chancellor's Messenger and the clerks of the Treasury, the Board of Green Cloth and the Council, Signet, Privy Seal and Patent Offices. His salary, the secret service fund at his disposal, and even the passage of accounts for salaries and board wages for his subordinates paid fees — totalling, indeed, £614 16s. 6d. in an income of £4,477 13s. 6d. But this was a two-way traffic, and his office secured fees levied on other offices and instruments totalling between £1,300 and £2,000 annually. In wartime the sum was even greater. In each of the fee accounts the Secretaries of State took the lion's share, but their subordinates were permitted to levy additional gratuities — described as the 'usual compliment of office' — which in some accounts amounted to more than half the total. In the busiest and most remunerative division of the office, the colonial service, fees and gratuities totalling about one thousand pounds were collected on the passage of documents and on the appointment of governors.[2]

Shelburne was shocked by the extent of fee-taking in his department, but in fact it was only a microcosm of the course of office in most government departments. Accounts had to be kept

[1] The Representation of the Clerks in the Secretary of State's Office, Complaining of the Loss of their Perquisites by the Post Office Act; The Case of the Clerks in the Secretary of State's Office, Shelburne Papers, vol. 134, fos. 101-3, 105-17; Kenneth Ellis, *The Post Office in the Eighteenth Century* (London, 1958), 41.

[2] Account of the Annual Allowances made by the Crown to a Secretary of State, and the net money he receives therefrom; Account of the Fees paid by the Secretary of State on his Appointment; Yearly Expence of His Office, &c.; Secretary of State, His Appointments, &c., Shelburne Papers, vol. 134, fos. 128-9, 131-3; Fees in the Secretary of State's Office, *ibid.*, fos. 155, 159-60.

of the sums passing through offices, documents had to be engrossed and recorded, and these services had to be paid for. Many of the services themselves were anomalous and unnecessarily expensive, but they were not corrupt, as Shelburne seemed to think, either in origin or function. Indeed, most of them were survivals of the medieval safeguards of office by which each sum of money and each legal document, in an age when documents were the keys to power, were recorded frequently and in separate records. As time passed some of the safeguards became obsolete and others were developed to supplement them. Since the great Commission of Fees of 1627–40, the fee system had been gradually weakened and progressively replaced, or at least supplemented, by a substantial salary establishment.[1] By 1766 most of the government clerks drew the largest part of their incomes from salaries. The institution of fees was more strongly rooted in the Secretary's office than elsewhere because of the variety of colonial instruments to which fees could be attached. The objection to fees was that they were bad for departmental discipline. They diverted efforts and divided the allegiance of clerks. They also deprived the administration of flexibility. Considerations of establishment and seniority were exaggerated when the prize for them was a lucrative fee-taking position. Anomalous offices were preserved because of their fee incomes and because it would be unfair (and perhaps illegal), especially if the office had a reversionary tenure, to deprive Buggins of his turn. Useless officers were kept in office out of similar considerations.

But there was no strong demand for reform and it was convenient for the Treasury to be able to eke out low salaries, and for politicians to reward dependents and supporters, with a variety of such offices. Their existence was seldom defended on the ground of these material conveniences. A doctrine of prescriptive right had grown up in response to the institutional instinct of the nation, and the clerks in Shelburne's office who petitioned for compensation from Parliament on the ground that their property rights had been abridged were merely stating a widely-held belief in the freehold theory of public office. In 1780 very few Members of Parliament thought Burke's expressed approval of 'places which have been considered as property' out of place in a speech on economical

[1] G. E. Aylmer, 'Charles I's Commission on Fees, 1627–40', *Bulletin of the Institute of Historical Research*, XXI, 58–67.

reform. By 1785 opinion was changing, but Charles James Fox spoke for his own generation's view of public office when he asked:

> Why should not a place, or the emoluments a man received under a grant of the Crown, no matter whether a duty, by fees, or by annuity, or in any other manner, be held as a freehold, as a person's freehold estate?[1]

In 1766 Shelburne decided against putative property rights. When Conway's undersecretary, William Burke, was ordered to prepare a plan for eliminating fees and increasing the clerks' salaries, Shelburne offered to surrender his own fees, amounting to £1,400, toward providing the £2,000 needed to meet the cost of a complete salary establishment. Burke was also ordered to distribute the main business of the office among the five senior clerks (instead of allowing each of them to specialise in one branch), and to secure from the Treasury provision for three clerks in addition to the nine already available in the Southern Department.[2]

The Treasury reluctantly agreed to add the clerks, but refused to make the increases in salaries necessary to suppress fees.[3] There was, besides, no guarantee that future Secretaries of State would be as altruistic as Shelburne (Conway had refused to surrender his fees). The defeat of the proposal left Shelburne convinced that fees were a form of corruption, and determined to suppress them when the occasion offered.

[1] *Parliamentary History*, XXI, 48, XXV, 310.
[2] William Burke to Shelburne, January 1, 1767; 'For the Regulation of the Secretary's Office under the Earl of Shelburne ... containing a proposal of an augmentation of the Clerk's Salaries', Shelburne Papers, vol. 134, fos. 137–40.
[3] Proposed Augmentation of the Clerks' Salaries, *ibid.*, fo. 147.

A Policy for America

Shelburne's most important task in his new office was administering the colonies. In the aftermath of the Stamp and Declaratory Acts the difficulties with America were assuming an almost apocalyptic significance. Attitudes toward the question of imperial sovereignty had hardened in the past eighteen months. Though there was not yet — and perhaps never was — a clear separation of all opinion into anti- and pro-American parties, the main groupings were already set in this form. On the one hand were those who regarded the assertion of British sovereignty over the colonies as an essential measure. Without it, solutions could hardly be approached — let alone achieved — to the detailed problems of settling the American frontier, finding a revenue from the colonies independent of colonial legislatures, and regulating and promoting imperial trade. Even apparent solutions without the assertion of sovereignty would be hollow and specious. Like their twentieth-century successors in the tradition of firm imperial government, they usually had a clear, if narrow, understanding of the elements of efficient administration. They also had an extensive knowledge of the legalities of the constitution and of the economic and political facts of empire. Because they were usually in the government, they were better informed about conditions in the colonies than were their opponents. Grenville, Egremont, Dartmouth, North, Germain and Hillsborough were knowledgeable, and Charles Jenkinson and William Knox erudite, compared to most of the leading figures in the Rockingham and Chatham parties. But though they had a good knowledge of most of the imperial problem, the advocates of a firm line missed the central paradoxical truth that the assertion of British sovereignty was the likeliest way to stimulate a reaction that would overthrow that sovereignty.

Their opponents, with a few exceptions like Burke, Dowdeswell and Shelburne himself, had much less inside knowledge of imperial administration. They tended to dismiss the question of imperial sovereignty as unreal and to urge, with Chatham, that all would be

well if the distinction between external and internal taxation was respected, or with Burke, that expediency rather than legal rights would settle the question. Shelburne himself supported the authority of Parliament over the colonies, but only when there were clear precedents, and he continued to hope to the brink of revolution that that sovereignty might be secured by mutual agreement between the colonies and the mother country. Probably the parliamentary Opposition could not have altered significantly the course of events had they been in office during the American crisis. But to the extent that the policy of conciliating Americans was less disturbing to Anglo-American relations and less actively damaging to British trade with America than the policy of coercion, the pro-Americans were less wrong than the anti-Americans.

Shelburne's own ideas about the empire had been developing since 1758, when as a young subaltern he had met Adam Smith at his father's house.[1] Their association was never very close, though in later life Shelburne attributed his trade liberalism to Smith and Morellet. A more obvious influence was Josiah Tucker. In the summer of 1762, while Shelburne was preparing to push the peace treaty through the House of Lords, he was visited by Tucker, who came to warn the Ministry against keeping Guadeloupe and Martinique in the peace settlement and stayed to discuss imperial economics with his host.[2] Tucker deplored the emphasis currently being placed on territorial empire. He was convinced that the expensive wars necessary to protect it and the restrictions on trade necessary to maintain an imperial economy were fatally hampering the development of the nation's trade and industry. The idea had its effect on Shelburne. In his notes prepared for his speech moving the preliminaries of peace in the Lords on December 9, 1763, he wrote:

> Heretofore the extension of limits was the single point aimed at. But now the possession of territory is but a secondary point and is considered as more or less valuable as it is subservient to the interests of commerce, which is now the great object of ambition.[3]

At the Board of Trade in 1763 he had very little scope even for

[1] W. R. Scott, *Adam Smith as Student and Professor* (Glasgow, 1937), 239–54, 292–8.
[2] Tucker, *Four Letters on Important National Subjects Addressed to the Earl of Shelburne* (3rd ed.; Gloucester, 1783), 2.
[3] Shelburne Papers, vol. 165. William Knox later claimed to have furnished the materials for this speech (*Extra-Official State Papers* (London, 1789), 19).

pursuing these vague mercantile enthusiasms, though he made the most of such opportunity to make colonial policy as the reorganisation of the empire at the peace and the Secretary of State's indulgence permitted. He had the valuable assistance of the Board's Secretary, John Pownall, though the other members of the Board were cyphers and one of them, John Yorke, complained of Shelburne's energetic management of their deliberations.[1] On May 5, 1763, the Board received instructions from the Secretary of State, Lord Egremont, to consider the clauses of the peace treaty relating to the ceded colonies, and particularly to suggest how the greatest possible commercial advantages could be reaped from the new conquests. They were also to suggest what form the governments for these areas should take, what military establishments should be maintained in them, and how a revenue for the support of both civil and military establishments might be secured from the colonies. The government were particularly anxious to have answers to their questions with respect to the great area between the Appalachian Mountains and the Mississippi whose cession had presented them, for the first time, with the problem of ruling a continental empire removed from the influence of sea power. What would the economic significance of this new area be? Would it, as many of their advisers on commercial matters seemed to think, ultimately act as a magnet to drain off the surplus population of the older colonies into harmless pioneer agriculture and thus postpone the concentration of population on the Atlantic seaboard where it would be led to develop manufacturing in competition with British industry? Perhaps the frontier might act as a safety valve, but if it was to do so some immediate problems must first be solved. The pressure of settlement pushing westward into the area, and the resultant lawlessness and disturbance of the Indians there must be controlled. The military government, which had operated since 1758, must be replaced by something more permanent. Egremont drew particular attention to the need for conciliating the Indians and taking account of the special situation created by alien European institutions in the neighbouring province of Canada.[2]

In their answers, Shelburne's Board tried to codify existing practices and mark out tentatively the necessary new lines of

[1] John Yorke to Lord Royston, May 2, 1763, Add. MSS 35,574, fos. 200–1, 204.
[2] Egremont to the Lords of Trade, May 5, 1763, Shelburne Papers, vol. 49, fos. 283–90.

development. If the new difficulties were to be met at all, the day to day administration must be made more efficient. The execution of colonial offices by deputy had become especially widespread during the war, when rewards for political and military service were made by appointment to such offices. Now Shelburne's Board recommended that service by deputy be forbidden and the residence of governors and principal officers be enforced. The financial problem of finding a permanent revenue from the colonies was more difficult. In the light of later developments it is interesting to note that Shelburne's Board considered and rejected proposals to place duties on all colonial exports — this would jeopardise the trade of the empire — and to enforce the collection of quit-rents on Crown lands in the royal colonies — they had too little information about the collection of quit-rents to say whether it was feasible or not. They referred the financial considerations to the Treasury where already the imperial fiscal structure was being refashioned in preparation for producing the Sugar Act in the next year.

The Board could be more definite about the destiny of the new areas. By recommending that representative government be encouraged to develop as quickly as possible in areas where large European settlement already existed or was contemplated soon, they specifically acknowledged that representative government was no longer an adventitious growth in the colonies, but a principle for the guidance of future imperial development. In Transappalachia and the Floridas no settlement would be undertaken for the time being. It might interfere with the trade with the Indians and create communities,

> ... in the Heart of America out of reach of Government, and where, from the great Difficulty of procuring European commodities, they would be compelled to commence Manufactures to the infinite prejudice of Britain.

In the absence of settlement, they continued, no representative institutions need be developed, but it was difficult to decide what form such non-representative government should take. They rejected the suggestion that neighbouring provinces share up the new lands as spheres of influence on the ground that this would disturb the Indian trade. The Board agreed with the Secretary of State on the desirability of ending the existing government; but on the advice of their Secretary, John Pownall, they rejected Egre-

mont's suggestion for governing the area by a civil governor alone, as being at variance with British traditions of civil government on the representative principle. A military government was undesirable, but it was a temporary expedient and while it continued was clearly the servant of the Army and Parliament. A permanent civil government with no representative element was a monstrosity, too reminiscent of Stuart tyranny. Already alarm was being expressed at the long delay in introducing the French and Roman Catholic population of Canada to the benefits of an elected legislature. Was Transappalachia, whose small European population was largely French-Canadian, to have the French régime perpetuated in the person of an authoritarian civil governor? It would be better, the Board advised, to continue the military administration of the area as a temporary measure and encourage the expansion of the Indian trade through the Army's forts and posts. But the Board concluded that specific plans for such administration and estimates of its costs would have to wait until they could get more information from the Commander-in-chief and the Superintendent of Indian Affairs.[1]

Egremont refused to accept this recommendation and on July 14, 1763, again requested the Board to consider creating civil government for the interior, if necessary by assigning part of Transappalachia to the jurisdiction of the Governor of Canada. By the time the Board could reply on August 5, the news of Pontiac's Rising had reinforced their argument in favour of military rule for the area. It was obvious that the condition of the Indians and of the fur trade must require the continuance of military rule, and no civil government, authoritarian or representative, could be contemplated for years to come. Shelburne and his Board enlarged on their previous suggestions by recommending that the Commander-in-chief be made protector of the Indians and regulator of trade; that he be empowered to send all criminals and fugitives from the established colonies taking refuge in the Western Lands back to be tried under the civil jurisdiction in their respective colonies of origin; and that a proclamation embodying these points be published immediately.[2]

[1] Report of the Lords of Trade, June 8, 1763, Shortt and Doughty, *Documents Relating to the Constitutional History of Canada 1759–91* (Cambridge, 1918), I, 132–47; Shelburne Papers, vol. 49, fos. 333–63.
[2] Shelburne Papers, vol. 49, fos. 319–22, 327–32; R. A. Humphreys, 'Lord Shelburne and the Proclamation of 1763', *E.H.R.*, XLIX (1934), 241–64.

D

But neither Shelburne nor Egremont was to have the drafting of the proclamation. Barely a fortnight after Shelburne's second report was delivered Egremont died. Shelburne resigned office on September 2, and the Proclamation of 1763, when it appeared in the following month, was authorised by the new Southern Secretary, the Earl of Halifax, and prepared under the supervision of Shelburne's successor at the Board of Trade, the Earl of Hillsborough. The terms of the Proclamation — that the area be reserved to traders and the Indians under military administration for the time being, and that settlement and government both be postponed, was bound to be unpopular with those Americans who wanted to settle and exploit the new lands. But it was obviously necessary to stabilise the area until more permanent arrangements could be made. The continued administration of Canada under a military governor was similarly intended to be temporary. In the face of growing demands from the few English settlers in the colony that representative government be granted forthwith, Governor James Murray was left by the home government to rule the colony under laws derived from his instructions and ordinances drawn by himself.

In Opposition Shelburne came closer to the realities of imperial economics than he had had time to do in office. In 1764 he met Samuel Garbett of Birmingham, at that time one of the principal partners in the great Carron ironworks near Falkirk in Scotland, and lobbyist extraordinary for the interests of the Birmingham ironmasters. Garbett flooded him with homilies on the needs of trade and the necessity for politicians to understand them. In the midst of the agitation of the merchants of London and the outports against the Stamp Act in the autumn of 1765, he suggested the organisation of a permanent body of members of both Houses of Parliament devoted to keeping open the trade of the country, and hoped that Shelburne would lead it.

Garbett placed particular emphasis on the stagnation of the economy which had set in after the war, and on its effects on British industry. This stagnation was to hang like a dark cloud over the life of the country for the next twenty years, but its effects were particularly severe and unsettling in the 1760's. The woollen cloth industry of the West Country was on short time; so were the coal and iron industries. Only the building industry, under the noses of the politicians in London, seemed at all flourishing. Harvests were

poor. Even before 1765 there was a shortage of meat and milk, and
the wheat and oat crops of 1764 were bad. But worse was to come.
The winter of 1765–6 was very wet and followed by a drought in
the summer of 1766 which resulted in an exceptional shortage of
meat. The government placed restrictions on the use of grain —
some of them, such as Chatham's embargo on grain exports in the
summer of 1766 causing particular agitation among the libertarian
enthusiasts in Opposition — and foreign wheat was allowed into
the country duty free. Nevertheless there was great distress,
especially in the industrial areas of the Severn Valley and in
London. There were food riots every spring in the years 1766, 1767
and 1768, on which the politics of Opposition, and in particular of
the City, fed. At the same time there was a depression in overseas
trade. The most serious decline was in shipments to Germany,
which dropped by half between 1764 and 1769. In addition,
largely as a result of the Stamp Act disturbances, shipments to the
American colonies dropped by one-quarter between 1764 and
1766. Garbett reported the suffering of thousands of artificers at
Birmingham in the miserable winter of 1765–6, and was very sure
that this was the consequence of the government's misguided
attempts to tax America which had interrupted the flow of
American trade just when it was beginning to rise after the war.[1]

Shelburne was already convinced that the economic interests of
the mother country and the colonies must be harmonised, but he
was not really sure how it could be done. For a moment during the
attack on the Stamp Act in the winter of 1765–6 he seemed to
favour the Rockingham Ministry's proposal to balance a repeal of
the Stamp Act with an assertion of parliamentary sovereignty.
He tentatively suggested to Pitt that repeal would not accomplish
much unless accompanied by 'some circumstances of a firm con-
duct and some system immediately following a concession'.[2] But he
did his best against the Declaratory Bill in the Lords, pointing to
the recent refusal of the Austrian Empress to tax her Belgian
subjects as a model for Britain to follow, and making one of the

[1] See my articles: 'Samuel Garbett and the Early Development of Industrial
Lobbying in Great Britain', *Economic History Review*, 2nd Ser., X, 450–60, and
'The Struggle for Carron: Samuel Garbett and Charles Gascoigne', *Scottish
Historical Review*, XXXVII, 136–45; T. S. Ashton, *Economic Fluctuations in
England, 1700–1800* (Oxford, 1959), 22–3, 151–5; Elizabeth B. Schumpeter,
English Overseas Trade Statistics 1697–1808 (Oxford, 1960), *passim*.
[2] Shelburne to Pitt, Pitt to Shelburne, December 21, 1765, *Chatham Corr.*, II,
353–61; Pitt to Shelburne, February 24, 1766, Fitzmaurice, *op. cit.*, I, 263.

minority of five who divided against the Act on the third reading.

He played a more active part in the spring when Burke's attempt to liberalise the West Indies trade split the merchant community. His own and Garbett's friends, the merchants trading to North America, demanded repeal of the Sugar Act of 1764 and the legalisation of American trade with the Spanish and French West Indies. In this way, Garbett explained, the American provision trade with the West Indies would be stimulated, providing the Americans with a surplus with which to buy British manufactures. Of course the Americans would also have to buy from the French and Spanish, and there was no reason that Garbett could see why the sale of French sugar should not be permitted in America on equal terms with British sugar.[1] But for the West Indies merchants, led by William Beckford, there was every reason in the world why their sugar trade should not be flung into unprotected competition with the much more robust trade of the French. Shelburne pointed out to Pitt how necessary it was for the prosperity of the country to stimulate the American trade, and Beckford how necessary to protect the Sugar Islands. Pitt tried to avoid committing himself to either, but eventually decided in favour of the North Americans, not so much because of Shelburne's persuading as because parliamentary opinion was setting strongly in that direction.[2] The Rockingham Ministry, who had also tried to get out of deciding between the two groups, eventually found a compromise in a bill creating a limited free port in Dominica, and made some modifications in the Sugar Act which made no serious impression on the sugar interests' protective shield. Then the Ministry fell and Chatham and Shelburne were given the opportunity to see whether they could cure the ills of empire which had resisted the firmness of the Grenville Ministry and the firm kindness of the Rockinghams.

At the beginning they had still to make a policy, a process dependent upon, and at the mercy of, Chatham's uncertain attitudes. He had been the principal champion of conciliation in Opposition, and he may have had some large scheme of devolution

[1] 'Thoughts on the Colonies by S.G.', Shelburne Papers, vol. 49, fos. 21–4; Garbett to Shelburne, April 2, 1766, Bowood MSS.

[2] Add. MSS 32,974, fo. 348; Add. MSS 32,975, fo. 58; Burke to Charles O'Hara, April 23, 1766, Copeland, *Burke Corr.*, I, 251–2. *Chatham Corr.*, II, 417–18, 420; Shelburne to Chatham [April 1766], Chatham Papers, vol. 56, fo. 64.

which he hoped to apply once the quarrels with the colonies had all been settled. But it required only a short continuation of the New Yorkers' resistance to the application of the British Mutiny Act to their colony, and only a few complaints from the other provinces about the widening jurisdiction of the Vice-Admiralty courts in America, to show how unreliable a quality Chatham's conciliatoriness was. At first he imagined that the news of his return to office had quieted the tumult in America, but he was soon convinced that a 'perverse infatuation' had siezed the colonists, a conviction exaggerated by the onset of his gout and his isolation from affairs in the winter of 1766–7. His rage grew as the New York legislature continued to resist the Mutiny Act and the Massachusetts legislature accompanied a grudging compensation for the Stamp Act riot victims with a wholly unacceptable indemnity for the rioters. In the middle of February 1767, he wrote to Grafton and Shelburne that the disobedience of New York was so weighty a matter that it ought to be laid before Parliament.[1] Shelburne had at first suggested that the trouble was 'only the remains of the storm, and wants a little good humour and firmness to finish'. He did his best to conciliate the extremes, reproving the merchants trading to America for petitioning in support of New York, urging moderation on General Gage at Boston. To the King and his own colleagues he expressed the hope that they and Parliament would take care to distinguish between New York and America in framing punishments.[2] He resisted as long as he could Chatham's demand that the matter be put before Parliament, hopefully citing Northington's opinion that the choice of what was put before Parliament concerning the colonies ought to be left up to the Secretary of State.[3] He was very conscious that the spirit in Parliament that spring was all for taking a firm line with all the American colonies, and of the danger that that implied for the future.

... whatever the conduct of New York, or even of America may be

[1] Chatham to Grafton and Shelburne, February 17, 1767, *Chatham Corr.*, III, 214–15.
[2] Shelburne to Chatham [September 20, 1766], [February 12, 1767], Cabinet Minute, August 5, 1766, Chatham Papers, vol. 56, fos. 60–1, 74–5, vol. 97; Shelburne to Gage, September 13, 1766, Clements Library, Gage Papers, English Series, vol. 8; Shelburne to Sir Henry Moore, October 11, 1766, P.R.O., C.O. 21/227, p. 7; Shelburne to Chatham [February 6, 16, 1767], *Chatham Corr.*, III, 191–3, 206–11.
[3] To Chatham, Thursday night [February 12, 1767] Chatham Papers, vol. 56, fos. 74–5.

[he wrote to Chatham], arising from ... diffidence and excess of apprehension ... it were to be wished not to establish a precedent in whatever is done, which may hereafter be turned to purposes of oppression, and to promote measures opposite to those general public principles upon which the Stamp Act was repealed ... [and] if these infatuated people should be tempted to resist in the last instance ... I think it too plain, from the accounts we daily receive, that France and Spain would no longer defer breaking a peace, the days of which they already begin to count.[1]

But Chatham was not impressed by the shape of things to come. The matter must be laid before Parliament 'in order that His Majesty may be founded in, and strengthened by the sense of his grand council', in enforcing the Mutiny Act. The supporters of firmness, who had been alarmed by Chatham's return to office, breathed easier again.

They had a somewhat erratic supporter in one of Shelburne's undersecretaries, Maurice Morgann. An accomplished critic of the drama, Morgann was inclined to take a rather theatrical view of the successive crises of imperial policy. He agreed with his principals that parliamentary taxation of the colonies must be avoided,[2] but he was as full of devices for exercising the substance, if not the legal form, of British sovereignty and for taxing the colonists without the assistance of parliamentary authority as was Charles Townshend.[3] He it was who revived the scheme of quit-rents, which Shelburne was to advance as his contribution to solving the problem of the American revenue.

This problem was the irritant which kept the question of sovereignty open like a running sore in the body of the empire. It was aggravated by the financial difficulties of the British government at the end of the war. The rather light-hearted attitude towards the national debt which had prevailed since Henry Pelham's day was being modified in the light of the debt of £128,564,808 which remained at the end of the Seven Years War to be managed by a national revenue whose annual yield seldom rose above five million. Government servants like Charles Jenkinson were already warning that the funding system was inadequate to meet the needs of the state, and the Chancellors of the Exchequer

[1] [February 16, 1767], *Chatham Corr.*, III, 209.
[2] Shelburne Papers, vol. 48, fos. 193–221, vol. 85, fos. 71–6.
[3] In April 1767, for example, he suggested the impeachment of James Otis for 'treasonably' encouraging smugglers (*ibid.*, vol. 49, fos. 711–19).

from George Grenville on were constantly looking for new sources of revenue.[1] One way to solve the problem was to shift colonial administration costs to the colonies where most Englishmen thought they rightly belonged. A colonial revenue was also necessary if the claims of imperial sovereignty were ever to be enforced effectively. The experiment of the Stamp Act had failed; but to those who believed in the need for a colonial revenue that did not seem to be any reason for giving up the quest. The Treasury was particularly anxious to unload the costliest item in colonial administration, that of the military establishments in the Western Lands.[2]

The Western Lands were in a particularly lawless and unsettled condition. The Proclamation of 1763 had provided in principle for an Indian reserve and a controlled fur trade in the area, and the Board of Trade had sketched out regulations to implement it. But essentially the government of the country was still the supposedly temporary military one established in the closing years of the Seven Years War, modified by the centralisation of Indian affairs and a limited civil jurisdiction in the hands of two Indian superintendents. Law and order had not been established in the Western Lands, but the interference of the authorities was just enough to infuriate the merchants, land speculators and sutlers who swarmed like locusts into this new Promised Land.

The home government knew it must find some better arrangement. In May 1766 Lord Barrington, the perennial Secretary at War, suggested abandoning the area to whatever control the separate American provinces might choose to exercise over it, and consolidating the British troops in North America in garrisons in Nova Scotia and East Florida. He argued that the trade of the Mississippi Valley was neither valuable nor accessible to British sea power; that the Western Lands, because they too were thus inaccessible, would become manufacturing centres and hence trade rivals of Britain; that the Indians could and would come to the settled colonies if they wanted to trade; and that the British now had an assured monopoly of the Indian trade in any case.[3]

Barrington was more interested in reducing the Extraordinaries of the Army than in imperial administration; but his suggestion

[1] Cf. Eric Hargreaves, *The National Debt* (London, 1930), 73–90.
[2] Cf. Thomas Bradshaw, Secretary of the Treasury, to Shelburne, September 4, 1766, Shelburne Papers, vol. 57, fo. 235.
[3] Lord Barrington's Plan [May 10, 1766], *ibid.*, vol. 50, fos. 45–51.

was supported by a particularly powerful lobby just then being
mounted by the Philadelphia trading company, Boynton, Morgan
and Wharton, with the encouragement of Sir William Johnson,
Benjamin and William Franklin and General Phineas Lyman.
Their aim was to get permission to develop a new permanent
settlement and government in the Illinois country. But where
Barrington justified British abandonment of the Western Lands to
the provinces to save money, they justified it on the ground that
trade to be successful must be free, and if successful would serve
as a useful medium for civilising or, if necessary, exterminating,
the Indians.

The Commander-in-chief in North America, General Gage, and
most of the officials in America, as well as General Amherst in
England, disapproved of Barrington's scheme but rather favoured
the idea of a new colony in the interior.[1] In Whitehall the balance
of opinion tended the other way: the Treasury liked Barrington's
scheme because it would save money; the Board of Trade disliked
the idea of the new settlement because it would conflict with the
established policy of protecting the Indians from exploitation by
the white settlers and because 'according to recent advices there is a
necessity for speedily making general regulations for the whole
area upon one uniform Plan, as may remedy the disorders which
have prevailed therein'.[2]

These various propositions were now brought to Shelburne for a
decision. At first he agreed with the Board of Trade that the
Indians must be protected and that any policy must be 'well-
digested', yet retreated steadily before Franklin's skilfully
marshalled arguments and the almost interminable memoranda of
General Lyman.[3] Some time in the autumn of 1766 he gave orders
for a general review of the policies pursued up to that time and the
proposals made in the different branches of government for secur-
ing the sovereignty of the mother country. The relevant documents
to be considered for the latter purpose were Barrington's proposal,
the plan of regulation made by Hillsborough at the Board of Trade

[1] *Ibid.*, vol. 50, fo. 51; 'Things to be Considered of in North America', *ibid.*,
vol. 49, fos. 17–24.
[2] Lords of Trade to Shelburne, September 3, 1766, P.R.O., C.O. 5/66, fos.
363, 367; C.O. 323/18, fo. 535; cf. *Illinois Historical Collections* (Springfield,
1916), XI, 245, 333–5, 338; Shelburne Papers, vol. 48, fos. 95–111.
[3] Shelburne to the Lords of Trade, August 16, 1766, Shelburne Papers, vol.
53, fos. 13–14; to Gage, September 13, 1766, Gage Papers, English Series, vol.
8; *Illinois Historical Collections*, XI, *passim.*

in 1764 and since partially implemented, and a general proposal for the reduction of American expenses which was put forward by Charles Townshend, Chancellor of the Exchequer.[1] These Shelburne submitted to various people for review and recommendations. But this consulting of opinion was more apparent than real. His advisers included Benjamin Franklin and Richard Jackson,[2] the leaders of the Western Lands lobby, and it was upon their comments on Hillsborough's regulations and Barrington's plan that his later policy was largely based.

The shape of that policy emerged gradually in the course of the next six months. In November and December he wrote to General Gage that the Board of Trade had been asked to consider the effects of instituting Barrington's plan and turning Indian affairs over to the provinces to administer. He had come to the conclusion that establishing a new colony in the west would solve the administrative problem and allow the western garrisons to be reduced without risk to British power in the area, and that the regulation of the fur trade might be taken out of the hands of the Indian superintendents and turned over to the provinces. He also gave his own solution to the problem of securing a revenue from the colonies.

The most obvious manner of laying the foundation for such a fund [he wrote] seems to be by taking proper care of the quit-rents, and by turning the grants of lands to real benefit, which might tend to increase rather than diminish the powers of Government in so distant a country . . . it is far, however, from his Majesty's intention that any rigour should be exercised in respect of quit-rents long due, but nothing can be more reasonable than that the proprietors of large tracts of land (which ought by the terms of the respective grants to have been cultivated long since) should either pay their quit-rents punctually for the time to come, or relinquish their grant in favour of those who will.[3]

[1] 'Things to be Considered of in North America', op. cit.
[2] Richard Jackson (ob. 1787), 'Omniscient Jackson' of Dr. Johnson's famous definition, was M.P. for Weymouth and Melcombe Regis (1762–8) and New Romney (1768–84). He was a follower of Shelburne at first, gravitated to Grenville between 1763 and 1765 (he was Grenville's private secretary in 1765), voted against the Stamp Act in 1765 and for its repeal in 1766. As standing counsel to the South Sea Company from 1764 and legal officer of the Board of Trade, he was active among financial groups in the City and in the East India Company. In 1782–3 he was a member of Shelburne's Treasury Board. Because of his special knowledge of trade and his position as agent for Massachusetts (1765–7) and Connecticut (1770–5), he was usually consulted by the Opposition on American affairs.
[3] Shelburne to Gage, November 14, 1766, Shelburne Papers, vol. 54, fos. 5–11; same to same, December 11, 1766, Gage Papers, English Series, vol. 10.

If the House of Commons was going to insist on finding a revenue from America, then the quit-rents might provide enough of an appearance of one to satisfy them and at the same time not reawaken the outcry from the Americans, so recently quieted by the repeal of the Stamp Act. The plan had plenty of precedents. From time to time the Board of Trade exhibited a desultory concern to make quit-rent collections more efficient and more remunerative; Shelburne himself had taken note of the matter in 1763; and in June 1765 the Board had issued instructions to the governors to tighten up the administration of land grants and quit-rents.[1]

A more immediate pressure on Shelburne to find a colonial revenue was coming from the Chancellor of the Exchequer, Charles Townshend, who demanded that he reduce the costs of American administration or let someone else try. On October 20 Thomas Whateley reported to George Grenville:

> A wild project is talked of for paying off the Civil List debt, and providing an American revenue both together. It is only supposing that the quit-rents in the colonies, if properly collected, will be sufficient to support the military establishments there.[2]

But Shelburne was in no hurry to begin the experiment. It was not until December 11, at the time he informed Gage of his intentions, that he circularised the colonial governors asking for an estimate of the colonial establishments and an account of the manner of collecting quit-rents and granting lands; and he apparently hoped to be able to cull some scheme for improving quit-rent collection from the governors' reports.

In the New Year Townshend grew more demanding, and with good reason. On January 26, 1767, during consideration by the Commons of the Extraordinaries of the Army, George Grenville moved for the reduction of the expenses to the Treasury of governing America and for the withdrawal of troops from the frontier areas. Grenville's immediate purpose was not to secure the evacuation of the garrisons, but to create an issue of economy on which to rally his supporters among the country gentry. He almost

[1] 'Hints Respecting the Civil Establishment in the American Colonies', Shelburne Papers, vol. 48, fos. 503–21; 'Hints Respecting the Military Establishments in America', Add. MSS 38,335, fos. 27–8; *Acts of the Privy Council, Colonial Series, 1766–83* (London, 1912), VI, 646.
[2] *Grenville Papers*, III, 334.

succeeded, but Townshend was too quick for him. Sneering at Chatham's artificial distinction between external and internal taxation for America, and likewise agreeing with Grenville on the justice (though not the expediency) of the Stamp Act, Townshend promised to find an American revenue which would be [Shelburne reported to Chatham] 'if not adequate . . . yet nearly sufficient to answer the expense when properly reduced', through the establishment of an American board of customs and 'by a regulation of the tea duty here, and some other alterations, to produce a revenue on imports there'. Shelburne warned that Townshend's speech introducing the proposal would be unpopular in America. On the other hand, an unobjectionable revenue might be found from quit-rents, though no plan could yet be made until more was known of American conditions.[1]

Chatham in his reply ignored the immediate question of finances and concentrated on deploring the current 'infatuation' of New York in resisting the Mutiny Act. He came to the unhelpful conclusion that 'whether these clouds will pass away or not is to me very problematical. One thing is still always clear; that in pursuing steadily one's duty one cannot lose one's way.'[2] Though the Cabinet marked time impatiently in hopes that something further would come forth from the oracle, Chatham would only suggest an appeal to Parliament to discipline New York.[3]

On February 27 Townshend allowed the Ministry to be defeated in the House of Commons and himself to be pledged to reduce the Land Tax from four to three shillings in the pound. Now a reduction in American expenses and the establishment of an American revenue seemed more necessary than ever. At a Cabinet meeting on March 12 Townshend threatened to withhold the budget unless the Cabinet determined on a policy for reducing American expenses which he could report to the House. The residue of such expenses, he stated, could be met by the duty on American external trade which he had already promised the House should be levied. Townshend, as Shelburne suggested to Chatham, may have been particularly obstreperous because of Chatham's recent unsuccessful attempt to replace him at the Exchequer by Lord North,

[1] Shelburne to Chatham, January 31, 1767, *Chatham Corr.*, III, 182–8.
[2] Chatham to Shelburne, February 3, 1767, *ibid.*, 188–90.
[3] Shelburne to Chatham [February 6, 1767], [February 16, 1767], Chatham to Shelburne, February 7, 1767, *ibid.*, 191–3, 193–4, 206–10; Chatham to Grafton, February 17, 1767, *Grafton Autobiography*, 119.

but there is no doubt, too, that he was growing impatient over the delay in implementing the suggestions of Barrington and himself for reducing expenses. Chatham, offered a last chance to settle the question, pleaded his inability to suggest any new plan for the administration of America, concluding that he would acquiesce in the opinion of the Cabinet.[1] In fact he was sinking rapidly into that mental disorder or retreat from responsibility which was soon to destroy his government. To Chatham it was coming to be all the same whether Parliament or the Cabinet searched for a solution to the imperial problem which was now — and perhaps always had been — beyond his comprehension.

It was the East India Company, not America, which provided the principal point of difference among his followers. His schemes for regulating the East India Company had all the characteristics of a stunt play to mass opinion: — the insistence on establishing the state's rights to the Company's territorial revenue; the determination to have the matter decided in Parliament where the prejudices of the City radicals and the country party would have full play; the various hints that a great resource would be made available to the nation (resulting, no doubt, in the reduction of domestic taxation);[2] the dark suggestions that the Directors of the Company were unrighteous stockjobbers who were trying to cover something up; and, most notably, the choice of William Beckford, the City demagogue, rather than Shelburne, the only Cabinet minister with influence in the Company, to introduce the enquiry in Parliament. These tactics united against them the majority of the Company's Directors and Proprietors, the various elements of the Parliamentary Opposition, and Townshend and General Conway in the Cabinet. On the other side, Shelburne's ally in the Company, Lawrence Sulivan, tried to negotiate an agreement on his own between the Directors and the Ministry.

Chatham's collapse and the failure of Beckford's parliamentary campaign left the field clear for Shelburne to intervene and save something of the Ministry's influence in the Company. From the second week in March to the middle of May Sulivan, trying to

[1] Shelburne to Chatham, Friday morning [March 13, 1767], *Chatham Corr.*, III, 233–6; Chatham to Grafton, Friday, ½ past Eleven [March 13, 1767], Grafton MSS 572.
[2] The general expectations may be judged from the King's note to Grafton of December 9, 1766, expressing his conviction that 'this is the only safe method of extricating this country out of its lamentable situation owing to the Load of Debt it labours under' (Grafton MSS 485).

make a place for himself at the head of the Company, and Shelburne, trying to keep his in the Ministry, threw all the energy they could spare from other preoccupations into securing a negotiated settlement between the Ministry and the Court of Directors and (which was much more difficult) securing the ratification of that agreement by the General Court of the Company and by the House of Commons. After complicated manoeuvres during which Sulivan led a revolt of the Proprietors and legislation was introduced to limit the dividend paid to proprietors and to regulate their voting qualifications, the agreement was made.[1] But in the process Shelburne had alienated Townshend and Conway past reconciliation and had not arrived at that policy for America whose formulation was so necessary if Townshend's American duties scheme was to be forestalled.

Meanwhile, at the end of March the reports from the colonial governors on expenses and quit-rents had started to come in. No quit-rents were collected in New England; in New Jersey, Pennsylvania and Maryland they produced nothing; no system had been developed in the Floridas, and most of the other colonies yielded almost nothing or their land records were in such a chaotic state as to render accurate account impossible. Even in Virginia, where there was some glimmer of hope, the arrears far exceeded the collections.[2] Not surprisingly, a memorandum prepared in Shelburne's office and embodying his views, argued strongly against rushing into any plan of reform for that year ('it is not at the close of a Session that measures of such consequence should be hurried on crude and undigested'). On the subject of the American revenue, the author of the memorandum suggested in addition to future regulation of quit-rents,

> such aids as may be beneficial to the Colonies, at the same time that they lessen the Burthen of the Mother Country, but chiefly on Requisitions from the different Provinces to be granted annually by their Assemblies according to their respective Abilities.

To return to the old system of requisitions was to confess defeat, but Shelburne still played for time, asking that the Cabinet wait until all the answers from the colonial governors were in. 'The affairs of America [ran the memorandum] cannot suffer much by

[1] Lucy Sutherland, *The East India Company in Eighteenth-Century Politics*, 146–76.
[2] Shelburne Papers, vol. 55, fos. 140–9, 150–3, vol. 51, fo. 540.

going on one more year in the Channel they have hitherto done, and
that year is short enough time for furnishing a Plan capable of
correcting past, and preventing future, Abuses.'[1]

It might be just possible to stave off the Townshend scheme if
the American expenses could be sufficiently reduced. The returns
of the governors hardly indicated that such a reduction was
possible, and Shelburne set his undersecretary, Lauchlin Macleane,
burrowing in the Council Office for more material. But the results
were so unsatisfactory that appeals had to be made to the Treasury,
the Board of Trade and the Admiralty for accounts of the establish-
ments of the governors, judges and other colonial officers.[2]

Before this new inquiry could bear fruit the focus of attention
shifted as the Cabinet prepared, toward the end of April, to enforce
the Mutiny Act in New York. Four possible courses were con-
sidered: giving the governor absolute power to billet troops, which
everyone rejected as against the traditional allowance of free
quarter for the troops; Conway's impracticable scheme for an
extraordinary port duty to be levied on New York; the appropria-
tion by Parliament of a provincial revenue for the service of the
troops, as had been attempted in 1710; and Townshend's plan for
an address to the Crown 'to assent to no law whatsoever till the
Mutiny Act was fully obeyed'. Lord Northington opposed this as
being applied to only one province, and as being beyond the
powers of the Crown itself to do, but suggested that it could be
managed by an Act of Parliament, and in that form it was agreed
to by the Cabinet. Shelburne, however, was very unhappy about
the decision. He was convinced that it was an unprecedented, and
perhaps unconstitutional exercise of the prerogative and of Parlia-
ment's power over the colonies, and that it was encouraging the
prerogative doctrines which the Opposition had been combatting
for years. But because Camden insisted that it was all right, he kept
quiet in the Cabinet. Instead, he proposed to Chatham that a fifth
plan be adopted — an act reciting the Declaratory Act and the
disobedience of New York, forgiving the colonists for past offences,

[1] Paper endorsed: 'Reasons for not diminishing American Expence, 30 March,
1767', Shelburne Papers, vol. 85, fos. 103–10. From the endorsations to this
paper in Shelburne's hand it appears that he used it as an outline for his
arguments to the Cabinet or perhaps presented the paper itself.
[2] Lauchlin Macleane to Shelburne [April 1767], *ibid.*, vol. 57, fo. 227;
Shelburne to the Lords of Trade, April 9, to the Lords of Admiralty, April 28,
1767, *Calendar of Home Office Papers, 1766–69* (London, 1879), 167, 169–70;
Report of the Board of Trade on Establishment of Salaries, April 16, 1767, C.O.
324/18, p. 148.

but making it high treason to disobey Acts of Parliament in the future, and enforcing the act by military power and the trial of offenders in Britain. The administration of this act ought to be in the hands of 'persons of dignity and resolution', who

> ... may be ready to come to every Dignified Explanation to shew the unreasonableness of the Conduct of the Colonists even on their own principles, since the Repeal of the Stamp Act was enough to shew them it was the decided policy of Parliament not to levy an Internal Tax in point of policy.

He concluded by confiding in Chatham's 'regard to liberty' and experience to decide the best plan to follow.[1]

But Townshend had the initiative. He was living in a perpetual excitement, warning Grafton against reneging on the coercion of New York,[2] acting as the erratic ally of the Opposition on the East India Dividend Bill, and pushing forward with his American revenue plan. The House was due to go into committee on America on May 5, but when the day came the debate was postponed to the 13th because Townshend was ill and unable to attend Three days later he had recovered sufficiently to deliver his famous 'Champagne Speech', directed against Grafton and Shelburne.

The Cabinet met on May 9 in what must have been a highly charged atmosphere to agree on means for coercing New York and securing an independent American revenue. The latter, they agreed, would be looked for in the first instance from Shelburne's quit-rent scheme; and as a supplement Townshend was to prepare his plan for an American customs service. But time was short. The plans must be ready when Townshend presented the financial resolutions on May 11 — in two days' time.

Time had run out for Shelburne. He had no policy ready; indeed, he already had enough information from the governors to show that quit-rents were hopeless as a source even of the token revenue which he had hoped would satisfy the House of Commons. He promised the plan for Sunday, May 10, but when Sunday came there was nothing ready. On the morning of May 11 Townshend wrote to Grafton that he

> ... sincerely laments that the opportunity has not been taken of soliciting His Majesty's assent to the proposition of independent

[1] Townshend to Grafton, April 23, 1767, Grafton MSS 452; Shelburne to Chatham [April 26, 1767], Chatham Papers, vol. 56, fos. 86–90.
[2] Townshend to Grafton [April 1767], Grafton MSS 453.

salaries for the civil officers of North America: especially as he has pledged himself to the House for some measure of this sort; and had the assurances of Lord Shelburne in the last Cabinet for the whole extent of the establishment and the D. of Grafton on Saturday adopted the idea at least as far as New York. In this distress, Mr. T. does not think he can with honor move the resolutions this day, and therefore hopes either to have the authority or that some means may be found of postponing the matter for a day or two till he can receive it. He feels his honor absolutely at stake![1]

The resolutions were postponed until May 13 and in the interval Townshend put the finishing touches to his own plan. In his *Autobiography* Grafton claimed that Townshend's proposal for the American board of customs had the Cabinet's consent, but that his proposed taxes on American trade were adopted 'contrary to the known decision of every member of the Cabinet'. It seems more likely that in the emergency after Shelburne's collapse, Townshend was able to persuade Grafton to agree to the alternative. On May 13, therefore, Townshend introduced his duties and on the same day the Privy Council disallowed the Indemnity Act of the Massachusetts Legislature and the House of Commons gave first reading to a bill for suspending the legislative powers of the New York Assembly. A proposal by Shelburne to recall the unpopular governors of Massachusetts and New York was dropped.[2] The policy of coercion was adopted, but largely for want of an acceptable alternative. Given the determination to secure a revenue from America, there could be no other result. Shelburne's hopes of success ultimately rested on a tacit surrender of the colonial revenue.

After this humiliation, Shelburne withdrew more and more from his colleagues. He had been useful enough to the Ministry in adjusting the controversy with the East India Company; but most of the members of the Cabinet had been irritated by delays of business in his office and none of them had any personal friendship for him. Both the King and Grafton complained of him to Chatham, and Northington hopefully imagined that he saw signs of Shelburne preparing to resign.[3]

On June 11 Northington reported to Grafton that Shelburne in

[1] Townshend to Grafton [May 10, 1767], Grafton MSS 441, 445; cf. King to Grafton, May 10, 1767, *ibid.*, 496.

[2] *Grafton Autobiography*, 127, 137; R. A. Humphreys, 'Lord Shelburne and a Projected Recall of Colonial Governors in 1767', *A.H.R.*, XXXVIII (1932), 269–72.

[3] *Chatham Corr.*, III, 260–1; *Grafton Autobiography*, 138, 175–6.

the Royal Closet was 'beginning a long account of the State of Ama., his having got to the mastery of it, and yesterday recd. genl. directions thereon from the K. &c.'[1] This was presented now in the hope that Townshend's duties might yet be forestalled. Essentially it was a précis of the comments made by Franklin, Jackson and others on the Hillsborough memorandum, to which he added an explicit declaration in favour of turning back the management of Indian affairs to the colonies and a defence of throwing the Indian trade open on the ground that all trade to be successful must be free. The perennial argument that the development of American manufacturing could be thus prevented was added for good measure. So were the arguments of Gage, Johnson, Lyman and James Amherst in favour of new colonial governments in the Western Lands. The frontier garrisons would be supported, the Indians civilised, and British trade profitted. As for the cost of these new governments, quit-rents would not only defray the expense but form a fund for other purposes, 'especially if the grants of lands were put under proper checks'.[2]

The plan was left with the members of the Cabinet to study during the summer, and with the end of the Session came a lull in the controversy. That summer Charles Townshend's 'brilliant orb' sank, glowed fitfully on the horizon, and suddenly went out. He had been dead a week when a thinly-attended Cabinet finally came to consider Shelburne's scheme on September 11, and promptly referred it to the Board of Trade for an opinion. The Board objected that it would aggravate, not correct, the problems of the frontier and it would not secure a colonial revenue. Shelburne proposed a compromise under which questions of trade and the direction of settlement would be controlled by the colonies while political relations with the Indians, purchase of land and the direction of settlement would be left to the Superintendents of Indian Affairs.[3] The gesture was halfhearted and unsuccessful.

[1] *Grafton Autobiography*, 175–6.
[2] 'Minutes Submitted to the Cabinet in the Beginning of Summer 1767 — relative to the System of Indian Traffic', Shelburne Papers, vol. 50, fos. 185–217; cf. 'Plan for the Future Management of Indian Affairs', Proposed when Ld. Hillsborough was at the Head of the Board of Trade, *ibid.*, fos. 356–83; R. A. Humphreys, 'Lord Shelburne and British Colonial Policy, 1766–1768', *E.H.R.*, L (1936), 257–77.
[3] Cabinet Minute, September 11, 1767, *ibid.*, vol. 161; 'Considerations submitted to the Board of Trade Relative to the Superintendance of Indian Affairs', October 5, 1767, *ibid.*, vol. 50, fos. 173–83; Paper endorsed in Shelburne's hand: 'The Substance of what passed between Mr. Dyson and me in regard to the Superintendents &c. given afterwards to Lord Clare', *ibid.*, fos. 219–26.

E

The Board prepared a final report. But with the coming of the New Year the whole question was swept out of Shelburne's hands with the creation of the Third Secretaryship of State.

Now Chatham's eclipse was having its predestined effect on Shelburne's career. In the spring of 1767 he could still co-operate with Camden and Grafton as one of the keepers of the Chathamite faith. But soon he found himself in a minority of one in Cabinet deliberations and the more frequently this happened, the more frequently he appealed to Chatham and the more insufferable his air of solitary virtue seemed to his colleagues. He was left out of the negotiations of July 1767 designed to bring reinforcements to the Ministry, though it is hard to believe his subsequent claims that he knew nothing about them. Rumours of his impending dismissal had been current since the spring, and at one point the King offered to create a secretaryship for the colonies out of Shelburne's department for Conway as an inducement to fix that political Hamlet in his allegiance.[1] In October Shelburne contemplated resigning and only held on, so he told Lady Chatham (who had become a sort of wailing wall for the leaderless Chathamites), out of deference to her husband's last expressed wishes.[2]

When, toward the end of November, the Bedfords finally agreed to join the Ministry, one of their principal stipulations was that Shelburne must be removed from the Southern Department. Grafton and the King hoped to push him to resign by dividing his department. But Grafton piqued Shelburne to hold on by referring vaguely to the inefficiency of his administration of the Southern Department. Since neither Grafton, Camden nor the King wanted to see the new American Department in the hands of the Bedfords, they offered it to Shelburne. But he was sick of American affairs, and he was sure that the new recruits to the Ministry would direct the American policy whatever he did. As he explained his difficulties to Sir John Eardley Wilmot:

> I have such a tendency on the one [hand] to rid myself of it entirely. On the other hand a great desire to finish well toward Lord Chatham, with whom I embark'd, and a wish above all not to act foolishly, so as to gratify those that don't wish me well and hurt perhaps those that do, that I am really embarrass'd very much what part to take.[3]

[1] *Grafton Autobiography*, 153–4; *Chatham Corr.*, III, 294; *Grenville Papers*, IV, 28, 32, 136–7; Fortescue, I, no. 548.
[2] October 9, 1767, *Chatham Corr.*, III, 286–7.
[3] December [12] 1767 (copy), Add. MSS 9828, fos. 108–9.

Eventually he decided to stick to the now truncated Southern Department.

He was completely isolated and his departure from the Cabinet only a matter of time. Grafton, the King and the Bedfords were determined on it and even the weak-willed Camden agreed that it was necessary. Henceforth he was the 'avowed enemy' whom the King claimed to have identified months before. While they waited for their chance to get rid of him, Shelburne lost no opportunity to blame Grafton for his apostasy from the Chathamite faith and to quarrel with his other colleagues. With Conway he opposed the Ministry's decision to coerce Massachusetts in the spring of 1768; with Rochford he tried unsuccessfully to save the British Iberian trade from falling victim to the protectionist regulations of Charles III and Pombal, and to prevent the annexation of Corsica by France. After a short hesitation, he also joined Camden in opposing the explusion of Wilkes from the House of Commons, and thereby altered the course of his career.[1]

In June 1768 began the final stage of his break with the Ministry when he quarrelled with the Bedfords over diplomatic patronage. Grafton appealed to the King who referred the dispute vaguely to 'those usually consulted in state affairs'. Both Grafton and Shelburne were prisoners of loyalty to Chatham: Grafton afraid to dismiss Shelburne, Shelburne afraid to resign, without Chatham's consent. Camden made some ineffectual attempts to patch up the quarrel, then agreed with Grafton (his new 'Pole star') that Shelburne must go.[2]

During the summer while Shelburne's dismissal was momently expected, he held on and even co-operated with his Cabinet colleagues in considering the crisis caused by riots in Massachusetts. On September 6, however, the Bedfords demanded that Weymouth be given the Southern Department. Grafton and the King nerved themselves to remove Shelburne, at the same time trying to ensure that his dismissal should not be glorified by Chatham's resignation. Pushed on by the King, Grafton appealed to Lady Chatham to secure her husband's agreement. But Chatham would not hear of it, and on October 12, as Grafton and the King were hesitantly making preparations to force Shelburne out, Chatham submitted his resignation. Notwithstanding their panics

[1] Walpole, *Memoirs*, III, 156; Fitzmaurice, *op. cit.*, I, 362–85, 386; *Grafton Autobiography*, 203–9; *Grenville Papers*, IV, 364.
[2] Fortescue, II, no. 628; Camden to Shelburne, June 24, 1768, Bowood MSS.

and protestations, Grafton and the King could not have been luckier. Had the sequence of resignations built up to the crescendo of Chatham's withdrawal, the Ministry must have fallen. Had they known that Shelburne's dismissal would be followed by Chatham's resignation, Camden, Grafton, Conway, Hawke and Granby would almost certainly have resigned. But the sequence of resignation began, unexpectedly, with the crescendo. After that anything else was anti-climax. In the event only Shelburne and Barré went out. Camden persuaded himself that he stayed on for the public good and persuaded Dunning to stay on to keep him company. Neither, henceforth, was in sympathy with the Ministry and Dunning, as Shelburne's legal adviser, almost immediately took an independent line, though he continued as Solicitor-General until the spring of 1770.[1]

Had Shelburne died shortly after his resignation in 1768 he would have been remembered only as a rather inexperienced and unsuccessful Secretary of State whose considerable grasp of European politics hardly compensated for his failures in colonial policy. His reputation would have been much less than those of Egremont, Halifax or even Hillsborough. In detail, he made mistakes in administration that they would never have made. But they, on the other hand, had a short-sighted view of Anglo-American relations from which Shelburne, because of his liberal sympathies and knowledge of trade conditions, was free. Anglo-American harmony was essential if the country was to be prosperous, and so long as it was prosperous, in Shelburne's view claims of sovereignty and taxing rights were dangerous irrelevancies.

He was not yet a finished statesman, nor yet very liberal. He was slowly learning his trade as a politician, and gradually, in the next decade in Opposition he would gather to him the elements of a genuine, though often disjointed, radicalism.

[1] *Chatham Corr.*, III, 333–5; *Grafton Autobiography*, 225, 227–8; *Grenville Papers*, IV, 296–300; Fortescue, II, nos. 660, 666; Barré to Shelburne [October 29, 1768], Bowood MSS.

The Great Opposition I:
The Campaign of 1769

Between 1768 and 1780 Shelburne became a reformer. This was partly an act of political calculation. As an ally of the City of London's political interest during the campaign for the rights of the Middlesex electors in 1769, he came to appreciate the advantages for himself and the Opposition of supporting parliamentary and administrative reform. But he also believed in reform because he thought it would make the government more efficient and more respectful of political and economic liberty.

Unfortunately it is hard to chronicle the development of his ideas on the subject, first, because the reforms in which he was interested did not form a harmonious whole, and second, because he rarely put down his ideas in much detail. Before 1780 reform is a homogeneous phenomenon only in the retrospective imaginations of historians. Its one unifying feature was the aim of all Opposition groups to limit the power of the Ministry. Parliamentary reform arose first in what the Opposition regarded as the scandal of the Middlesex election — the attempt by a Parliament dominated by the Ministry to deprive the electors of their franchise. Opposition and independents alike were receptive to proposals designed to prevent a recurrence of this scandal, in particular to shortening Parliament's term and increasing the county representation. But in addition, the Opposition parties, having called the masses, in the form of the political interest of the London metropolis, into the political arena to help redress the balance of politics in their favour, found themselves under an increasing necessity to concede to their allies a measure of popular control over politics. Administrative reform essentially aimed at making the government more efficient, and in this form was merely the latest extension of a process which was as old as government itself. It was the work of administrators and civil servants, not political agitators. It became

popular by stages: first as a result of the Opposition's demand for the elimination of undue influence of the Crown; later through the demand for economy during the American War. Its real aim, efficiency, never attracted much support outside the ranks of the professional administrators.

Shelburne's ideas on both these aspects of reform developed slowly and in piecemeal fashion. He was in close touch with many leading radical thinkers of the age — with Price from about 1771, with Priestley from 1772, and Bentham from 1781; and with the City politicians — Townsend, Sawbridge and Horne Tooke — for somewhat longer. But his correspondence with them is disappointingly lacking in references to his political and economic ideas. In the cases of Townsend and Priestley this is easily understood — he was in almost daily contact with them and had little occasion to write. But even his much fuller correspondence with Morellet and, later, with Bentham, contains remarkably few references to public affairs and fewer still to his ideas about them. He admitted to Price on one occasion that he was shy about revealing his ignorance. Only in the period of his political eclipse did he put his ideas down in extended memoranda and in the autobiographical fragment published by Lord Fitzmaurice.

For the period of his development as a reformer, the most significant material is to be found in a few exchanges with Price on American affairs and financial reforms between 1773 and 1776. Otherwise it is necessary to rely on his day to day political correspondence from which only occasional hints about his ideas and activities may be gathered. The most important of the correspondences — that with Chatham — is especially unsatisfactory in this respect, since it was coloured on Shelburne's part by a deference bordering on sycophancy.

Though the detailed record of Shelburne's intellectual growth is lacking, the effects of it are clear and emerge from time to time in the early history of the reform movement. Already in 1768 he had an established liberal bias in his political conduct, drawn from a variety of sources. At its foundation was the eighteenth-century whiggish belief that the purpose of politics was to maintain the mutually-sustaining rights of liberty and property. As Dr. J. G. A. Pocock has pointed out,[1] eighteenth-century political theory was

[1] J. G. A. Pocock, *The Ancient Constitution and the Feudal Law* (Cambridge, 1957), ch. ix.

dominated by the ideas of the 'ancient constitution' as edited by the seventeenth-century common lawyers. The most important of these ideas was the sanctity of prescriptive right. Its corollary was the respect for property rights (prescriptive or chartered) as the guardians of liberty behind which a man might defy unconstitutional authority and influence, even if this meant (as it frequently did) holding up salutary reform in state and society for generations.

In Shelburne's case *customary* justifications for political conduct were supplemented by the beginnings of *utilitarian* ones: by a still imprecise idea of the public interest, and by his understanding of the effects of economic stagnation on relations with America and on politics at home. The latter effects were especially important. Agricultural distress made country Members of Parliament critical of governments which failed to control the 'wretched regrators and forestallers', and of Opposition demagogues who by their 'levelling' doctrines encouraged agricultural labourers to riot against their betters. Stagnation of trade made artisans and labourers in the industrial districts of the Severn Valley and the trades of London, on short time or shorter commons, riot against the authorities and cheer for any political figure who for the moment seemed to have the same enemies as themselves.

As Secretary of State, Shelburne was constantly reminded of these troubles. His office was flooded with reports on the unrest among farm and industrial workers, and he was responsible for ordering the suppression of their riots. But he had fallen out of sympathy with his Cabinet colleagues and was not very active in home affairs when the furious climax came in the spring of 1768. Lord Weymouth, the Northern Secretary, had the main duty of dealing with the London coalheavers' attack on their 'Undertakers', the seamen's seizure of the port of London, and the separate, but not unconnected riotings for 'Wilkes and Liberty'. Shelburne's activity was largely confined to issuing orders for the suppression of the Spittalfields riots on January 26, 1768, and signing the order in June 1768 for the arrest of Wilkes to face the consequences of his outlawry.[1]

Earlier, on May 12, 1768, he had stated his opposition to any further harrying of Wilkes.[2] On the same day his followers — Dunning (who was Solicitor-General) and Barré — were noticeably

[1] P.R.O., State Papers, Domestic, 37/6, no. 80/2. fos. 186–7; Thos. Bradshaw to Grafton, June 2, 1768, *Grafton Autobiography*, 203.
[2] Walpole, *Memoirs*, III, 143–4; *Grenville Papers*, IV, 371.

absent from a meeting presided over by Lord North at which the chief government supporters in the Commons unanimously decided to secure the expulsion of Wilkes from the House of Commons.[1]

Shelburne's growing association with the City of London radicals was carrying him in the same direction. It began with, and depended upon, his friend James Townsend.[2] The elder Shelburne and Chauncey Townsend, a ministerial supporter in the City, had been supporters of Bute in the first years of the new reign, and the younger Shelburne had known Chauncey's son James since 1759. Since then this James Townsend had gravitated to the radical side in City politics and from Bute to Pitt and Shelburne in national politics. Like most of the City politicians, he was not a London man, but the owner of Bruce Castle, Tottenham and of Welsh coal mines, and Member for West Looe in the Buller interest. By 1765 he had secured a promise from Shelburne to seat him at Calne when, as was expected, the Bullers withdrew their support from him at the next general election.[3] Through him Shelburne came to know John Sawbridge,[4] also just beginning his career in radical City politics. Calcraft was drifting out of Shelburne's orbit and into Chatham's, but he too provided a link with the City in the person of William Beckford, Chatham's principal ally there. This link was further strengthened by Townsend and Sawbridge, who were soon to be Beckford's lieutenants in the campaign of 1769. Through Beckford Shelburne also came to know Samuel Vaughan, another radical West Indian merchant. In the winter of 1768–9 they were all drawn together in their support for Wilkes, whose imprisonment and impending expulsion from the House were now the almost exclusive rallying grounds of the City radicals. On February 20, 1769, at the suggestion of Wilkes's most active supporter, the Reverend John Horne of Brentford,[5] they banded themselves together into the Society of the Supporters of the Bill of Rights, the public purposes of which were to defend the legal and constitutional liberty of the subject, and support Wilkes and his cause. Shelburne, Barré and Dunning were all enrolled as members.

Shelburne was acceptable to the City in spite of his connections with the East India Company, and largely because of his recent

[1] Brooke, *Chatham Administration*, 355–6. [2] 1737–87.
[3] Dunning to Shelburne, January 19, 1765, Bowood MSS.
[4] 1732?–95. [5] 1736–1812.

declaration in favour of Wilkes and his opposition to the disciplin-
ing of Massachusetts. It was important that he should be acceptable
on his own account but not attempt to be active personally in the
City because the favour of the City could be kept only by observ-
ing very strictly the rules of conduct demanded by the commonalty.
Professional politicians from the outside like Townsend and
Beckford, had been coming into City politics since early in the
century when the technical business of regulating the City's
economic life had passed out of the hands of the Court of Alder-
men, and admission to the Court no longer required that a
candidate be any more of a merchant than was required to make
him free of one of the Liveried Companies. But such outsiders
were not ordinarily popular with the Common Council. The
political aim of the Common Councilmen, and of their rowdy
constituents, the Livery, was to have their revenge on the Court, the
aristocracy and the great monied magnates who excited their envy
and hatred. They also demanded opportunity for the small
entrepreneurial class, whom they chiefly represented, to share in
the good things monopolised by the great of the City. A gentleman
was suspect to them, a peer doubly so. So long as that peer gave his
support and goodwill to the City's cause and made no obvious
attempts to pull strings in the City's politics, the Common
Councilmen would accept whatever help he could give. But they
were not interested in promoting the fortunes of the Opposition
parties in return. Though most of the leadership and most of the
ideas in City politics came from the outside, genuine City men did
not care to be reminded of the fact. They would have preferred to
do without them. Only the prospect of reducing the power of their
enemies held out to them by the professionals persuaded them in
the late 1760's to adopt such measures as bribery bills, shorter
parliaments, electoral and representational reform, open subscrip-
tions for government loans and detailed appropriation for the
Civil List. Like their country counterparts, they preferred to
concentrate on local affairs. Among the 'middling people', excite-
ment and a feeling of importance rather than any radical change
were the touchstones of politics. Honour was satisfied if they could
put a scare into Parliament. The demagogue who excoriated the
Court, proclaimed the majesty of the people and called for blood
and broken windows, was popular. The theoretical democrat with
schemes for changing the constitution was not. The success of

Wilkes and Fox in the metropolis was due to their recognition of this fact.

The activities of the Common Councilmen and, on another level, of the London mob in the 1760's and 1770's were only salient examples of the rebellious spirit which ran through a wide range of classes. Economic depression, increasing differentiation of social groups resulting from the growth of London's trades, and the xenophobia inspired by the presence in East London of Irish weavers and coalheavers, German and Jewish artisans and seamen of all nations, ensured a constant supply of rioters to burn Bute in effigy, huzzah for 'Wilkes and Liberty', and patriotically defend the liberties of Englishmen from Popery and Wooden Shoes. The 'middling people' would never identify themselves with the mob — they were horrified by the riots of coalheavers and seamen which took control of East London in 1768. But they saw that violence got results, so that in their Common Halls and petitions to the Crown and Parliament they were violent too. It was the social variety of the people who were ready to indulge in violence or condone it, more or less, in the cause of the Middlesex electors in 1769 which justifiably alarmed the Ministry and their supporters with fears of social revolution. A continuous link stretched from Shelburne and, more uncertainly, Chatham and Rockingham, through Wilkes, Beckford, Townsend and Horne Tooke to the gentry, merchants, shopkeepers, artisans, labourers and paupers. Many in the chain had second thoughts, even about supporting the cause of Middlesex, which they came to suspect was a channel by which 'levelling doctrines' were advanced; most eventually fell away when the cause dwindled after 1770 from being the rights of Electors to being the grievances of the City. But for a moment in 1769–70 a radical alliance against the establishment encompassed peers and sweeps.

Shelburne's association with the City provided him with a much-needed place in politics. For the time being there was no more Chathamite party, and Chatham had formed a family alliance with Temple and George Grenville which Shelburne found even less congenial than friendship with the Rockinghams. He must take a leaf out of Chatham's book and go privateering.

★ ★ ★ ★

In this situation, when his interest and influence in the City

were growing and he was in a fair way to establishing himself as a leader of Opposition in his own right, the financial collapse of Lauchlin Macleane in the late spring of 1769 came on him like a thunderclap. This is the shadiest passage in Shelburne's life, and his biographer is hard put to explain it satisfactorily, if only because of the remarkable dearth of evidence and the equally remarkable wealth of supposition about it.

The charge against Shelburne hinges on the nature at particular times of his financial connection with his undersecretary and agent Lauchlin Macleane. Macleane was an Irishman, originally a military surgeon, a friend of Wilkes and an associate in his West Indies schemes with William Burke, by whom he had been introduced to Shelburne in 1766. Was Shelburne directly involved in Macleane's stockjobbing activities in the East India Company, or in his stocksplitting activities,[1] or both? Was his involvement in any or all of these indirect and perhaps unconscious? More specifically, was the involvement, if any, close or active during the period that Shelburne was in office, from July 1766 to October 1768? Miss Lucy Sutherland has brought out the facts of the case about as far as they can be brought out.[2] But there remains a vast field for speculation on which Shelburne's reputation can be won or lost.

The facts are that Shelburne went bond for Macleane without security for two debts of £15,000 each owing to Isaac and John Francis Panchaud, the English bankers in Paris, and Lord Verney when Macleane failed badly at the biennial rescounter or accounting of the East India Company in May 1769. Later in his life Shelburne wrote that he had lost,

> ... nearly £40,000 by being bond for other men, a great part of which I was obliged to borrow rather than put myself in the power of others to be bound for me. If anyone will take the trouble of computing this at the rate of compound interest . . . it will be seen to what a frightful sum it amounts, though it gives a faint idea of the embarrassments and disadvantages it occasioned me, far exceeding the pecuniary consideration, and all the return I had was treachery, and a great deal of unjust public abuse.

[1] In the Company's General Court of Proprietors, each stockholder, no matter what his holdings, had only one vote. Because of this, in anticipation of elections in the Court, large stockholders temporarily arranged to parcel out their holdings among dependents in order to multiply voting qualifications.
[2] Lucy Sutherland, 'Lord Shelburne and East India Politics, 1766-9', E.H.R., XLIX, 450-86; Sutherland, East India Company in Eighteenth-Century Politics, 179-212.

From an entry in Lady Shelburne's diary of this period it appears that the money was required for Macleane.[1] It is also clear that Macleane was heavily engaged at least from the middle of 1767 in stockjobbing and stocksplitting for various clients, though he had been ordered by Shelburne to stop when he became an undersecretary in 1766.[2]

Shelburne's anxiety to rescue Macleane in 1769, and particularly his anxiety to make sure that his association with Macleane was not revealed, even to the extent of sending Barré and Dunning scurrying around London in August to prevent one of his bonds to the Panchauds being sold abroad, raises the suspicion that he was involved directly in Macleane's activities. To support this conclusion there were the contemporary remarks of Charles Lloyd, Grenville's private secretary, on June 1, 1769, that 'Lauchlin Macleane I hear is absolutely ruined; Lord Shelburne is very deep';[3] the plea of Macleane's creditors in later legal proceedings that Macleane's credit was dependent on his being known as Shelburne's man;[4] and the statement in Malcolm's *Life of Clive* that Shelburne had split £100,000 of stock for the Sulivan party in the elections for the company directorate in 1769.[5] Finally there is the very powerful impression which all these facts and suppositions taken together made. As Miss Sutherland wrote:

> . . . for a statesman to give bonds to the amount of nearly £40,000 for debts incurred in dealing in a stock to a man who is known as his political dependent, his close personal follower, and who has been recently his undersecretary at a time when that situation implied a close connexion with the Minister, is an action which lays itself open to uncharitable constructions. These constructions would not be shaken by anything we know of the reputation of Macleane.[6]

But against these conclusions may be laid the fact that Shelburne was the moving spirit in 1767 of a policy which was the antithesis of jobbery — the restriction of the East India Company's dividend. Under the circumstances it is improbable that he was active in stockjobbing behind the cover of Macleane. Nor is it likely that at this period he was engaged in stocksplitting. Only at the beginning

[1] Fitzmaurice, *op. cit.*, II, 338. [2] Sutherland, *East India Company*, 210.
[3] Charles Dilke, *Papers of a Critic* (London, 1875), II, 338.
[4] Sutherland, 'Lord Shelburne and East India Politics', *op. cit.*, 484.
[5] III, 245. [6] Sutherland, 'Lord Shelburne', *op. cit.*, 480.

of his term of office and just after its conclusion were his policy and the interests of the Sulivan party in the Company in harmony. In the period between, when he opposed the Sulivan party's policy of increasing the Company dividend, there was only one occasion on which a considerable split of stock took place — during the three weeks preceding the General Court's vote on May 6, 1767 for increasing the dividend. Shelburne's name does not appear in the record of stock transfers, and of his associates, Macleane split only £500 to provide one voting qualification, Captain John Jervis provided £500 and Thomas Tomkyns provided £500 for James Townsend.[1] Shelburne's interest was not mobilised either for or against the proposal on this occasion.

It is much more probable that, as Malcolm claimed, he was active in helping Sulivan in anticipation of the directoral elections of 1769. Under new regulations which he had been responsible for introducing, the splitting had to be undertaken six months in advance — that is in October 1768. At that time Shelburne was just leaving the government and was not likely to be enquiring closely into Macleane's management of his interest in the Company or, indeed, into Macleane's other activities. Like Sulivan, Shelburne and Macleane were caught in the rescounter of May 1769 that followed closely on Sulivan's triumph in the elections, with their stock extended to various straw men and not available to cover the sums for which they were responsible in the accounting. Then — and I think only then — did Shelburne realise the full extent and nature of Macleane's activities — that he was an active stock-jobber and had been one throughout his period in office, and for various patrons. Worse, the whole unsound structure of his operations was giving way, and Shelburne was involved in the crash. As Miss Sutherland has explained, it was hard for his contemporaries not to suspect that Shelburne had been stock-jobbing too, particularly when it was remembered that he had got his start in the Company under the aegis of that prince of stock-jobbing politicians, Henry Fox. Shelburne certainly must have realised that appearances were clear against him, the Minister who had campaigned against the higher dividend and who would soon be branded as the most double-dyed of hypocrites. He tried to cover up by saving Macleane. But Macleane had failed on too grand a scale to be saved. With Sulivan he had to seek the protection of

[1] Add. MSS 18,464, fos. 367-94.

the government to survive, thus inspiring Shelburne's charge against him of treachery.

Even had he been no more than careless in trusting Macleane, Shelburne could not have given a public explanation which would have been accepted. His reputation as 'Malagrida', already gaining currency from 'Corregio's' satire, would have been doubly confirmed. Stockjobbing on the part of a public official was an unorthodoxy which was not lightly tolerated by eighteenth-century public morality. The memory of the Craggs and the South Sea Bubble was still fresh; so was that of Henry Fox.

Miss Sutherland suggests that the episode provides a clue to Shelburne's reputation for unscrupulousness, but this is doubtful. It certainly would have had it become widely known. As it was Shelburne escaped immediate detection, and the details revealed in court proceedings had so little currency and provided so little concrete information that even the Wilkites in the City, who in the next few years had plenty of occasion to abuse Shelburne, never accused him of stockjobbing. Nor was it mentioned during the furious pamphleteering of the American War period. Only at the peace of 1783 was he accused by the Coalitionists of having profited from his inside knowledge about the treaty — but this was of a piece with the accusation against Bute in 1763, even to the description of Shelburne House (which Shelburne had bought from Bute) as having been begun by the profits of one peace and completed by those of another.[1]

<p align="center">* * * *</p>

Immediately, the episode had the effect of bringing Shelburne more closely into alliance with the City radicals. He broke off all financial and personal connections with the Company, thus eliminating the principal circumstance inhibiting the alliance. But it was the emergence, almost together, of the issues of reform and the rights of the Middlesex electors, and the practical necessity of binding the supporters of the two issues together in opposition to the Ministry, that really cemented Shelburne's relations with the radicals.

Reform appeared first in the spring of 1768, just before the general election. The country Members' periodic worry that they were losing their local parliamentary influence to the Court and the

[1] Nathaniel Wraxall, *Historical and Posthumous Memoirs* (London, 1884), I, 230; *Edinburgh Review*, XXV, 211–12.

nouveaux riches from London,[1] inspired Beckford, who in 1761 had already demanded the abolition of rotten boroughs, to introduce a bill to require candidates to take an oath not to bribe at elections. Both the bill and William Dowdeswell's amendment to it proposing to disfranchise revenue officers, though defeated, were popular with the country Members. In the next session the initiative was taken up by radical opinion in the constituencies, apparently under direction from the metropolis. Even before Wilkes was expelled from the House in February 1769, meetings of freeholders in Middlesex, and later of electors in Westminster, the City, Norwich, Southwark, Bristol, and Bath had been organised to instruct their Members to make a wide variety of demands. The City voters in a particularly forceful set of instructions, demanded shorter parliaments, the exclusion of placemen and contractors from Parliament, the calling of Lord Holland to account for his balances of public money, and an enquiry into the Civil List. The demands for shorter parliaments had been a preoccupation of the country party since the passage of the Septennial Act and twice, in 1744 and 1758, had been the subject of unsuccessful motions in the Commons. It was made on the assumption that a more frequent election would eliminate corruption by making it too expensive, though the period of triennial parliaments at the beginning of the century had seen an unparalleled growth of influence in elections. Excluding placemen and contractors from Parliament was the aim of every opposition since Elizabethan times, and had become hackneyed by repetition. None of these demands, in fact, was particularly original, but for that very reason — because they were familiar measures which could secure a large amount of support — they were likely to be effective; and the fact that they were embodied in instructions to Members was sharply at variance with the tradition of Members' independence of their constituents and for that reason revolutionary.

[1] There were a few isolated examples of the *nouveaux riches* attempting to invade established electoral interests in 1768. Earl Verney lost one of his Wendover seats to a group from the City (T. H. B. Oldfield, *Representative History of Great Britain and Ireland* (London, 1816), III, 89–90), and Dowdeswell, writing to Lord Hardwicke about the election at Gloucester, noted, 'a strange Opposition has lately risen there within these few days. Two persons, not at all known there, Mr. Cater, a timber merchant in Southwark, and Mr. Roberts, an East India merchant, are now there, and Mr. Cater is a declared candidate. By what I hear a very laudable spirit rises against these adventurers' (March 8, 1768, Add. MSS 35,607, fo. 130; cf. J. M. Holzman, *The Nabobs in England: A Study of the Returned Anglo-Indian 1760–85* (New York, 1926), 15–16).

The demand for an enquiry into the Civil List was the most immediately important of the issues because it was about to come before Parliament where suspicion of the Crown's patronage united the Opposition parties, the City and the country Members. The two latter groups were easily convinced of the sins of the authorities, and the longer the Opposition parties remained in Opposition, the more convinced they became of the truth of their own claims that they were kept out of office by the Crown's exercise of an undue influence through patronage and corruption.

> We could never have seen measures so foolish and destructive rashly adopted and obstinately persisted in [wrote Serjeant Adair to Rockingham in 1780] in spite of dreadful experience of their mischief, if there had not existed a degree of influence and patronage, so corrupting and so extensive as to need no proof, to admit of no controversy and to preclude all hope of honest and rational attempts to save the country till some remedy is applied to this evil.[1]

The Opposition parties wanted to reduce the sum total of influence — of East India nabobs, government servants, placemen, pensioners, borough owners — but they had rather hazy ideas of how to go about it. They believed that a good strong blow at the influence supposed to be at the disposal of the government in the Civil List and in the government's electoral machinery would cause the whole system to fall apart. But it was hard to prove specific examples of such influence, and in debates on the Civil List they rarely followed up an accusation where North might have been able to produce statistical refutation.

Their demand for an enquiry into the Civil List, occasioned by North's application to Parliament in 1769 for payment of the Civil List debts, went beyond any claim to interfere with the details of executive government hitherto advanced by Parliament. On other such occasions — in 1717, 1721, 1725/6 and 1728 — the debts had been paid by Parliament without enquiry, and figures had been submitted later to justify the application. But in 1769 the Opposition thought they could tie the question to their accusations of secret influence. When application was made on February 28, Beckford demanded full accounts of the Civil List since the beginning of the reign. He went on to suggest that the debt had been incurred for the corruption of Parliament, that the Civil List was greater now than it had been in the time of the King's

[1] April 24, 1780, Fitzwilliam MSS, Rockingham I, 1057-1.

predecessors, and that the monarch was, after all, merely the trustee of the Crown revenues for the people. North made a miserable defence and promised to submit the figures later. Had he done this at the time, he might have shown how inadequate the Civil List was to meet the legitimate expenses of the Crown, how much the burden of Address Money, laid on it by the House of Commons itself to meet civil contingencies, was depleting it,[1] how much less it was than the Civil List of George II, and how little the secret service contributed to the debt.[2]

After the expulsion of Wilkes the Opposition took the right of the electors to elect whom they wanted as their principal cause. At first the metropolitan radicals kept the issue in their own hands. By April 27, Shelburne's friends in the City, Townsend and Sawbridge, with Wilkes's supporters — Walpole Eyre and George Bellas — had prepared an extreme bill of grievances and apprehensions of Middlesex, to be presented to Parliament by Serjeant Glynn, the sitting Member for Middlesex. But at this point Rockingham intervened and persuaded them to allow him to redraft the petition with the help of Burke and Dowdeswell. They toned it down to a simple protest against the seating of Luttrell.[3] This was presented to the Commons by Sir George Savile on April 29. But on May 8 the Commons reaffirmed the seating of Luttrell. Next day, at a dinner meeting, representatives of the City, the parties, and the independents, pledged themselves to support this issue in the country during the summer months, and it was hoped that from this meeting would develop one united Opposition party.[4]

Both Horace Walpole and Lord Holland mention that Shelburne, whom they describe as the patron of the City, was present

[1] During the debate on the abolition of the Great Wardrobe on April 28, 1780, North pointed out that the Civil List was in arrears only because of the money advanced from it for public purposes (*Parliamentary History*, XXI, 551). Sometimes these diversions were not authorised by Parliament, as, for instance, the payment of £26,000 out of the Civil List in November 1779 to pay for a secret expedition to reinforce the Minorca garrison (John Robinson to the King, November 16, 1779, Add. MSS 37,835, fos. 24–5).

[2] Grafton MSS 1051, 1052; 'Account of Debt on the Civil List. 1762 . . . 1763 . . . 1766', *Parliamentary Papers of John Robinson*, ed. W. T. Laprade (London, 1923), 138–9; 'Pensions Paid by the Paymaster of Pensions, 1765–6', Fitzwilliam MSS, Rockingham 15–5. The figures submitted by North in 1770 showed that issues from the Exchequer for the Civil List had fallen sharply in the new reign (*Commons Journals*, vol. 32, 465–603).

[3] Fitzwilliam MSS, Rockingham 871 (1–2); *Rockingham Mem.*, II, 110.

[4] 'A similar club is proposed the day preceding the meeting next session, and it is to be hoped from the occurrence of the day that all the subdivisions of the minority will be consolidated into one grand constitutional party' (Lord Mountmorris to Earl of Charlemont, May 11, 1769, H.M.C., *Charlemont MSS*, I, 29).

at the dinner — though two lists of the diners make no mention of peers.[1] Whether or not he was present, his followers Barré and Townsend were, and with Shelburne planned the liaison between the City and the country party. Such management was essential, for the differences between the two groups were fundamental. The City's turbulent behaviour was anathema to the country neighbourhoods for whom the corn riots in the South Midlands were a recent and unpleasant memory. However alarmed their representatives might become at the attack by the Ministry on the rights of the Middlesex electors, they were unwilling to be hustled by the City into joining a campaign of abuse against the Court. Nor were they pleased with the champion and symbol of oppressed virtue on whose behalf the City rose in 1769. In their eyes Wilkes was a blasphemer and lecher, and a libeller of monarchy. Unfortunately his expulsion had given the Opposition its best constitutional case against a government for half a century.

Shelburne and his friends also found it inconvenient that they could not take up the cause without taking up the man. Wilkes, confined as he was in the King's Bench Prison, was still the darling of the Livery, to whose prejudices he catered with remarkable skill; and though the Shelburne party and Beckford[2] could influence the commonalty while Wilkes was in prison, it was seldom in the direction of that decorum and appearance of being concerned with the nation's, rather than the City's, welfare which were essential if the City was to have the help of the other opponents of the Ministry. The Shelburnites must pose as the champions of Wilkes's cause in bidding for popular favour, but not antagonise the political parties and the independents by going much beyond the central issue of the Middlesex electors and whatever constitutional changes might be necessary to protect those electors' rights; and they must be skilful in the management of these ill-assorted political steeds, or lose the reins to Rockingham or Chatham. At first, in the Society of Supporters of the Bill of Rights and among the freeholders of Middlesex and the commonalty of London, they acted as Wilkes's agents, drafting the instructions to Members, petitions and — after these were rejected — remonstrances, by which the campaign of 1769 was carried on. But their endeavours

[1] Walpole, *Memoirs*, III, 242; *Memorials of Fox*, I, 54-5; cf. *Chatham Corr.*, III, 359-60, note 1; *Baldwin's London Weekly Journal*, May 13, 1769.

[2] Beckford was not a supporter of the Bill of Rights Society, and maintained his independence of Shelburne throughout their alliance.

to place the question of the Middlesex electors' rights before the country received little encouragement from Wilkes, whose main concern was to keep his own name and grievances before the public. He maintained a separate contact with the Livery through Michael Lovell of Mark Lane, a West India merchant, and encouraged Lovell to propose successive petitions and remonstrances to the Crown which, though they were abusive to the Ministry and insulting to the King, disregarded or played down the various constitutional and party issues with which Shelburne's allies endeavoured to adorn the Middlesex issue.

As early as April 15 Townsend had urged the Middlesex freeholders to see the 'necessity of seeking out some new remedy for a new grievance'; and shortly before the end of the Session he announced in the Commons that they would petition the Crown to dissolve Parliament, on the ground that only a purified Parliament could be relied upon to give justice to Middlesex. As events were to prove, this line was well chosen to command the support of the country constituencies. But unfortunately Shelburne's party could not adopt it in Middlesex, where the Wilkites were pressing hard for the declaration of a variety of their own grievances. Thus the special committee of four appointed by the Bill of Rights Society to draw up the petition — George Bellas, Horne, Sawbridge and Townsend (who was in regular consultation with Shelburne) — came up with a document demanding that the King dismiss his 'evil and pernicious counsellors', abolish general warrants, cancel the outlawry of Wilkes, restore habeas corpus, jury trial, freedom of the press, and the right of petition, and call a halt to the excessive use of the military against the citizens, the squandering of public money, and the mismanagement of relations with the American colonies. The City Livery, under Lovell's leadership, produced a shorter, but even more extreme document at a tumultuous Common Hall on June 24.[1]

Somewhat earlier Horne had tried to do the same in Surrey, with the encouragement of Sir Joseph Mawbey, Member for Southwark. But it was apparent that the county freeholders here were much more conservative than those of Middlesex, and the Rockinghams much more powerful than in the City. Horne's original draft was rejected, and on Shelburne's instructions Townsend quickly closetted himself with Horne, Barré and

[1] *Annual Register*, 1769, Chronicle, 90–1, 102–3, 197–200.

Charles Wolfran Cornwall to produce another — a simple 'case' of the electors of Middlesex, 'without any county mark on it,' which called on the King, by the exercise of his prerogative, 'to give us such relief as to your royal wisdom shall seem meet.'[1] But the damage was done. Rockingham wrote:

> I wish the zeal of the Revd. Mr. Horne may not have gone too far and that the petition that wold. be presented will be too much in the general vague and wild manner of the other two.[2]

The harmony of May was rapidly draining away as the more cautious of the country gentry drew back. The petitioning separated itself into three groupings, according to whether the petitioners were directed by the moderate or extreme supporters of the Bill of Rights Society, by the conservative Rockingham group, or were independent of both and relied on the enthusiasm of the freeholders for the Middlesex cause independent of that of Wilkes.

> Wilkes's character [wrote William Dowdeswell concerning opinion in his native Worcestershire] of which men are inclined to think much worse than it deserves, and the advantage which he necessarily must receive from the restitution made to the public of its rights at present lost, have checkt this proceeding in most places. The injudicious list of grievances which filled the first petitions, still more disinclined the sober part of the people to signing petitions which they concluded must partake greatly of the same spirit. . . . It is amazing how in most places People of rank and fortune shrink from this measure; and with what deference all orders below them wait for their leaders.[3]

Ironically, so far as the country gentry were concerned, the most provocative act of the radicals during that summer was committed by Shelburne and his supporters when they sallied out from London in August to arrange for the capture of the Corporation of Bedford from the Duke of Bedford.[4] If the holders of established electoral interests in the country were alarmed at the threat of being displaced by East India nabobs and followers of the

[1] Townsend to Shelburne, June 10, Barré to Shelburne, June 18 (2 letters), 1769, Bowood MSS.

[2] To Burke, June 29, 1769, *Correspondence of Edmund Burke*, ed. Lucy S. Sutherland (Cambridge, 1960), II, 36.

[3] To Burke, September 5, 1769, Clements Library, Dowdeswell Papers; cf. Dowdeswell to Rockingham, September 5, 1769, *ibid.*

[4] *Annual Register*, 1769, 128; *Cavendish Debates*, I, Appendix, 'Private Journal of John, Duke of Bedford', 662; Walpole, *Memoirs*, III, 255.

Court, they were terrified at the thought of radical, and perhaps reformist, forces capturing the constituencies.

Unfortunately, too, for the unity of the cause, the Shelburnite idea of asking for the dissolution of Parliament was not adopted until nearly half the petitions had been voted. Westminster was the first to propose it. How different the fortunes of the campaign might have been had it been adopted at the outset may be seen by comparing the petitioning in Shelburne's own counties — Wiltshire and Buckinghamshire. In the first, where Shelburne, Beckford and other metropolitan figures had influence, the petition was modelled on the metropolitan ones, though the reluctance of the solid figures in county politics — William Hussey, Charles Penruddock and Ambrose Audrey — led to a compromise: half the petition concentrated on the wrongs of Middlesex, the other half on the failure of the Court to prosecute the Irish chairman McQuirk responsible for a murder in the anti-Wilkite rioting at the Brentford election in December 1768. But in Buckinghamshire the differences of opinion which might have arisen between the rival interests of Grenvilles, Rockinghams and Shelburnites were avoided by following Westminster's lead and concentrating on the generally acceptable point of a dissolution of Parliament. Shelburne made no attempt to presume on his small electoral influence at High Wycombe to take a lead, and at the county meeting his interests were represented by his friend and neighbour, John Aubrey. The main work was wisely left to the Grenvilles and Rockinghams under the joint management of Thomas Whately and Edmund Burke.[1]

Perhaps the most serious result of the early emphasis on City issues was that Rockingham was in no hurry to mobilise Yorkshire, the most important county in the North and the centre of his greatest power. After the awkwardness about the Surrey petition he wanted no more radicalism, and was more sympathetic than usual to Lord John Cavendish's argument that

> ... we have been a great many years teaching them [the country gentry] to acquiesce and be contented with what their Members do for them; if we encourage them to take everything into consideration, they may chuse to interpose much oftener.[2]

[1] *Burke Corr.*, II, 48, 50, 56, 59, 76, 78–9; Add. MSS 35,609, fos. 34–5; H.O. 55/6; *London Chronicle*, August 28–30, 1769.
[2] To Rockingham, July 1, 1769, Fitzwilliam MSS, Rockingham I, 668.

Throughout the summer he toyed in desultory fashion with the alternative to petitioning, supported by Sir George Savile, of a decorous address to county Members against the Middlesex decision. Only in September, after some forceful pleading from Burke and Dowdeswell, would Rockingham consent to move. The meeting, held at York on September 24, was a great success, being attended by almost all the nobility and gentry of the county; their petition, condemning the seating of Luttrell and asking for a dissolution, secured the remarkable total of 11,000 signatures and acted as an example for the other northern counties.[1]

But undoubtedly the lateness of Yorkshire's mobilisation lost the campaign its impetus and probably a good deal of support as well. In all, fifteen counties and twelve, or perhaps fifteen, cities and boroughs, involving 50–60,000 signatures, submitted petitions, ranging from the radical complaints of Middlesex and Herefordshire, through the sensible moderation of Buckinghamshire, Gloucestershire, Somerset and Yorkshire, to the almost irrelevant Montesquieuan support for a balanced constitution submitted by Devonshire freeholders. The resistance to petitioning was also strong. Meetings in Essex, Kent, Surrey, Shropshire, the Universities, Bristol, Coventry, Liverpool and the Scottish counties and burghs sent 'humble addresses' approving the conduct of the Ministry, and meetings in Essex, Hertfordshire, Norfolk, Nottinghamshire and Lincolnshire, after some debate, refused to petition. The political pressure generated by the petitions was remarkable, considering the still relatively unsophisticated state of political opinion in the constituencies, but it was not enough to reduce the parliamentary majority of the Ministry below forty or raise the parliamentary showing of the Opposition above 180.

The Ministry still stood, and with luck survived the shaky transition from Grafton to North at the end of January 1770. Soon the Opposition fell out among themselves on what to do next. Dowdeswell's motion of January 30 that the House ought to judge of elections by the law of the land and the custom and practice of Parliament was intended to lead on to a condemnation of the Middlesex decision, and as such had the united support of the Opposition. But when the Ministry, after admitting the general principle, refused to accept the condemnation, the Grenvilles,

[1] *Burke Corr.*, II, 38, 41, 51–2, 54, 61–5, 71, 84; *Rockingham Mem.*, II, 132–6; Chatham Papers, vol. 25, fo. 28; H.O. 55/2.

Chatham and Shelburne blamed the cautious wording of the motion for their discomfiture. Chatham and Camden thundered specifically against the Middlesex decision, and Rockingham, as in the crisis of his own Ministry, wanted to solve everything by a declaratory resolution to establish the law and custom of Parliament. Forty-one Opposition peers, including Shelburne and Chatham supported him. The Ministry then secured a resolution to the effect that the Commons alone had the power to decide its own affairs, without interference from the Lords. This was a more difficult proposition for the Opposition to resist, but the same minority of peers did so.[1]

Other issues soon displaced Middlesex in the Opposition's attention: Dowdeswell's proposal to disfranchise revenue officers, Grenville's Controverted Elections Bill, Savile's enquiry into the Civil List, and America. The initiative for protest went back to its point of origin, the City. At the beginning of March 1770 Beckford (now Lord Mayor), Sawbridge and Townsend (now sheriffs) and Horne, in consultation with Shelburne produced an Address, Remonstrance and Petition to remind the King that the grievances of Middlesex had not been redressed. The remonstrance compared the 'secret and malignant' influence in the Ministry with the worst excesses of the Stuarts, and demanded a new Ministry and a new Parliament, calling

> ... God to witness, that as we do not owe our liberty to those new and subtle distinctions which Places, Pensions, and lucrative employments have inserted; so neither will we be deprived of it by them; but as it was gained by the stern virtue of our ancestors, by the virtue of their descendants it will be preserved.

The Rockinghams austerely disapproved, but the mob was ecstatic as they accompanied the City officers with it to St. James's on March 14. The Ministry supporters at the Cocoa Tree Club hinted that Beckford and Townsend were to be impeached for presenting such a document, and suggestions were made that they might be called to account in the Commons for breach of privilege; but the King merely reproved them for the tone of the remonstrance, and the Ministry contented itself with passing addresses in both Houses approving of the King's answer.[2]

[1] *Parliamentary History*, XVI, 785–807, 811–29.
[2] *Annual Register*, 1770, 195–201; Shelburne to Lady Chatham [March 7, 1770], Calcraft to Chatham [March 12, 1770] (3 letters), Chatham Papers, vol. 56, fo. 108, vol. 25, fos. 36, 38, 40–1.

The presentation of the remonstrance marked Shelburne's full reconciliation with Chatham. It was not quite on the same basis as the old relationship. Shelburne was an equal now, and perhaps more than an equal since such followers as they had in the Commons and the City were his. They were agreed on America and the need for a vigorous opposition. Chatham needed allies and Shelburne, himself without a large following, could not be a serious rival for power. In the City Calcraft, who was now Chatham's man of business, criticised the management of City opinion by Beckford and the Shelburnites, and tried to bring Sawbridge into Chatham's camp,[1] but they were all having to close ranks now against Wilkes.

Shelburne and his friends and Beckford were all agreed that the Middlesex issue must be made a part of a general programme of redress and reform, including Beckford's bribery bill, shorter parliaments, parliamentary control of the Civil List and reduction of the number of placemen and pensions in Parliament. But in March 1770 Beckford made the mistake of trying to trick Chatham, Rockingham and Grenville into subscribing to this programme while they were his guests at a City banquet.[2] Had he succeeded, the position of himself and Shelburne as interlocutors between the City and the parties would not have been strengthened, but his failure seriously weakened it. Rockingham and Grenville drew back from the reconciliation with the radicals which Beckford had been promoting; Chatham was reluctant to commit himself because it would limit his freedom to manoeuvre for the support of the Rockinghams. The radicals of the Common Hall had no interest at all in such high-falutin' aims. Wilkes was more than ever their idol. Released from prison on April 17, 1770, he was intent, next after restoring his own fortunes, to give his supporters what they wanted. As spring passed, Beckford and the Sheriffs were forced by pressure of Wilkes's influence to associate themselves with the increasingly extreme statements issuing from the Common Hall.

Shelburne was especially active that spring. On him fell the main burden of co-ordinating the Opposition efforts within and without doors. With the Duke of Richmond he helped prepare a

[1] Calcraft to Chatham [March 12 1770], September 13, 1770, Chatham Papers, vol. 25, fos. 40–1, 59.
[2] Cavendish Debates, I, 517–35, 624; Chatham Corr., III, 423–32; Walpole, Memoirs, IV, 71–2, Rock. Mem., II, 171–2.

series of resolutions condemning the Ministry's policies in America which steered between the Scylla of Chatham's condemnation of the Declaratory Act and the Charybdis of Rockingham's defence of it.[1] With the rising tide of Wilkism threatening to engulf their forces in the City, he planned with Chatham to bring the Middlesex issue back into Parliament. Early in May Chatham presented a bill to reverse the Middlesex decision, during the debate of which Shelburne suggested that North be impeached for having advised the seating of Luttrell.[2] In anticipation of the bill's rejection Shelburne arranged a follow-up within and without doors: Chatham would move a resolution condemning the advice which had induced the King to reply as he had done to the City's remonstrance in March, on the ground that it threatened the right of petition; if that failed to get anywhere the City should present another remonstrance. The object was less to defeat the Ministry, of which there was no hope, than to keep the City happy in the knowledge that Chatham and Shelburne were looking after its interests. In the Lords the Ministry gave the Opposition a magnificent opening by answering that the King's reply had not been unprecedented, for the later Stuarts had replied to the City in a similar way on occasion. What, thundered Shelburne, were the examples of the Stuarts to be held up as models of constitutional conduct? Much better to recall the practice of the immortal King William, who had dissolved Parliament in response to the Kentish Petition. The present government seemed to delight in opposing the wishes of the people, and perpetuating the existence of the offending Parliament. After twitting the Ministry on their silence in the face of Opposition attacks, and warning them that 'the public is a wolf, which if it does not bite, will certainly worry a profligate ministry into justice', he gave a classic definition of what the Opposition meant by secret influence:

... secret influence, are measures adopted by a set of men, who, on his Majesty's accession, listed under the banners of the earl of Bute; who impudently call themselves the King's friends, but who are in reality nobody's friends but their own; who have acted without principle, with every administration, sometimes supporting them, and sometimes betraying them, according as it served their views of interest — who have directed their attention more to intrigues, and

[1] Shelburne to Chatham [May 3, 1770], Chatham Papers, vol. 56, fos. 98–9.
[2] *Parliamentary History*, XVI, 966.

their own emoluments, than the good of the public. This is that secret influence; and if that noble lord, or his adherents, want to be further informed, I refer them to an excellent pamphlet just published, called 'Thoughts on the Cause of the Present Discontents'.[1]

It was his best performance yet, and marked his emergence as an Opposition paladin second only to Chatham.

Meanwhile, in the City Beckford and the Shelburnites had prepared their remonstrance, reproving the King for taking the 'malignant and pernicious' advice of 'insidious and evil counsellors' as depriving them of their right of petition. When they presented it on May 23, the King replied in a set speech that to grant a dissolution would have been an improper exercise of his prerogative. The radical cause had reached an impasse; but Beckford lashed out unforgettably in an unprecedented warning to the startled King:

> ... whoever has already dared or shall hereafter endeavour by false insinuations and suggestions to alienate your Majesty's affections from your loyal subjects in general and from the City of London in particular, and to withdraw your confidence to and regard for your people, *is an enemy to your Majesty's person and family, a violator of the public peace, and a betrayer of our happy constitution as it was established at the glorious and necessary Revolution.*[2]

Like Shelburne's outburst three weeks earlier, this was defiance in defeat. A month later Beckford was dead, and his power passed largely to Wilkes.

For a time Townsend and Horne continued to co-operate with Wilkes in dividing the succession. Richard Oliver, one of Townsend's friends, succeeded to Beckford's aldermanic seat, and at the mayoral elections at Michaelmas Wilkes's friend Brass Crosby was set up in partnership with Townsend.[3] The parties also co-operated in promoting another summer campaign among the country constituencies, this time of remonstrances, which, however, petered out in the autumn without approaching the success of its predecessor. But the harmony did not last long. Horne insisted that the Bill of Rights Society did not exist to pay Wilkes's debts, and quarrelled with him in glorious publicity. Wilkes

[1] *Ibid.*, 972–4; *Chatham Corr.*, III, 435–9.
[2] *Annual Register*, 1770, 201–3.
[3] Townsend to Chatham [June 3], [June 21], [June 26, 1770], Calcraft to Lady Chatham, July 29, August 12, September 1, 13, 18, 1770, Chatham Papers, vol. 64, fos. 129, 131, 133, vol. 25, fos. 49, 51, 53, 59, 57.

replied in kind. He was not opposed to reform or constitutional causes, but he would not allow them to interfere with the promotion of his own fortunes. During the winter of 1770–1, with the encouragement of the Rockinghams, he showered Shelburne's friends with abuse and drove them out of the Bill of Rights Society in the spring.[1]

For the moment the Shelburnites were in the ascendant in the City,[2] but chance and Chatham came to Wilkes's help. Chatham swelled into a tower of patriotic rage when that winter the City magistrates refused to back the Navy's press-warrants in the City during the Falklands Islands crisis, and no amount of cajoling from Shelburne would satisfy him. But worse was to follow. In the spring of 1771 when the same magistrates protected the radical printers from punishment by the House of Commons in the Printers' Case, Chatham would not give countenance to the magistrates and, notwithstanding Shelburne's pleadings, objected to Townsend joining them. Wilkes made great play of Townsend's reluctance to come forward when 'he did not find he should be supported by any *great* men, and otherwise that it would be imprudent to act in it'. The 'banditti of the Shelburnes', as Wilkes described them, took no part in the release of the printers and no share of the credit with the Livery arising from the subsequent martyrdom of the magistrates on behalf of the City's rights.[3]

Partly to recover from this debâcle, Shelburne and Chatham tried to revive reform in Parliament. In the last year the parliamentary Opposition had come to adopt in piecemeal fashion the various elements of the reform programme that Beckford and Shelburne had tried to promote among them in the winter of 1769–70. The Rockinghams supported two: the publication of Civil List pensions taken up by Sir George Savile, and the disfranchisement of revenue officers by Dowdeswell. Sawbridge

[1] *London Chronicle*, September 4–6, November 1–3, 1770, *Burke Corr.*, II, 157, 163. Rockingham explained his support for Wilkes: 'If in the end Wilkes gets the better, he will be a great power but perhaps not so dangerous as the others would be if they get the rule, and probably too *Wilkes single* in the end would be easier to manage than a whole pandaemonium' (to Burke, February 3, 1771, *Burke Corr.*, II, 192).

[2] 'The Corporation of London [whatever it may be] possessed more entirely than ever by the Shelburne faction' (Burke to Rockingham, December 29, 1770, *ibid.*, 175).

[3] *Chatham Corr.*, III, 464–5, IV, 94–6, 105–7, 115–35, 146–7; *Letters of Junius*, II, 99, footnote 1; *Parliamentary History*, XVII, 73–81.

moved to shorten parliaments (preferrably to a year's duration), and Chatham, after coyly refusing to be bound to support reform in the terms of an address of thanks presented to him by the City in June 1770,[1] proposed the addition of two members to the representation of each county in order to purify Parliament. There was still very little agreement on the proposals; Rockingham saw in Chatham's idea of adding to the county representation merely a stunt play for the support of the country party; Chatham regarded Dowdeswell's measure as a useless palliative; Shelburne thought Savile's Civil List publication unlikely to attract support out of doors;[2] and both Rockingham and Chatham resisted Sawbridge's proposal for shortening parliament.

In the spring of 1771, however, Shelburne made a last effort to draw the City and Opposition together in the cause of reform and the defeat of the Ministry. In the previous autumn with Townsend and Horne he had prepared a draft 'Heads of an Address, Remonstrance and Petition from the City', as a sort of general climax to the remonstrating campaign of the summer of 1770. That campaign had fallen flat. Chatham's demurings at the inclusion in the draft of a proposal to shorten parliaments, and later Shelburne's mourning for his wife in the spring of 1771, delayed publication. But some of Chatham's objections were met by adding to the remonstrance his proposal for increasing the county representation, and eventually it was decided in April 1771, as a result of the Shelburne party's defeat in the City, to pursue the plan, but in its separate parts.[3] To begin, Sawbridge moved a resolution for shorter parliaments in a nicely-calculated appeal to the country gentry that shorter parliaments would weaken the power of the monied placemen in elections and return the constituencies to the control of the independent interests who relied on local loyalty rather than bribery. It was the first of many such appeals; but the Session was drawing to a close, most of the gentry had already started for home, and his resolution was met, as its successors would be met in future, by the silent negatives of the ministerialists.

Chatham had been full of assurances of support for Sawbridge,

[1] Townsend to Chatham [June 4, 1770], Chatham Papers, vol. 64, fo. 129.
[2] Shelburne to Chatham [November 16, 1770], *ibid.*, vol. 56, fos. 106–7.
[3] 'Address from the City of London', 'Heads for an Address, Remonstrance and Petition', Shelburne Papers, vol. 165, fos. 287–92, vol. 166; Shelburne to Chatham [October 12], [November 13, 20], [December 5, 1770], Chatham Papers, vol. 56, fos. 112–13, 104–5, 92–3, 100; Townsend to Chatham, January 14, 1771, *ibid.* vol. 64, fo. 135.

but these dwindled as it came time for the debate, when he wrote to Shelburne that he found 'a real dislike to the measure, in minds very sound about other public matters'. 'Many people' (meaning Temple) dreaded the increased corruption that more frequent elections might bring, and 'as I am persuaded that this opinion is genuine, and very widely extended, I should think it totally inadmissable for me to stir it'. There was no question of his stirring it; he was merely asked not to obstruct. But having done everything to discourage Sawbridge, he announced himself a convert to triennial parliaments on the last day of the Session, when Sawbridge's motion had been defeated and he had the political stage to himself.[1] Even as a distraction from the City defeat, Shelburne's programme of reform was a failure; nor did his championship of the City's case against the Durham Yard Embankment Bill do much to revive his friends' credit there.[2]

In the City Wilkes continued to profit from his rivals' mistakes. He now had the support of Rockingham, and at the mayoral elections of 1771 determined to support Brass Crosby for a second term. Sawbridge and Townsend stood in partnership. The result was that the popular party was split. Wilkes refused to take Junius' advice to abandon Crosby for Sawbridge, and the Court candidate, Nash, was elected with the help of the Rockinghams in the City. The main blame for the result lay with Wilkes, but Sawbridge was inclined to blame Townsend for not withdrawing in his favour, and the burden of the defeat fell on the Shelburne party, which went further into eclipse.[3]

Now firmly in the saddle as the chief radical in the City, Wilkes pushed reform a bit further. In the summer of 1771, when the rights of the Middlesex electors had palled on his followers, he encouraged a meeting of the Bill of Rights Society to adopt articles of engagement, drafted by Dr. John Lee, requiring parliamentary candidates to support annual parliaments, the elimination of bribery and placemen in politics, and 'a full and equal Representation of the People in Parliament'. Some of the members of the Society defined this last aim as including the representation of the larger industrial towns, the enlargement of

[1] *Chatham Corr.*, IV, 153–70; *Parliamentary History*, XVII, 173–85, 220–3, 322–7, 690–6, 1050–1, XVIII, 216–19, 1267–8.
[2] Shelburne to Chatham [May 26, 1771], Chatham Papers, vol. 56, fo. 204; *Parliamentary History*, XVII, 35–43.
[3] *Letters of Junius*, II, 71–2, *Burke Corr.*, II, 245; *Grenville Papers*, IV, 535–7; *Annual Register*, 1771, 147.

the franchise and the abolition of rotten boroughs — all of them challenges to existing electoral interests and hence challenges to property rights as well.[1] For a year or two more reform served its turn to rally the commonalty and was generally regarded as a City cause, though it was no longer of much interest in national politics except in Shelburne's circle.

Wilkes held the centre of the stage in the City for a little longer largely because of his enemies' determination to keep him out of power. In the mayoral elections of 1772, though he had a majority of the Livery behind him, he was cheated of the mayoralty by the ministerialists in the Court of Aldermen, who gave their votes to Townsend. A depression among weavers and other working people during Townsend's mayoralty provided Wilkes with ample opportunity to embarrass his rival, who lost ground steadily as he showed himself reluctant to associate himself with the violent petitions of the workers to the Crown which Wilkes and his friends promoted.[2] Once more in 1773 a majority of the Aldermen decided against Wilkes, electing Frederick Bull. But the great days of Wilkes and the City were coming to an end. At Michaelmas 1774 Wilkes became Lord Mayor at last. A month later he was returned as Member for Middlesex at the general election and permitted to take his seat. From that moment his grievances ceased to be an issue and his influence declined. His quarrel with the Shelburnites evaporated, and in the autumn of 1775 they co-operated in securing the election of Sawbridge as Lord Mayor and in denouncing the Ministry's coercion of America.

That 'Wilkes and Liberty' was no longer a distinct cause was made evident by Wilkes himself in March 1776, when he moved the House to take into consideration the state of the representation in terms which owed a good deal to the work of the Shelburnites. After their efforts to keep alive constitutional reform as the theme which would make the City's cause the nation's, they listened and cheered on their old enemy as he carried reform back into Parliament once more. In his speech he publicised the idea of popular rule. It was now more than a century old, and had recently had new currency in the writings of various radical theorists as an answer to the doctrine of 'virtual representation' with which Mansfield had justified the non-representation of the American

[1] *Letters of Junius*, II, 71-6.
[2] Cf. *Calendar of Home Office Papers, 1773-5*, 13-14, 39-45.

colonists in Parliament. The re-statement of accepted, or even of dimly apprehended usages, may contain attempts to define authority as it has not been defined before. When Wilkes repeated James Burgh's recent statement that a parliamentary majority which depended on the votes of only 5,723 persons had no mandate to rule the nation, much less commit it to the suppression of American liberties,[1] he was beginning a new challenge to the established political order. The arguments were now placed in a larger philosophic framework, and he was drawing on a more sophisticated inspiration than any offered by the loyalties to City or country as he proclaimed that all government was ultimately vested, as of right, in every individual 'who may be supposed to be comprised in a fair majority'. The reform cause was drawing on a new inspiration, and Shelburne was playing an important part in bringing it into the world of practical politics.

[1] *Parliamentary History*, XVIII, 1287–98.

The Great Opposition II:
Theorists and Politicians

To understand Shelburne's part in this new phase of reform, it must be examined in the general setting of his intellectual interests during these years. His liberal views developed at least partly under the inspiration of the great figures of the Continental Enlightenment, with whom he became acquainted on his extended tours of the Continent in the early 1770's. In Italy in 1771 he met Beccaria and Bernis, and began his dealings with the professional antiquary, Gavin Hamilton, which were soon to provide Shelburne with one of the finest collections of antique statuary in Europe.[1] Later he attended the *salons* of Mmes. de Boufflers, Geoffrin and Helvetius, and met D'Holbach, Turgot, Trudaine and Morellet. As the lieutenant of Chatham and one of the chief opponents in British politics to the coercion of America, he was very popular in these circles.[2] With Morellet he formed a lifelong friendship, and under his stimulus extended his ideas about trade beyond the need for preserving the Anglo-American trade system and expanding markets for British manufactures. Now, as the crisis of the American conflict approached, under the influence of Morellet's *bienfaisance*, he came to believe that friendship with France and open trade with all nations were the foundations on which Britain's external policy ought to be based.[3]

Shelburne's friendship with Morellet and his association with the other *philosophes* strengthened his general libertarian views, but the further development of his specific political ideas on reform,

[1] Lord Fitzmaurice, 'Letters of Gavin Hamilton edited from the MSS at Lansdowne House', *The Academy*, August 10, 17, 24, 31, September 6, 1878; Adolf Michaelis, *Ancient Marbles in Great Britain* (Cambridge, 1882), 104–5, 435–7; A. H. Smith, *A Catalogue of the Marbles at Lansdowne House* (London, 1889).

[2] *Correspondence of Horace Walpole* (Yale Edition; New Haven, 1939), V, 144–5, 153, 157, 163; *Letters of Mlle. de L'Espinasse*, ed. C. A. Ste-Beuve (London, 1902), 155, 168–9, 182–3.

[3] Fitzmaurice, *Life of Shelburne*, I, 430–1; André Morellet, *Lettres à Lord Shelburne*, ed. Lord Fitzmaurice (Paris, 1898), *passim*.

so far as they were influenced by the ideas of anyone else, was owing to an inspiration that was English, not Continental. It came from that remarkable network of relationships which bound together dissident Churchmen, Dissenters, Unitarians and radical theorists in a loose alliance to promote reform in Church and State in the years between the Middlesex election and the French Revolution. 'Dissenting Interest' is an inadequate description for it, since it included in various circumstances Francis Blackburne's circle of heretical Anglican clergy who were responsible for the Feathers Tavern Petition, and Christopher Wyvill who never left the Established Church. Nor was the group strictly speaking 'tolerationist', since Blackburne's circle and many of the political theorists — notably Thomas Brand Hollis and Capell Lofft — were strongly anti-Catholic. The Baptists, Robert Robinson and David Williams, looked back to the libertarianism of the Interregnum and forward to that of the French Revolution. Radicals predominated; so did Dissenters. Many of them had begun their careers in one of the famous Dissenting academies: Warrington, Hackney or Newington Green. An unbroken thread of relationship — in many cases a close relationship — may be traced between all these individuals. To a widely representative range of English prejudice the rise of the Dissenting interest was synonymous with the revival of Cromwellian dictatorship, and Shelburne's association with it yet further proof of his desperate revolutionary and/or Jesuitical designs.[1]

The emergence of these people to political consciousness after 1769 was marked by a rapid secularisation of their ideas concerning the relations between church and state and about liberty in general. Their ultimate purpose was to secure the equality of Dissent with Establishment. In applying to Parliament in 1772–3 to extend the scope of the Toleration Act by relieving the Dissenting clergy of the obligation to subscribe to most of the Thirty-Nine Articles, they put their trust in the power of the state to relieve them of the power of the state, rather than in their older argument that the civil magistrate could not and should not interfere with matters of conscience. They relied on the 'candour', or spirit of secular enlightenment among the leading figures in politics. For Shelburne, the Duke of Richmond and Sir William Meredith this meant believing that the political and ethical communities ought to be

[1] Cf. John King, *Thoughts on the Difficulties and Distresses in which the Peace of 1783 has Involved the People of England* (London, 1783), 16; *Gentleman's Magazine*, January 1783, 22–3.

G

co-extensive. For Mansfield and Burke it meant believing that religion ought not to be a test for full citizenship. But the Dissenters also relied on less altruistic aid: on the willingness of the Opposition to use the shortcomings of the religious settlement as a line of attack on the Ministry; and on the fact that Members on both sides of the House depended for their seats on Dissenters' votes. For these secular-religious politicians the lesson of their defeat in 1772–3 was that they must have more of the power of the state on their side. They turned more definitely than before to politics and to radical politicians until they included in their tribute to Caesar those things that were God's.[1]

By the time the American War broke out their reorientation had already borne fruit for reform and for Shelburne. In 1774 James Burgh, drawing on a lifetime of troubled thought about liberty, summarised the prejudices of the City of London politicians in his conclusion in *Political Disquisitions* that only one estate, dominated by the merchant interest, was necessary for the well-being of the constitution. A little earlier Joseph Priestley, in his *First Principles of Government*, had provided a utilitarian justification for middle-class government.[2]

Priestley's was the strongest personal influence shaping Shelburne's political ideas during these years. Richard Price introduced him to Shelburne in 1772 and from 1773 to 1780 he acted as librarian at Bowood and paid companion to his widowed patron. He was the principal link between the Christian liberty tradition of the Dissenters and the materialist doctrines of the utilitarians, and introduced Shelburne to the world of utilitarian middle-class politics. According to the scale of values which he imparted to Shelburne, virtue was to be found in a middling station in life, liberty of conscience, private secular education, self-help, thrift, and respect for property as the trust of the righteous and the test of political responsibility; vice was to be found in idleness, luxury, established religion, pauperism, and the life of the English poor generally. His principal contribution to Shelburne's political education (years before Jeremy Bentham arrived at Bowood) was

[1] *Parliamentary History*, XVII, 301–8, 317–21, 431–6, 742–91; *Chatham Corr.*, IV, 199–219, 239, 252; *Rockingham Mem.*, II, 224–5; Fortescue, II, no. 1049; Anthony Lincoln, *Some Political and Social Ideas of English Dissent, 1763–1800* (Cambridge, 1938), 182–270; Caroline Robbins, *The Eighteenth-Century Commonwealthman* (Cambridge, Mass., 1959), 320–77.

[2] James Burgh, *Political Disquisitions* . . . (London, 1774), I, *passim*; Priestley, *First Principles of Government* (London, 1770), 16–17.

the idea that the measure of the value of all institutions must necessarily be that of utility.[1]

If his association with Priestley made Shelburne a utilitarian, his friendship with Richard Price was a constant reminder that liberty was more than a hedonistic hypothesis. Shelburne had been introduced to Price in 1769 by Elizabeth Montagu, 'The Queen of the Blues', but their friendship blossomed only after Shelburne's support for the Dissenters' application of 1772. He was attracted more by Price's moral earnestness than by its specific application. They disagreed on the great crisis of the age, for Shelburne was reluctant to recognise American independence and Price welcomed it as a great moral advance for mankind. But on the larger implications of the crisis of liberty and reform they were at one. At the nadir of the Opposition's fortunes Shelburne adopted Price's apocalyptic explanation for the decay of British liberty as the effect of indifference, luxury, dissipation and the cardinal sin of trying to coerce America. He also used Price's principal argument for the necessity of reforming Parliament and 'returning' it to the control of the people: that the unreformed Parliament had committed what Price, like most Dissenters, regarded as the most tragic crime of destroying the unity of the British nation.[2] Later Price was a collaborator with Cartwright and Horne Tooke in campaigning for shorter parliaments and a broadened franchise. But his principal contributions to Shelburne's political education were his schemes for financial reform. His sinking fund, and plans for reforms of the financial offices and purification of the government's contracting system gave form and system to the Opposition's demands for place bills and the elimination of influence. Shelburne drew liberally on him during the years of the wartime Opposition and frequently acknowledged the debt. In his more sanguine moments Price hoped that Shelburne in office would implement his plans.[3] But he

[1] Priestley, *Memoirs* (London, 1806), 72–83; Priestley to Shelburne, May 20, 1773, September 11, 1776, December 20, 1778, May 12, 1779, Bowood MSS.
[2] Price, *Observations on the Nature of Civil Liberty* (7th ed.; London, 1776), 9–10, 13.
[3] 'It is wrong to despair of the State. . . . A Minister wise, honest and great, wanting nothing for himself, rich by frugality and simplicity of life, superior to the indulgences of luxury and the pomp of greatness, and ambitious only to serve his country. Such a minister may arise, and, by shewing himself the friend of the people, may introduce himself gradually into their confidence and gain an ascendant in the State like to that which Ld. Chatham once enjoyed. It is by *such a Minister* that the measures necessary for our preservation must be carried into execution' (A Sketch of Proposals for Discharging the Public Debts . . . , Shelburne Papers, vol. 117).

also recognised that his ideal of a moral polity was unrealisable in the England of his own day, and after the American War transferred his hopes to America as the future regenerator of the English race.[1]

In the spring of 1776 Price showed Shelburne the manuscript of what was perhaps the most important reformist pamphlet of the age — John Cartwright's *Take Your Choice!* It carried the agitations of the Bill of Rights Society and the Livery to the logical conclusion to which those bodies by themselves would not have come. Cartwright wrote that corruption, tyranny, the national debt, the ferocities of the criminal code, unemployment and such incidental abuses as ale houses, vagrancy, prostitution, the Church Establishment, East India nabobs, and 'the luxury and avarice of the people' would disappear or be mitigated as a result of instituting annual parliaments; indeed, class distinction itself might be expected to yield to social equality under such a dispensation. Like all good English revolutionaries he claimed that his proposals would not change, but merely restore, the constitution to its ancient purity. But he went beyond his contemporaries in the substance, and beyond the egalitarians of the seventeenth century in the precision, of his proposals. Every man, according to Cartwright, had a right to vote by a double title: that of a share in the English constitution by birthright, and that of a stake in the country if he had a wife and children. Freedom, moreover, admitted of no degrees and implied that every man had some voice in deciding his destiny. Hence, he concluded, all men subject to militia service, i.e. over the age of 18, had an absolute right to vote. To implement and safeguard this and other rights, he proposed annual elections, regular electoral rolls (kept by the local vicars), payment of Members of Parliament and the abolition of plural voting. He also favoured eliminating the property qualification for Members and the royal prerogative of assembling and dissolving Parliament. He concluded that there was nothing that 'an associated nation' might not do to secure its liberties. No throne, no authority, was sacrosanct and only the nation's belief in the expediency of such authorities could preserve them for long.[2]

Locke and his predecessors in the seventeenth century had

[1] William Morgan, *Memoirs of the Life of the Reverend Richard Price* ..., (London, 1815), 31; Price, *Observations on Civil Liberty, passim.*; Lincoln, *op. cit.*, 101–50.
[2] *Take Your Choice!* (London, 1776), *passim.*

perhaps said as much, but in 1776 such statements had a dangerously revolutionary implication for the politicians of the unreformed Parliament struggling to maintain the unity of the British empire Even Shelburne was cautious. When Price showed him the manuscript of *Take Your Choice!* he commented that the public 'had a right to expect that the leaders of Opposition should hold forth to them some public objects which they will bind themselves to do all they can to gain', and that he would not be backward in uniting with 'any respectable man' in doing this. But in the absence of support from the Rockinghams it seemed that Cartwright would have to be content with his good wishes, and Price wrote regretfully to Cartwright:

> It will not be easy to get any number of great men, though favourable in their opinions to such a scheme as yours, to be active and zealous in carrying it into execution; nor have I much hope that any great reformation will take place in this country till some calamity comes that shall make us feel more, and awaken us more to reflection.[1]

That calamity was now upon them.

* * * *

How that calamity was faced, and how it influenced the fortunes of both Shelburne and reform, was determined very largely by the nature of the Opposition which the Rockingham and Chatham parties mounted against the Ministry during these years. For most of the time its most salient feature was the sharp disagreement between the parties. This was much more habitual and personal than ideological. Shelburne was an active ally of the City radicals and Chatham talked of 'measures not men', but it did not follow that Rockingham and Burke disdained City alliances or that theirs was a party of 'men not measures'. Shelburne held firm, if often vaguely expressed, ideas about reform; but the Rockinghams too had ideas — the reduction of the undue influence of the Crown, the reversal of the Middlesex decision and, later, peace with an independent America — which they held to with remarkable faith and consistency.

Sometimes the disagreements between the parties arose from consistently following the lines they had adopted in the 1760's. Thus in the crisis of the East India Company's fortunes in 1772

[1] Price to Cartwright, April 2, 1776, *Life and Correspondence of Major John Cartwright*, ed. F. D. Cartwright (London, 1826), I, 95.

and 1773 the Rockinghams, under Richmond's leadership, rallied to protect the chartered rights of the Company and, by implication, the liberty of the subject, from the encroachments of the Crown. Chatham, Shelburne and their friends supported the right of the state to the lion's share of the Indian territorial revenue and the need for state regulation of the Company. Each line had its dangers: the Rockinghams had to dissociate themselves from the shortcomings of the Company while defending it; the Chathamites had to distinguish their conduct from that of the Ministry.[1]

But the disagreements were more often clashes of personality than genuine differences of belief. The Rockinghams blamed Chatham's peripatetics and Shelburne's treachery for producing what Sir George Savile described as the alternating palsy, 'of that very peculiar and whimsical kind that when one side would move, the other is struck motionless.'[2] Their conduct over the Irish Absentee Tax of 1773 was a case in point. When the news was first heard in England that the Irish House of Commons, with the approval of the British Ministry, was going to levy a special tax on absentee landlords, Shelburne had agreed with the Rockinghams that the tax must be resisted. Indeed, he egged them on to rally the Opposition gentry against it. But after consulting with Chatham, Shelburne realised that he was denying the Irish Parliament the right of taxation which he was fighting to secure for the Americans. He promptly told Rockingham that he would not support the appeal to the Ministry to prevent the Irish Parliament levying the tax, and would oppose the Ministry interfering to force them to levy it. He also persuaded Townsend, then Lord Mayor, to take the same line. Anticipating an opportunity to push the principle of local self-government on to the Ministry, he wrote to Chatham:

> If the Absentee Tax is given up, it remains to be seen what use the Opposition and the people at large will make of the Principle upon which the English Ministry have committed themselves.[3]

The issue never came to this, because the opponents of the tax were able to defeat it in the Irish House of Commons. Shelburne was not alone in regretting that the opportunity for forcing the principle on the Ministry had been lost — Richmond and Sir

[1] Lucy Sutherland, *East India Company*, 213–68; *Chatham Corr.*, IV, 252–65 270–3, 276–85.
[2] Savile to Rockingham, November 15, 1777, *Rockingham Mem.*, II, 323–4.
[3] November 14, 1773, Chatham Papers, vol. 56, fo. 149.

George Savile had taken a similar view and Rockingham had grudgingly admitted that there was something in it. But Burke, Bessborough, Portland and the other *ultras* of the Rockingham party spread the word that Shelburne had sold out to the Court on the issue, and the accusation stuck.[1]

What began as an accident of personal antipathies became a habitual line of conduct. Chatham and Shelburne seemed to resist every claim of the Rockinghams to speak for the Opposition, giving to their resistance a somewhat specious justification by posing as defenders of the 'just prerogatives of the Crown' against the encroachments alike of corrupt placemen and ambitious Opposition oligarchs. Shelburne in particular frequently and forcefully attacked 'undue influence' and stated his conviction that reducing the influence wrongly exercised in the Crown's name, rather than changing the Ministry, was the most important reform to be made.[2]

After 1774 the relations between the groups in Opposition were dominated by the American War and by the possibility of one or other of them returning to office. Almost to the end no one thought seriously of the possibility of American independence. Shelburne informed Price in the spring of 1775 that he was prepared to 'risk his head' on the colonists proving themselves 'not only Faithful Subjects, but Faithful Colonists to the Parent State'.[3] Most of the country gentry disliked America as that part of the empire that kept the Land Tax high by refusing to bear its fair share of the common tax burden; but the City had a sentimental bond with the colonists born of common resistance to the Ministry and an economic stake in the maintenance of Anglo-American trade. Dissenters on both sides of the Atlantic, too, were united against the Establishment. Members of the Parliamentary Opposition idealised the American as the free Englishman who was yet intelligently moderate in resisting the usurpations of the Ministry. Most of them knew that most untypical American, Benjamin

[1] Shelburne to Chatham, November 14, December 5, Rockingham to Shelburne, December 1, 2, 5, 1773, *ibid.*, fos. 148–51, 121–3, 136–7, 138; Rockingham to Townsend (2 letters), October 30, Townsend to Rockingham, November 3, 1773, Shelburne Papers, vol. 130; Burke to Rockingham, November 7, 1773, Fitzwilliam MSS, Rockingham 3–148a, 165; *Rockingham Mem.*, II, 227–34; *Chatham Corr.*, IV, 296–308, 317–21.

[2] Shelburne to Price, December 26, 1774, 'The Price Letters', *Proceedings of the Massachusetts Historical Society*, 2nd Series, vol. XVII (May 1903), 274; *Chatham Corr.*, IV, 199, 203–4; *Parliamentary History*, XVII, 394, 407–9, XIX, 610, 1048–9.

[3] Shelburne to Price, n.d., 'Price Letters', *op. cit.*, 274–5; cf. *Parliamentary History*, XVIII, 221–65, 722–6.

Franklin, whose calm dignity in the face of Wedderburn's invective at the Privy Council had won their hearts and suppressed any suspicion, if it had ever been entertained, that he might have been guilty of tampering with the mails while serving as Deputy Postmaster-General for America.

As on other issues, the policies of the Opposition parties on American affairs were already shaped by their attitudes and policies adopted in the 1760's. They did not advocate popular rule nor, specifically, imperial decentralisation; but rather a defence of the contracts (real or implied) by which the respective parties supposed that imperial relations were governed. For the Rockinghams this meant vigorous defence of the Declaratory Act and insistence that it was inexpedient to enforce the sovereignty of Parliament on the colonies, unless through the voluntary assent of Americans to an 'original' tacit compact. Chatham varied this formula by denouncing the Declaratory Act as claiming 'a mere legal power' inexpedient to exercise or to recall to the minds of Treasury lawyers; but he proclaimed the authority of Parliament and Britain over all matters of imperial concern, including 'external' taxation. In his plan for conciliating America in February 1775, he suggested that the assemblies vote requisitions for the imperial service, that Congress decide the distribution of the burden among the various colonies, and that this tax constitute the permanent revenue for the support of government in America for which successive ministries and colonial governors had striven in vain since the beginning of the century.[1] To the end of his life Chatham remained convinced that the Americans had been perfectly willing to grant this revenue; they had only to be asked in the right way, and by the right person. Shelburne was more realistic. Like Dowdeswell and Burke, he urged the need to take every opportunity to promote every possible agreement with the colonists, for without a wide measure of agreement the empire became an expensive incubus to Britain, to be maintained, if at all, by force of arms. At the end of 1775 he proposed that Parliament give up all idea of imperial taxation and instead adopt Richard Price's proposal of an agreement with the colonists to contribute together to a sinking fund to pay off the common debt and thus eventually benefit the common credit and trade of the empire.[2] But the time

[1] *Parliamentary History*, XVIII, 198–216.
[2] Cf. Price, *Observations on the Nature of Civil Liberty* (London, 1776), 60–1; *Parliamentary History*, XVIII, 924, 1387.

was past for such schemes, which were now irrelevant to the sort of autonomy or independence for which the Americans were contending.

The crisis in the winter of 1773-4 came as an unpleasant surprise to the Opposition. They had just built up a credit with the country party by supporting the perpetuation of Grenville's Act for trying controverted elections, and since the country Members were likely to vote to coerce America, the Opposition were tempted to bend with the American storm. Barré went so far as to support the Boston Port Bill and the Rockinghams retreated into silence.[1] But not for long. With or without the country support they were committed to America by their past statements.

They were also committed to believing the worst of the Ministry, and the exercise, or threatened exercise, of prerogative powers in the emergency gave a new plausibility to the Rockinghams' old argument that the prerogative was dangerously expanded and ought to be reduced. Shelburne did not immediately support this line, but by stages he fell back, first with Dunning's help to the eternal principles of the Bill of Rights as restricting the military powers of the executive, then to demanding some means of restraining 'the power and mode of exercising the constitutional plan of royal requisition'.[2] Both the ineptitudes and the successes of North's Ministry were tightly woven by the Opposition into circumstantial proof of tyranny. Shelburne affected to see the heaping of error upon error, ever since the collapse of the Ministry of 1766, as the effect of secret influence, 'this uniform, lurking spirit of despotism,' which at length had openly established, by the Quebec Bill, 'popery and arbitrary power over half America.'[3]

The impression of tyranny was made more sinister by the apparent support enjoyed by the Ministry and its policy.

Who could have imagined [complained Camden to Grafton at the beginning of 1776] that the Ministry could have become popular by forcing this country into a destructive war, and advancing the power of the Crown to a state of despotism?[4]

At the beginning of the crisis it was generally admitted that the

[1] *Parliamentary History*, XVII, 1178-9; *Chatham Corr.*, IV, 334-43; *Rockingham Mem.*, II, 252-6.
[2] *Parl. Hist.*, XVIII, 816, 959, 1271; Dunning's Notes on the Bill of Rights, October 1775, Shelburne Papers, vol. 168, part III, fos. 179-80.
[3] *Parl. Hist.*, XVIII, 725; cf. *ibid.*, 102-3, 319-58, 448-50, 1005-27.
[4] January 4, 1776, *Grafton Autobiography*, 279.

country independents would be hostile to America, and as the war progressed they became steadily more entrenched in the ranks of the administration supporters until Shelburne remarked in 1777 that there were 'modes of corruption that have found their way even to the landholder'.[1] But the Opposition hoped and believed that the merchants would stand firm in support of America and what the Opposition told them were their own best interests. Camden went so far as to describe the quarrel with America as 'a war between the Land and Trade of this Kingdom'.[2] As in 1765, the London and Bristol merchants trading with America produced their petitions against the coercion of America. But they were balanced this time by a considerable number of 'loyal addresses' from Liverpool, Birmingham, Manchester and even some of the London Livery. Some of these may not have been very representative, but undoubtedly opinion in the Midlands was not pro-American. Some manufacturers apparently dreamed of shifting trade away from America and toward continental Europe in the hope — vain as it turned out — of ending the stagnation into which British exports had fallen. An increase in purchases from Baltic countries in 1775 relieved the Navy of the worst effects of the American troubles for the time being, and the good harvest of that year and the general stimulating effect of mobilisation on manufacturing led the manufacturers to adopt a 'wait and see' attitude, if not to express support for the Ministry.[3]

The Ministry suffered from one supreme disadvantage: they were responsible for making policy, and as each crisis came and their previous assurances were discredited, or seemed to be, the Opposition took heart. The occasions upon which parliamentary oppositions have been justified by events in matters of external policy are so rare as to be momentous. It was being in the position to say 'I told you so' at frequent intervals for the next seven years that eventually brought the Opposition back to power in 1782.

But their attitude to the American War was not governed solely by considerations of party advantage. Most members of the Opposition believed and were concerned that the Americans were being oppressed, and must be defended from a tyranny which, if it

[1] *Parliamentary History*, XIX, 347.
[2] Camden to Grafton, August 23, 1775, Grafton MSS 55.
[3] Cf. my article: 'Samuel Garbett and the Early Development of Industrial Lobbying in Great Britain', *Economic History Review*, Second Series, X, 450–60; *London Chronicle*, August 29–31, September 14–16, 30, October 3, 1775; *Parliamentary History*, XVIII, 168–98, 379–400, 719–20.

was not restrained, would soon engulf their own liberties. To them it seemed in 1774 that Boston was going to be made an example of, and in 1775 that the Americans were going to be given the alternative of Dundas's 'merciful starvation' or the devastation of war. Such impressions seemed to be confirmed by the statements of some of the Ministry's least responsible supporters. Moreover the Opposition's physical detachment from the scene of action caused them to give a horrendous and circumstantial credence to the atrocity stories from America that could never have been roused by the crushing of riots in the City. Troops were being sent to quell people of whom they knew very little except that they were Englishmen defending the liberties of Englishmen. Indian warfare was practised in America and its horrors were being directed against the colonists. The charters of the colonies were being suspended as the charters of the corporations had been suspended by the later Stuarts. The Quebec Act had been passed apparently to protect and establish the Roman Catholic faith, to violate the Uniformity and Test Acts and the Bill of Rights, to deny habeas corpus and jury trial to the King's subjects and to encourage the raising of popish forces for the suppression of Protestant freedom in the other colonies. The days of James II seemed to have come again. Even when the War had developed into a struggle against American independence the Opposition refused to consider it as anything but an unnatural conflict for the suppression of the Americans' rights. They attempted to have the American prisoners of war released on writs of habeas corpus, they mourned after Long Island and rejoiced after Saratoga; Shelburne, at least, carried on a correspondence with Franklin and Silas Deane in defiance of the existing rudimentary prejudices (they were not yet regulations) against intercourse with the enemy. The same mixture of political expediency, doctrinaire wrong-headedness and generous humanitarian reluctance to see the British name used to justify the barbarous practices of a lesser civilisation which was later to characterise the attack on Warren Hastings was present here. Its effect in keeping alive the long opposition to the American War should not be underrated.

After the Declaration of Independence the Opposition had to choose between defending what they thought was liberty (and what the Ministry and the Americans recognised as revolution) or defending the unity of the empire. The Rockinghams chose the

first, at least officially. Chatham refused under any circumstances
to recognise independence; and Shelburne preferred to take a
middle ground in which he argued that if only the War could be
stopped an agreement might be made to secure a federal alliance
with the Americans on the basis of common trade interests and the
Navigation Acts. The Ministry's proposal in the spring of 1778 to
negotiate with the Americans on these lines forced him to declare
himself openly against independence. On the other side, recogni-
tion of independence became one of Rockingham's 'measures'.
But perhaps the disagreement was more apparent than real. Fox
wrote to Richard Fitzpatrick toward the end of 1778:

> If the acknowledgement of Independence would not procure peace,
> it is certainly useless. I own my present idea (considering all things as
> well at home as abroad) is rather with Ld. Shelburne for being silent
> upon that subject, but acting as if it were acknowledged, withdrawing
> our troops from North America, and making the most vigorous attacks
> upon France or possibly Spain too.[1]

And a year later Barré reported to Shelburne that he had

> ... talked to K[eppel?] about independence on which his friends had
> so particularly committed themselves. He set such committments
> much at nought, said it came only from the D. of R. and C. Fox, and
> that they were very able to explain themselves out of that scrape.[2]

As in the pre-war era, disagreements seemed to have their root
in personal and party rivalries rather than conviction. The greater
the crisis the greater the rivalry between the parties in bringing
forward measures for attacking the Ministry and, paradoxically,
the greater the tendency for them to co-operate in trying to over-
throw it. Each crisis of the Ministry or defeat of the British armies
— the suppression of Boston in the spring of 1774, the news of
Lexington, the formal acknowledgement of war by the Prohibitory
Act in the winter of 1775–6, the news of Saratoga, the entry into
the war of France and Spain and the supreme crisis of the summer
of 1779 — brought such activity in rivalry and co-operation.
Conversely, ministerial successes or British victories — the passage
of repressive measures in the spring of 1775, the string of British
victories in 1776 and the early part of 1777, and the apparent
recovery of the Ministry in the winter of 1778–9 — depressed the

[1] November 11, 1778, Add. MSS 47,580, fo. 37.
[2] Barré to Shelburne [early autumn, 1779], Bowood MSS.

Opposition and, on the part of the Rockinghams at least, brought on a tendency to secede from Parliament. They hoped, by thus dramatically abandoning their parliamentary duties, to draw public attention to the dangerous tendencies of the administration. But they were too few in numbers and the gesture too obviously out of character for them to carry it off. The effect was spoiled in any case by Members succumbing to the temptation to turn up for exciting or crucial debates, or to keep an eye on what Shelburne and the rest of the Opposition were doing.[1]

In these circumstances Shelburne's role in the Opposition became increasingly important. After 1773 he was the real leader of his party, since Chatham was unable to attend Parliament except for short intervals in the Sessions of 1774–5 and 1777–8. Chatham apart, he was the most capable debater among the Opposition lords, and certainly the best informed. His apparently occult knowledge of what was going on inside the government and in France and America was the wonder of the Lords. According to Bentham, he was in regular correspondence with Caron de Beaumarchais, the playwright who was also the French government's agent, through the Hortalez Company, for supplying the Americans.[2] There is no evidence in Shelburne's surviving correspondence to support this, but he did receive letters fairly regularly from the American Commissioner Silas Deane, and from Thomas Walpole, a British merchant who resided in Paris to avoid his creditors and was particularly well-informed on French affairs. Shelburne also visited France himself in the summer of 1776, when he made a special tour of the western provinces where war preparations were being made. Richard Oswald, whom he was later to employ in the peace negotiations, was also a useful correspondent. Oswald had been a business associate of Henry Laurens of South Carolina and was kept informed about American relations with France. For information concerning British policy in America Shelburne relied on Sir Charles Grey who commanded there, and on the complaints from Quebec of his friend Sir Guy Carleton.[3] Captain John Jervis and Captain John Blankett were his authorities on naval affairs, and Nathaniel Smith was his chief contact with the East India Company. There were also other, less prominent and more mysterious figures, mostly clerks whom he had befriended in

[1] *Rockingham Memoirs*, II, 282–324. [2] Bentham, *Works*, X, 93.
[3] Carleton to Shelburne, January 13, August, September, November 6, 1777, Bowood MSS.

the 1760's or disgruntled placeholders, who supplied him with secret or confidential information. Bentham mentions one Hodgson who, on his way to an expedition to the Honduras coast in the summer of 1781, stopped off to tell Shelburne all about it.[1] Robert Gregson, the Clerk of the Acts in the Navy Office, gave particularly full and regular reports on the dispatch of ships and on the sins — real or imagined — of Lord Sandwich. There is no evidence of how he came to be Shelburne's agent, but plenty in the form of his persistent and hectoring demands for gifts, loans, favours and the use of horses, of Shelburne's dependence on him.[2] When he returned to office in 1782, Shelburne not only broke off the connection, but tightened up security arrangements in the offices against future leaks of this sort. Wraxall, who appears to have been echoing the popular opinion, attributed Shelburne's knowledgability to a private espionage system.[3] It was hardly as developed as that. The evidence in his papers suggests that Shelburne depended for his information on what Bentham described as his 'systematic plan for gaining people', and, as in all good intelligence, on his capacity for fitting the pieces together.

During the years of the American War Shelburne was more obviously active than Rockingham in pressing on a vigorous opposition to the Ministry, a fact which he seldom neglected to point out when co-operation between them was being discussed.[4] It was easy for him to be active, since he was not the leader of a substantial party — his followers numbered nine or ten in the Commons and half a dozen in the Lords — and he was under no compulsion to modify his opinions to suit them. His consciousness of superior vigour and intelligence made it especially hard for him to co-operate when co-operation meant, as it usually did, playing second fiddle to Rockingham. In an effort to free himself from this subordination he went to some pains to make an alliance with the Duke of Grafton when the latter joined the Opposition at the end of 1775. Perhaps it was not worth the effort since it was not the least of Shelburne's difficulties both in Opposition and in office that he was continually having to appease the injured sensibilities or voracious patronage appetites of Grafton or his ally Camden,

[1] Bentham, *Works*, X, 109–10. [2] Shelburne Papers, vol. 146, *passim*.
[3] *Historical and Posthumous Memoirs*, II, 61–2.
[4] Cf. Priestley to Savile, October 28, 1775, H.M.C., *Savile Foljambe MSS*, 149; Manchester to Rockingham, October 22, 1777, Fitzwilliam MSS, Rockingham 10–24–1.

only to have them stay in the country when important business was afoot in Parliament. More fruitful was his alliance with Charles James Fox during the latter's independent phase between 1776 and 1778. Both were disgusted with the inactivity of the Rockinghams, both toyed with the idea of making some separate arrangement with the Ministry by which they would come to power and have the opportunity of settling the war and reducing the influence of the Crown before the Bourbon Powers tipped the military scale against Britain.[1] Shelburne's second marriage in the summer of 1779 to Lady Louisa Fitzpatrick, sister of Lord Upper Ossory and Richard Fitzpatrick, Fox's close friends, could have been a further bond of alliance. But by that time their co-operation was languishing, largely, it may be supposed, because Fox was no longer an independent, but becoming a leader of one of the sections of the Rockingham party and Shelburne's rival for power.

Saratoga and the Franco-American alliance initially helped Shelburne more than they did the Rockinghams. Chatham was back in Parliament and it was widely rumoured that the man who had 'won the war' would be called back to win another. In that case, it was generally agreed, Shelburne would be Secretary of State responsible for managing the war and effective minister. Their stock rose abroad,[2] and even at Court, where their refusal to recognise American independence made them more acceptable than the Rockinghams.

But the offers of the Ministry for a change between 1776 and 1782 were never all-inclusive ones, never designed to bring in all the Opposition or even all the Rockinghams. Any small group that took the bait was bound to be swallowed up in the mass of the Ministry. Thus, though they disagreed sharply on granting American independence — and never more sharply than when the news of Saratoga showed that independence was going to be achieved — Chatham and Rockingham hastened to strengthen their alliance just as it was about to be threatened by offers from the Ministry. Shelburne, who was less committed to a dependent America than Chatham, arranged for the City to petition the Crown for an end to hostilities at the same time as Chatham moved

[1] Cf. Fox to Rockingham, January 4, Fox to Burke, January 24, 1779, Fitzwilliam MSS, Rockingham I, 1009, Burke 759 (1-2); Richmond to Fox, February 7, 1779, Add. MSS 47,568, fos. 71-5.

[2] Cf. comments of the French Ministers, B. F. Stevens, ed., *Facsimiles of Manuscripts in European Archives Relating to America* (London, 1889-98), nos. 524, 1316, 1814.

for an address to the same effect in the Lords. Barré and Dunning took care in the Commons, meanwhile, to abstain from voting on Wilkes's motion to repeal the Declaratory Act, a subject on which most of the Rockinghams were still sensitive.[1]

In March 1778 came the expected offer from the Ministry, delivered by William Eden, through Fox, to Shelburne. Shelburne and Barré were invited to join the Ministry, but not Chatham, whom the King had sworn no advantage to the country nor danger to himself would induce him to approach. Shelburne merely stipulated that 'Lord Chatham must be dictator', and Chatham demanded a genuine all-party government including Grafton and Rockingham, and excluding Mansfield, Thurlow, Gower and Germain. But Eden could give no encouragement for such an arrangement, and Shelburne refused to move without Chatham.[2] The Ministry, however, soon took new heart again as the alliance of Opposition broke into a bitter wrangle over granting American independence. In the midst of it Chatham collapsed and died.

Shelburne was now free to manoeuvre toward or away from the Rockinghams or the Ministry, without having to take account of Chatham's prejudices. But he was hardly more of a free agent than before. The Ministry's offers in February and November 1779 were just as restricted as that of March 1778. The only useful alliances he had — with Richmond and, more guardedly, with Fox — led ineluctably to Rockingham. He might kick against the pricks, resent Rockingham's self-conscious rectitude, and weary them both with his urgings to court a little popularity with the radicals and at least show a little vigour against the Ministry.[3] But even if he dreamed sometimes of displacing Rockingham and eventually forming his own Ministry, he had to admit that everything depended, now and in the future, on the solid phalanx of the Rockingham party.

[1] Manchester to Rockingham, October 22, 1777, Fitzwilliam MSS, Rockingham 10-24-1; *Memorials of Charles James Fox*, I, 181; *Correspondence of Edmund Burke*, III, ed. G. H. Guttridge (Cambridge, 1961), 420; Shelburne to Chatham [December 4, 18, 20, 1777], [January 13, 15, 1778], Chatham Papers, vol. 56, fos. 168-70, 176-7, 202-3, 200-1, 178-81, 172-5.
[2] Fitzmaurice, *op. cit.*, II, 15-18; Bentham, *Works*, X, 101.
[3] Manchester to Rockingham, October 22, 1777, Fitzwilliam MSS, Rockingham 10-24-1.

The Great Opposition III:
The Beginnings of Economical Reform

The American crisis and the war were of no immediate benefit to the reform cause. Rather the reverse, since all Opposition parties at first concentrated on denouncing the iniquities of the war. In the City, when they were not resisting the returning tide of the ministerialists, the Livery directed the decreasingly effective fire of their manifestoes to the American issue. Even Price, in drafting a remonstrance of all the radical complaints, took the troubles of America, not those of England, as the most intolerable.[1] Sawbridge's motions for annual parliaments, thinly supported in peacetime, came to be regarded as a rather stale, and perhaps unpatriotic, joke in the emergency of war. Most of the Opposition preferred to show that the Ministry was corrupt by showing that the undue and burdensome expense of the war was the result of corruption. Reform first became a serious parliamentary issue in its economical, not its parliamentary, version.

Since 1769 the campaign against influence had had a tenuous existence. The City was less interested in condemning contractors in the abstract than in resisting them in the Court of Aldermen. In parliament the monotonous harping on influence was enlightened by very few genuine examples. Lord Sandwich's administration at the Admiralty excited largely uninformed denunciations after 1771; and from time to time Dowdeswell moved his proposal to disfranchise revenue officers, though like Sawbridge's motion for shorter parliaments, it was a favourite butt of ministerial witticisms and was invariably thrown out by overwhelming majorities.

Shelburne's understanding of the issue advanced a little more rapidly than that of most of his associates in Opposition. Without the embarrassment of followers, especially followers from the

[1] Rough Draft of a Petition on American Affairs, Shelburne Papers, vol. 88.

country neighbourhoods, he could afford to be experimental. It was unusual for a nobleman out of office who had no commercial connections to interest himself in the details of financial administration. When he displayed such knowledge at length it was felt to be in bad taste and that he was showing off. But over the years the range of his knowledge excited a grudging respect.

In October 1775 Priestley, in the course of a letter to Sir George Savile to arrange an alliance between Rockingham and Shelburne during the coming Session of Parliament, wrote:

> Lord Shelburne is not without the prudence and circumspection that becomes his situation, but he has no deep political secrets. What he wishes is, when the times are a little more ripe to bear the proposal, that the power of the Crown should be abridged, especially with respect to the disposal of the Revenue, and that a thorough enquiry be made into the source of the present wretched Administration, and proper examples be made. I believe he will never be brought cordially to acquiesce in anything that he shall think to be less effectual remedies than these.[1]

The suggestion was much more than the usual one for the eradication of influence and the promotion of general economy. Shelburne had purchased the papers of James West, Newcastle's perennial Secretary of the Treasury, and from them was culling a detailed knowledge of Exchequer procedures and public accounting. Unlike most of the current economical reformers, he knew that reform of the financial system involved much more than simply economy in office, and he realised, on the larger question of the control of public finances, that to be effective and efficient, control must go beyond the mere cash to the objects of expenditure, to the offices and services themselves.

He was still regarding the ultimate aim of that control as a political one — that is to say as the Revolution tradition had instructed his generation to regard it, as a matter of suppressing undue influence and preserving liberty, rather than promoting efficiency. The attitude was strengthened by the current alarms of the American War. Far from favouring control by a central executive as the condition precedent to efficiency, he looked on decentralisation of administration, at least into the hands of separate independent boards, and preferably to such neighbourhood functionaries as the local commissioners of the Land Tax (both being

[1] H.M.C., *Savile Foljambe MSS* (London, 1897), 149.

accessible to parliamentary regulation), as the only guarantee of honest administration, and hence of free government.

> In the most arbitrary countries [he wrote to Price early in the American War] it is considered as no Impeachment of Power to leave this [the control of financial administration] in the hands of the People. In some, when the people have lost it, [it] has been returned to them for the sake of augmenting the produce. It has been practiced not only in North America where 3 million of people have been governed at the small expense of about £70,000 yearly, but it is actually the case in Portugal and partly in the King of Prussia's dominions, the two most despotick countries, one in the North, the other in the South of Europe. Its advantages are likewise felt in those Provinces of France where the States have retained this last and best of their antient Privileges. In truth it may be seen among ourselves in the simple Instance of the Excise, which owes as much to its having the nomination of its officers independent of the Board of Treasury as it does to its other more odious Powers. How far a Reformation should extend, what new checks might be formed to simplifye the receipts, to purifye the channels thro' which it passes, to correct the Expenditure, and to quicken the mode of accounting, are details which it would be an ungrateful task for an individual to enter upon with any hope of publick Support. The body of the people in all countries must be the last description to be corrupted. Whether ours will have force enough in behalf of themselves and their Posterity, and their country to assert the honest exercise of their undoubted constitutional Rights, it is impossible to determine in times of such constitutional Inactivity as the present....

He proposed that these ideas, which he claimed to have learned from Price, be included by Price in his latest pamphlet, and put forward by himself in the Lords.

> If ... these opinions make any Progress [he concluded] or the Hint takes, I will set it agoing in the City, and am ready to hackney myself, as long as there is the remotest prospect of bringing the Subject forward.[1]

With the coming of the war, the prospects improved rapidly. Now it was obvious that expenditure and the influence of the executive were increasing. But it was necessary for the Opposition's purposes to show that these were the effects of undue influence and corruption, not simply the war. This was not easy. Most of the

[1] Shelburne to Price, n.d., Bodleian Library, Oxford, Eng. MSS, Misc., c·132, fos. 47–8.

expenditure was being incurred to maintain a larger force at a greater distance from home than ever before in British military history. The accounts were larger, more complicated, more specialised, and more likely to be incomplete than ever before. Most Members of Parliament out of administration had no experience or knowledge of the complex paying and accounting procedures of government. But what they lacked in concrete information they made up in enthusiasm for the chase. Since they began with a conviction that the Ministry was corrupt and tyrannical, it was fairly easy for them to believe that defects in accounts or changes in accounting procedure were the effect of that corruption and tyranny. And if their accusations were sometimes disingenuous, they could take comfort in the maxim that where there is smoke there must be fire. Shelburne must be given credit for having seen the faults in systems of administration which to most of his contemporaries seemed to be working well enough. But what he actually discovered to be wrong — and he had good advice from various disgruntled government servants — was only a small part of what he imagined and declared to be wrong.

It was in the interest of Opposition Members to keep their accusations general. Shelburne's technique, for example, was to throw out in the middle of speeches on general topics broad charges of jobbery in the hiring of troops or condemnations of the inexhaustible field of influence opened up by government contracts. Barré specialised in turning debate away from the facts and figures — where North usually had an advantage — to defending the House's right to examine accounts or to laying the blame for waste and corruption (as yet unproven, but becoming daily more certain by repetition of the charge) on placemen and contractors.[1]

The debate on North's application to Parliament in April 1777 for payment of the Civil List debt and an increase in the Civil List revenue provided a full demonstration of this technique. It had been becoming steadily clearer during the preceding century that administration of the civil government's expenditures in conjunction with those of the Household was highly inconvenient — that the money of the Crown as a public institution and the money of the monarch as an individual must be separated, and that Parliament was using the Civil List as a device for putting off recognising their own responsibilities for the management and

[1] *Parliamentary History*, XVIII, 925, XIX, 148-9, 184-5. XX, 359-63.

support of Civil Government. The opposition of gentry and Court supporters, under the leadership of Thomas Gilbert, to a parliamentary regulation of the Household arose from motives of delicacy toward the sovereign; Sir Fletcher Norton went a good deal further in expressing from the Chair a wish that the private and public affairs of the Crown might be separated. But the Opposition's largely unjustified suspicion that the Household was a fortress of influence, permitted them to look at the question only through the spectacles of parliamentary jealousy of the executive.

In 1769 North had secured payment first and then submitted accounts; in 1777, however, he was applying to increase the Civil List as well as have its debts paid, and submitted accounts beforehand. Far from turning away the Opposition's wrath, this merely gave them advance warning. No longer reluctant to meddle with what had been regarded as the King's affairs, they agreed with Shelburne and Wilkes that the Civil List was a trust from Parliament to the King, and that such constantly accumulating arrears demanded the investigation of Parliament. A large part of the argument was concerned with the adequacy of the accounts submitted. North pointed out that they were as complete as they could be in view of the fact that his predecessors in office had taken many of the papers home with them on leaving office. Opposition did not really want a full set of accounts, but only an analysis of the secret service and pensions funds which they were sure had been used for corrupting Parliament. Few would go so far as Sawbridge and Governor Johnstone in claiming that Members of Parliament had been bribed by the Civil List; most preferred not to make specific charges that could be nailed down by North, but to create the impression that the Civil List debt had been due to sybaritic waste and vague 'corruption' directed against the liberties of the subject. Shelburne made the most of a careless remark by Lord Onslow that £30,000 was only a trifle. No doubt the noble lord regarded the £100,000 being asked in augmentation of the Civil List as a trifle also. For his part, he considered it a very great sum.

It would, if appropriated to the purpose of supplying other taxes, under which the poor were suffering, occasion joy and gladness to millions of miserable, though industrious poor; it would answer for the duties now raised on leather, soap, candles and salt; it would let in the light by day, and be the cause of cheering the lonely, miserable,

dusky mansions of the poor labouring part of the community by night . . . instead of corrupting the morals of all ranks, of influencing parliament, and of furnishing means to the idle, extravagant, and profligate, of wallowing in vice, riot, luxury and dissipation.[1]

And much more to the same effect.

At the heart of the administrative reform issue was the question of the soundness of North's financial policy. The policy was that of the last half century, based on the assumption that taxation must fall on property, rather than labour, property rather than trade, the rich rather than the poor, luxuries rather than necessities, on all who received benefits from the state, and should never take the form of an income tax. The tax base was extremely narrow, depending primarily upon the Land Tax which had degenerated into a rather unproductive rent charge upon land, proportioned among the counties on quotas which had changed hardly at all for a century; upon the Customs and Excise, whose productivity was severely limited by the multiplicity of rates, the complexity of administration and prevalence of smuggling; and upon a variety of so-called luxury taxes, administered separately (because separate government securities were funded upon them), inefficiently, and hence, unproductively. By North's time the prospect for finding new sources of revenue under existing canons of taxation was almost negligible.

Quite apart from the fact that these taxes were never as productive as the Ministry hoped they would be, they were wholly inadequate to meet the cost of the war which was borne, like the cost of previous wars in the century, by loans in three, four, and five per cent stocks. But since the market price of new stocks was low because of the policy of borrowing at low interest when the general interest rate was high, an elaborate system of inducements, in the form of lottery tickets, special annuities and stock bonuses grew up. These had the effect of increasing the capital of the debt without commensurate benefit to the state. As the war went on market conditions grew worse, partly because of the wide range of government securities on the market, and especially because of the large circulation of unfunded Exchequer, Navy and Ordnance Bills. Thus the terms of the loan of 1781, which increased the debt by nearly twenty millions for an immediate cash return of about twelve, seemed very steep indeed.

[1] *Parliamentary History*, XIX, 103–87.

Nevertheless the Opposition's outcry against North was largely misdirected. He was merely unfortunate enough to see the bankruptcy of policies which had served the nation well since Walpole's day, and perhaps only his ingenuity in manipulating the taxes and securing the best possible bargain for the public in the managements of loans, could have kept the system going to the end of the American War. Criticism was slow in growing and was confined for a long time to a few economic theorists. Various warnings about increasing the *capital* of the debt (the cost of servicing the debt, by modern standards the really important yardstick, was largely ignored), and suggestions for reducing it by capital levies and improved sinking funds had been made at frequent intervals since Walpole's day; but the first of these to make much impression was Price's *Appeal to the Nation on the Subject of the National Debt*, published in 1772. Its reputation owed a good deal to the date of its publication — just before the financial panic of 1773 which seemed to justify Price as a prophet. His alarm at the increase of the capital of the debt, his suggestions that the government borrow in terminable annuities at relatively high rates of interest for the future, that the existing debt be converted to higher rates so as to lower the capital, and that a new, inviolable, sinking fund be created, secured a popularity with the Opposition out of all proportion to their merit. The first two took no account of the probable unwillingness of investors to accept terminable annuities and an upward conversion, nor of the probability of such changes merely saddling the nation with a higher interest bill without providing any clear advantages.[1] The third was more substantial. Price's fund would have been based on securing an annual surplus from taxation and administrative savings totalling one million which would have been put into a fund inviolable from ministerial interference. From the fund stock would be purchased and put to the credit of independent commissioners. The interest on it would be used to purchase further stock and through the operation of compound interest would pay off the debt at a steadily accelerating rate. Two of the most important (and eventually

[1] William Eden commented: '. . . if this plan had been adopted, all the existing taxes must have been continued; and all the new exigencies of war, as well as the deficiencies of the peace establishment . . . must have been defrayed and made good, either by the supplies raised within the year, or by funds to be secured by new and perpetual taxes. It is obvious to see in this case, what immense burdens, additional to what were actually laid, the country must have borne from 1717 to this time' (*Four Letters to the Earl of Carlisle* . . . (London, 1780), 90).

disastrous) features of the scheme — its inflexibility and its
publicity — appear to have been suggested by Shelburne.

> Is it not to be wished [he wrote to Price after studying the original
> plan] that nothing should be left to the discretion of the Commis-
> sioners, and that they should be merely ministerial? It's a vast object
> to ensure the gradual diminution of our debts, but it will lessen the
> excellence of this measure, if it admits of that intolerable evil, stock-
> jobbing. Wherever discretion is left, I conceive that must follow, and
> surely the nature of our debt is such that all possibility of jobbing
> might be prevented by prescribing the order in which they should be
> discharged, — which being publick, every body would have an equal
> advantage, and no secret could avail.[1]

To secure his surplus, Price proposed to make the tax system
more productive and also more favourable to the growth of manu-
factures. Like most contemporary theorists and administrators,
including North, he favoured the consolidation of taxes, though
because of the funding arrangements, which pledged particular
taxes to the support of particular loans, this was easier suggested
than done. In 1781, he proposed to Shelburne that a single tax,
like that advocated by the physiocrats in France,[2] be levied to
replace Customs and Excise. This might take several forms: a
pound rate of ten per cent on all incomes; a poll tax of £2 10s. for
all persons over the age of sixteen; or a tax on houses, windows,
servants, and other indications of ability to pay, 'in order to
proportion it to the different circumstances of different persons' —
an echo of Sir Matthew Decker's proposal of 1743, and perhaps
one of the inspirations for Pitt's commutation of the tea duties in the
1780's.[3]

Price's list of advantages to be expected from the single tax
reflect the mixture of administrative and political considerations,

[1] December 26, 1774, 'Price Letters', *Proceedings of the Massachusetts
Historical Society*, 2nd Series, XVII, 273.

[2] 'A plan similar to that which will be here proposed has been for many years
recommended with great zeal by the Oeconomical writers in *France*; and it is
said that the French Court is now entering upon measures for carrying it into
execution' (A Sketch of Proposals for Discharging the Public Debts, Securing
Public Liberty, and Preserving the State, Shelburne Papers, vol. 117, fo. 2).

[3] He calculated that there were at least ten million windows in the country, of
which eight million could pay £1 annually, and this, together with a rate upon
houses of 10 shillings per £100 according to the rank of the householder, his
carriages, horses, servants, etc., would produce more than £10,000,000. The
current house tax produced no more than £300,000 but he believed that it could
be made a substitute for all other taxes (*ibid.*, fo. 3; cf. Horne Tooke, *A Letter to
Lord Ashburton* ... (London, 1782), *passim*.

of Roman virtue and partisan dogma that motivated those who were clamouring for the reform of the finances. Administratively it would have the advantages of simplicity (eliminating the 'chaos of the Customs House') and cheapness of collection; it would be paid by persons in remote parts of the country who escaped taxation under the existing system, and it could be easily increased in wartime. Economically, it would make free trade possible by doing away with the necessity for customs and excises; it could be used to secure the surplus for the sinking fund; and, Price supposed, unlike taxes on consumption, it could not be shifted and thus would not raise prices. Politically, it would eliminate the existing inequalities in tax burdens, it would enable the nation to see and feel its taxes and thus be more attentive than hitherto to the management of its financial affairs.

> But the main point is, that the cause of liberty would be essentially favoured, and the constitution restored, by delivering the Kingdom from that army of revenue Officers now so hostile to it, by abolishing the *excise* laws, and the destruction of that unbounded influence which the present taxes give to the Crown.[1]

North's loans were criticised by the Opposition only incidentally because their terms were supposed to be extortionate, and principally because they were negotiated by North searching about privately in the City for the best terms. They attacked such 'closed' arrangements because they gave North the opportunity to exercise 'influence'.[2] Publicity, as Shelburne asserted, was certainly the ultimate and necessary safeguard of honesty in government finance; but the government did not yet dominate the financial affairs of the nation to an extent sufficient to allow them to dictate the terms of a loan in advance, nor were market conditions sufficiently stable, nor independent financiers so customarily solvent as to allow open subscriptions. In North's last loan, in 1782, he negotiated with a private syndicate for the whole loan, a practice which Shelburne, though he had demanded open subscriptions for seven years in Opposition, apparently proposed to follow in his own abortive arrangements of 1783.[3]

The same arguments were applied to government contracts.

[1] *Ibid.*, fos. 6–7.
[2] North wrote to his father in 1770: 'My lottery will, I believe, be on a footing which will not permit me to oblige my friends by trinkets as they and I should desire' (April 20, 1770, Bodleian Library, North MSS, d24, fo. 79).
[3] Pitt to Shelburne, January 1, 1783, Bowood MSS.

Victualling Board contracts were open, but those of the Treasury — especially for overseas service — were generally closed, for the good reason that only a few large firms could support these undertakings and the government could not afford to have defaults in contracts for the army overseas. Proven examples of malversations were sufficiently rare that they were made to do service over and over again. One of the first contracts of the war was made by North personally with Christopher Atkinson to supply rum to the army. North was careless and Atkinson profiteered. As a matter of fact, Atkinson was dishonest; a parliamentary select committee, established at Barré's insistence, forced him to lower his charges and demanded that he fulfil the contract; and he was eventually brought into the criminal courts in 1780 and expelled from Parliament for perjury in 1783.[1] But Barré and Shelburne never left the question alone. When Richard Atkinson, of Mure and Atkinson and Christopher's partner, was found to be the Treasury's manager of the Transport Service, and that Service was found to be paying ten per cent more for its charters than the Navy Board was doing, they cried corruption. They concentrated on Atkinson, rather than the facts, which were that the charters were as reasonable as they could be considering that freights were inflated by war and the competition of the Navy Board.[2]

Contractors of all sorts were suspect, contractors who sat in Parliament more so. Since Tudor times Oppositions had been convinced that Members of Parliament would not be contractors if extraordinary and improper advantages were not given them. The contracts themselves were expensive — Barré with characteristic inaccuracy said they were fifty per cent over market price[3] — more expensive than in the Seven Years War because of the larger scale of the war, the difficulties and expense of safe transportation across the Atlantic, and the greater wartime inflation. Without controls on the prices of commodities and services it had to buy, the Ministry was bound to make expensive bargains.

The most pernicious cause of expense and one which because

[1] *Parliamentary History*, XIX, 53–8, 901–8, 972–80, XX, 1286–90, XXI, 414–57; Horne Tooke and Price, *Facts Addressed to Landholders . . .* (London, 1780), 50–66; Minute on Christopher Atkinson's Dealings with the Navy Board, Report from the Committee of the House of Commons Respecting Christopher Atkinson's Transactions with the Victualling Board, Shelburne Papers, vol. 151; Minutes of the Victualling Board, 1780, P.R.O., Admiralty 111/83–4.
[2] *Parliamentary History*, XIX, 901–8.
[3] *Ibid.*, 149, 1089.

of its technical nature the Opposition did not examine in detail, was the system of credit financing indulged in by the Navy and Ordnance Boards. Instead of paying cash, the Boards issued bills, usually 'In Course' bills which, because they were negotiable and funded only at infrequent intervals, circulated at large discounts. Contractors, in order not to absorb the discount, added it to the price of their contracts. In the case of Navy Bills, which bore interest, this discount was substantial; in the case of Ordnance Debentures it was exorbitant. Yet the Opposition persisted in regarding high prices as the result of dishonesty and dragged in 'Rum' Atkinson's case on every possible occasion. Shelburne's part in these accusations was supported by Robert Gregson's reports from the Navy Office.

The Army Extraordinaries were a favourite target of the Opposition, but in this case, too, they missed the important point. The scandal of the Extraordinaries was that they were financed by Exchequer issues to the Paymaster-General in advance of the date of due payment and by witholding the annual pay of the Army for various periods. Thus the burden was borne, until a parliamentary vote was secured, by the soldiers. To the Opposition the shame of the Army Extraordinaries was that they were incurred before Parliament could sanction them and were thus dangerously at variance with the principle of parliamentary control over the armed forces. Quite an impression of corruption, or at least of irresponsibility, could also be created by pointing out that no vouchers had been submitted for the Extraordinaries of the Army in America, though as North explained at the beginning of the war and at frequent intervals thereafter, the money was usually paid over in the form of an advance to the commander-in-chief who remained responsible for it though he could submit no vouchers.[1] It was a safer method of transfer than remittance. No matter; three years later Shelburne and his friends were still demanding vouchers and describing the Extraordinaries as the Civil List or secret service of the minister.

Accounts were usually incomplete since it was impossible for the overworked clerks in the accounting branches to secure up-to-date records on the expenditure in North America. The condition of the accounting offices and their procedures was such that the larger paymasters' accounts took at least twenty years to clear. To the

[1] *Parliamentary History*, XVIII, 1239-47, 1302-15, XXI, 76-7.

Ministry's reasonable excuse that there were not enough clerks, Barré and his friends were likely to answer with sarcastic disbelief or further freewheeling accusations of corruption.[1]

But however wrongheaded the Opposition might be on the question of the influence of Crown, however wrong their guesses, by their reiteration of the 'unreal' libertarian formulae of reducing influence, they were establishing a new whig tradition, or perhaps re-establishing an old one. In the next age it was to make reform a fighting creed and give the reformers a glorious past to appeal to.

What was important to them for the moment was that their propaganda should persuade a majority in Parliament to over-throw the Ministry. To appeal to the country gentry in particular, they emphasised less the undue influence of the Crown than the heavy expense of the war. At first they ridiculed the gentry for their apparent subservience to the Ministry, and suggested that they had been tricked into supporting the coercion of America by the Ministry's keeping the armed forces on a peacetime footing until 1776. Shelburne went so far as to suggest that they had been bought by the Ministry.[2] After Saratoga the Opposition's morale and numbers rose and the gentry showed signs of changing sides. Some were alarmed at the suggestion for equalising the Land Tax assessments whereby those in the 'low-rated' districts would lose an advantage they had enjoyed since the Civil War;[3] and signi-ficantly their old distrust of the Court was reflected in their support for Opposition proposals to prune — not the undue influence of the Crown — but the perquisites of placemen and pensioners. Thomas Gilbert's motion in March 1778 for a bill to tax all places and pensions at twenty-five per cent was defeated by a margin of only 147 to 141; Sir Philip Jennings Clerke's first two presentations of his bill to exclude contractors from the Commons

[1] *Ibid.*, XIX, 123, 972–80.
[2] *Parliamentary History*, XVIII, 1302–15, XIX, 344–7, 468–9, 500–2, 542–3, 979.
[3] The Land Tax reassessment was a favourite bogey with which to frighten the gentry of the North and West, and was used at intervals throughout the century. Christopher Wyvill used it in December 1779 to hurry the Yorkshire-men into signing his appeal for a county meeting and Rockingham used it frequently thereafter to discourage them from supporting the parliamentary reform movement. Its effectiveness, however, was not great. By the 1770's it had been used so often without the threat materialising that only the simplest of bumpkins believed it. Far more serious, in the view of the more knowledgable gentry, was the gradual centralisation of the Land Tax administration in the hands of the Treasury, but this was too complicated for the Opposition to deal with politically (Cf. *A Serious Address to the Electors of Great Britain on the Subject of Short Parliaments and Equal Representation* (London, 1782), 16–18).

were defeated — both at the committee stage — by 113 to 109 and 165 to 124.

The disasters of the summer of 1779 brought a still more decisive swing of opinion. It was a time of desperation when the allied fleet rode almost unopposed in the Channel, and the Ministry, with the prospect of invasion daily before them, hurried through bills to augment the militia and tighten the pressing regulations for the Navy. Tempers were short and fears high; North was accused of treason in the Commons and Barré, convinced that the Court would not resist a French invasion, plotted with Shelburne and Townsend to raise the City and lead the Opposition in a *coup d'état*.[1] The Irish resurgence, similarly, provided grist to the Opposition mill. When the Volunteers took command and intensified their demands in the spring and summer of 1779, Shelburne took care to exonerate the English merchants from any accusation of narrow opposition to Irish commercial liberty and the Irish Volunteers from any desire to rebel. The onus must be on the Ministry, whose shuffling conduct had forced the Volunteers to demonstrate as it had previously forced the Americans to revolt.[2]

Circumstances seemed to be combining to create the opportunity for which Shelburne had been hoping since 1775. The gentry were becoming disturbed by the continuous propaganda of the Opposition, by the crisis (especially Paul Jones's victory off Scarborough), by the example of the Irish Volunteers, and perhaps most of all by their common experience in the militia and the militia associations. Earlier in the war the Opposition had strongly opposed private contributions to, and associations for, the support of the war effort as derogating from Parliament's control over the armed forces. They had even opposed the raising of a militia as debasing the industrious part of the population with military slavery. But everyone had to play his part in the crisis, and the Opposition were prepared to play theirs. When the militia was increased in June 1779, preference was given to the private associations in which they were active.[3] Throughout the summer and early fall the gentry camped on Warely Common or Coxheath, where Richmond commanded the Sussex detachment, Sawbridge that of East Kent, and Rockingham and Savile that of Yorkshire. Early in October

[1] Parliamentary History, XX, 918–9; Barré to Shelburne [summer 1779] (2 letters), Bowood MSS; cf. Fitzmaurice, *op. cit.*, II, 34–5.
[2] Ibid., XIX, 1265, XX, 649–50, 663–75, 1156–78.
[3] Ibid., 915–62, 969–1018.

Savile led the first battalion of the Yorkshire militia across the Pennines to help protect Arkwright's machinery from rioters at Stockport.[1] It is not improbable that the officers of the militia found time from their military duties to exchange views on the state of the nation. Certainly in the autumn of 1779 some of the Yorkshire gentry had been meeting more frequently than quarter sessions and race meetings made possible.

On November 29, the Yorkshire clergyman Christopher Wyvill sent out his famous circular letter to the gentry of Yorkshire, inviting them to join him and his friends of the North Riding in a county meeting with the purpose of petitioning the House of Commons to appoint a committee 'to inquire into the state of the Civil List, that all sinecure places, exorbitant salaries to efficient places, and pensions unmerited by public service may be rescinded and abolished'. Wyvill, however, was determined to sustain the petition with a permanent organisation.

> In the present decline of trade and land-rents [he wrote], and the apprehension of an additional land-tax, such a measure, it is believed, would be supported by a large majority of this County; and if properly supported by an Association here, and by other Counties adopting a similar plan, would probably prove successful in another Parliament. It certainly could not fail to have a very considerable effect at the next General Election; and if once the fund of corruption was reduced, it would be an easy matter to carry the other regulations which are thought necessary to restore the freedom of Parliament. A free Parliament is now, as it has ever been in times of great distress, the only refuge of the Nation; measures evidently tending to that desirable end, would meet with general support of independent men; by whose united assistance, we trust, the Constitution might be preserved, and restored to the purity of its original institution.[2]

In the next two weeks the Yorkshire M.P.'s were mobilised in support of the cause and after a slow start the notice of meeting was signed by a large proportion of the substantial and middling gentry. Great care was taken (on Savile's advice) to dissociate the movement from the Rockinghams and other professional politicians. By the middle of December the local newspapers were full of the

[1] *London Chronicle*, June 23–5, July 9–11; *Lloyd's Evening Post*, October 11–13; *Morning Post*, October 18, 1779.
[2] Wyvill to Sir William Anderson, and other Private Gentlemen of the County of York, November 29, 1779, *Political Papers Chiefly Respecting the Attempt of the County of York and other Considerable Districts . . . to Effect a Reformation of the Parliament of Great Britain* (York, 1798–1802), III, 116–17.

affair. The Home Counties were taking up similar petitions, though not directly in imitation of Yorkshire, and the newspapers of the metropolis were beginning to comment on it.

Middlesex, too, was on the move again. The City's radical champion, Serjeant Glynn, died that autumn and the Ministry, in its anxiety to elect a successor as Member for Middlesex, made an obviously partial use of the Chiltern Hundreds. Worse, the discrimination was against George Byng, the candidate of both the popular party and the Rockinghams. As Barré reported to Shelburne: 'The Rocks . . . are excessively warm and talk of the *people* and of communing with the City.' In the City it was quite like old times. A meeting of the freeholders at Hackney on November 12 with Townsend in the chair and Wilkes as chief spokesman agreed to petition the House of Commons for a law permitting Members to be elected for other constituencies without having to go through the archaic interlude of the Hundreds. Barré reported Nathaniel Smith's opinion that 'that the discontents *every where* are not only general, but universal', and that Townsend and the Rockinghams were agreed that Middlesex must lead the other counties to petition as in 1769. Townsend, however, would have preferred to keep the question in London for the moment, because the Middlesex Association intended further proceedings, and Barré doubted the effectiveness of going to Parliament on that particular issue. Barré was right; the petition fell flat, since North showed an awkward willingness to agree to the legislation. But attached to the petition was the demand for

> an immediate and thorough enquiry into the true cause of those
> . misfortunes which have reduced this once powerful empire to a state
> which words cannot describe . . .

and this gave Wilkes occasion to announce his intention of moving for such an enquiry after the Christmas recess. Meanwhile another meeting of the freeholders on November 22 agreed that a general monthly meeting of freeholders ought to be held to safeguard the people's interests while Parliament was sitting. Soon it was to take up the further proceedings hinted at by Townsend.[1]

The parliamentary Opposition was closing ranks as well. The failure of the war, the diplomatic blunders of the Ministry, the

[1] *London Chronicle*, November 11–13, *London Courant*, December 4, 11, 1779; Barré to Shelburne [November 1779], Bowood MSS; *Parliamentary History*, XX, 1267–70.

martyrdom of General Burgoyne and Admiral Keppel, the naval failure of the summer, the Ministry's supposedly shuffling and ungenerous conduct toward a resurgent Ireland — all brought them out in a harmony of common abhorrence. Offers from the Ministry in February and November 1779 hardly ruffled that agreement. Shelburne was persuaded to give up whatever pretensions he may have had to the Treasury in favour of Rockingham. In November he held to that agreement, and publicly repudiated Mansfield's proposal that he succeed North as the head of the existing Ministry.[1] Hardly a whisper of old differences about measures and men, or even independence for America could be heard as, echoing one another's condemnation of undue influence, Rockingham, Richmond, Grafton and Shelburne pledged themselves and the nation to unity in the hour of trial.

The new session of Parliament began as the four previous ones had begun — charges of undue influence, corruption, mismanagement at home and abroad, the Ministry's answers, and their inevitable majorities. But now there was a difference. The scare of the summer and the Irish revolt seemed to support the Opposition's contention that the war could not be won. Lord Gower left the Cabinet and his friends plotted to get rid of North. Yorkshire and Middlesex were reviving the petition campaign of 1769 as the Opposition opened its batteries in the Lords.

On December 7 Richmond moved for an address to the Crown to set an example of economy by a considerable reduction in the Civil List expenditure, but hastened to exclude from the economies the pensions paid to persons who had wasted fortunes in the service of the country — the Pelhams, the Walpoles, the Pitts. The Lord Chancellor Thurlow ridiculed the vagueness of the proposal, the lack of evidence for the distresses of the nation, and the impracticability of undertaking an investigation of the Civil List in the midst of the war. Shelburne came to the rescue. The learned lord must be the only person in the kingdom who did not know of the distresses and waste. The annual cost of the foreign embassies alone had risen to £90,000 from the £43,000 that had been adequate in the reign of King William of glorious memory;

[1] *Grafton Autobiography*, 306–8; Fortescue, IV, nos. 2823–5, 2858, 2882, 2897; *Parliamentary History*, XX, 1092, 1164–5. Shelburne's appearance at Court with the new Lady Shelburne helped to stimulate rumours of his adherence to the Ministry (*London Chronicle*, November 19, *Morning Post*, November 23, 1779).

the secret service money had risen from £237,000 in the victorious days of Pitt to £280,000 in the present disastrous year; contractors and extraordinaries abounded: Mr. Atkinson was still contracting for the government. He (Shelburne) had proposed an enquiry into the Army Extraordinaries last session, now he would bring it forward.[1]

A week later, as the *Morning Post* reported a 'flaming petition ... now on the anvil' in Yorkshire and Burke gave notice of his plan for public reform and economy, Shelburne introduced his motion. His speech ranged over the subject in a breadth and depth of detail more appropriate for a budget speech than an address to the Lords. He attributed the unprecedented size of the Extraordinaries to the exorbitant terms of the provision contracts, and the exorbitance to dishonesty and waste. Mr. Gordon at Cork was paid £40,000 simply for transferring provisions from warehouses to ships; Mr. Atkinson was still in the government service, and still resisting fulfilling his rum contract; Alderman Harley's specie contract (admittedly performed at a low commission) was draining the nation of specie and yet no vouchers were submitted to accountants. On the larger scene the funded debt for the war alone stood at twenty-six millions, the unfunded debt at sixteen millions. Soon the total burden of debt would be over two hundred millions, and the tax resources of the nation were at an end. Suggestions were being made for taxes on horses, on dogs, on the East India Company — even on lawyers. It was impossible to think of any source that had escaped the eagle eyes of the financial adventurers at the Treasury, who in the bright sunshine of the Court or at Tunbridge Wells formed schemes 'for disposing of the property of the honest and industrious part of the community'. He warned that the day of reckoning was at hand when they would be forced to surrender the spoils of office to the public.

In spite of Thurlow's prodding, the Ministers remained silent; even Sandwich, for once, was willing to rely on the Ministry's foreordained majority. The defeat of the motion seemed almost an Opposition victory. Shelburne followed it up by giving notice of a second motion:

That a committee be appointed, consisting of members of both Houses, possessing neither emolument nor pension, to examine without delay into the public expenditure, and the mode of account-

[1] *Parliamentary History*, XX, 1255–67.

I

ing for the same; more particularly into the mode of making all contracts: and at the same time to take into consideration what savings can be made consistent with public dignity, justice, and gratitude, by an abolition of old or new created offices, or reversion of offices, the duties of which have either ceased, or shall on enquiry prove inadequate to the fees, or other emoluments arising therefrom; or by the reduction of such salaries, or other allowances and profits as may appear to be unreasonable; that the same may be applied to lessen the present ruinous expenditure, and to enable us to carry on the present war against the House of Bourbon, with that decision and vigour which alone can result from national zeal, confidence, and unanimity.[1]

Economical Reform had begun.

[1] *Ibid.*, 1285–93.

Economical Reform

Shelburne's motion acted as the signal to a variety of reformers to stake out their claims in Parliament, and before the Christmas Recess Burke had given notice of his Economical Reform plan as an improvement on Gilbert's bill, John Crewe was taking up Dowdeswell's old proposal to disfranchise revenue officers and Sir Philip Jennings Clerke revived his bill for excluding contractors from the House of Commons. Attention was therefore not focused, as Shelburne would have preferred, on his proposal for a strictly financial reform, but on proposals to reduce influence. Given the accompaniment in the country of the Economical Reform agitation of Yorkshire, this was probably inevitable.

But even without this support for economical reform, and even had Shelburne's proposal not been taken over by the Ministry, it would still not have been as popular with the Opposition as Burke's plan was. For Shelburne's proposal was to reform the financial administration on the principle that all useless expenses be eliminated; Burke, much more selectively, was going to eliminate all that undue influence which maintained the Ministry in office and the Rockinghams out of it. It was not hard to imagine where their sympathies would lie.

Just how selective the reform must be to satisfy the Rockinghams was demonstrated by an episode during the Recess. Charles Jenkinson, the Secretary at War, received a proposal from Thomas Ramsden,[1] a minor placeholder, for the Ministry to steal the Opposition's thunder. As soon as Parliament assembled, Ramsden suggested, the Ministry should move for a select committee to enquire into the salaries and profits from the offices of Usher of the Exchequer (held by Horace Walpole), Tellerships of the Exchequer (three of the four of which were held by Opposition supporters), Paymaster-General (with Lord Holland's profits in

[1] Thomas Ramsden was formerly Latin Secretary to the King and sinecurist Collector and Transmitter of State Papers.

mind), Treasurer of the Navy (with the late George Grenville and Lord Howe as the principal targets), and the grants made to Charles II's children and their descendants, in particular the so-called 'Richmond shilling' levied on coal imported into London.[1] The suggestion was not adopted, but the vulnerability of the Opposition was patent. Burke in his speech on economical reform therefore felt it necessary to defend private placeholding in principle and to single out for abolition that 'bad' influence which was not shared by Members of the Opposition — that influence to be found in the Household Offices, the administration of the Crown lands, the Third Secretaryship of State and the Board of Trade (which symbolically at least, had been responsible for the loss of America). This selective approach also helps to explain why he progressively surrendered parts of his plan as his friends, or friends of his friends, or people the Rockinghams wanted to attract to their support, objected. Hence, too, his reluctance to reform the financial administration, in which the Duke of Manchester's sinecure Collectorship of the Customs and the Tellerships of Northington, Temple and Pratt were all too prominent features. This is not to suggest that Burke had not a genuine concern for economical reform. But he believed that the essential reform, from which efficiency, financial stability and free government would naturally flow, was the reduction of the influence of the Crown and Court.

By contrast, Shelburne intended a fundamental and indiscriminate reform of the financial administration. So much is clear from his speech of February 8, 1780, proposing a committee of accounts. This was to include Members of both Houses, but none who held places or pensions under the Crown. Thus would the committee be protected from influence while rescuing the nation from it. Its primary tasks would be to put the receipts and expenditures on a clear and simple footing, abolish all offices that answered no other purpose than that of increasing the influence of the Crown, open all contracts so far as this was consonant with the safety of the state, and abolish all sinecures and useless offices with high emoluments.

So far as they went, his aims were sound, contemplating changes which were long overdue. But he chose rather doubtful means of accomplishing them. He claimed in his speech that he was reviving

[1] Add. MSS 38,213, fos. 39–41.

the form of the parliamentary committees of accounts of the reigns of William III and Anne. Even allowing for the fact that he was playing for independent support by thus hearkening back to the heroic age of whiggery, his choice of form was unfortunate. As Mansfield pointed out in the course of the debate, Shelburne was setting his committee far too much to do if it was to be served by Members of Parliament. By excluding officeholders he would also deprive his enquiry of the services of the most experienced administrators; and having attributed the failure of the old parliamentary committees to becoming bogged down in old accounts, he proposed that his committee should not undertake a retrospective examination of administration.[1] The fact of the matter was that in Opposition he had developed a too easy disdain of the detailed skills of the trained administrators and had fallen into the habit of seeing this issue only through the eyes of an Opposition leader intent on defeating his adversaries. Once in office he would have recognised and corrected these shortcomings. He had a better understanding of administration and finance than any other Opposition leader, and had grasped the essential fact that had eluded most of them — that the parliamentary regulation of offices of expenditure was the essential reform to be aimed at. He was confident in his knowledge of Exchequer procedure, and presumably in his ability to guide the committee through its intricacies without the help of officeholders. But everything depended on his being a member of the committee.

When Barré introduced the plan in the Commons on February 14, however, the Ministry was ready with an alternative. By 1780 North and Charles Jenkinson, at least, were aware of the need for reform, and North had made some considerable improvements in Treasury procedure and financial policy.[2] War emergency, the inertia of office, North's reluctance to face large issues, and his preoccupation with the political manipulation necessary to keep his government in being had prevented much being done. The Opposition's criticism forced his hand, if only because he felt bound to prevent their proposals from being implemented.

In taking them over, he perhaps may not have intended more than to investigate the Army Extraordinaries to quiet Barré and Shelburne. But in the hands of Charles Jenkinson the measure

[1] *Parliamentary History*, XX, 1318–70.
[2] J. E. D. Binney, *British Public Finance and Administration 1774–92* (Oxford, 1958), *passim*.

became one for an independent commission, rather than a select
committee, to examine accounts, discover what balances were held
in the hands of public accountants, report on the defects in
receipt, collection, expenditure and accounting procedures, and
suggest improvements in all of them. The advantages of an expert
commission were obvious, but the Opposition denounced it as a
mere device to take the matter out of Parliament's hands. They were
particularly loud in these claims after North revealed that his first
two choices for commissioners were Sir Guy Carleton, former
Governor of Canada, and Thomas Bowlby, Comptroller of Army
Accounts. Both Carleton and Bowlby were chosen because of their
extensive knowledge of army accounts. But the Opposition
demanded to know whether both men were not subject to investiga-
tion themselves and whether, as placeholders, they were not
excluded from the commission by the terms of North's plan. In
vain North reminded the House that Bowlby was not an accoun-
tant, but one who examined the accounts of others, and that his
expert knowledge should be allowed to outweigh his possession of
a place.[1] Eventually Bowlby was dropped, though Carleton,
perhaps because the Opposition liked him for his quarrel with
Lord George Germain in 1777, was allowed to stay. Also in
deference to the Opposition, North dropped the part of his plan
providing for the commission's remuneration. Eventually its
membership was completed by the appointment of a Master in
Chancery, a former Attorney-General of Grenada, two directors of
the Bank of England and two obscure persons who may have been a
private banker and a former army paymaster. It then proceeded to
its examinations, the most thorough and far-reaching of their kind
to that date.

Shelburne complained publicly that the commission had been
'taken out of disinterested hands, and assumed by the Authors of
our Distress, in such a manner as to mock every idea of Parlia-
mentary Independency or Popular Enquiry',[2] but by the end of the
year he had recovered from his chagrin sufficiently to acknowledge
the usefulness of the commission, and by the time its first four
reports came up for debate in May 1781 he and his friends were
supporters of it, though they still tried to have it converted into a
parliamentary committee.

[1] *Parliamentary History*, XXI, 145-9, 278-85, 552-70.
[2] To John Audrey, Chairman of the Wiltshire Committee of Association,
March 26, 1780, *Wyvill Papers*, IV, 131-6.

In the spring of 1780, even after the appointment of the Commission of Accounts, the Opposition contrived to keep up the advantage which the new popularity of public economy had given them. On February 21 they came within two votes of pushing through Savile's motion for an account of all places and pensions under the Crown, in spite of North's plea not to expose the necessities of ancient and noble families.[1] On March 8 the Third Secretaryship of State was saved from abolition under Burke's Establishment Bill by only seven votes, and on the 13th the Board of Trade was abolished by a margin of eight. Then the tide turned. On March 20 Burke's Establishment Bill was hamstrung, as he claimed, by the rescue of the Treasury of the Chamber by a margin of fifty-three votes. It was a demonstration, if one was wanted, that the gentry could not yet be pushed to tamper with the King's Household or personal finances. Economical reform was losing its impetus in Parliament.

In the counties the attendant association movement was just reaching its climax. The Yorkshire Association had secured an early prominence in this movement not strictly justified by the effectiveness of its organisation or the cogency of its proposals. True, the latter were moderate and summed up most of the Opposition measures of past years: the attack on influence; the plan of association modelled on that of 1769; even a refusal to pay new taxes reflecting the dissatisfaction in some quarters with North's recent budgets and the fear of an alteration in the Land Tax assessment. They were not nearly so extreme as John Jebb's proposal to the Middlesex freeholders on December 20 for a national association of deputies that looked very like a revolutionary assembly. But it was not only their moderation that explains the prominence of the Yorkshire men. The rest of the Opposition — professional politicians and City men — were anxious not to have repeated the experience of 1769 when Yorkshire had failed to rally quickly to the petitions, failed to carry other counties with it, and demonstrated a strong distrust for the professionals and the City. Thus they were at pains to emphasise that Yorkshire had begun to move before anyone had heard of Burke's plan and that the professionals in Parliament had not inspired them. Even the Middlesex leaders, at the meeting on December 20, deferred with rare abnegation to Yorkshire and

[1] *Parliamentary History*, XXI, 83–104.

voted to postpone adopting a petition until they could copy Yorkshire's. They could always be sure of raising a protest in the metropolis; but one in Yorkshire was a delicate growth and must be carefully nurtured.[1]

The good understanding did not last long. The Yorkshire men found themselves threatened on either side by the hostile extremes of the Rockinghams and the urban radicals. To do Rockingham justice, he was not himself a last-ditch opponent of the association nor even of the parliamentary reform proposals which they eventually adopted. He recognised that the Associations could be a powerful support for economical reform. He approved in principle the adding of one hundred Members to the county representation, and he was not opposed to shorter parliaments (he resisted annual ones), nor to an 'equitable' reform of the rotten boroughs, though he reminded enthusiasts for this change that half Yorkshire's constituencies were of that description and a reform might destroy the protection against a reassessment of the Land Tax which they had thus far enjoyed by being overrepresented. Nevertheless he would not support any of the measures for parliamentary reform because he believed them to be 'at best but crude propositions, whereof perhaps no man can well ascertain the effects may be', and because he would support nothing that was not agreed to by the constituents. He was also opposed to the instruction of Members because it destroyed the idea of election to Parliament being a trust. Burke was a much more forthright opponent of parliamentary reform, condemning the Duke of Richmond's advocacy of it as subversive of all established political allegiance. Savile maintained a rather priggish independence, advising Wyvill how to approach the gentry, giving his personal support to the articles of association, and then refusing to agree publicly to them unless his constituents approved.[2]

In fact parliamentary reform was only gradually insinuated into the Yorkshire programme. Wyvill could not produce all his ideas at once since he, equally with outsiders, must defer to the preju-

[1] Cf. Herbert Butterfield, *George III, Lord North and the People, 1779–80* (London, 1949), 195–6; *Parliamentary History*, XX, 1293–1305.
[2] Rockingham to Stephen Croffts, December 12, 1779, to Lord Effingham, May 1, Portland to Sir Robert Clayton, May 26, Burke to Joseph Harford, April 4, to Richmond [1780], Fitzwilliam MSS, Rockingham 1–1041–1, 1058, 1064, Burke, 894, 343N (photostat); Rockingham to Pemberton Milnes, February 28 to Reverend Henry Zouch, March 23, 1780, *Rockingham Memoirs* II, 395–400, 402–6.

dices of Yorkshire. If any reform was to be adopted by them it must appear to come from the neighbourhoods of the county and not from some assembly of deputies in London, and it must come gradually. Wyvill was leading slowly forward from economical reform to a moderate plan of correspondence with the other counties (centring the effective power in a small sub-committee), to the reform of Parliament and the instruction of Members.

As in 1769 the gentry's greatest objection to the association was that it allied them with the radicals of the metropolis. They did not like hearing their modest and proper demand for economy in government equated approvingly with revolutionary activities in America and Ireland. The Middlesex meeting on January 7 felt it necessary to delete all mention of America from their petition for fear of irritating the Yorkshire petitioners, and when Fox, less cautious, praised these examples of successful revolution at Devizes on January 27, he very nearly caused the defeat of the association in Wiltshire. Suffolk, Derbyshire, Herefordshire and Northumberland, indeed, refused to associate, though they had petitioned; and from Kent, Sussex, Surrey, Hertfordshire, Nottinghamshire and Norfolk came protests against association to compete with petitions for Parliament's attention. The Ministry, naturally, played on the revolutionary and levelling tendency of the association, which made the Yorkshire petitioners emphasise their respectability even more and draw further away from the metropolis.

There Fox and his supporting theorists — Jebb, Thomas Day and Granville Sharp — were mouthing the whiggish doctrines of Sidney and Locke, and appealing to the 'Ancient Constitution' of the seventeenth-century constitutional lawyers, and to the proposals of Burgh and Cartwright for a Grand National Association for Restoring the Constitution. Beyond them stood the real revolutionaries, those among the commonalty who wanted violence.

There will never be any effectual reformation in this country brought about by lordlings [commented the *Public Ledger* on December 16 concerning Shelburne's motion of the previous day]. Instead, *a committee of the people with musquets in their hands and spirit in their hearts*, are the only means to redress the public grievances. . . . Lords and great men never look further than to establish a *pitiful aristocracy*. Their pride will not suffer them to mix with the people, and yet without the people, what figures do they cut in a despicable minority?

What gives the Congress of America power? being joined by, and joining themselves to the PEOPLE. What now gives efficacy to the parliament of Ireland? Being strengthened by associations of the PEOPLE. How happens it, that the Parliament of England carry every thing by a corrupt majority? Because those who oppose that majority will not leave off *caballing* and apply for assistance to their masters, the PEOPLE. . . . The people should feel their dignity and despise them.

It was to this sort of opinion that Fox appealed. A year before he had been ready to come to terms with North to return to power, for without power he was doomed to ineffectual opposition. Now he felt the promise of power as patron and demagogue of the metropolitan radicals. By temperament and the fact that he was a first-class House of Commons man, he was better equipped than Shelburne to be patron and than Wilkes to be demagogue. He was not really interested in parliamentary reform nor, since it called up the vexed question of Lord Holland's unaccounted balances, in economical reform. But he had a theme which was just what the commonalty wanted: the people must force their will on Parliament and replace the Crown's influence with their own. His instrument, the Westminster Committee of Association (of which Shelburne and Barré were both nominally members)[1] overawed the other metropolitan committees by the violence of its manifestoes and contrived to give the impression that it was the authentic voice of the people. As his experience and confidence grew Fox used the committee as a lobby in support of his own career, timing its rallies and resolutions to coincide with important Opposition measures.

The Westminster Committee took the initiative in calling the General Assembly of Deputies in London in March 1780, and only Wyvill's vigilance and influence, exerted to the full, prevented it from becoming an adjunct of Fox's parliamentary party. As it was, Wyvill was barely able to prevent a majority of Foxites being appointed to the main committees of the Assembly. He also persuaded the delegates not to include a demand for annual parliaments in the articles of association, and to limit the latter to the instruction of Members, shorter parliaments and 'a more equitable representation' through the addition of one hundred Members for the counties. If by nothing else, Wyvill and Shelburne

[1] Fortescue, V, no. 3204.

would have been united by a common antipathy to the 'Man of the People'.

Shelburne was closely associated with the Yorkshire group from the outset. On December 16, 1779, the day after the debate on his motion concerning the Extraordinaries, Shelburne received a letter from the Reverend Frederick Dodsworth of York informing him of Wyvill's plans to petition for a committee to reduce sinecures and to form an association to require Members and parliamentary candidates to support the petition.

> I wish much for my own private satisfaction [he concluded] for your Lordship's opinion of the expediency of the above measure, or if any other mode of procedure might in your judgment be more eligible. Lord Rock: is not consulted, nor is it meant he should interfere in calling the county together, for the principles upon which we act would be much injured by the interference of any Ld. The undersigned begs for an answer before the next meeting of the County at York between the 25th and 30th of December.[1]

Since Dodsworth was apparently in the secrets of the Association (he informed Shelburne of the intention to resist new taxation and to instruct Members, features of the Yorkshire plan which Wyvill had not yet revealed to the rank and file) and since the prohibition against consulting lords apparently did not extend to Shelburne, it may be supposed that the inspiration for the approach came from Wyvill himself. Very shortly it ripened into an alliance.

On all counts Shelburne was a natural ally for Wyvill. Without a large following in Parliament he was not suspected, as Rockingham was suspected, of wanting to control or suppress the petitioners. His interventions in the movement were unobtrusive. He had favoured Cartwright's proposals in 1776, was the patron of Price and Horne Tooke, and the champion of economical reforms which seemed to go further than any other proposals of that nature from the Opposition side of Parliament. In metropolitan politics Townsend and Horne Tooke represented his interests, leading the moderate City delegates in the various metropolitan committees and the assembly of associations. Further afield, Shelburne was encouraging his new ally, the young Lord Mahon, to organise a petition in Kent.

Shelburne was also active in his own counties. In February and March he joined Mahon in mobilising Buckinghamshire. Un-

[1] December 12, 1779, Shelburne Papers, vol. 168, Part II, fos. 32–3.

fortunately this brought up Lord Temple, ever suspicious that
Shelburne meant to overthrow the Grenville interest in Bucking-
hamshire. Allied with Temple were Burke and Lord Verney. They
proceeded to oppose Shelburne first and the association second.
As identification with the Yorkshire movement came more and
more to mean identification with parliamentary reform their
resistance grew stronger. Temple balked at agreeing to add one
hundred Members to the county representation and succeeded in
having the meeting of the Buckinghamshire Committee removed
to London where the Rockinghams and Foxites could influence it
and where Shelburne could not persuade his supporters among the
Buckinghamshire freeholders to follow. He wrote to Mahon for
publication to the county that he could not 'discover in the plan of
the Yorkshire Association a single exceptionable principle', and
that shorter parliaments and adding to the county representation
were reasonable proposals. But the best they could secure from
Buckinghamshire was the formation of two associations: one,
managed by themselves and supporting Wyvill's programme; the
other, dominated by the Grenvilles and confining itself to the
one point of public economy.[1]

Shelburne took a more direct part and had even worse fortune
in Wiltshire. Here the gentry, like those in Yorkshire, had many
reasons to resist parliamentary and economical reforms, not the
least being their overrepresentation in Parliament. But since they
had formed political clubs and rebelled against the Herbert, or
Court, interest in 1772 (a rebellion in which Shelburne and other
magnates had taken part) there was some reason to hope they
would associate, particularly since the Herbert interest, in the
person of the Earl of Pembroke, had now gone over to Opposition.
At the county meeting on January 27 Shelburne's friend Sir
William Jones warned them that the nation's grievances would not
be redressed until Parliament was reformed because future un-
reformed Parliaments would be sure to repeal whatever measures
could be forced from the current Parliament. Shelburne followed
this up with a reminder that 'our late great countryman Lord
Chatham' had supported the increase of the county representation
as a cure for corruption, and that though he personally could not yet
pledge himself to support one particular method of reform more

[1] Lord Wenman to Lord Abingdon, February 20, 1780, Clements Library,
Lacaita-Shelburne Papers, vol. I; Shelburne to Mahon, April 7, 1780, Fitz-
maurice, op. cit., II, 51–2; Butterfield, op. cit., 384–7.

than another, he was ready to support 'the idea of rendering Parliament more free in its Election, and more Independent in its Conduct'. Any good effect that this circumspect appeal might have had, however, was dissipated by Fox who spoke after him. He refused to undertake to support 'every scheme of Reformation which might be supported by individuals', but instead urged the people to insist firmly on their rights, consider their own consequence in the state; not to sit still in expectation of it from any statesman, 'but follow the grand example of the Americans and the Irish.'[1]

This was not the way to talk to the Wiltshire gentry and though they agreed to petition on the Yorkshire model and to form a committee of association, they harboured an intense suspicion of the managing tactics of professional politicians as exercised in the small committees of association. Later Shelburne tried to take off the effect of this suspicion by a long letter to the county Committee to be read at the county meeting. In it he reminded them of the grievances yet to be redressed: the hampering of reform by the unregenerate Parliament, the unchecked abuses of contractors, the retention of balances by public accountants, distortion of the Commission of Accounts and, nearer home, Lord Pembroke's removal from the Lord Lieutenancy of the county for no other reason 'but for having voted as a free man on a public question'.[2] Most particularly, in disregard of the petitions, new taxes, some of them, such as those on brewing and salt, bearing particularly hard on Wiltshire, had been levied without the suppression of unnecessary offices, savings in expenditure or other economical reforms which required only integrity to accomplish and from which triple the sum of the taxes might have been secured. He repeated Sir William Jones's warning that redress could only be peacefully effected by shorter and more representative parliaments; but if these measures were supported by a fair majority of the people not even the unreformed Parliament would dare to reject them. He suggested that the county meeting might choose to pass declaratory resolutions on these points and wait to see what

[1] *Wyvill Papers*, I, 108–9; *Victoria County History of Wiltshire*, vol. 5 (London, 1957), 200–2, 204.

[2] In the course of moving on March 6 an address to enquire who had advised Pembroke's dismissal, Shelburne referred to the Scottish Colonel William Fullerton as 'a mere *commis*'. Fullerton challenged and a duel was fought from which Shelburne emerged slightly wounded and, for the first time, a hero to the Opposition.

the other counties did, rather than 'pushing the Right of the People to its utmost Extent, by insisting upon an Annual Election, and total change of the Representation'.[1]

Nothing was further from the minds of the Wiltshire gentry. They had no intention of being hurried into parliamentary reform. Even Rockingham complained that they were 'too cold', and the Reverend Joseph Townsend reported that under William Hussey's[2] direction they had come out strongly for public economy, and were convinced that by itself and without any further reform it would check influence and preserve the nation from bankruptcy.[3] In the end the county meeting decided that no representative should be sent to meet with representatives of other counties except to promote the original object of public economy and that such representatives be chosen only by a properly constituted meeting of the Committee.

The reformers had overreached themselves and elsewhere too the reaction was setting in against them. The Rockinghams were thoroughly alarmed by the calling of the Assembly of Deputies and particularly by its adoption of Wyvill's programme of parliamentary reform. Wyvill's concession to work for triennial rather than annual parliaments was wasted on Rockingham who complained bitterly to Shelburne that 'discretion and correctness have not predominated', and warned him not to 'lay more stress upon some circumstances than the *whole facts* might bear', — a reminder that though a majority in a county meeting might vote for reform, he was still the master of Yorkshire. Shelburne replied that he was sorry that the meeting had extended the association to all points of reform 'because your Lordship wished them to follow', that union called for every sacrifice, that he dreaded 'if good men go to make alterations for the better, bad men *will* avail themselves of the example to make essential ones for the worse', and that the points of the original Yorkshire petition could not 'fail of becoming with time universal thro' England'.[4]

Perhaps this was true, but it seemed to the gentry that these points — of public economy and the reduction of influence — and the petitioners themselves had been lost sight of. Parliament

[1] Shelburne to John Audrey, March 26, 1780, *Wyvill Papers*, IV, 131–6.
[2] William Hussey (1725–1813) of Salisbury, retired merchant, interested in public finance and a crank on economy in government.
[3] March 29, 1780, Bowood MSS.
[4] Rockingham to Shelburne, April 2, 1780, Fitzmaurice, *op. cit.*, II, 50; Shelburne to Rockingham [April 1780], Fitzwilliam MSS, Rockingham 1–1021.

debated Shelburne's public accounts proposal and the labyrinthine complexities of Burke's economical reform while out of doors the petition movement, *their* petition movement if the Opposition's speeches meant anything at all, was being railroaded by the professionals into a scheme for parliamentary reform. Only twelve counties and four cities had sent deputies to the General Assembly and some of the deputations were highly unrepresentative, having been packed with professional politicians from the Westminster Committee. The gentry felt hard done by, boxed in between radical reform and increasing government extravagance. But their opportunity to break out and express themselves came on April 6.

There is no evidence that the Opposition's tactics on Dunning's Resolution were long in planning. Economical reform was not prospering and the county petitions were the second string to the Opposition's bow. On March 13 the Speaker Norton, weary with the wrangles on Burke's Establishment Bill, called attention to the neglect of the petitions, some of which had been tabled since the beginning of February. Fox moved for a call of the House on April 6 when they would be taken into consideration. The time was well chosen; immediately after the Easter Recess the attendance of the county gentry was likely to be at its best. The call brought them in. It also speeded up the petitions from the counties which had been wavering hitherto. But there was no assurance that the country Members would vote with the Opposition. That some attention had been paid to their sensibilities may be gathered from the choice of Dunning, the much-respected common lawyer as spokesman, and from the silence during the debate of the more radical of the Opposition's champions. Dunning had probably read the Reverend Joseph Townsend's report to Shelburne of March 29 concerning the Wiltshire meeting's anxiety for the suppression of influence and the promotion of economy. His resolutions were worded to minister to that anxiety. The first — that the influence of the Crown was increasing and ought to be diminished — was passed by 233 to 215; the second — that the House of Commons was competent to enquire into and correct abuses in the Civil List — and the third — that it was the duty of the House to redress the grievances complained of in the petitions — without a division. The reaction to this victory in the counties — that the petition movement was no longer necessary because the

House could secure economy and reduce influence by resolution — was almost identical with the ideas of the Wiltshire people as recorded by Townsend.

It was not the intention of Dunning and his friends, however, to reduce economical reform to a series of parliamentary resolutions. After their unexpected victory on April 6 they held a conference to decide what to do next. Thomas Pitt proposed the parliamentary abolition of all useless offices on the Civil List, following the terms of the county petitions; David Hartley a place bill of limited extent. More realistically, Dunning argued that they ought to stick to resolutions which the gentry would agree to, beginning with one for an account to be published at the beginning of each Session of the pensions and salaries paid to Members of Parliament, and working up by stages to a statement 'that every Minister who shall advise the King against any resolution of the House is an enemy to his country'.[1] A few more victories like that of April 6 and, like a second Troy after a ten-years siege, the Closet would be taken.

But the new majority was very uncertain. A resolution of April 10 to exclude officers of the subordinate treasuries from the House was carried by only two votes; Crewe's Bill to disfranchise revenue officers was defeated at second reading on April 13 by 224 to 195 and Clerke's Bill to exclude contractors from the Commons was defeated in the Lords on the following day. At the critical moment the King kept North firm, and an adjournment of ten days because of the Speaker's illness gave the Ministry time to rally. Rumours of a dissolution were in the air and the Opposition, which for weeks past had been warning the country Members that they would be called to account at the election if they had not supported the petitions,[2] became caught up in their own panic. The result was Dunning's resolution of April 24 calling for an address to the Crown not to dissolve or prorogue Parliament 'until proper measures have been taken to diminish the influence and correct the other abuses complained of by the petitions of the people'. It may have seemed to some of the country Members to be tampering with the royal prerogative of dissolution. Sixteen of Dunning's supporters of April 6 voted with the Ministry, about twenty-four abstained, and the resolution was lost by fifty-one votes. Sawbridge voiced the general opinion of the Opposition that the influence of

[1] Barré to Shelburne, April 6, 1780, Bowood MSS.
[2] Cf. Shelburne to Mahon, April 7, 1780, Fitzmaurice, *op. cit.*, II, 51–2; *Parliamentary History*, XXI, 300.

the Crown had obviously increased since April 6.[1] The Opposition continued to lose ground: Burke's Bill was given the *coup de grâce*, Dunning's resolutions were buried in committee and by May 5 the Ministry had so far recovered as to defeat Conway's proposal for conciliating America by 123 to 18.

The association movement, too, was entering a new chapter. County or borough meetings in Yorkshire, Middlesex, London, Westminster, Essex, Surrey, Somerset and a contested meeting in Huntingdonshire[2] had engaged to associate on the three points of economical reform, a more equal representation and shorter parliaments; and meetings in Bedfordshire, Berkshire, Dorset, Gloucestershire, Hertfordshire and Sussex and Committees of Association in Devonshire and Kent had supported one or other of the propositions.[3] But most of the counties were now ready to leave reform to Parliament, and Wyvill concluded that to call another session of the Assembly of Deputies under these circumstances would make the movement look ridiculous.[4] He was settling down to patient lobbying for parliamentary reform. The Westminster Committee, with the new Society for Constitutional Information founded under its auspices, provided a forcing ground for improving on the theme of the 'ancient constitution' and developing the natural rights and egalitarian implications in the writings of Burgh and Cartwright. But the significance of their labours was to be less for the reform campaign of the immediately following years than for the age of revolution, still a decade away.

[1] *Parliamentary History*, XXI, 524-8, 617-18.
[2] From different points of view Lord Sandwich and his supporters, and Earl Fitzwilliam and the Duke of Manchester had strongly protested the decision of the Huntingdonshire meeting to associate (Sandwich to the King, April 20, 1780, Fortescue, V, no. 3000).
[3] Chart of the Vote of Counties on Parliamentary Reform, Shelburne Papers, vol. 165, fo. 299.
[4] *Wyvill Papers*, III, 193-6.

K

The Opposition Divided

Co-operation between the Opposition parties, which had barely survived the clashes over reform, now succumbed to the additional strains put on it by the Gordon Riots and Rockingham's subsequent negotiations with the Ministry. Shelburne's annoyance with Rockingham in the spring of 1780 arose from a variety of causes of which their difference over reform was almost the least. He was impatient with Rockingham's apparent indecision and particularly so with Rockingham's selective intolerance (encouraged, as he suspected, by Burke)[1] that could not brook co-operation with Wyvill or himself, but accepted Fox and Richmond who were much more radical on the question of parliamentary reform. It may have seemed to him merely another instance of the old exclusion from the circle of the Revolution families from which he had been suffering since the beginning of his career. He had not tried to belong, had prided himself on his independence and his leadership of a party that made up in talents what it lacked in numbers, and had refused to be reduced to the subordinate status of such borough patrons as Grafton, Rutland, Abingdon and Eliot. He would probably have been willing to make some sort of permanent and reasonably equal alliance with Rockingham. Some time in April or May they had a meeting at which he proposed it. His terms can only be guessed at, but he apparently put the proposal as an alternative to the parties seeking accommodation with the Ministry separately, perhaps because he had heard that the Ministry were opening negotiations with Rockingham.[2] Overshadowing all these disagreements was the question of the leadership of Opposition and perhaps, eventually, of the Ministry. Shelburne had promised Grafton and Camden not to contest it with Rockingham, but as the spring wore on the promise wore thin.

The Gordon Riots aggravated the situation still more. Rocking-

[1] *Leeds Memoranda*, 29–3. [2] Fitzmaurice, *op. cit.*, II, 70–1.

ham and Burke were drawn into sympathy with the government by their abhorrence of the rioters, while Shelburne played a part which the Ministry and a good many other people regarded as treasonable. Even had he been less active than he was, his allies must have implicated him to some extent with the Protestant Association in its early stages. In the City his allies of the Townsend party had taken up the Protestants. Alderman Bull seconded Lord George Gordon's motion of June 2 to repeal the Catholic Relief Act of 1778, and in the minority of seven who voted with them on that tumultuous day were Shelburne's ally Wilbraham Tollemache and Sir James Lowther, the borough magnate whose support Shelburne had been wooing. Among the petitions which he presented in support of his motion, Gordon gave particular prominence to one from High Wycombe. In the Lords, Grafton and his hanger-on, John Hinchcliffe, Bishop of Peterborough, echoed the mob's alarm at the supposed increase of Popery and Camden, who had led the opposition to the Quebec Act, revived his old cause.[1]

But it was especially easy for the press to put the worst construction on what Shelburne said and did during the riots and convict him of treasonable conspiracy without the tiresome formality of sifting the evidence. It seemed a suspicious circumstance that in the excitement of June 2 and 3 when the Houses of Parliament were besieged by the rioters, he was one of the few peers who came and went unmolested. His speeches in those days seemed to give such aid and comfort to this new enemy that Rockingham dated their quarrel from them,[2] though read apart from their setting they seem only to partake of the customary extravagance of opposition. He blamed the Quebec Act and the Ministry's laxness in not keeping control on Catholic proselytising for causing the riots, and the Ministry's incompetence in not mobilising the magistrates early enough for their continuance. In an almost wilful disregard of the notorious fact that most of the magistrates were co-operating with the rioters, he and Richmond blamed the Ministry for using the military, rather than the civil, power for suppressing the upheaval. He took the opportunity to urge the reform of the police on the French model (a sure indication, to the suspicious, of his complicity with the national enemy) and according to the *Political Magazine*

[1] *Parliamentary History*, XXI, 628–9, 660.
[2] Rockingham to Richmond, July 11, 1780, Fitzwilliam MSS, Rockingham 166–26.

he threatened to secede from Parliament 'till matters were ripe and there was greater likelihood of speaking there to some purpose', and dared the Ministry to send him to the Tower. Later it was remembered that he and Barré had been down at Portsmouth the week before the riots, no doubt subverting the dockyard.[1] Who else but the Jesuit in Berkeley Square could have so efficiently directed the mob of London to the verge of successful revolution?

Against this flood of suspicion were a variety of facts. He had supported the Catholic Relief Act, had no sympathy with the rabble cry of Gordon and his followers. Unlike some of the Rockinghams, notably the Duke of Manchester, he did not demand the repeal of the Relief Act in panic concession to the rioters. He snubbed Gordon when the latter led a deputation to him as Home Secretary in 1782 demanding repeal.[2] Probably he intended no more than to take somewhat irresponsible advantage of the Ministry's desperate situation, or perhaps at most to use the Protestant Association as he had hoped to use the association movement to alter the balance of power in Opposition in his favour. He was contemptuous of the Rockinghams for having so frequently called upon the people to exert their own strength and then being 'officiously forward in bringing the insurgents to justice'. In the following spring he remarked to Carmarthen:

> When *we* had once raised the Devil we ought to have kept the management of him in our own hands, instead of which it got into other people's, and they by their folly and misconduct had forefeited every degree of consequence and weight with the public.[3]

But if he intended anything he never attempted it. Shortly after the riots he carried out his threat to secede from Parliament for the rest of the Session. Later he commissioned Dunning to prepare a memorandum exculpating them from complicity in the riots, but he made no public attempt, as he had on some other occasions, to clear his name. His ally Wyvill was perhaps the principal sufferer from the riots among the reforming politicians. Fox was too valuable to the Rockinghams for them to indulge in the luxury of attacking him. But Wyvill, who was already in competition with the Rockinghams in Yorkshire, lost ground badly among his respec-

[1] *Parliamentary History*, XXI, 669–86; *Political Magazine*, I (1780), 428; Fortescue, V, no. 3038.
[2] Manchester to Rockingham, June 8, 1780, Fitzwilliam MSS, Rockingham 1–1065; *General Advertiser*, June 1, 5, 10, 1782.
[3] *Leeds Memoranda*, 41, footnote 42.

table neighbours who suspected him of having led them on into a levelling movement.

The spectre of mob rule hurried Rockingham into negotiation with the Ministry. He stipulated the same terms as those he was to come into office under in 1782: no royal veto on granting independence to America, reversal of the Middlesex decision, and reduction of the influence of the Crown through the passing of Crewe's and Clerke's Bills and the largest part of Burke's plan. But the Ministry, strengthened by the recent news of the capture of Charleston, insisted on more definite policies on America and economical reform, the King refused to replace Sandwich with Keppel at the Admiralty, and the negotiations collapsed.[1] Their effect on Shelburne was to drive him deeper into already established isolation and discontent. Richard Fitzpatrick reported that he seemed very sore on the subject and claimed that the Ministry were sounding him even while they negotiated with Rockingham. Even six months later he was still bitter against Rockingham to a degree that can hardly be explained except as the result of a bad fright. If Rockingham and North came to an agreement his career was finished. Richmond, who had sympathised with Shelburne and threatened to secede from Parliament himself, thought it was foolish to exclude him from the negotiations. In extenuation Rockingham explained that they had all thought that Shelburne had declared himself opposed to any union with the government in his speeches at the time the mob was besieging Parliament.[2]

In the autumn attention was temporarily drawn away from these disputes by the larger struggle of the general election. The election made no decisive change in the balance of forces in the Commons and it returned a majority which, as North subsequently pointed out, remained faithful to the Ministry until after Yorktown. Undoubtedly economical reform encouraged the Opposition and alarmed the Ministry so that each side was drawn into contesting a number of important elections — in the City, Westminster, Surrey, Bristol, Windsor and Colchester — with a fury and expense almost without precedent. This had two significant effects: Opposition candidates won a number of impressive victories in the

[1] Ian R. Christie, 'The Marquis of Rockingham and Lord North's Offer of a Coalition, June–July, 1780', *E.H.R.*, vol. 69 (July 1954), 388–406.
[2] Fitzpatrick to Lord Upper Ossory [July 13, 1780], Add. MSS 47,579, fos. 81–2; Richmond to Rockingham, July 9, 12, Rockingham to Richmond, July 11, 1780, Fitzwilliam MSS, Rockingham 166–26, 27; *Rockingham Memoirs*, II, 419–20; Fitzmaurice, *op. cit.*, II, 57–8.

counties; and what were, in fact, the slim electoral funds at the disposal of the Ministry, were so seriously overtaxed that North, reluctant to burden the secret service funds, unwisely relied on the King's electoral fund of £1,000 monthly from the Privy Purse to pay off the expenses gradually, with embarrassing results for the electoral creditors when the debt was repudiated by North's successors in 1782.[1] In Yorkshire Rockingham tried unsuccessfully to come to an agreement with the Bedfords to share the York seats, since he was determined not to yield to the Association. He and Lord John Cavendish were embarrassed by the fact that Charles Turner, Cavendish's fellow Member for York, had pledged himself to the Association and that most of the Rockingham candidates, indeed, had been similarly pledged at the county meeting of March 28. Rockingham worked among his friends and neighbours at the York Races to discredit the Associators as outsiders. He was only partly successful in York, where Cavendish and Turner were returned, and in the county Savile, after endeavouring to dissuade the Associators, bowed to the wishes of what was apparently a majority of his constituents and pledged himself to support an addition to the county representation and triennial parliaments.[2]

Reform hardly played a part in Shelburne's electoral activities. His immediate following was returned — Barré and Dunning at Calne, and Lord Mahon (replacing Shelburne's brother Thomas Fitzmaurice) at Chipping Wycombe. Shelburne arranged with Edward Eliot to return Wilbraham Tollemache in place of Edward Gibbon at Liskeard and John Baring, Dunning's brother-in-law, was elected for Exeter. Shelburne also had some setbacks. His follower Alexander Popham was beaten out at Taunton by Colonel John Roberts after failing to make an arrangement with the Treasury; Nathaniel Smith, Barré's East India friend, failed to carry Rochester, and James Townsend, who had been out of Parliament since 1774, declined the poll in the City when it became clear that Wilkes and the Court would divide the honours there. Shelburne made an effort to persuade Grafton to support the Younger Pitt in the University of Cambridge, but failing, Pitt

[1] Fortescue, V, nos. 3663, 3668–9, 3674, 3680.
[2] Ian R. Christie, *The End of North's Ministry, 1780–1782* (London, 1958), 111–15; Rockingham to Lord St. John, September 7, Cavendish to Rockingham, September 4, 5, 6, 1780, Fitzwilliam MSS, Rockingham 141–4, 5, 6, 7, 8, 11.

eventually found a vacated seat at Appleby by courtesy of Sir James Lowther.[1]

His party was hardly impressive in numbers, but Shelburne's influence extended more widely than its limits. He had the support of William Clayton in Buckinghamshire, and shared that of John Aubrey with Lord Abingdon. Abingdon himself, with four borough seats, oscillated between the Rockingham and Shelburne connections. Shelburne also had the friendship and support of the Earl of Pembroke and of his son, one of the Members for Wilton; the occasional support of Edward Eliot and two of his members; the friendship but not the support until 1782 of Richard Jackson, and on some issues the support of Sir James Lowther and his followers. After 1780 he made a special effort to catch the deserters from the Ministry, which may help to explain his later moderation on the question of the influence of the Crown, where the Rockinghams were very strong. On a hypothetically perfect issue he might have had the support of twenty members; in the absence of it his personal following was not much more than a half dozen.[2] So far as he was concerned the numerical domination of the Rockingham connection over the Opposition was absolute, and only their relative lack of debating talent, their caution, or the divisions in their ranks offered him any chance of recovering even the junior partnership with them which he had enjoyed in the previous spring.

All three factors were operative during the Session of 1780-1, but neither Shelburne nor any other Opposition leader was in any position to take advantage of them. The Opposition prospects were as dead as ever they had been since the war started. From America came the news of Cornwallis's victory at Camden, and the country gentry stayed away from an autumn sitting that promised nothing but triumphs for the Ministry. Nevertheless the Ministry were not especially reassured by this circumstance and Rockingham, at least before the sitting began, was optimistic that the elections had increased the number of conservative independents in Parliament, and that a concentrated blast on the trumpet of economical reform (unsullied by any note of parliamentary reform) must bring the walls of Jericho tumbling down. Both Shelburne

[1] Pitt to Shelburne [February, 1780], Clements Library, Pitt Papers; Rockingham to Grafton, February 20, 1780, Grafton MSS, 1009.
[2] Shelburne to John Jervis, September 11, 1780, Add. MSS 29,914, fos. 147-8; Christie, *End of North's Ministry*, 222-6.

and Savile thought it would have been better to concentrate on
electoral reform, a subject that the recent election had made
topical.[1] But Rockingham refused to interfere with the electoral
system. The respectable people in the country, he was convinced,
would support only economical reform.

An initial difficulty arose when so few of these could be per-
suaded to come to parliament for the autumn sitting. The Opposi-
tion's attack had to be postponed until spring, and there were
stirrings of discontent with Rockingham's leadership. Lord
Pembroke reflected unhappily:

> That we come down resolved not to divide, & only to hear Ld.
> Rockingham lay a claim to future disapprobation, that we did divide,
> & that Ld. R. let every matter of the highest importance pass without
> opening his lips.[2]

Camden predicted the early collapse of the Rockingham party,
and as if to confirm it Richmond appealed to Barré to persuade
Shelburne to come back to town, expressing his own sympathy and
apologising for the negotiations of the previous summer and
Rockingham's feebleness.[3]

Shelburne was nursing his resentment. He was full of friendship
for Richmond, but he was in no hurry to make up with Rockingham,
and he would not come up to Parliament that autumn. After
Christmas he appeared, to speak in the debate on the outbreak of
war with Holland on January 25. He took the opportunity to
declare himself free of all party connections and to ridicule the idea
of any party Opposition existing.

> Opposition was composed of a great number of petty squads of
> individuals; but their conduct, if it aimed at anything, had defeated
> the very purposes of an effectual opposition; and whenever they
> seemed to unite in opinion upon any important questions, their
> attempts had always, and ever would, ... miscarry.

Having dealt with Rockingham, he explained that he had come to
Parliament only as a privy councillor to offer advice to his
sovereign and nation in distress, and proceeded to give a compre-

[1] Shelburne to Barré [November–December, 1780], Fitzmaurice, *op. cit.*, II,
72; Savile to Rockingham [1781], Fitzwilliam MSS, Rockingham I, 1210.
[2] *Pembroke Papers (1780–1794)*, ed. Lord Herbert (London, 1950), 62–3.
[3] Camden to Shelburne, November 13, 1780, Bowood MSS; Barré to Shel-
burne [November 11, 1780 — wrongly dated December, 1780], Fitzmaurice,
op. cit., II, 66–70.

hensive criticism of the Ministry's management of foreign affairs and the war.[1]

It was the right issue to take up that spring since the war was not going nearly as well as the Ministry would have liked the country to suppose. On domestic issues they were almost invulnerable, in part because of the bad management of the Opposition who staked everything on the county members flocking to support economical reform. The call of the House on January 31 was disappointing; the county Members had stayed at home. After a little delay Burke proceeded to re-introduce his Establishment Bill. North allowed it to reach second reading before crushing it. Crewe's and Clerke's Bills were thrown out again and the debate on the Budget — from which some advantage might have been snatched, since North's loan of £12,000,000 for that year had been secured at the extraordinarily high price of increasing the debt by £20,000,000 — degenerated into a fruitless squabble over whether or not allocations of stock were being used for purposes of corruption.[2]

There was no confidence in reform as an issue and Rockingham was not the only one who was bidding for the support of the respectable. The County Associations were anxious to clear themselves of the imputation that they were agents of mob rule. Wyvill and Yorkshire were still loyal to parliamentary reform as the essential measure precedent to all other reforms, but at the second assembly of deputies in February and March they were faced with the refusal of some delegations — notably that of Kent — to speak for the freeholders of their counties. Dunning defended the legality of the delegations on the rather weak ground that the petition implied that the petitioners were representative (indeed, without such an assumption it would have had no weight). For the sake of unity with the moderates Wyvill agreed to change its form, water down its content and change the description of its sponsors from the delegates of the Associations to thirty-two leading freeholders of the counties of York, Surrey, Hertford, Huntingdon, Middlesex, Essex, Kent, Devon and Nottingham and electors of Westminster. In its final version it asked not for parliamentary reform, but for measures to reduce the unconstitutional influence of the Crown and the waste of public money, such as its authors

[1] Shelburne to Barré [November–December, 1780], Fitzmaurice, *op. cit.*, II, 70–2; *Parliamentary History*, XXI, 1023–43.
[2] *Parliamentary History*, XXI, 1223–92, 1325–73, 1379–99, XXII, 1–47.

claimed the old Parliament had been about to institute when it was dissolved.[1]

This moderation was completely wasted. It was April 2 before the Opposition had agreed to present the petition, May 8 before it was considered. By that time most of the gentry who had come up to Parliament had left for home again, and most of the rest obviously agreed with Abraham Rawlinson that the petition ought to be rejected whether it was the plea of only thirty-two individuals or of unconstitutional and illegal delegations trying to deceive the House.

> Every independent character [wrote a ministerial pamphleteer] will now be no longer alarmed by Association, or insulted by instructions.[2]

The fact that in the form of the Commission for Examining the Public Accounts economical reform had led on to the much more fundamental topic of administrative reform was also unsatisfactory for the Opposition since it gave the Ministry some positive achievements to flaunt. The Rockingham line, as stated by Savile, was that North had stolen the Commission of Accounts from the House of Commons and paid the Commissioners fat salaries in secret for merely discovering what balances were in the hands of the public accountants — a task that could have been done by a committee of the House or the four idle Lords of the Treasury. Could the existence of undue influence of the Crown and public waste need better proof? Barré, who knew something of the work of the Commissioners, did not agree. Nor did he agree with Burke's misplaced facetiousness concerning the Commissioners' first four reports which North presented to the House on May 10. He still preferred a parliamentary committee (and was strongly seconded in this by the Younger Pitt making his second speech), but he preferred the existing commission to none at all. North, for his part, promised a thorough reform of the Army Extraordinaries. He offered to show Barré the state of the army contracts, which, he assured him would be examined by the Commission, and also offered to consider any suggestions which Barré might like to make for the improvement of the Commission. But Barré excused him-

[1] *Wyvill Papers*, I, 317–18, IV, 139–43; Sir James Northcliffe to Rockingham, February 23, 1781, Fitzwilliam MSS, Rockingham I, 1090–1, 2. Wyvill had vague ideas of extending the scope of the petition to include an attack on the government loan and the Commission of Accounts (*ibid.*, IV, 144–6).

[2] *Commonplace Arguments against Administration, with Obvious Answers (Intended for the Use of the New Parliament)* (London, 1781), 77; *Parliamentary History*, XXII, 95–9, 138–200.

self on the ground that he did not want to become responsible for what was now a government measure.[1] North proceeded to introduce legislation to implement the most urgent of the Commissioners' recommendations: that the public accountants should cease to be bankers and pay their balances into the Bank within three months (21 George III, c. 48). The fact that Burke had already urged this change did not make the Ministry's victory less complete or more gratifying to the Opposition.

When the Session came to an end that summer — the summer when the trap was closing around Cornwallis in Virginia — it seemed as though the struggle for reform had reached an impasse. Wyvill bravely hoped that the nobility would soon be persuaded to take up parliamentary reform, but their sentiments were represented by Savile's comment: 'Nothing but sufferings and disappointment will awaken the People, so nothing but violence will be to be (sic) expected of them.'[2]

Out of Parliament for the moment, Shelburne seemed to mellow. He had leisure to consider the oddities of his latest protégé, encamped that summer at Bowood. Fifty years later the aged Jeremy Bentham dated their acquaintance from Shelburne seeking him out in the summer of 1781 after reading and marvelling at the *Fragment on Government*. The true account was more characteristic of Bentham. Since Lord Mansfield had paid little attention to him, he contrived to call himself to the attention of the Lord Chief Justice through the patronage of other great men. After some manoeuvring he secured an introduction to Shelburne through Francis, Baron Maseres, late in 1778. The ostensible occasion of the introduction was to introduce Samuel Bentham to the Russian Court. For eighteen months Jeremy forwarded Samuel's accounts of Russia to Shelburne House hoping to be invited to accompany them. The invitation came at last, in July 1780, but Bentham shied away, afraid of appearing too eager and wanting to send a copy of the *Fragment* ahead as a herald.[3] At about this time he wrote in a fanciful pilgrim's progress of utilitarianism:

[1] *Parliamentary History*, XXII, 140-1, 204-18, 358-70; Barré to Shelburne [May 1781], Bowood MSS.
[2] *Wyvill Papers*, III, 326-7, IV, 149-50.
[3] 'History of the Intercourse of Jeremy Bentham with the Lansdowne Family, Addressed by Himself to the Present Marquis of Lansdowne, 12 January, 1828,' Add. MSS 33,553, fos. 26-7; Add. MSS 33,538, fos. 245-6, 248-59, 285-93, 310, 325, 333, 337, 428; Add. MSS 33,539, fos. 66-71, 81, 106, 171; John Lind to Maseres [November 1778], J. Bentham to Shelburne, September 17, 1779, July 27, 1780, Bowood MSS.

One day as I was musing over this book [*Principles of Legislation*] there came out to me a good man named Ld. S. and he said unto me, what shall I do to be saved? I had forgot, continued he, I must not talk of myself — I yearn to serve the nation. I said unto him — take up my book and follow me. We trudged about a long while in search of adventure without any sort of plan, and without thinking of when we were to go fast and when not and of what we were going about as to the fashion till we spied a man named George who had been afflicted with an incurable blindness and deafness for many years. I said unto my apostle give him a page of my book that he may read, mark, learn and inwardly digest it: the man struggled a good deal at first, and made a good many faces as much as to say this is some of the nastiest stuff I ever tasted in my life: but no sooner was it down than before a man could have said 'expatha' up came faster out of his bosom seven Devils. . . . Immediately the man heard everything that a man could hear and there fell the scales from his eyes, and not seeing what better he could do with himself, he also followed us. We had not travelled far before we saw a woman named Britannia lying by the waterside all in rags with a sleeping lion at her feet: she looked very pale, and upon inquiring we found she had an issue of blood upon her for many years. She started up fresher farther and more alive than ever; the lion wagged his tail and fawned upon us like a spaniel.[1]

After some further coyness on Bentham's part they met in the winter of 1780, but by that time Bentham was becoming disillusioned with Shelburne since he had discovered that he was not on good terms with Mansfield, as he had once supposed.[2] He cheered up again when Shelburne borrowed the *Fragment*, and on Shelburne's suggestion he took up the study of constitutional law, which he had hitherto neglected as being that part of the law which least promoted the happiness of the people. By way of return he introduced Shelburne to James Anderson's tract on the Scottish poor laws and suggested that Shelburne might soon help him correct the defects in poor law administration. At Bowood he luxuriated in the company of his betters (until the prospect of a parental visit from old Jeremiah Bentham threatened to spoil the fun), and was employed by his host in straightening out legal tangles in his Irish estates and ordering fossils for the Bowood grotto and tracts for the Bowood library. He waited on tenderhooks for the arrival of Camden and Dunning who were to sit in judgment

[1] University College London, Bentham Papers, Box clxix, 79.
[2] Add. MSS 33,539, fo. 106.

on the *Fragment*; and at the ingathering of the Shelburne party in September he was able to observe at close quarters the great of the Opposition — Barré, Pitt, Camden, Dunning and the rest — preparing for the new Session.[1] For Bentham that summer was his introduction to the world of politics and government; but it may be doubted if Shelburne, who had taken him up with his accustomed enthusiasm for people with 'liberal and enlightened' views, had paid anything but passing attention to Bentham's philosophy.

Lady Pembroke noticed that summer that 'he had nothing but party in his head'.[2] He was probably in the process of altering his political doctrines to the line they were to follow in the coming Session. The new line, like the old, had to differ from the ideas of the competing parties and differ in ways calculated to appeal to one or other of the groups of independents. On the main question of the day Shelburne had endeavoured to combine refusal to recognise American independence with opposition to the 'unnatural' war. Formerly out of deference to Chatham he had stressed the first element. But he ran the risk, as the war came to appear more and more hopeless, of discrediting himself with the radicals in Opposition and driving them into Fox's arms without gaining the conservative independents who were also becoming sick of the war. While not surrendering his hope for a federal reunion with America, Shelburne in his speech of January 25, 1781, had made it clear that he had 'waked from those dreams of British dominion' which had gripped him hitherto. Much as he valued America and fatal as the separation must be, as a friend to liberty he would prefer to see separation rather than a reunification by force of arms.[3]

He had said very little in defence of the 'just prerogatives' of the Crown after the economical reform campaign began, but in its defeat he had read a lesson that Burke refused to read: that the country gentry's support for economical reform stopped short at interfering with the King's Household, and that as Norton had hinted in the debate on Gilbert's Household reform plan, it was time the Civil government and the Household were separated. Shelburne's disapproval in the summer of 1780 of the free-wheeling attack on the expenses of the whole Civil List by Horne Tooke and Price in their pamphlet *Facts Addressed to the . . . Subjects of Great Britain*

[1] *Ibid.*, fos. 199–200, 204–14, 219–27, 230–5, 255–8; University College London, Bentham Papers, Box 169, fos. 114; Bentham to Shelburne, July 18 1781, Bowood MSS; *Pembroke Papers*, 142, 144.
[2] *Pembroke Papers*, 144. [3] *Parliamentary History*, XXI, 1035–6.

and Ireland is the first indication that he was applying this lesson.[1]

The principal change was in his attitude toward his own prospects. These brightened correspondingly in 1781 as Rockingham's leadership dwindled almost to inaction. Shelburne told Carmarthen that he was well disposed to Rockingham personally and wanted his support in case any cabinet arrangement was made with the Opposition,

> particularly as Ld. Rm's principles and his connections would be of great use to combat any artful and underhand dealings in the closet.[2]

In a new alliance perhaps their positions would be reversed. Rockingham had shot his bolt. Only a little longer and the time might be ripe for Shelburne to come into office at the head of a union of dissident Rockinghams, reformed ministerialists and independents. Richmond was anxious for an agreement with him; and in the previous autumn Barré reported Lord Frederick Cavendish as saying:

> Ld. Shelburne must with little attention and management be at the head of us, our body has property, &c., but we have not those powers that enable men to take the lead in public assemblies. You see what has been the case of C. Fox. We must naturally give way to such men.[3]

That autumn he was full of reasonableness, ready to come to town and to co-operate with anyone in the cause of Opposition. And his brightening prospects with the Opposition made him more inclined than ever to protect himself with the radicals by publicly declaring his approval of Wyvill's latest address to the Yorkshire Association, insisting that economical reform was a palliative and that parliamentary reform was the only sure cure for corruption and waste. Shelburne promised

> ... to enter into the strictest and most unequivocal union with any public man, or public body of men, who may be deemed, in point of national weight and opinion, competent to the effecting of those important ends.[4]

As he soon discovered, he had underestimated the strong loyalty of the Rockinghams to their leader. Rockingham might be exasperatingly slack as a leader, but he was incomparable as a friend; and friendship, no matter how Burke might try to develop distinc-

[1] Fitzmaurice, *op. cit.*, II, 65. [2] *Leeds Memoranda*, 42–3.
[3] Fitzmaurice, *op. cit.*, II, 70.
[4] Wyvill to Shelburne, October 17, Shelburne to Wyvill, October 24, 1781, Bowood MSS.

tive principles of political unity among them, was still the cement of the Rockingham party. If Rockingham stepped down, Portland or Richmond, or even Cavendish or Fox, but not Shelburne, would take his place. And considerations of friendship apart, Shelburne still gave too much the impression of the political privateer for him to be considered as the leader of a party.

On coming to town that autumn he repeated his offer of alliance to Rockingham. Alternatively he was willing to accept any suggestion that would as effectively reform Parliament or 'any other radical and effectual plan, which would unite and satisfy the friends of the country, both within doors and without'. He added that he disapproved of third parties and wanted to see only two — those of the Crown and the People. Rockingham, who had been confessing to Portland the complete hopelessness of Opposition, suggested uniting on an amendment to the address, expressing severe disapproval of the Ministry's mismanagement which was most probably about to cause the loss of Cornwallis's army in Virginia. Shelburne turned it down as too vague and too inadequate to the country's needs.[1]

For once Rockingham was right. Two days before the Session opened, the news of Yorktown arrived. It caught the Opposition by surprise. So often before the Ministry had been able to snatch victory from good news about the war or the alarm of the respectable at the prospect of reform that now their opponents could hardly believe that they had the game in their hands. The Amendment to the Address, drafted by Dunning and moved by Shelburne in the Lords and by Fox in the Commons, merely called for a better and more united national effort. The debate, however, centred on ending the war, as it did on almost every occasion until the Christmas Recess. Until then the Ministry kept a comfortable majority, but the Opposition were still feeling their way. Most of the country gentry would not be up until after Christmas, they were expected now to support the Opposition and already the Ministry was losing some of its regular supporters. As early as November 30 the Lord Advocate, Henry Dundas, was insisting that the American War must be stopped, and he was coercing his colleagues into agreement. Kempenfelt's uncomfortable encounter with the Brest fleet on December 20 provided the Opposition with the excuse for widening their attack to include Sandwich's administration

[1] Fitzmaurice, *op. cit.*, II, 82; Christie, *End of North's Ministry*, 269.

of the Admiralty, and Dundas with a further argument to North for dropping unpopular ministers and making peace. But not until the Ministry's defeat by 19 votes on Conway's motion of February 27, 1782, for stopping the American War could the King be persuaded to open negotiations with the Opposition, and it was another four weeks before he permitted North to resign his martyr's crown.[1]

Meanwhile the Opposition parties were drawing together reluctantly. In the Commons Dunning, Barré and Pitt were in regular conference with Fox, though the leaders, according to Carmarthen, who apparently spent the Christmas season running back and forth between them, were still sharply divided on measures.[2] A meeting of the Rockinghams on December 15 concluded with a resolution that 'our present calamities could not be attributed to any fault in the constitution, but arose merely from a maladministration of government'.[3] Later at Bowood Shelburne, Barré, Dunning and Pitt drafted a proposal for a moderate reform of Parliament including the addition of one hundred Members to the county representation, the compensated abolition of rotten boroughs and a bribery bill.[4] But independence for America, rather than parliamentary reform, was the chief bone of contention at this time. Dunning strongly opposed the evacuation of America when Fox proposed it in the Commons on December 12, and some time during the Recess Shelburne and Barré drafted a resolution to recommend to the King as an alternative to the American War:

> To consider distinct, specific and unequivocal terms of reunion and reconciliation, founded in a just attention to our mutual interests, which may be offered to them by His Majesty with the concurrence of both Houses of Parliament accompanied with every step on the part of His Majesty, as well as that of Great Britain and Ireland which can inspire confidence and command respect.[5]

Dunning persuaded Fox to agree to support a policy of federal and economic union between Britain and America rather than independence as the basis for uniting the Opposition, but at a conference in February 1782, Shelburne was unable to get Rockingham to adopt this *via media*. A full-scale conference of all the leaders at the

[1] *Parliamentary History*, XXII, 634–751. [2] *Leeds Memoranda*, 48–50.
[3] Add. MSS 27,918, fos. 45–6.
[4] Shelburne to Camden, January 26, 1782, Bowood MSS.
[5] Shelburne Papers, vol. 165, fo. 58; cf. *Leeds Memoranda*, 52–3, 59–60; *Parliamentary History*, XXII, 830–1.

end of February came no nearer agreement, and according to the *Morning Herald* broke up when Shelburne suggested that he and Fox should conduct negotiations with the Court, excluding Rockingham.[1]

Since the middle of December rumours had been growing that Shelburne was about to join the Ministry. Thurlow, whose manners were often a good barometer of Court opinion, was unusually complimentary to Camden and Shelburne, and within a few days Thurlow was negotiating with Shelburne. From a cryptic memorandum from Thurlow to the King and his subsequent summary of the negotiations, it appears that the King made his usual proposal of a non-party or broad-bottom administration including all the leading politicians, and that Shelburne countered by stating that there must be a complete change of men and measures and that 'all parties and sects should be brought together to assist in so dangerous a moment'. He was ready to join such a government without portfolio and Dunning must also be of the Cabinet, preferably with the Great Seal, but if not, as Chief Justice of King's Bench. Shelburne was particularly anxious that the public account of the negotiations explain that he had been sent for because he had no party connection — an explanation that Thurlow thought inept and likely to raise, rather than calm, the suspicions of the Rockinghams that the Court was trying to split the Opposition. He regarded Shelburne's terms as having at least the advantage of a 'quicker union of sentiments', though this was not, in his view, as important as 'a general satisfaction' (including the Rockinghams) for securing a solid administration.[2]

[1] Pitt to Shelburne [February 1782], Bowood MSS; *Leeds Memoranda*, 52; *Morning Herald*, March 6, 7, 1782.

[2] *Rockingham Memoirs*, II, 438; *Leeds Memoranda*, 48, footnote; *Morning Herald*, January 4, 1782; *Parliamentary History*, XXII, 692, 976; Fitzmaurice, *op. cit.*, II, 89, 319; King to North, February 28, Thurlow to the King [March 6, 1782], Fortescue, V, nos. 3537, 3542; Thurlow to the King, March 10, 1782, Egerton MSS 2232, fo. 47. I assume that the negotiation took place before and after March 6, though admittedly Thurlow's first memorandum (Fortescue, V, no. 3542) may have been misdated by the King or (more probably) by Sir John Fortescue. Some light may be thrown on Shelburne's terms by what the ministerial press supposed them to have been a fortnight earlier. About the middle of February Shelburne was reported to have been approached by Jenkinson. Dunning opposed the negotiation but the party eventually agreed to offer the following terms: ending the American War, but no recognition of American independence; the Southern Department for Shelburne, Presidency for Camden, Great Seal for Dunning, Secretary at War for Barré, and eleven inferior posts. Jenkinson countered with the lesser offices of Chief Justice of Common Pleas for Dunning and Vice-Treasurership or the embassy at St. Petersburg or Berlin for Barré. On this the negotiations were broken off (*Morning Herald*, February 16, 1782; *Political Magazine*, February 1782, 82–3).

L

The King, however, refused to consider the proscription of the existing Ministry on any terms and turned to Gower, Weymouth and Grafton. He soon discovered 'every description of men equally unwilling to stand forth', and North braced him for the inevitable negotiation with the Rockinghams by reassuring him that they were really quite conservative and would be glad to have Thurlow in the Cabinet to help them resist any dangerous popular measures.[1] At Rigby's suggestion Thurlow saw Rockingham on March 11 and Richmond and Fox on the following day. Rockingham, though reluctant to negotiate through Thurlow, demanded, like Shelburne, the exclusion of 'those who had been considered as *obnoxious* ministers, or of those who were deemed as belonging to a sort of secret system', and repeated his stipulation of July 1780 with respect to American independence and economical reform. Burke steeled him to 'be under no embarrassment at all about seeming to break off about men', and to stick to the Establishment Bill — Burke's Establishment Bill — as the popular measure which above everything else would ensure the success of a Rockingham ministry. The result was an ultimatum on American independence and economical reform which the King indignantly rejected.[2]

But the Commons division of March 15, which went against the Opposition by only nine votes, destroyed the last illusion that the Ministry could maintain themselves in office. It was Rockingham or chaos. Gower, when appealed to by the King, suggested that Rockingham might be weakening, but North warned the King that he must yield to the popular will and send for either Rockingham or Shelburne, preferably the latter since he made less stipulations as to measures than did Rockingham. On the 19th Thurlow talked to Shelburne on the Woolsack, but Shelburne, very conscious that Fox was looking on, refused to discuss terms except with the King. North could wait no longer; on the next afternoon he resigned. On the 21st Shelburne declined the King's invitation to form a ministry of Thurlow, Gower, Weymouth, Camden and Grafton, and the Rockinghams if they 'would agree to state their pretensions of what they meant by a broad bottom, for the King's

[1] King to Thurlow, March 10, 1782, Egerton MSS 2232, fo. 45; North to the King, March 8, 1782, Fortescue, V, no. 3545.
[2] Fitzwilliam MSS, Burke 23; Fortescue, V, no. 3564; cf. *Rockingham Memoirs*, II, 451–60; Fortescue, V, nos. 3531, 3553, 3555–6.

consideration', and urged the King to send for Rockingham, agreeing to act as go-between if the King insisted.[1]

On the 23rd the last stage of the negotiations opened. Shelburne, after vainly urging once more that the King send for Rockingham, made his own stipulations: that the King should agree to his terms as set out at the beginning of the month, that the assistance and co-operation of the Rockinghams must be secured at all costs, that he must have full power and confidence to conduct the negotiations, and that after the administration was formed the leaders should make patronage recommendations jointly.[2] Rockingham did not learn of these terms until after the administration was formed. Nor was he fully aware of another secret reservation. At the suggestion of Thurlow and North the King decided to treat Rockingham's terms as matters to be settled subsequent to the Ministry's formation, rather than as the *sine qua non* of the Ministry's formation, since Rockingham had not officially presented them to the King. Rockingham helped this deception by being understandably reluctant to say, when he was asked point blank, whether or not his terms were the 'ultimatum of the party'. By March 25 the King was describing the terms as something to be bargained over and urging Shelburne to stand fast against them.[3]

Shelburne was in no position, and probably had no desire to do so. The stipulation concerning American independence (that there should be no royal veto of it) met his wishes and he was much more concerned to get the best share of the places he could in the arrangement. Rockingham replied to his overtures that he intended to form such a cabinet as was suitable for carrying out the measures he had submitted to the King, and if Shelburne wanted to know what these were he had merely to wait until the King had called for Rockingham and signified his agreement to them, upon which he (Rockingham) could discuss cabinet-making and other things with Shelburne. Shelburne answered that he would not presume to give his opinion on the measures proposed since he was sure they were 'so respectable that it is unnecessary' and went off to discuss the situation with Camden and Grafton. After a further interview with the King he spent most of the 25th cabinet-making with Rocking-

[1] Fortescue, V, nos. 3565, 3568, 3571; Thurlow to Shelburne, King to Thurlow, March 21, 1782, Clements Library, Lacaita-Shelburne Papers, vol. I; Fitzmaurice, *op. cit.*, II, 88.
[2] Fitzmaurice, *op. cit.*, II, 88; Fortescue, V, no. 3632 and enclosure, no. 3639 and enclosure.
[3] Fortescue, V, nos. 3564, 3567, 3571, 3578, 3582.

ham. Rockingham complained that Shelburne made no suggestions for the membership of the cabinet and left it all to him, but this was hardly fair, since two of Shelburne's suggestions — the Great Seal or the Chief Justiceship of King's Bench with Cabinet rank for Dunning and a cabinet post for the Younger Pitt were turned down. Burke held Rockingham firm to the main propositions and to demanding the lion's share of the offices.[1] By the 26th the King had been brought to a grudging acceptance and the struggle was over. Even then there were ambiguities. The King affected to believe that Rockingham's terms with respect to economical reform permitted him to reform the Household himself, leaving the Civil Government to be reformed by Parliament. Burke certainly, and Rockingham probably, had no such intentions, and the difference remained to blight the new ministry.[2]

Rockingham had the Treasury, Cavendish the Exchequer, Keppel the Admiralty and a peerage, Fox the Northern (now Foreign) Secretaryship and Richmond the Ordnance and the Garter. Grafton and Camden were Privy Seal and Lord President respectively and Conway, half-way between the parties as usual, was Commander-in-chief with Cabinet rank. As the junior partner Shelburne had done well: the Southern (now Home) Secretaryship and the Garter for himself, the Duchy of Lancaster for life, a peerage and Cabinet rank (accepted unwillingly) for Dunning, and the Treasurership of the Navy and a pension for Barré.[3] And Shelburne had the ear of the King.

[1] Fortescue, V, nos. 3575–7; Fitzmaurice, *op. cit.*, II, 91; Rockingham to Shelburne [March 25, 1782], Fitzwilliam MSS, Rockingham, I (P), 1136. John Robinson reported that Pitt had attended a meeting of the full Rockingham party at Thomas Townshend's on the evening of March 24 and had declared himself full of attachment to the Rockinghams (Robinson to Jenkinson, March 25, 1782, Add. MSS 38,218, fo. 50). Presuming the report to have been correct, his subsequent disappointment may have confirmed him in his loyalty to Shelburne.

[2] Fortescue, V, no. 3648.

[3] Shelburne also claimed credit for the appointment of Thomas Townshend as Secretary at War (*ibid.*, no. 3592; Fitzmaurice, *op. cit.*, II, 89–91).

CHAPTER IX

The Rockingham Administration

The long opposition was over at last, but the new ministry was neither the homogeneous party administration that the Rockinghams had worked for, nor the firm union of the patriotic dreamed of by Shelburne. It was a coalition of the two parties, parts of the court interest and independent connections, loose enough to satisfy even the King's exacting tastes. The members of it disagreed among themselves on measures and men, on patronage and political theory, on reform and most of all on war and peace. The second Rockingham administration marked the penultimate round in the quarrel between its leaders which had been going on since 1769, and which was to shape politics for a generation to come.

To the established elements of the old rivalry were now added the influence of the Crown (the real private influence of George III, not the political 'influence' of Opposition legend), the floating political interest of the court, formerly attached to the old Ministry and now perhaps to be attached to the new, and the patronage of government. Years later Shelburne was supposed to have remarked that the King had possessed one art beyond any man he had ever known:

By the familiarity of his intercourse, he obtained your confidence, procured from you your opinon of different public characters, and then availed himself of the knowledge to sow dissension.[1]

In the case of the Ministry of 1782, the King had only to improve on the dissension already existing, a task made easy by Shelburne's willingness to take advantage of royal favour to strengthen his own position and weaken Rockingham's. Shelburne's conduct was to be weighed by the Whig historians of the nineteenth century in the balances of constitutional propriety and political loyalty, and in both found wanting. In fact, he was doing nothing particularly outrageous on either count. He was justified by a strict interpretation

[1] John Nicholls, *Recollections and Reflections . . .* (London, 1820–3), I, 389.

of the constitution as it then stood in claiming that the King had a right to consult a department head (himself) independent of Cabinet approval, and had no duty at all to consult the Cabinet as a body. Both he and the King were inconsistent in their doctrine, claiming a little later that Rockingham had an obligation to submit the Establishment Bill to the Cabinet before presenting it to Parliament.[1] But Rockingham, in claiming to act as the exclusive interlocutor between King and Cabinet, was claiming a privilege enjoyed by every strong eighteenth-century minister by virtue of his dominance over his colleagues, and not by virtue of constitutional mandate. Shelburne admitted that Rockingham's claim could not be resisted if he pressed it, since neither the King nor Shelburne was willing to split the Ministry on the question — at least until the heavy work of making peace was finished.[2] To Rockingham they had two answers: that tradition supported the independence of department heads, and that the Ministry was a coalition at whose birth the King had agreed to consult Shelburne equally with Rockingham on policy and patronage. Nor was Shelburne or his party guilty of personal treachery to Rockingham. The King was outrageously partial to Shelburne from the outset and particularly unfair to Rockingham, but in the situation of parties in 1782 it was not especially improper of Shelburne to take advantage of the circumstance. As Shelburne reminded Rockingham more than once, he was an independent party leader, not a subordinate Secretary of State, Rockingham's rival and only his temporary ally. Shelburne's language to the King was awkwardly obsequious, but so was his language to other people, and no more obsequious than Chatham's would have been. He and Dunning (now Lord Ashburton) were not foreswearing any of their former statements when they catered to the King on American independence and executive reform of the Household. They were less intent, in any case, on captivating the King than on securing the support of the old ministerialists and the royalist independents in Parliament.

These were now the principal floating vote and the great political prize to be seized. It was apparent that the government servants

[1] Fortescue, V, no. 3648.

[2] *Ibid.*, nos. 3699–3700. Later in the spring the King countered Rockingham's objections to Shelburne recommending Lord Cornwallis for the governorgeneralship of India by remarking that he thought the Secretary responsible for Indian affairs a more appropriate person than the First Lord of the Treasury to make the recommendation (*ibid.*, VI, no. 3786).

and party supporters of the old ministry who could decently do so would give their support to the new administration, the more readily because of the completeness of the nation's defeat and the stunning effect of North's fall. Gilbert Elliot, for example, welcomed the prospect of necessary reforms in the constitution being peacefully effected which formerly might have been accompanied by popular tumults if forced through by Opposition in the midst of war.[1] But such men could not rally to the new Ministry if the new Ministry would not have them, if it insisted on a complete change of men as well as measures. In this respect both ministerial parties were prisoners of their past utterances: the Rockinghams were pledged to reduce the influence of the Crown and regulate the whole Civil List in Parliament; Shelburne had ideas of reforming Parliament and impeaching Lord North. But Shelburne, as the weaker party, was less particular about men than measures. His net was out for the Northites.

His most useful catch was Henry Dundas. His alliance with the 'Old Party' in the East India Company in defence of Hastings and Impey led Shelburne first to conciliate, and then to make a parliamentary alliance with, the remarkable triumvirate dominating the Secret Committee — Dundas, Charles Jenkinson and Thomas Orde. Early in April he appointed Orde his undersecretary. Dundas at this time was working with Fox and Burke to bring down Hastings, and the Rockinghams might have had him for an ally. But Rockingham was ill at the critical moment, and as Burke complained, nothing was done by the party either to make the alliance with Dundas permanent or to take the initiative in making Indian policy. Burke warned that if Shelburne and Dundas came together,

> There is wherewithal in the H. of C. to form such a cabal as may shake the whole of that power, which, but a week ago, made you through the medium of the majority of that House irresistable in every other quarter. . . . What strength they may gather from rallying together the routed corps of the late Ministry, and from the secret support of the Court, you may easily guess. . . . This connection will also give the whole Kingdom of Scotland to Ld. Shelburne; and this I know he is working at; as he is indeed at everything else, indefatigably, and with great success.[2]

[1] Gilbert Elliot to Hugh Elliot, April 22, 1782, Countess of Minto, *Notes from the Minto Manuscripts* (Edinburgh, 1862), 212; cf. *Beneden Letters, London, Country and Abroad, 1753–1821* (London, 1901), 212–14.
[2] Burke to Rockingham, April 27, 1782, Fitzwilliam MSS, Burke, 1102.

At the beginning of May Orde brought Dundas over to Shelburne. The price of this valuable accession was high, not in patronage (since for the moment Dundas remained out of office) but in Shelburne's reluctant consent to throwing Hastings to the wolves of the Secret and Select Committees on East India affairs.[1]

As Burke said, Shelburne was working indefatigably at every-thing necessary to strengthen himself, and not least at controlling the disposal of patronage, the indispensable bait for attracting to him not only former Northites, but independents and even associ-ates of Rockingham as well. Among his candidates for preferment were the radical (and Foxite) Lord Surrey, his own brother-in-law, Lord Upper Ossory (also a Foxite), the independents Powys and Sir John Rous, his friends Lord Cholmondeley and Edward Eliot, and even an opponent of the Ministry, Sir Francis Basset, whom he suggested might be made Warden of the Stannaries if only he would support the government. When Lord Carlisle, friend of Fox and the recent Northite Lord Lieutenant of Ireland, was to be compensated for the loss of his office by appointment to the Lord Stewardship, Shelburne endeavoured to arrange the appointment through his own hands, though in so doing he ran into difficulties with the Northite Duke of Marlborough to whom he had committed himself. When the Irish Vice-Treasurership came vacant he hoped to secure it for Marlborough's Northite brother Lord Charles Spencer, but the Rockinghams insisted on appointing Lord Robert Spencer, another brother who was a Rockingham follower. Shelburne also played up to the old Bedford clan by taking credit for the appointment of Lord Weymouth as Groom of the Stole, though as Portland's brother-in-law, Weymouth had been proposed by the Rockinghams as well.[2]

Naturally Rockingham resented these pretensions which were threatening to nullify the victory for which he and his party had fought for nearly two decades. Early in April he demanded from the King at least the control of patronage enjoyed by North or which

<hr/>

[1] Lucy Sutherland, *East India Company*, 381–8; Burke to Rockingham, April 27, 1782, Fitzwilliam MSS, Burke 1102; Fox to Fitzpatrick, May 11, 1782, Add. MSS 47,580, fos. 113–15.

[2] Fortescue, V, nos. 3612, 3620–1, 3631, 3635, 3664–5, 3671–3, 3686–7, 3692, 3696–3702, VI, 3704–5, 3716, 3736–7, 3742–7, 3761–2, 3773, 3782–3, 3785, 3790–3; Upper Ossory to Fitzpatrick, May 3, Fox to Fitzpatrick, May 11, 1782, Add. MSS 47,579, fos. 293–4, Add. MSS 47,580, fos. 115–16; Burke to Rockingham, April 27, 1782, Fitzwilliam MSS, Burke 1102; The King to Shelburne, April 26, 1782, Rockingham to Shelburne, May 4, 1782, Bowood MSS.

he himself had had in 1765; but the King replied with a memo-
randum stating that the Ministry was a coalition whose leaders
were equally entitled to make recommendations.[1] Ill and harried
with the problems of keeping the Ministry together and passing a
large legislative programme through a potentially hostile Parlia-
ment, Rockingham did his best to prevent appointments from
passing through Shelburne's hands by making his recommenda-
tions to fill vacancies quickly and putting them before the Cabinet
where Shelburne usually backed down. But especially where
Household appointments were concerned, he was at a disadvantage.
He could not force his friends on the King, and Shelburne
generally took the line that the King's friends were his.

Under the circumstances the Rockinghams naturally regarded
his proposal that the Household be reformed by the King and not
Parliament as made only to pander to the royal sensibilities. The
Rockinghams had insisted that as a part of the latest version of
Burke's Establishment Bill the entire Civil List be reformed in
Parliament, the King's part to be confined to a royal message
surrendering authority over the Civil List to Parliament as an act
of grace and favour. Administratively it was a small point;
Parliament would merely authorise the reforms which would have
to be implemented in detail by government servants under the
direction of the Treasury. Politically it was a large one; in Opposi-
tion it had been one of the Rockinghams' 'measures' that influence
of the Crown must be reduced by Parliament. But it was not only
consistency that demanded that matters be arranged in this way.
The Rockinghams must show that as a Ministry they were able to
make a stand against the King; they must use this opportunity (a
fleeting one, if the narrow margin by which North had fallen, the
thin Houses which supported them during the spring, and the
divisions in their own ranks were any indication) to reduce the
great general fund of influence and eliminate all special reservoirs
of *royal* influence that might be hidden in the Civil Government or
the Household. Once influence was reduced the details could be
left to be implemented by such cranks as Thomas Gilbert or any-
one else who cared for the complexities of administration.

But even in early April Burke was writing prophetically:

The next contrivance is to keep the reform wholly out of Parliament
upon a pretence that it may be done by the Crown. If it could, it

[1] *Ibid.*, V, nos. 3726–8, 3632, 3637–9.

ought not. . . . No effectual part of the reform can take place, but in Parliament. . . .[1]

The King, like an experienced campaigner, brought his defence forward by stages. He may genuinely have been surprised that Rockingham intended to reform the whole Civil List by Act of Parliament and not permit him to reform the Household himself, though in view of the ample warnings he had had over the preceding years such surprise must probably be accounted the opening manoeuvre to force concessions out of Rockingham. On the morning of April 12, just before the Cabinet was to meet on the Establishment Bill, he complained that he had hitherto believed that reforms in the Household would be settled by 'interior regulations' and accused Rockingham of having changed his tune since the Ministry was formed. He also remarked to Shelburne that it had been only with the greatest difficulty that he had prevailed on Rockingham to submit the Establishment Bill to the Cabinet before presenting it to Parliament. He wanted Shelburne to resist the suggestion of a royal message to introduce the bill, and to insist that the Cabinet should be unanimous on the bill before presenting it. His objections to the details of the reform were a characteristic mixture of the frivolous and cogent: the Master of the Robes must not be suppressed 'because he has the peculiar employment of carrying my train in the House of Peers as well as all Ceremonies of the Garter'; the royal table ought not to be furnished by contract; the officers of the Household ought not to be deprived of ready money since it would be inconvenient to have to apply to the Exchequer for it when quick payments had to be made.[2] In reply Rockingham pleaded that the King had already agreed to the plan of reform as one of the conditions on which the Ministry took office and that he could not get unanimity nor even general agreement on it from the Cabinet.[3] Thurlow was hostile to the plan, Shelburne, according to Fox, seemed 'more *bothered* about it than anything else and does not seem to understand it' (a good description of Shelburne's smoke-screen in the face of opposition), and Camden, Conway and Grafton were reluctant to insist on a public reform of the Household. The remaining five members of the Cabinet did insist on it, not on Burke's ground that

[1] *Correspondence of Edmund Burke*, ed. Earl Fitzwilliam and Sir Richard Bourke (London, 1844), II, 467.

[2] King to Shelburne, April 12, 1782, Fortescue, V, no. 3648.

[3] Same to same, April 13, 1782, Bowood MSS.

it was necessary for eliminating influence, but on the ground that it would be quicker than allowing the King to reform the Household and time was important if they were to publish the plan to Parliament and show that they were really in earnest about reform. After some wrangling they all agreed that the King should first authorise the abolition of all the offices objected to, and that then Parliament should approve the abolition, order that the offices should not be revived and regulate appropriations to the Civil List.[1]

There was more jockeying when the message was presented to Parliament. Fox in the Commons appealed to the gentry to stay in town and support the reform which the King had so graciously invited them to make. Shelburne, who presented the message in the Lords in spite of Fox's efforts to prevent him, lavished extravagant praise on the King for the generosity of his message and spoke as though he was presenting his own reform plan, modelled not on Burke's bill, but on the recommendations of the Commissioners for Examining Accounts.[2] Seizing the initiative next day, he suggested to the King that he require a statement from Rockingham of the alterations to be made in the Household, together with expert estimates of the present and future establishments and their costs.

> Whoever has to explain these details to the House of Commons [he remarked] can easily put them on paper for Your Majesty's consideration and Your Majesty may refer them afterwards to the Cabinet.[3]

This was cutting the ground out from under Rockingham, Burke and Fox who had no such estimates ready and no time to see that they were prepared. They had counted on Burke's original procedure being followed: Parliament would give approval to general reforms, the details of which (though Burke had estimated the savings roughly) would be worked out at leisure after they had passed their measure through Parliament and got the credit for it. Burke's concentration upon the political effects of his plan had prevented him or his friends from seeing its shortcomings as a piece of legislation. Shelburne's suggestion opened up a whole Pandora's box of criticism. Was it wise, asked Ashburton, to limit the pension list to a definite sum thus making pensions, like places,

[1] Fox to Fitzpatrick, April 12 [April 13], 1782, Add. MSS 47,580, fos. 73, 79–80.
[2] *Parliamentary History*, XXII, 1269–75; Fortescue, V, nos. 3607–8.
[3] April 16, 1782, Bowood MSS [misdated April 17 in Fortescue, V, no. 3665].

a matter of solicitation and waiting lists and thus preventing the
sovereign from rewarding genuine merit? The original purpose of
the limitation — stopping corruption — had been accomplished
by making the pension list public. Had the Ministry increased the
establishment of clerks in the Privy Council office to take care of
the colonial business transferred from the suppressed offices of the
Third Secretary and the Board of Trade? enquired the King.
Could not the redundant messengers in the Chamberlain's office
be used by the Secretaries of State? Would it not be a saving to
put the Captain of Gentlemen Pensioners on salary rather than
allow him to continue to mulct his Band of fees? None of these and
many other details had occurred to Burke in his fever to reduce
influence. Shelburne suggested that the King insist that the bill be
prepared by the Law Officers and reviewed by the law lords in the
Cabinet before it was presented to Parliament.[1] The Rockinghams
resisted or conformed to the criticisms as necessity dictated but
refused to take the drafting out of Burke's hands. Burke, under
pressure, gave up the clauses providing for supplying the King's
table by contract, the regulation of the Crown Lands in Wales,
reform of the Ordnance, reform of the Mint, and the abolition of the
offices of Treasurer and Cofferer of the Household. Even then his
friends were uncomfortably aware of the inaccuracies in the
truncated remnant, and of the fact that the Session was drawing to a
close before they had the bill ready. For both these reasons they
hurried it through the Commons rather shamefacedly, giving
awkward and unconvincing explanations to their followers as to
why the glory of economical reform which had seemed so radiant
in the spring, had departed so completely by midsummer.[2] The
bill's defects were left to be corrected under the Treasury's
authority; but by the time it had received royal assent Shelburne's
Treasury that was charged with the task of implementing it.

The Ministry showed no greater unity in their reform of the
civil government. The habits of fifteen years in Opposition died
hard, and at first they approached the question armed with the old
stereotypes of reducing influence and securing economy. In debate
on the Army Extraordinaries, Barré still described commissaries as
'so many cormorants preying upon the vitals of this country', and
Camden and Shelburne, when challenged by Thurlow to prove

[1] Fortescue, V, nos. 3676-7, 3690, 3692, 3698, VI, 3704-5, 3729; King to
Shelburne, April 24, 1782, Bowood MSS.
[2] *Parliamentary History*, XXIII, 122-7, Fortescue, VI, nos. 3792-3.

that contractors had helped to corrupt Parliament, still repeated that the fact was 'notorious' and that the high style in which the contractors were known to live was proof enough.[1] But they were capable of denying their former selves as well. There was now dawning among them the realisation of how misinformed had been their former hypotheses of limitless pension lists and enormous corrupt contracts. They were acutely uncomfortable when their old ally Sawbridge launched into a diatribe against the last-minute grant of a pension by North's ministry to John Robinson. Such a pursuit of one who, as North pointed out, had amply earned his pension, was not likely to endear the new Ministry to the government servants upon whom they now had to depend, and Fox hastened to dissipate the effect of it by enlarging its scope to include a general enquiry into the disastrous mismanagement of the war. In addition, the politic sympathy which, as leaders of a great party, Rockingham and his friends showed toward the small-fry in office operated to ensure that reforms which they did undertake caused as little inconvenience and created as few enemies for the Ministry as possible.

> It is not necessary at this moment [Rockingham wrote in advising Shelburne to be merciful in breaking the news to peers and M.P.'s who had been removed from their offices] the *under officers* in their offices should be instantly dismissed. It is an unpleasant task, and tho' on changes of *men and measures* numerous dismissals always ensued — yet as these vacancies were *filled up* by other persons, there were as *many* pleased with the coming in as there were *displeased* with being turned out.[2]

This was political wisdom that Shelburne was only beginning to appreciate. At the Home office his determination to remodel the administration brought him a good deal of unpopularity among his subordinates,[3] but did result in one major reform measure — to suppress absenteeism among the officers, sinecurist and active, in the governments of the West Indies. All the colonies had patent sinecurists on their establishments, but only in the West Indies were the fees large enough to support the sinecurists *in absentia* throughout their official careers. The same difficulties which were operative in the administration of the home government — the

[1] *Parliamentary History*, XXII, 1344–50, 1368–9, 1376.
[2] Rockingham to Shelburne, April 30, 1782, Bowood MSS; cf. *Parliamentary History*, XXII, 1346–9, 1377–82, XXIII, 74–5.
[3] Cf. William Knox, *Extra-Official State Papers*, 1–16.

lack of an alternative salaried establishment and the freehold
sanctity of patents — stood in the way of reform here. Samuel
Estwick, West Indies planter, agent for Barbadoes and Lord
Abingdon's Member for Westbury, drew Shelburne's attention to
the abuse by complaining of the excessive fees being collected by
Governor Cunningham of Barbadoes. Shelburne recalled the
governor and in conformity with his prejudices in favour of
popular control of administration and of enlarging the ambit of
colonial legislatures wherever possible, encouraged the Barbadoes
Assembly to prepare an act regulating fees which, he assured them,
would be favourably received at home. Meanwhile he ordered
Estwick to prepare a survey of the patent offices in the West Indies.

According to Estwick's report, since 1763 the increasing
centralisation of West Indies' administration in the hands of the
home government had brought with it a rapid increase in the
number and influence of sinecure absentee placeholders for whose
support the colonies were taxed double and sometimes more than
double. Abuses which had a legal or political remedy in the mother
country, multiplied unhindered Beyond the Line. The Secretary of
South Carolina was the widow of a former Secretary of the
Treasury, the Secretary and Clerk of the Courts for the Leeward
Islands were the infant heirs of another beneficiary of government
gratitude, and the reversion of this post was held by the heir of a
former Speaker and then by the son of a former Lord of the
Treasury. The Register in Chancery of Barbadoes was George
Augustus Selwyn.

> The laws of the islands [wrote Estwick] do not remedy the abuses
> because the interest of the collective body of the patent officers here
> is greater than the united interest of all the suffering inhabitants of all
> the islands put together. Governors go out with instructions to protect
> the interest of the patentees. Bills upon bills have passed the councils
> and assemblies in remedy of the abuses complained of, and as often,
> under the instructions of governors have been rejected. Sometimes
> indeed under the administration of upright governors they have passed
> into laws, but no sooner have they reached this country, for the con-
> firmation of the Crown, than the overbearing interests of the patentees
> have buried them in oblivion.[1]

[1] Samuel Estwick to Shelburne, June 13, 1782, 'Notes on West Indies Patent
Offices', 'List of Officers of the Colonies residing in Great Britain', 'List of Civil
and Naval Officers in the West Indies with a List of their Salaries', Shelburne
Papers, vol. 67, fos. 267–85.

It was a situation which to the new Ministry seemed to justify every one of their attacks on the colonial policy of their predecessors. That way, but for their superior resolution in resisting the tyranny of the mother country, would have gone the Americans. Concern not only for honesty, efficiency and economy, but also for the good name of Britain, and especially of the Ministry, demanded that such infamy should not be perpetuated. Shelburne's remedy was an act (22 George III, c. 75) to require patentees to reside and perform their duties in person in the colonies unless granted leave of absence by the governors. But in tribute to the freehold prejudice he was forced to exempt existing patentees from its operation, and these, put on their metal, soon contrived to render it nugatory for the future. The Coalition refused to allow the Barbadoes legislature to regulate fees, appointments to offices were soon being made by Sign Manual in order to evade Shelburne's Act, and Secretaries of State adopted the practice of ordering governors to allow influential patentees to go on prolonged leaves of absence. Soon the situation was as bad as ever and no permanent correction was made until after the turn of the century, when the Commons Select Committees on Expenditure eventually forced the Colonial Office to take action.[1]

If the disputes within the Ministry over economical reform were greater than might have been expected, those over parliamentary reform were much less. This was because moderates and conservatives drew together in the face of the pressures put on the Ministry by the metropolitan radicals; Shelburne in search of allies, and Rockingham and his friends in their anxiety to keep the Ministry together, were both unexpectedly conciliatory.

At the accession of the Ministry the parliamentary reformers, according to their positions, had prepared to support a reforming ministry or force reform on a reluctant one. The Yorkshire Committee on April 4 decided to postpone their appeal to Parliament until the next Session, both because it was now too late in the season to canvass Yorkshire and because they were willing to give the new ministry time to find its feet.[2] The metropolitan radicals, on the other hand, were more determined than ever to press

[1] J. H. Parry, 'The Patent Offices in the British West Indies', *E.H.R.*, vol. 69 (1954), 200–25; cf. *Parliamentary History*, XXIII, 135–9. Estwick was rewarded by Shelburne for his work with the places of Secretary and Register of Chelsea Hospital and the sinecure Searcher of Customs for Antigua.
[2] *Wyvill Papers*, IV, 158–68.

forward. In December 1781 the committees of the five metro-
politan constituencies — the City, the Borough, Westminster,
Middlesex and Surrey — had come together under Townsend's
chairmanship in a Quintuple Alliance, a parliamentary pressure
group designed as an extension of the Westminster Committee and
a permanent substitute for the cumbersome General Assembly of
Deputies.[1] Wyvill understandably condemned this concentration
of his rivals as:

> likely to create disgust and alarm, from the natural tendency of such
> prodigious assemblies to confusion and violence; and from the want
> of any limitation of the nature of a compromise in the Plan of
> Association respecting a Reform in the Representation.

The Alliance, for their part, condemned Yorkshire's quiescence
during the spring, arguing that they now had the best possible
opportunity of forcing the Ministry to concede reform,

> ... but when delay shows to them and to the Court that we may be
> safely put off, they may delay forever ... and in the meantime those
> who are most our friends in the Ministry by delay will be put out of
> countenance in their requests in our favour.

As a concession, however, Wyvill agreed, when it was too late to
interfere with his plans for the season, to attend a conference with
Townsend, Jebb, Horne Tooke and Samuel Vaughan at which
they agreed to co-operate during the coming Session in support of the
Yorkshire programme with the abolition of rotten boroughs added.[2]
Meanwhile Shelburne and his friends took up the initiative in
Parliament. In January at Bowood with Barré, Dunning and Pitt,
he had prepared a parliamentary motion embodying the demands
for shorter parliaments, addition to the county representation and
the abolition of rotten boroughs.[3] He had very little hope that
Parliament would adopt it, but the news of his intentions would
strengthen his popularity with the reformers, and indeed it helped
to give Townsend a triumph in the City in April over Sawbridge
and Wilkes.[4] With this proposal Shelburne associated his militia
scheme, portentously named 'A Bill for Arming the People'. The

[1] *London Courant*, December 6, 18, 1781, January 8, March 13, 1782.
[2] *Wyvill Papers*, IV, 158–63, 168–9 footnote, 363 footnote.
[3] Shelburne to Camden, January 26, 1783, Bowood MSS.
[4] 'Six weeks ago he had not the slightest degree of power in the Corporation of
London. At present he is master of it; and Sawbridge is by no means able to
resist him' (Burke to Rockingham, April 27, 1782, Fitzwilliam MSS, Burke
1102).

expiration of North's Militia Act gave the new government the opportunity of replacing what they had condemned as influence and the threat of standing armies with 'the free association of citizens in defence of their country'. Shelburne and the reformers intended that it should be an armed force raised by local efforts, at local expense and under the command of locally-elected officers which might back their cause after the example of the Irish Volunteers. But the country gentry and the leaders in the smaller boroughs were alarmed at the idea of arming the populace and even more alarmed at the thought of bearing the cost of it. Only the City and a few of the larger towns showed any willingness to support the proposal.[1]

But Shelburne was not alone in the Cabinet in support of some measure of parliamentary reform; Fox was egging on his followers in Westminster, and Richmond had stipulated as a condition of his taking office that a parliamentary committee should be appointed to examine the whole question of parliamentary reform. Rockingham had the choice of accepting this moderate demand or seeing Richmond unite with Shelburne in support of much more immoderate ones. Richmond's condition was reluctantly agreed to at a meeting of the Rockinghams on April 30, and after some negotiations with Shelburne, Pitt presented a motion on May 7, asking for the committee but pointedly disclaiming advocacy of any particular mode of reform. In the course of the debate Fox seemed determined to ignore his quondam allies among the radicals and promote the interests of the Rockinghams. To put Shelburne in his place he lavished praise on Richmond as 'the most able man to carry a reform', and made it clear that he would not challenge the right of anyone in a rotten borough, but could support only an addition to the purest part of the representation, the county Members, and a more equal representation so that Middlesex in particular might be fairly represented. But even this unaccustomed moderation was not enough to counterbalance the force of Thomas Pitt's argument that as the unreformed House of Commons represented independent property in battle with 'influence', it should not be weakened

[1] 'Outline of the Militia Proposal', 'Right of the People to Arm', 'Extracts of Comments of Cities and Towns on the Militia Plan', Conway to Shelburne, June 3, 1782, Shelburne Papers, vol. 136; Mahon to Shelburne, August 4, Duke of Newcastle to Thomas Townshend, September 12, 1782, Lacaita-Shelburne Papers, vol. II; Circulars to Towns on the Militia Proposal and Answers to the Circulars, H.O. 42/1, 205; King to Shelburne, May 12, 1782, Bowood MSS; *General Advertizer*, May 11, 21, June 5, 15, 20, 26, 1782.

by 'opening a shop to receive all the projects of the wildest projectors'.[1] The motion was defeated by 161 to 141.

It represented a remarkable effort, the best for a generation. Lord John Cavendish, Edward Eliot and other conservatives had been persuaded to vote in the minority. But it fell far short of the expectations of the reformers. Richmond threatened to desert the Ministry unless the committee was appointed and tried to pin Shelburne down to support him; and Fox characterised the defeat of the motion as the prelude to the revival of royal influence.[2] The parliamentary campaign was not quite over. Sawbridge's annual motion met its annual defeat. Three bills of Lord Mahon to prevent bribery and provide a moveable poll and an electoral register in each constituency were rejected after a debate in which Fox picked a quarrel with Pitt and made a stirring defence of the intimate relationship between the elector and elected that in his opinion was threatened by the bills.[3] Then the tide of debate rolled on, and parliamentary reform was put aside for yet another season.

* * * *

The bitterest of the Ministry's divisions and that by which its effectiveness was finally destroyed arose from the peace negotiations. Both the Rockinghams and Shelburne approached the negotiations with America in a highly unrealistic frame of mind, an unreality whose effects were aggravated by their disputes. Their fixations about the essential friendliness of Americans and the community of interest between the two peoples had yielded not at all to the march of events. They still imagined that Britain had only to make some generous gesture of repentance to bring the Americans back, if not to dependent status, at least to some sort of federal alliance with strong commercial ties. When Benjamin Franklin in Paris discovered that his frequent denials of this proposition made no impression on British liberals who could not understand that their own goodwill toward America would not be reciprocated, he fashioned this illusion into a most effective diplomatic lever.

[1] Richmond to Rockingham, May 11, 1782, *Rockingham Memoirs*, II, 481; Add. MSS 27,918, fo. 71; *Leeds Memoranda*, 67–8; *Parliamentary History*, XXII, 1416–38.
[2] Richmond to Rockingham, May 11, 1782, *Rockingham Memoirs*, II, 481–5; Shelburne to the King, May 13, 1782, Fortescue, VI, no. 3735; Fox to Fitzpatrick, May 11, 1782, *Memorials of Fox*, I, 322.
[3] *Parliamentary History*, XXIII, 45–57, 101–9.

He was also helped by Shelburne's ambitions. Convinced that in the American negotiations lay one of the keys to the future domination of the Ministry, Shelburne hastened to make his entrance into them through a chain of personal acquaintanceships. An agent of the Treasury named Digges had reported recently to North's Ministry that John Adams was dissatisfied with the French Alliance and wanted to make a separate peace for America. The report was apparently confirmed by the dispatches of Henry Laurens, the recently captured American commissioner-designate to the Netherlands. Benjamin Vaughan, son of Samuel Vaughan of the Quintuple Alliance, in the self-appointed role of diplomatic adviser to Shelburne, persuaded his patron to send Laurens under parole to sound out Adams. Shelburne arranged that his old acquaintance and Laurens's former trading partner, Richard Oswald of Auchencruive, should accompany Laurens to the Continent and make contact with Franklin. Oswald, in his seventy-seventh year,[1] was rather simple-minded and wholly unversed in diplomacy, but it was intended that he should merely give the appearance of negotiating with Franklin while Laurens carried on the important conversations with Adams. It was not expected that Oswald should accomplish anything, and his choice was determined by the fact that he was acceptable to Laurens as a travelling companion.[2]

But while Shelburne was arranging this mission he received, on April 5, a letter from Franklin expressing his hope that negotiations would be opened. This put a new face on the mission. Shelburne could not hope to keep the arrangements entirely to himself since it was necessary to get passports for the envoys from Fox at the Foreign Office. Rockingham suggested that either David Hartley, former Member for Hull and one of his own supporters, or William Hodgson, a London merchant, would be more appropriate negotiators than Oswald. But Shelburne, determined not to lose his small foothold in what was likely to be the key measure of the Ministry, insisted on Oswald, and Rockingham gave way.[3] From his anxiety not to be left out of the negotiations Shelburne became committed to Oswald, with increasingly embarrassing results both for himself and the country.

[1] (1705–1784).
[2] Vaughan to Shelburne, April 4, 1782, Shelburne Papers, vol. 72, fo. 261; *London Courant*, October 1, 1782.
[3] Fortescue, VI, nos. 3611, 3613, 3631, 3635; Rockingham to Shelburne [April 1782], Bowood MSS.

He put the best face on the dispatch of this Boanerges, describing him to Franklin as:

> . . . a practical man, and conversant in those negotiations which are most interesting to mankind. This made me prefer him to any of our speculative friends, or to any person of high rank.

Franklin was delighted; much might be done with Oswald. By the end of the first week of negotiations he had convinced Oswald by oblique hints that though the Americans were not supposed to treat separately from their allies, Franklin might be able to stretch a point if Britain showed her goodwill by ceding Canada to the United States. As the plan unfolded, Oswald found himself more and more convinced that this was the key to peace. If Canada was ceded, the Americans, preoccupied with that inland expansion which colonial theorists in the 1760's had hypothesised, would forget about developing native manufactures to compete with those of Britain. As Franklin suggested, Congress might pay the American claims for damages from the late war from Canadian land sales, might even pay the claims of the American loyalists as well. Oswald begged to be allowed to take a memorandum on the subject back to Shelburne. Franklin graciously consented.

Meanwhile the principal dove had returned empty-beaked to the Ark. Laurens had been brought to his senses by Adams, and explained that a separate peace was out of the question.[1] If Shelburne was to keep his stake in the negotiations everything now depended on Oswald. Unless he brought good news the negotiation must be broken off, to begin again probably through the Foreign Office, where Fox was engaged in tortuous manoeuvres with Catherine the Great and Frederick the Great to secure some sort of joint mediation in return for British recognition of the principles of the Armed Neutrality.

Oswald's return was hardly the triumph for which Shelburne had hoped. The Canada Paper was ridiculous and Shelburne rejected it out of hand, making the counter-proposal that the United States should compensate Britain for surrendering New York, Charleston and Savannah. There was no reason that these unofficial bargainings should be made public, and Shelburne neglected to inform his colleagues of them. Incapable or not, Oswald was now Shelburne's stake in the peace negotiations and

[1] Fortescue, V, no. 3686.

could not be got rid of. At a Cabinet on April 23 Shelburne was able to persuade his colleagues to send Oswald back to arrange with Franklin the time and place of the official negotiations, and to suggest as terms the recognition of American independence, subject to a general peace with all the allies being signed, and the restoration to Britain of the territorial position she had enjoyed by the Treaty of Paris in 1763. Fox was to send an envoy to make a similar offer to Vergennes.[1]

Thus the negotiations were split between the two Secretaries. Fox's mercurial temperament at first allowed him to be optimistic that either Shelburne would co-operate and subordinate himself to the Rockinghams' 'system', or that he could be overborne in the Cabinet. In this he was influenced by Grafton, who always hoped that his friends would agree, and by Richmond, who found Shelburne a congenial ally on reform questions and could not help but agree with many of Shelburne's criticisms of Rockingham. By the end of April, when it became apparent that Shelburne had horned into the peace negotiations and Fox was interfering in Shelburne's negotiations for conceding legislative independence to Ireland, the relations between the two Secretaries had become a constant squabble. But it was a squabble between rival politicians, and not a quarrel over purposes. Some of Fox's friends, notably his new negotiator Thomas Grenville, believed that the Americans could be persuaded more quickly to desert the French alliance if Britain showed her goodwill by recognising independence unconditionally; but Fox himself at this point agreed with Shelburne in regarding recognition as a bargaining counter to separate America from her allies and perhaps ultimately reunite her with Britain in a federal union.[2] Shelburne has been pictured as the lone liberal champion of the idea of federal union.[3] But the truth is that it was a popular idea among the members of the new Ministry in the spring of 1782 and by no means peculiar to Shelburne.[4]

Oswald went back to Paris thoroughly briefed with Shelburne's hopes of federal reunion and British trade dominance in America, and instructed to demand separate negotiations. He was followed shortly by Thomas Grenville, who had been instructed to secure

[1] Shelburne to the King, April 26, Cabinet Minute, April 23 (misdated April 25) enclosed, Fortescue, V, no. 3687; Add. MSS 47,559, fos. 9–10; Fitzmaurice, *op. cit.*, II, 128.
[2] Fox to the King, May 18, 1782, Fortescue, VI, no. 3757; *Memorials of Fox*, I, 360.
[3] Harlow, *op. cit.*, 251. [4] Cf. *General Advertizer*, June 14, 1782.

the *status quo* of 1763 from the French as the price of British recognition of American independence. Not surprisingly Vergennes refused to consider separate negotiations and refused to receive Grenville officially until he had full powers to conduct a negotiation with all the allies. More and more the negotiations fell into the nerveless hands of Oswald.

He returned to London on May 21 with the news that Franklin seemed to be weakening on the question of a separate peace. At that moment the Cabinet was considering stiffening the British terms as the result of the news of Rodney's great victory at the Saintes. Shelburne's reaction was to hold even more firmly to his line of making the recognition of American independence conditional upon a general peace, but Fox decided that now was the time to recognise independence unconditionally and thus persuade the Americans to make a separate peace. On May 23 the Cabinet decided on a compromise. Grenville would be ordered to inform Vergennes that Britain was ready to recognise American independence in the first instance, and not as a condition of a general treaty. But Grenville was not to be sole negotiator. Oswald was to return at Franklin's request to negotiate with the Americans.[1] In a thorough briefing at which Shelburne thought it necessary to have Ashburton present as a witness, Oswald was impressed with the importance of making independence the condition of a general treaty and not granting it in the first instance. Apart from the diplomatic advantage it would give, such a position would keep the discussions in Shelburne's hands as Secretary for colonial affairs. The Cabinet's supposed compromise had resulted in sending two negotiators with contradictory sets of instructions, designed to separate allies who refused to be separated.

Oswald soon revealed his instructions to Grenville who complained to Fox, adding that he believed that his own lack of success with Franklin had been due to Oswald's presence in Paris. Fox wanted proof of Shelburne's duplicity to lay before the Cabinet, but this Grenville could not or would not give. Meanwhile Franklin, who had no intention of making a separate peace and had seen the terms for America improving steadily from the quarrels of the British Cabinet, continued his discussions with Oswald, while the inadequately-credentialled Grenville kicked his

[1] Fortescue, VI, nos. 3757, 3771; *Memorials of Fox*, I, 357. Richmond and Camden were absent which reduced the voting in the Cabinet to four a side with Conway holding the balance.

heels in Paris and pleaded with Fox to be recalled.[1] By the time the
Enabling Act authorising official negotiations with America was
passed on June 19, Oswald's (and Shelburne's) position was
impregnable. On June 20 the Cabinet authorised a commission for
Oswald to treat with the Americans without any mention of
Grenville in it.[2]

Fox grudgingly agreed that Grenville's name must be left out,
but the decision left him with control only of the sterile negotia-
tions with Vergennes. He apparently delayed sending instructions
to Grenville announcing the new arrangements and at a Cabinet
meeting on June 26 revived the question. He demanded, not the
recognition of Grenville as negotiator-in-chief, but the recognition
of American independence in the first instance. This was merely
clarifying the Cabinet minute of May 23, a clarification that would
get rid, once and for all, of Shelburne's point of making indepen-
dence conditional on the general settlement. Fox chose this,
rather than the defence of Grenville, because he knew that it would
have the support of Richmond who had been acting as interlocutor
between the parties, and because it was asking the Cabinet merely
to confirm something they had decided already. But conditions
had changed since May. The negotiations with Franklin seemed to
be going well without a complete surrender of independence, and
the majority decided against Fox.[3] Even the Cabinet's agreement
(over Shelburne's objections)[4] to offer Catherine the Great a
private British adherence to the principles of the Armed Neutrality
in the hope that this would persuade her to mediate, was no
compensation for Fox.[5] The effective negotiations were already
started, they were in Shelburne's hands, and there was not the
slightest likelihood that Fox, through the mediation of the
Northern Powers, could recover control of them. As he left the
meeting he informed Richmond, Cavendish and Conway that he
intended to resign. On the 28th he complained to Grafton that the
Cabinet was obstructing him, but that he would not write to
Grenville until he had given them one more chance to change their

[1] *Memorials of Fox*, I, 358-82.
[2] Fortescue, VI, nos. 3807-8, 3813-14, 3818.
[3] In the absence of Rockingham and Camden the division was probably: for:
Fox, Cavendish, Keppel and Richmond; against: Shelburne, Ashburton,
Grafton, Thurlow and Conway.
[4] Shelburne later told Bentham that he had wanted to offer adherence to the
Armed Neutrality, but as the price of mediation (U.C.L., Bentham Papers,
Box IX, fo. 92).
[5] Fortescue, VI, nos. 3821-2.

minds. On June 30 Fox called another Cabinet at his house. Again the question of the unconditional recognition of American independence was put before them, and again the vote went against Fox, though the majority tried to straddle the issue by agreeing to the formula that the general treaty should accompany the acknowledgement of independence and it was advisable that independence should be acknowledged in the first instance as the basis to treat on.[1] Fox then announced to his friends that he would resign from the Cabinet as soon as Rockingham was well enough to deal with the matter.

But Rockingham's refereeing days were over. He had been ill on and off since taking office and was out of action for a week early in May. He seemed to recover, but the quarrels of his colleagues and the burdens of office dragged him down. On June 23 he fell seriously ill. By the 28th his condition seemed desperate and Shelburne was discussing future ministerial arrangements with Pitt and Charles Jenkinson 'whose assistance I wish for sooner or later in my government'. He hoped to keep the support of the Rockinghams, but asked the King to consider 'the weight which Your Majesty should think it proper to give Mr. Fox in case of any new arrangement'.[2] The next day Rockingham rallied and Fox spread the glad tidings. But it was a false dawn, and at noon on July 1 Rockingham died. The way was clear for Shelburne, but the last thread that held the Ministry together had parted.

[1] *Grafton Autobiography*, 321–3; *Memorials of Fox*, I, 438–9; Thomas Pelham the Younger to Thomas Pelham the Elder, July 14, 1782, Add. MSS 33,128, fo. 83. Shelburne reported only that the Cabinet had come to no final resolution on the question of independence (Fortescue, VI, no. 3824).

[2] Fortescue, VI, nos. 3824–5; Fox to Portland, June 29, 1782, Add. MSS 47,561, fo. 39.

Reform of the Civil List

The fate of Shelburne's government was determined by the event which gave it birth — the death of the Marquess of Rockingham. Had Rockingham died earlier, Shelburne's acceptance of the premiership (for there seems no doubt that he was determined not to take second place again) must have been followed by a repetition of the Bath-Granville fiasco of the spring of 1746. The Phalanx would have closed ranks behind Richmond, Portland or Fox — or more probably all three — and Shelburne's careful preparations to build a party from dissident Rockinghams and old ministerialists would have collapsed ignominiously. Pitt would probably have made terms with the Rockinghams and Dundas would have returned to North, leaving Shelburne and his personal following more isolated than ever. Had Rockingham lived until autumn Shelburne might have been firmly placed in power. His party was growing, particularly from recruits among the independents and Northites, and he had won the struggle with Fox in the Cabinet, from which the latter was on the point of resigning. Richmond was working well with Shelburne, and together their popularity with the reformers was beating Fox on his own home ground. The Quintuple Alliance was dominated by Shelburne's friends, and even in Westminster Richmond was regarded as the reformer from whom most was to be expected. By autumn Shelburne would have been in a much stronger position, and the inevitable breach with the Phalanx, had it come when Parliament was just beginning the Session, would probably have worked more to his advantage than to Fox's. The Coalition, had it been formed at all, would have been much weaker than it was, and many of the reformers who were later to drift over to Pitt's ministry, would have supported Shelburne. But Rockingham died on July 1, and Shelburne took what, under the circumstances, was probably the only opportunity he would ever have to form a ministry.

He left it to the King to break the news to his colleagues, while he made arrangements to fill the vacancies created by his own elevation and the anticipated resignations of Fox and his friends. In the event these last were much fewer than he expected. To the Rockinghams the death of their leader was an unmitigated disaster. They knew that North and his followers were recovering and were still powerful in the House of Commons; they knew that Shelburne had been strengthening his own following and had the ear of the King; they felt power being snatched from them after only four months, and sensed the revival under Shelburne's leadership of that 'system' that had kept them in Opposition for so long. To argue, as Shelburne's defenders were to argue, that he did not support any system of royal authority or influence, and was a better reformer than many of the Rockinghams, was beside the point. Shelburne supported the 'system' as North supported the 'system', and as Chatham in the 1760's supported the 'system'. What kept the Rockinghams out of power was the 'system'.

> To think [wrote Burke to Loughborough] that all the labours of his (Rockingham's) life, and that all the labours of my life, should in the very moment of success produce nothing better than the delivering of the Kingdom into the hands of the E. of Shelburne, the very thing (I am free to say to you and to everybody) the toils of a life ten times longer and ten times more important than mine would have been well employed to prevent.[1]

But many of them were hopeful that disaster could be averted. Perhaps they might be able to defeat Shelburne, or perhaps Shelburne might not be as bad as Fox was painting him. Fox, having already blundered in the Cabinet of June 30, continued to play his hand badly. Not sure whether or not to resign, he reassured the House on July 2, during the debate on the West Indies Patents Bill, that Shelburne had given up any idea of resisting American independence.[2] Burke was reluctant to resign and urged that the Rockinghams could do more to combat Shelburne by staying inside the Ministry, at least until Parliament could be appealed to in the autumn, than by going out. In the meantime they ought to try to persuade the King to appoint Fox or Richmond to the

[1] July 17, 1782, Fitzwilliam MSS, Bk. 1170; cf. Burgoyne to Fox, July 5, 1782, Add. MSS 47,568, fos. 101–2, for a similar reaction from Portland.
[2] *Parliamentary History*, XXIII, 135–9.

premiership.[1] But Fox, from his knowledge of the Westminster electorate and his experience in Opposition, was convinced that he must dramatise his quarrel as a difference of principle; and this meant that he must resign and explain his sacrifice as the effect of Shelburne's refusal to recognise American independence. Perhaps most of the Ministry might be persuaded to resign under popular pressure. Burke had suggested as much to him.

> If this country is really to all intents a monarchy, where everything is decided by factious manoeuvres of the Closet, you must consider Parliament as only a sort of auxiliary to give you preponderance over your colleagues.[2]

Shelburne took the public position that since the King had exercised his just prerogative in asking him to form a government, he, Shelburne, would not be dictated to by the Phalanx, but would stand firm in office, secure peace and promote reform.[3] Most of his colleagues found no fault with this. Richmond, screwed up to believing in Shelburne's treachery on the night of July 3, swung back on the 4th after Fox resigned and Shelburne had reassured him as to his intentions with respect to American independence and reform. This saved the Ministry. Keppel, who wanted to bring the naval war to a victorious conclusion, decided to stay when Richmond's decision gave him an excuse to do so; Conway made a similar decision. Of the Cabinet, only Cavendish joined Fox. Burke, after trying to secure the Receivership of the Crown Land Revenues for Essex for his son and the Reverend Walker King, resigned and tried to pry the Clerkship of the Pells out of the Walpole family.[4]

The vacancies were filled without much difficulty. Thomas Townshend went to the Home Office and was succeeded at the War Office by Sir George Yonge; Lord Grantham, whose principal qualifications were that he had been an ambassador and President of the Board of Trade and had no enemies, succeeded Fox at the

[1] Add. MSS 47,568, fos. 103–5.

[2] *Ibid.*; cf. Fox to Portland, July 12, 1782, Add. MSS 47,561, fos. 43–4.

[3] Shelburne to Marlborough, July 8, 1782, Add. MSS 34,418, fo. 484; *Leeds Memoranda,* 70, 72; Duke of Buckingham, *Memoirs of the Court and Cabinets of George III* (London, 1852), I, 51.

[4] Thomas Townshend to Burke, July 4, Pitt to Burke, November 7, Burke to Pitt [November 1782], Fitzwilliam MSS, Burke 1161, 1199, 1200; Walpole, *Last Journals,* II, 453–6. Burke resigned on July 8. Five days later he wrote to Fitzwilliam: 'from S. I am sure I never should have requested nor even accepted anything' (*ibid.,* Burke 424N).

Foreign Office. Barré replaced Burke at the Pay Office and was succeeded by Dundas as Treasurer of the Navy. The one difficulty arose over the Exchequer. James Grenville refused it, 'Single-Speech' Hamilton preferred a sinecure; finally Shelburne persuaded the King to take a risk for the sake of giving the Ministry some debating strength in the Commons, and William Pitt, rising twenty-three, was appointed.[1]

Beyond the limits of the Ministry Shelburne marshalled support among the independents and Northites. Edward Eliot the Younger was appointed to the Admiralty Board, and Sir James Lowther, without reward other than the promise of an eventual peerage, specifically gave his support to Shelburne against Fox. More important, Charles Jenkinson at the King's request rallied to the Ministry himself and called on John Robinson to give a professional touch to the management of Parliament in the coming Session. Through Robinson, they were soon opening up the lines to the real master of the Commons, Lord North.[2]

After a quarrelsome meeting at Lord Fitzwilliam's on the 6th, which made the split among the Rockinghams complete, Fox made his appeal to the House on July 9. Like all his speeches, this one was disorganised and repetitious, but at first he seemed to have struck just the right note of injured rectitude. He had gone into office, he said, on a particular system and when he and his respectable friends saw that it was being departed from and the system of the old ministry revived, they had no choice but to resign. He regretted having to leave office, he particularly regretted parting with old friends, but there were considerations superior to ambition and friendship. When Conway answered that Shelburne had not departed from the measures of the Rockingham Ministry and the quarrel had been a personal one, Fox turned the discussion to his responsibility to his supporters. He could not remain in office because there were persons for whom his presence in office was a pledge of the government's good intentions; he could not stay in a cabinet from which such a respectable figure as Lord John Cavendish had resigned. As to the suggestion that their differences were mere shades of difference between persons and parties, could the question of war or peace be considered a shade of difference? In breach of his privy councillor's oath he revealed that he had

[1] Fortescue, VI, nos. 3830–1, 3837–9, 3798, 3841.
[2] Fortescue, VI, nos. 3832, 3846–7, 3871–3; H.M.C. Abergavenny MSS, 53.

been outvoted in the Cabinet on granting unconditional and unrestricted independence to America, a measure 'necessary to the salvation of this country'. Perhaps now Shelburne had changed his mind on the question; if so it was because of his, Fox's, resignation, and he was obviously of more use out of the government than in it.

The real cause of his resignation, Shelburne's appointment to the Treasury, he dealt with according to the canon of Rockingham orthodoxy:

> ... it was but just and fair, that those who went into office upon certain public principles, should be satisfied that none were introduced into the cabinet, who were hostile to those principles; and they either should have a right to retire, or to have a voice in the appointment of all persons who should be nominated to fill those vacancies that might happen; when that power was taken from them, their power was at an end. ...

On Rockingham's death, he said, it was natural to suppose that the new prime minister should be as much like the old as possible in virtue, influence and popularity, 'and the eyes of all men were naturally turned to the Duke of Portland.' But now they had a ministry that would not brook reform; that could not be popular; that would say that the King had a right to use his veto, and would threaten the use of it on all bills of reform; that would follow the principles of North's Ministry and even, perhaps, include some of its members among them. Just as he could tell the sort of measures to be proposed in the House by seeing the mover rise, so he could tell the sort of measures to be proposed in Cabinet by its members.

Pitt joined Conway in paying a measured tribute to Shelburne's sincerity of purpose, but it was hardly necessary. The House was willing to suspend judgment for the moment. In the Lords Shelburne made his own defence, following the line he had already taken in correspondence with his supporters: that he would not agree that the cabinet should dictate the choice of prime minister and that he had reluctantly bowed to the necessity of recognising American independence, though it should be granted at the price of a good peace for Britain. For the rest, he would trust to his measures of recovery and reform rather than to the patronage of the Treasury to secure him the favour of Parliament. Richmond, like Conway, paid tribute to Shelburne's sincerity on the American issue, and political opinion, in and out of doors, seemed generally

to agree, for the moment, that Fox had been foolish and Shelburne should be given a chance.[1]

* * * *

He was in the saddle for the time being but hardly anyone expected him to stay there. It all depended, as John Wilmot pointed out, on his being able to attract the support of the independents and the Northites by making successful war or immediate peace.[2] In the meantime there were his 'measures' on which he promised to stake his government's existence, to be attended to. He was still convinced that the main purpose of the reforms — in the first instance the implementation of Burke's Act and the recent recommendations of the Commissioners for Examining Accounts — was to effect popular control of administration with the purposes of reducing influence and promoting economy. Hence his belief, which remained unshaken almost to the end of his Ministry, that these detailed and highly technical changes must make his administration popular with independent opinion. At the same time, as he delved ever more deeply into the details of financial administration, he was becoming progressively disabused of the Opposition notions that influence abounded and that economy could be achieved easily.

His first and most pressing undertaking was the implementation of Burke's Act. By the fourth clause of the Act, the Treasury was authorised to direct the preparation of plans to implement the reforms of the Civil List in detail and to appoint or continue in office such officers as were necessary for carrying them into execution, under the direction of the great officers of the Household. Like most of the Act this instruction was big with the possibilities of controversy. The Act had undergone considerable changes since Burke had first introduced it in February 1780. The specifically political motivation of reducing the influence of the Crown had become more apparent as, one by one, he gave up his suggestions for a real economical reform in the Exchequer, the Ordnance and the administration of the Crown Lands in order to have a freer hand with what he considered were the principal concentrations of influence. The emphasis on economy was also strengthened. The Civil List, despite its increase to £900,000 in

[1] Parliamentary History, XXIII, 160–98; General Advertiser, July 12, 16, 18, 23, 1782.
[2] John Wilmot to Shelburne, July 10, 1782, Shelburne Papers, vol. 87, fo. 66.

1777, had once more incurred deficits, amounting to more than £300,000 by 1782, and economy was a popular argument that Burke could not ignore. The economies, however, were badly planned, with very little consideration given the real, as distinct from the ostensible, functions of the various offices, and unrealistically limited total budgets within which the various departments were expected to confine themselves. No matter how the Civil Government and Household might be reformed to function more efficiently, the Civil List was simply not adequate to meet the steadily increasing demands on it, let alone pay off the Civil List debt as Burke proposed.

Burke's ideas about the Household and its function may be gathered from the clauses in the Act providing for the abolition of the six Clerkships of the Board of Green Cloth. The Board of Green Cloth, originally the Counting-House, consisting by 1782 of the Lord Steward, Treasurer of the Chamber, Comptroller, Cofferer, and Master of the Household, three Clerks and three Clerks Comptrollers of the Green Cloth, was the committee responsible for administering the Household. Its development, like most of the chamber administration which Burke was now endeavouring to dismantle, had been largely the work of Thomas Cromwell who, observing that the great officers of the Household had been becoming political figures and losing touch with the Household, threw the principal power and business into the hands of professional men of business, the Clerks.[1] Since his time the functions of the great officers — the Lord Steward and Lord Chamberlain especially — had become largely ceremonial and nominal, the business of the Treasurer, Comptroller and Cofferer had been gradually absorbed into the Treasury, and only the Clerks had any real business, though on such a reduced scale that Burke decided to abolish their offices along with those of the Treasurer, Comptroller and Cofferer. Nevertheless, in Clause Five of his Act, he specifically stated that the jurisdiction of the Board had not been taken away. What he meant by this exception was difficult to imagine, and it was referred by Shelburne, along with the clauses relating to the payment of salaries and pensions by and to suppressed offices and the payment of special and secret service money, to the Attorney-General for interpretation. Attorney-General Lloyd Kenyon's opinion was that the Board had not been

[1] G. R. Elton, *Tudor Revolution in Government* (Cambridge, 1953), 388–94.

abolished and that its powers must continue to be exercised by its remaining members, but that the new Clerks of the Household, appointed to do the routine work of the old Clerks, were not members of the new Board. Burke's reform had thus had the interesting, though unintended, effect of undoing Cromwell's work and making the Lord Steward (and, in another context, the Lord Chamberlain) efficient officers of business which they had not been since Tudor times.[1]

The selective abolition of offices had also created an appalling tangle for the Treasury to unravel. In some cases — as, for instance, the Groom of the Stole, the Treasurer of the Chamber and the Cofferer — leading offices were preserved as sinecure tributes to the dignity of the Crown, while their establishments were abolished. In others, Burke had eliminated the leading offices and the establishments, but had apparently left it to the Treasury in some sort of conjunction with the great officers of the Household, to determine whether the lesser offices should remain abolished, be temporarily revived to effect the necessary reforms, or be revived permanently.

Under the circumstances, the great officers and their principal subordinates had risen to the occasion, preparing emergency plans to carry on their departments and, perhaps, avert the enquiry and reform from the Treasury which was now almost inevitable. The Master of the Horse had suggested economies and had urged the compensation of the dismissed officers with full salary; the Master of the Household, Sir Francis Drake, prepared a rough plan for absorbing the duties of the six Clerks of the Green Cloth into the Lord Steward's office and for a spartan reduction of the establishment from £13,397 to £3,798. These were approved by the Lord Steward, Rockingham and the King, and put into execution just before Shelburne became prime minister.[2] The Lord Chamberlain, the Duke of Manchester, prepared a similar plan for transferring the business of the suppressed departments of the Jewel Office, the Treasurer of the Chamber, the Great Wardrobe and the

[1] Copy of a Case relative to the Jurisdiction of the Verge since the passing of Mr. Burke's Act with the Attorney General's Opinion Thereon; Opinion of the Attorney General on the Clauses of the Establishment Act, August 1, 1782, Shelburne Papers, vol. 125.

[2] Observations on the Fourth Section of the Act for Enabling His Majesty to discharge the Debt . . . by the Duke of Montagu, Master of the Horse, August 3, 1782; An Account of the Late Alterations in His Majesty's Household, 1782, Shelburne Papers, vol. 125.

Board of Works into the hands of a new secretary or treasurer to be
appointed by his warrant and responsible to him. This officer was
to be paid a substantial salary, to be met out of economies in the
Removing Wardrobe, and such fees as were 'usual and not
chargeable to His Majesty'.[1] Two features of the plan — putting
the office of secretary in the gift of the Lord Chamberlain, and
paying him by fees — were unlikely to commend themselves to the
new prime minister.

But in any case Shelburne had other intentions. The Treasury's
powers under the Act were extensive and Shelburne determined to
exercise them as powers of *quo warranto* over the offices of the
Household. Setting aside the plans already made, on July 19 he
issued orders requiring the great officers to submit returns of the
establishments of their departments.[2] On August 1 the Treasury
appointed Thomas Gilbert to examine these returns and prepare
comprehensive reforms of the Household. Gilbert's qualifications
for the work included a previous attempt to reform the Household
when he had held the office of Comptroller of Accounts to the
Treasurer of the Chamber (an office since suppressed); his leader-
ship of the resistance to Burke's proposal for a parliamentary
reform of the Household; and the fact that he was Member for
Lichfield in the interest of Earl Gower whose support Shelburne
was hoping to secure.

At first he was ordered to examine only the returns and accounts
as they were submitted and report his observations thereon to the
Treasury; later, at his own request, he was authorised to examine
the records of the great officers. To this Manchester objected that
he had already said all he had to say in his report and that his office
had not been put under the authority of the Treasury except with
respect to the additional business arising from the suppressed
offices, but he grudgingly opened his records to Gilbert.[3]

In two reports, submitted in October and November, Gilbert
set out the principles on which the reform was to be conducted.
He commented disapprovingly on the wide variations between the
offices in making and receiving payments. He advised that, since
the revenue arose from one source and all the officers were under
the authority of the Crown, the operations of establishments should

[1] Report of the Lord Chamberlain, *ibid.*
[2] Treasury Minutes, July 19, 23, 25, 1782, Shelburne Papers, vol. 162.
[3] Treasury Minutes, August 1, 8, 1782, *ibid.*; Manchester to George Rose,
August 12, 1782, Chatham Papers, vol. 155.

be according to one method of transacting business, paid by one paymaster, in accordance with one mode of payment. Accordingly, he prepared administrative regulations to prevent unnecessary and unwarrantable charges, consolidate offices of business and suppress sinecures. The selling of offices and the taking of fees were to be forbidden (except fees on salaries at the Board of Green Cloth and fees of the Wardrobe collected on the creation of knights of various orders, titles of honour, election of bishops, etc., which were to be pooled and funded to help pay off the Civil List debt); no further increases were to be made in the establishments without royal warrant; accounts were to be submitted quarterly to the new Superintendent and Paymaster of the Household, and new works were not to be undertaken without being accounted for to the great officers and the Superintendent and Paymaster. As provided for in Burke's Act, compensation for loss of office through the reforms was not to be given as of right, but on the basis of individual circumstances after close enquiry.

Great economies were going to be needed — how great was not yet fully realised — if the Civil List debt was to be met. On Gilbert's plan total savings of £35,332 might be made in the actual administration of the departments of the Lord Steward, Lord Chamberlain and Master of the Horse. This was a significant proportion both of the nearly £125,000 which had been the expense of the Household and of the £50,000 which must be saved annually to pay off the Civil List debt.[1]

One of the largest savings to be made was in the Board of Works. The Board's Comptroller and almost sole active functionary, Sir William Chambers, had scandalised reformers for a number of years by his apparent incapacity to control the mounting cost of public works and especially by his insistence on expressing his classical taste at expensive length in the reconstruction of Somerset House. Part of this was not Chambers's fault since houses belonging to the Crown had been allowed to fall into decay as a result of Parliament's penury and increasing charges for emergency repairs could not be avoided. It was Chambers's bad luck that among these repairs were a new foundation for the Chancellor of the

[1] Report of Thomas Gilbert, P.R.O. T 1/38, no. 507; Schedule of Reforms referred to in Mr. Gilbert's Report; The Expense of the King's Household paid by the Cofferer at the Board of Green Cloth for the year 1780; Instructions for the Lord Steward's Office for the Well Governing of Our Household; Rules, Ordinances and Instructions for Our Master of the Horse, Master of the Robes and Lord Chamberlain . . . March 12, 1783, Shelburne Papers, vol. 125.

Exchequer's house in Downing Street and a new roof for Bushy Park, then occupied by the North family. Yet Chambers was unquestionably extravagant and muddled his accounts. Parliament noted with disapproval in 1780 that he had collected money for his buildings by drawing directly on the Excise and Stamp Offices without the money first passing through the Exchequer. This was the cause of some annoyance to the Tellers of the Exchequer, who were thus deprived of their customary fees,[1] and to the Commissioners for Examining the Accounts, since the revenue could not be controlled by the proper authorities and accounting was unduly complicated. Thus, when Burke produced his plan, the Board was marked down for destruction.

In its place Burke's Act provided for a single surveyor or comptroller who should be a professional architect or builder, and whose freedom to undertake new building was to be severely restricted by his having to report all new works to the Lord Chamberlain and the Treasury. Shelburne appointed a professional architect to oversee Chambers's work and give an opinion on all estimates, pending the completion of Gilbert's investigation. When Chambers submitted a salary estimate for the new works department of £5,302 2s. 10d. Gilbert countered with one of £2,916 2s. 10d. Chambers replied with one of £3,882 2s. 10d. and it was eventually settled at £3,767 14s. 2d.[2]

The heart of Gilbert's plan of reform was his proposal for the office of Superintendent of the Household and Paymaster of the Civil List. This official was to oversee all paying and accounting functions of the Household, superintend all contracts and work done, authorise any assistance he might need and certify it to the Treasury. He was to supervise Inspecting and Resident Clerks in each department of the Household (later consolidated in one Clerk Comptroller of the whole Household) in preparing estimates and managing accounts; to receive into his account in the Bank all money issued out of the Exchequer for the Household and draw drafts on it for the recipients in the various offices, and to deliver accounts to the Treasury at the end of each quarter and annually to the Auditors of the Imprest. As chief financial officer he was to

[1] Cf. Daniel Wray to the 2nd Earl Hardwicke, June 3, 1780, Add. MSS 35,402, fo. 240.
[2] Account of the Different Proposals about the Board of Works, Shelburne Papers, vol. 125; Treasury Minutes, August 2, 13, 28, 30, October 3, 26, November 18, 1782, *ibid.*, vols. 162, 163.

preside over monthly meetings of a remodelled Office of Works to authorise the estimates submitted by the professional Surveyor of Works, and over the quarterly meetings to make and present accounts to the Lord Chamberlain. He was to keep a check on the Surveyor and Examining Clerk of the Works. In return for performing all these duties he was to be paid the modest salary of £1,000 with £320 in allowances. Under the original terms of Gilbert's plan, the Superintendent was to be appointed by, and responsible to, the great officers of the Household and the Treasury together. Neither Shelburne nor the King liked the arrangement, however, and it was decided that he should be appointed by and responsible to the Treasury alone.[1] Thus the process begun by Cromwell and halted by Burke was now carried a stage further. A man of business, an agent of the Treasury, was to have control of every operation that mattered in the Household and the patronage of appointment connected with it.

Naturally the great officers objected. Lord Carlisle, the Lord Steward, resigned and Manchester attacked the appointment of a Superintendent and Paymaster as expensive and unnecessary. Manchester argued that the great officers were currently authorised to pay all servants and tradesmen, and that this was the cheapest and most expeditious method of handling the matter. If it was necessary to have these duties performed by someone else, a proper person might be found in each department to undertake it, at a salary additional to his established pay, whereas 'if a new office was to be created, with the sounding name of *Paymaster General*, large appointments with a usual retinue of clerks will probably be expected'. Besides, the proposal was in violation of Burke's Act, infringing on the rights of the Lord Chamberlain who was already Superintendent of the Household, 'and saying that that *Officer* is not fit to be trusted with the power hitherto lodged in his hands.' If it was thought necessary to give the Treasury sole direction of payments, 'there does not appear to be any pretence for the Board to interfere in any other detail of office.' The patronage of appointment must be vested in the hands of the Lord Chamberlain, and this included the appointment of tradesmen, officers of Works and

[1] Instructions for the Government and Direction of our Superintendent and Paymaster; Estimate of the Expenses of the Office of Superintendent and Paymaster; Instructions for the Government of our Office of Works, Shelburne Papers, vol. 125; King to Shelburne, October 5, 1782, Bowood MSS; Shelburne to King (2 letters), October 7, 1782, Fortescue, VI, nos. 3947-9.

even the Inspector and Superintendent.[1] Shortly afterwards Manchester blew up a new storm by making two successive appointments to the position of Plate and Jewel Officer though the Attorney-General ruled that the office was not in his gift. On the second occasion he even refused for a time to deliver up the keys of the office to the Treasury's nominee.[2]

Manchester was only the most distinguished of a wide variety of complainants against Gilbert's arrangements, the largest number of whom were naturally dismissed officials. It proved impossible to make the savings in the Civil List required by Burke's Act and at the same time give pensions to all former holders of patent places and allowances to lesser displaced officers until they could be re-employed. Most of the patent holders were liberally compensated at a rate in direct proportion to the disturbance they could create. Shelburne, to give an instance, found it necessary to preserve the office of Knight Harbinger and a sinecure place in the Excise for Richard Stonehewer — who already had a private pension on the Civil List — because the Duke of Grafton demanded it, and complained bitterly that another of Stonehewer's offices, that of Historiographer, had been suppressed.[3] The royal physicians drove a hard bargain, refusing to give up their patents without full compensation. One, at least, declined to serve the Household on contract of twenty shillings a head on the ground that it would

> ... materially injure my fortune, disable me from doing credit to His Majesty's Service, and disgrace the character and reputation that I have had the happiness honourably to acquire.[4]

Not to speak of the threat to the doctor-patient relationship.

[1] Manchester to Gilbert, December 30, 1782; Lord Chamberlain's Observations on the Superintendent and Paymaster General of Works, December 30, 1782, Shelburne Papers, vol. 125.

[2] Treasury Minutes, December 23, 28, 1782, March 29, 1783, Shelburne Papers, vols. 163, 164; Case, with Attorney-General's Opinion Respecting Mr. Egerton's appointment as Yeoman of the Jewel Office, December 27, 1782, Gilbert to Shelburne, March 23, 1782, ibid., vol. 125; King to Shelburne, Manchester to Shelburne, March 17, 1782, Bowood MSS; Manchester to the King, Shelburne to the King, March 18, King to Shelburne, March 19, Shelburne to King, March 20, 1783, Fortescue, VI, nos. 4212, 4216-17, 4227.

[3] Shelburne to Grafton, March 7, 1783, Grafton MSS 108; Emoluments of Mr. Stonehewer's Offices, Shelburne Papers, vol. 125; Grafton Autobiography, 358, 372.

[4] Gilbert to Shelburne, October 31, 1782, Shelburne Papers, vol. 125; Dr. Robert Hallifax to Manchester, January 24, February 13, to the King, February 13, 1783, Fortescue, VI, nos. 4082, 4116-17.

For the smaller offices Gilbert prepared a schedule of three categories of petitioners, in order of priority for compensation. The first, made up of persons who enjoyed small sinecure places which had been their sole or chief support and who would be reduced to great distress if no provision was made for them, included a variety of carvers, cup-bearers, servers, messengers, housekeepers, turners, chamber-keepers, farriers, joiners, bricklayers, engine-keepers and labourers. Their former salaries and wages had amounted to £1,824 10s. 2d.; their proposed pensions would be £1,408. The second class — those who had enjoyed places with larger salaries, but having considered them as provision for life, had neglected other pursuits — included a clockmaker, the deputy examiner of plays to the Lord Chamberlain, the master of the revels, an arras keeper, the principal painter (Allan Ramsay, whose salary of £200 was to be replaced with a pension of £150), a laundress, an avenor and almost the entire establishments of the Office of Robes, the Jewel Office and the Office of Police for Scotland. Their salaries had been £6,651 10s. 8d.; but Gilbert proposed to allow them only £3,697 in pensions. The third class were persons who had been dismissed from offices of real business, were fitter to be employed than to receive pensions, and would be given pensions only until employment could be found for them. These included the playwright, Richard Cumberland, who had been Secretary of the Board of Trade, and John Fisher, late Undersecretary of State, as well as the Clerks of the Paymaster of Pensions and the various sub-treasuries. Their salaries had totalled £3,124 2s. 7d.; Gilbert proposed to give them only £680 in pensions. In spite of strenuous appeals the Treasury, very conscious of how difficult it was going to be to meet the other demands on the Civil List, supported Gilbert.[1]

The price they paid for this necessary firmness was a reputation for being harsh with the little men in the government service. Complaints were made by Grafton on behalf of his displaced friends, and by William Knox and Horace Walpole on their own behalf, that Shelburne had 'struck off a parcel of small offices and pensions that had been bestowed on old servants and dependents now grown aged and incapable of getting their bread', while lavishing pensions on Ashburton and Barré. When Parliament

[1] List of Persons Dismissed from their Employments whose Circumstances and Situation make them Objects of Royal Bounty, T 38/507. Treasury Minutes January 14, 29, February 5, March 11, 24, 1783, Shelburne Papers, vol. 164.

met, the Foxites took it up with gusto. Burke compared his own reforms — public, generous and designed to check parliamentary influence — with Shelburne's — mean, inhuman and aimed at 'poor inferior officers of twenty, thirty and forty pounds a year, which was all their dependence and support, after a life of service for themselves and their families'.[1] But the Coalition was soon to discover the difficulties of Civil List reform for themselves.

Meanwhile Gilbert had applied for the office of Superintendent and Paymaster for himself, though it would mean giving up his seat in Parliament. It was an office of work, responsibility and power, hardly a plum for a sinecurist; but Gilbert wanted the power of controlling the Household and also — since his loss of the Comptrollership — a safe place for life. The King objected that Gilbert should not be a member of the Board of Works since he was not a professional builder, and that appointments for life in such offices were 'the bane of all Government in this Kingdom'. In spite of these apparent departures from the spirit of reform, Shelburne was willing to approve the appointment, and it passed the Treasury Board in the interregnum after his fall. But Gilbert could not make up his mind whether or not to sacrifice his seat for the post and the King was unwilling that the arrangements should be completed until after the new administration was formed. In the event the Coalition decided the question by cancelling the appointment.[2]

The Coalition, indeed, set out at first to dismantle all Gilbert's arrangements. Burke insisted that they were in contravention of his Act, the Lord Chamberlain that they were incompatible with the services to be performed by his office, and Sir William Chambers that they reduced him to the status of a footboy of the Lord Chamberlain. But as late as October 1783 the Coalition had failed to produce an alternative,[3] and it was left to Pitt's government to take up the regulation of the Household where Shelburne's administration had left off.

* * * *

[1] Walpole, *Last Journals*, II, 457; *Parliamentary History*, XXIII, 225, 244, 263-4, 1070; *London Courant*, December 18, 1782.
[2] King to Shelburne, December 17, 1782, Shelburne to King, King to Shelburne, March 1, 1783, Fortescue, VI, nos. 4031, 4144-5; King to Shelburne, February 28, 1783, Bowood MSS; Treasury Minute March 14, 1783, Shelburne Papers, vol. 168, Part III, fo. 53.
[3] Colonel Whitshed Keene to Burke, April 11, Chambers to Burke, October 18, 1783, Fitzwilliam MSS, Burke 1245, 1285; Keene to R. B. Sheridan, October 27, 1783, T 1/584, no. 333, c/83.

The most popular part of Burke's reform, the part from which most was expected, was the regulation of private pensions and the secret and special service money. It seemed that all the fears of the Opposition concerning 'dark and creeping influence' were now to be set at rest. When Savile made his motion for an account of all places and pensions in February 1780, North had successfully resisted revealing anything but the list of the relatively public pensions paid at the Exchequer. Burke's Act was designed to prevent such concealment in the future by making all pensions payable at the Exchequer.[1] New pensions were to be limited to £600 a year, and no person was to receive a new pension of more than £300 until the pension list was reduced to £90,000. Thereafter the limits on new pensions would be raised to £5,000 for the total of new pensions and £1,000 for any single pension. Exceptions were made in the cases of pensions for ambassadors of long service and special service money and Royal Bounty, though an accounting was required for these.

In order to bring the existing pension lists within the limits of the Act, Shelburne's Treasury found it necessary to have the Attorney-General clarify the clauses relating to pensions and secret service money, and to order an accounting of all the secret service and pension funds. This accounting, made up in the Treasury, probably by Thomas Orde, included recommendations for making Burke's regulations workable.

The secret service and secret pension lists proved to be not nearly so dark and scandalous a secret as the reformers had imagined. Pensions under the Civil List[2] were described according to the list on which, or the person by whom, they were paid, rather than by the reason for payment, though this latter usually determined the mode of payment. Some, paid at the Exchequer, were not at all secret. These included a variety of small payments to university professors, preachers and schoolmasters and also larger pensions to persons of quality, such as £4,000 to the Duke of Leeds, two pensions of £2,400 to the retired Chief Justice of Common Pleas

[1] The transfer of pensions to the Exchequer and the restrictions on them were postponed until April 5, 1783 so as to give time for the pensions to Ashburton, Barré and other supporters of the Ministry to take effect (*Parliamentary History*, XXIII, 583).

[2] No consideration is given here to the so-called Hereditary Pensions, nor to the Parliamentary Pensions — such as were voted to General Eliott and Admiral Rodney — since no decision had as yet been made as to the fund from which they should come, and parliamentary salaries voted to some magistrates, clerks and sheriffs.

and the retired Chief Baron of Exchequer (a recent innovation), an allowance to Lord Loughborough of £1,000 as compensation for agreeing to accept the Chief Justiceship of Common Pleas rather than the Great Seal in 1780, the £1,000 granted to John Robinson on the fall of North's ministry and a number of charitable donations to Scots lords, including one of £800 for twelve years to the Earl of Dalhousie. Three Members of Parliament besides Robinson also appeared on the list: Sir Richard Sutton and Lovell Stanhope had pensions granted on termination of their services as under-secretaries of State, and Thomas Dundas of Fingask had one, probably as a part of the payment to his family for their political support. The total of this list in the summer of 1782 was £22,736 10s.[1]

Of a much more confidential nature were the pensions paid by the Paymaster of Pensions, Lord Gage. Some of these were grants in lieu of other benefits, such as apartments formerly held in Somerset House. A substantial proportion — more than one-sixth — was accounted for by permanent charities to chaplains, preachers, teachers, schools, churches and the poor; some were rewards for long service in government, and some were compensations for offices surrendered. Here, too, there were charities to indigent nobility and gentry. The total of this list was £61,658 9s. 4d.[2]

'Secret service' was a general term covering not only the gathering of foreign and domestic intelligence, but also the making of payments for charity and compensations in a secret manner so as to avoid burdening the pension with Exchequer fees and Land Tax payments. It also covered political payments which, considering the nature of their purposes and the prevailing sentiments of many Members of Parliament concerning those purposes, were best left concealed. The main source of secret service money was the Civil List, though before the American War various other Crown revenues had provided about forty per cent of it and also, in the case of the Four-and-a-Half Per-Cent or Leeward Islands Duty, supported a number of private pensions. These revenues included: the Four-and-a-Half Per-Cent Duty, the revenues of the

[1] Pensions and Perpetuities Payable at the Exchequer, Shelburne Papers, vol. 124.
[2] An Exact List of all Pensions and Bounties which on the 5th Day of July, 1782 were payable in the office of the Rt. Hon. Lord Viscount Gage, Paymaster, Chatham Papers, vol. 229.

Duchy of Cornwall, quit-rents from Virginia, Nova Scotia and Georgia, and a few smaller items from America and the West Indies. When the war came, the overseas sources dried up and though small sums were drawn from the Land Revenues of the Crown in North Wales and Chester, the main burden of providing secret service money fell on the Civil List.[1] This was unfortunate from the government's point of view because it increased the burden, and hence the debt, on the Civil List and brought parliamentary investigation appreciably nearer. The loss of outside sources was also unfortunate because it was convenient to have available funds free of Parliament's control, and never more so than when the government, conducting a losing war, felt itself more than ever in need of the psychological solace which the expenditure of a large sum on secret service might bring. Most of the money, whether spent for information or political friendship, was wasted, since the government chased after help that it already had, that did not exist, or if it existed, was unobtainable, or if obtainable, was of no use. The sums issued to the Secretaries of State and the First Lord of the Admiralty for foreign information and 'detecting, preventing or defeating treasonable or other dangerous corre-spondence, or other dangerous conspiracy against the State,' remained constant at £3,000 each to the Secretaries of State and £5,000 to the First Lord of the Admiralty, until 1781 when it was reduced in the case of the Secretaries to £2,250 each. Burke's Act reduced the annual total of secret service money to £10,000 and ordered it paid as part of the salaries of the office rather than as a separate account, apparently in order to keep its disposition secret. The Act also required the Secretaries and the First Lord to account for the secret service money within three years of the date of issue and to swear that it had been used for *bona fide* secret service purposes. The issue to Anthony Todd, the Secretary of the Post Office, for conducting the Post Office's secret office was also fairly constant, but as a result of the Act it was reduced from about £7,100 to less than £2,000 and paid through the undersecretary of the Foreign Office rather than on separate account.[2]

The large sums issued to the Secretaries of the Treasury for political and other purposes had been the principal target of Burke's attack. These rose in anticipation of elections (from

[1] *Parliamentary Papers of John Robinson*, 138, 150–66.
[2] Treasury Accounts Departmental, Civil List 1777–82, T 38/167, Fortescue, VI, no. 4287, Enclosure 3.

£57,000 to £62,000 between 1777 and 1779) and fell after them (to £37,000 in 1780). The issue of these sums was not a secret but their expenditure was. The secret pensions, though generally considered together as a group, were paid in various ways: on the King's Private List of Pensions and Bounties, on the list entitled 'for secret service', on the Treasury List. The analysis prepared in the Treasury for the purpose of deciding which pensions should be transferred to the Exchequer and which should be kept secret (as provided for under Burke's Act, by the Minister taking an oath that they were not being used for purposes of political corruption), arranged them in seventeen categories.[1] Considered in order from the purely charitable or 'meritorious' to the purely political, these were:

1. Bounties or the King's Bounty: These were payments of charity and compensation to old and indigent former servants of government and to the displaced small fry of office. They were paid on the secret list to avoid having them mulcted for Exchequer fees and the Land Tax. They were defended by the reformers as the sort of charity the Crown should support and under Burke's Act were not restricted as to amount. But for practical purposes of charity the Bounty was no longer of much use, since it could not be paid to the same person oftener than once in three years, otherwise it would be regarded as a regular pension and subject to the restrictions governing pensions. Moreover all pensions transferred from the various lists to the Exchequer were to pay no more in fees and taxes than they had customarily done, which eliminated the main incentive for keeping Bounties secret. The total under this heading was £2,896.

2. Charity to the Nobility: This was similar to the preceding category, but was given to peers who had fallen on hard times. It was this group to which Fox and Burke were referring in February 1780 when they accused North of hiding behind the reluctance of the 'Lady Marys and Lady Bettys' to have their reduced circumstances made public.[2] Only a few of this group were indigent gentlewomen. Lords Bolingbroke, Essex, Northampton

[1] List of Private Pensions and Secret Service Money Paid by one of the Secretaries or by the Chief Clerk of the Treasury, without any Deduction, Previous to the Passing of the Civil List Act of the Last Session, Chatham Papers, vol. 229. I have not stuck strictly to the arrangement in the analysis where items, in my opinion, belong in different categories than those to which they were originally assigned.

[2] *Parliamentary History*, XXI, 93-4.

and Montford were bankrupts whose pensions were kept secret in order to frustrate their creditors.[1] Another pension, to a Mr. Heming, said to be held on behalf of a peer, may have had the same purpose. The category also included a pension of £500 to Lord Fairfax, poverty-stricken successor to the American Lord Fairfax, who had been receiving it since 1759 and who on his succession to the title in the spring of 1782 asked Shelburne for a raise.[2] When North was winding up his accounts in April the King warned him that pensions to peers would be regarded as 'influence' by the new administration; but the author of the analysis, whose advice in this respect Shelburne followed, regarded them generally as charities. The total for this category was £6,400.

3. Compensations for Losses from Rioters, Rebels or War: These included an Algerine who had suffered losses at Gibraltar; Father Hay, a Scottish priest whose house had been pulled down in the Gordon Riots and who must be compensated secretly so as not to alarm the Protestant and freeborn; and three informers who had given intelligence about the American rebels and whose pensions must remain secret for similar reasons. The total of these pensions was £600.

4. Support for Servants and other Dependents of the Royal Family: The total for this category was £2,160.

5. Literary and University: These were granted to literary people or their survivors and recommended by members of the Ministry. The recipients included Kennicott, the translator of the Bible; Bentley's son; an anatomy lecturer at Cambridge; a teacher of Greek (recommended by Burke); and the heirs of a former Headmaster of Westminster School. This group totalled £1,130.

6. Favour Grants: to those who had once been or were still politically useful and who had fallen on hard times. These included grants to Sir James Cockburn, destitute Member for Selkirk (in the name of Lady Cockburn); to the wife and children of Thomas Bradshaw, the former Secretary of the Treasury who had worn himself out in the public service, and to several old dependents of Grafton. The total here was £3,180.

7. Pensions which were really salaries and should have been paid as such in the appropriate departments of the government: These included £1,500 to Lord Scarsdale as Chairman of Com-

[1] Northampton's had been in arrears for ten quarters (Fortescue, V, no. 3669).
[2] Cf. Namier, *Structure of Politics* (2d. ed.), 413-17.

mittees in the House of Lords, £500 to John Ord as Chairman of the Committee of Ways and Means in the Commons, £200 to Thomas Pratt, Chief Clerk at the Treasury, for paying the secret pensions on the Treasury List, £1,000 to a Mr. Bindley for regular help in making up the new taxes, £500 to his assistant, and £300 to a Mr. Talbot for similar service in the Salt Office. There seems to have been no obvious reason for keeping these secret except perhaps that in some cases they were rather high salaries for the services undertaken and the recipients may have been dodging fees and taxes. The total under this heading was £4,000.

8. Official Service Rewards: These were made mostly to Treasury clerks and others whose service had been of a confidential nature and required a secret reward. They included a woman who had been a messenger for carrying secret papers for the Post Office, and also Richard Stonehewer, Grafton's former private secretary, who received £600 in addition to his other pensions and sinecures. This category totalled £1,820.

9. Compensation for loss of office or change of office or in lieu of office: This type of award was given to a wide variety of people and was likely to remain on the books for a great many years, since offices suitable to the pretensions of such people seldom became available and when they did were usually wanted for someone else. Among these grants was that to Thomas Bowlby, M.P. for Launceston, former Commissary of Musters and Commissioner of Excise, who had been persuaded to give up the latter office in 1780 to become one of North's original Commissioners for Examining Public Accounts. North had later withdrawn his name because of the outcry from the Opposition, but Bowlby had still to be compensated. The pension was made out in the name of Lady Mary Bowlby, his wife, who already had £285 on the late Princess of Wales's establishment. Three other M.P.'s figured in this group: John Mayor, recently retired Member for Abingdon, who had been helpful in securing the passage of the Paper Duty and who wanted an employment with an income equal to his pension;[1] Captain Charles Wolseley, former Member for Milbourne Port, who was being compensated for the trouble and expense of preparing to go abroad as Minister to Bavaria and then not

[1] On November 8, 1782, North wrote to an unknown correspondent (perhaps Thomas Orde, Secretary of the Treasury) bearing witness to Mayor's services and recommending a pension of from £600 to £800 (Clements Library, North Papers).

securing the post;[1] and Lovell Stanhope, former undersecretary of State, who received £100 in the name of William (or Thomas) Cory as compensation for the abolition of his place as Law Clerk in the Exchequer. In addition, there were compensations to a resigned Collector of Customs at Savannah; a resigned consul (a relative of the Duke of Hamilton); the former Secretary of Customs in America, resigned in 1772 but still waiting further employment; a commissioner of the Lottery dismissed by Rockingham in 1766; and a former agent of the 3rd Regiment of Guards who had done well as a magistrate during the Gordon Riots, who pleaded great distress and a large family, and whose pension had been secured for him by the Duke of Gloucester. This category accounted for £3,680.

10. Favour Grants to those who had been politically useful: Prominent among these was that paid to Sir John Shelley, Newcastle's relative, whose defection to the Court in 1768 had so embittered Newcastle's last months; and the Earl of Macclesfield, who was still being paid for the great expense of fighting the Oxfordshire election of 1754, nearly thirty years after the event.[2] The group also included a brother-in-law of Sir John Hynde Cotton, former Member for Cambridgeshire; Loughborough's sister, Lady Erskine; the brother of Sir John Delaval as compensation for not being appointed Regius Professor of Modern History at Cambridge; and the brother-in-law of Lord Rochford as compensation to Rochford for not being made Ranger of Bushy Park. These pensions amounted to £5,300.

11. Foreign Public Service: This included a small pension to Prince Ferdinand of Brunswick's secretary, given at the end of the Seven Years War. The total in this category was £750.

12. Foreign Secret Service: This included standing expenses for information from Corsica, a pension to Paoli, and pensions to the egregious Paul Wentworth, the government's principal spy on the Continent, and to Captain Joe Hynson, the American sea captain who had absconded to England with Franklin's dispatches in 1777. It also included a pension to a Mr. Tyrell who was dead — an item that gave point to the twenty-third clause of Burke's Act requiring the Secretary of the Treasury to take an oath that persons

[1] The fragmentary account of pensions in the *Parliamentary Papers of John Robinson* (49–50) lists twelve pensions totalling £7,750 given to former or sitting Members. Only Wolseley's was still paid in 1782.
[2] Namier, *Structure of Politics*, 199.

in receipt of secret service pensions for more than five years were still alive. The total for Foreign Secret Service was £7,437 10s.

13. Secret Service Home: This was paid for past services of informers among workmen and the London mob. Considering the frequency of outbreaks among these groups it was not money well spent. Prominent among the names in the list was that of John Green, Beckford's former agent among the coalheavers in Billingsgate. The list also included a spy who had served at Brest during the Seven Years War and probably should have been included in the Foreign Secret Service category. The total for this group was only £451 18s.

14. Magistrates: These payments were closely related to the preceding category, being money granted for the support of the Westminster and Bow Street magistrates' courts for the purpose of maintaining the embryo police service conducted by those institutions.

> It is a question [noted the author of the analysis] whether the stipends on this list allotted to certain magistrates and purposes of magistracy should not be concealed, as the disclosure of these might cause obstructions to the effect of those reasonable purposes, for which they seem to have been granted.

The total was £2,175.

15. Corporations: These were the vestigial remainder of the substantial sums used for nursing constituencies which Sir Lewis Namier has noted for the 1760's.[1] In 1782, however, the largest sum being paid was only £160, only the Corporations of Harwich, Lyme Regis, Seaford, Winchelsea, Hythe, Rye and Camelford were being paid, and the total sum was only £870. The payment of £100 at Lyme Regis was made to one of the Members (probably Henry Fane) as a bounty, and another £100 was paid to the Corporation. The author of the analysis commented severely:

> The allowances to the corporations require more explanation than has yet been procured. The payments to one of them being to the Member for the Borough as a Bounty carries with it an appearance of such a purpose, as wd.. bring it under the same proscription as the last mentioned.[2]

16. Political or, more properly, Political Hacks: First on this

[1] *Ibid.*, 200.
[2] The reference is to grants made for securing parliamentary interest see category 17).

list was Dr. Johnson's pension for £300. It also included payments to the heirs of John Lind and a few others. The total was £930.

17. Pensions given for political interest: This chimera of the Opposition must have seemed very disappointing when finally revealed. Lord Montague had been paid £1,000 for his borough of Midhurst; a Mr. Jenner, one of the voters who returned Sir Grey Cooper and Charles Jenkinson for Saltash received £100; and a J. Osborne, who had formerly been useful in elections at Rochester, received £40. Total: £1,140, out of nearly £45,000 in secret pensions. It might have been more than double this sum had not the King refused North's request in April to continue the payment of £1,500 to George Augustus Selwyn for his interest at Ludgershall.[1] The reason for the smallness of this 'hard-core' payment for political influence is not far to seek. Elections, at least the election of 1780, had been fought with the help of other funds — the £1,000 a month set aside from the Privy Purse between November 1777 and February 1781, private contributions (which proved disappointingly small), and by the absorption of the remainder as debt by private individuals, notably North. This deficit was due, as the King reminded him, to North's reluctance to load the secret service list with political pensions and payments.[2]

Outside the main account the author of the analysis drew attention to the bounties and allowances made in the Secretary of State's office and the Household, totalling £2,897 15s., and to some (but not all) of the pensions allowed in the separate secret service funds of the Post Office, now eliminated by Burke's Act. These last included £500 to Thomas Ramsden, a connection of Rockingham's and sinecurist Collector and Transmitter of State Papers; and £1,000 divided among three persons appointed by George Grenville to put the State papers in order, whose continuance in office had converted Ramsden's place into a sinecure. Also included were pensions for Cuchet Juvencel, Chatham's former private secretary, and for the widow of Peter Morin, former undersecretary. It was probably these pensions which were referred to in the Treasury Minute of March 14, 1783:

> A considerable sum has been paid from the Civil List [to the Post Office] under the head of Secret Service which has been applied to

[1] 'He must view it like the loss of a place, and must look to better days' (King to North, April 18, 1782, Fortescue, V, nos. 3668–9).
[2] *Ibid.*, nos. 3663, 3668–9, 3674, VI, 3714–15.

the support of unnecessary employments which ought to be suppressed, to the payment of absolute pensions which are now transferred to the List at the Exchequer, or to objects belonging to the business of that office which call for reduction and which might, by proper regulation under the authority of Parliament, be wholly provided for out of the Post Office revenues.[1]

After subtracting Tyrell's pension and the allowances to Thomas Pratt and to Joseph Planta, as keeper of the manuscripts at the British Museum, the net total for the secret service account was £44,082 5s. To this Shelburne added the pensions formerly paid by the Paymaster of Pensions, amounting to £64,182 9s. 4d.; pensions, perpetuities and annuities paid at the Exchequer; and pensions to the servants of Queen Caroline and the Dowager Princess of Wales — a total of £166,668 8s. 2½d. or, if the annuities payable at the Exchequer, consisting of allowances to the Lord Chancellor, Speaker, Lord Chamberlain, Lord Steward, Warden of the Cinque Ports and a few others, were excluded, £144,986 1s. 6¼d.[2]

To reduce this to £90,000 and contribute to the savings of £50,000 required to pay off the Civil List debt was probably impossible, but Shelburne's Ministry did its best. Two or three pensions could be eliminated as improper political influence; the allowances to the corporations might be similarly questioned. Salaries could be transferred to the appropriate offices. Some of the items — the allowances to magistrates and the compensations to victims of riot and rebellion, as well as secret service proper — must remain secret, but they might be transferred to the Secretaries of State's funds to be paid out of the Foreign Secret Service. Thus the pensions fund would be relieved and a fund which was not limited by statute would be charged, though the Civil List as a whole would be no better off. A better suggestion was to transfer some pensions to funds which were not part of the Civil List. The author of the analysis suggested pensions totalling £3,710 that might be transferred to the Scottish establishment and £330 to the Irish. Shelburne, taking into account the whole sum of Civil List pensions, listed four, totalling £1,200 that might go to the Scottish establishment and three, totalling £3,300 that might go to the Irish. This opened up new possibilities for the evasion of Burke's Act that were to be realised to the full in the years to come.

[1] Shelburne Papers, vol. 168, Part III, fos. 54–5. [2] Ibid., vol. 124, fos. 143, 147.

o

Where it was impossible to transfer pensions, Shelburne proposed to abolish some, such as those of the Duke of Somerset, Lord Bolingbroke and his sons, and Lord Montague, totalling £6,100, and all pensions held by warrant rather than on establishment; and to reduce others, such as Lord Scarsdale's salary. He hopefully listed pensions to the value of £11,065 which were held by old people, and in harmony with the provisions of Burke's Act adopted the policy of disallowing the payment of arrears of more than two years on any emolument and of more than three quarters on any emolument that was to be abolished. Lord Gage, the former Paymaster of Pensions, was a particular sufferer from this policy, losing more than £1,600 in poundage and incident bill fees.[1]

Even then the savings were far too small. The most optimistic estimates showed savings of only £40,000 rather than the £72,000 predicted by Burke,[2] and the fall of Shelburne's Ministry increased the charges. On February 28, 1783 Shelburne submitted estimates to the King showing net charges of £842,514 14s. 6½d. With the £50,000 required for the retirement of the debt the charges would total £892,514 14s. 6½d., leaving a net surplus in the Civil List of £7,485 5s. 5½d. But on the same day the King informed Shelburne that Thurlow, in the uncertainties of the moment, had decided to call on the King to fulfil a promise made in 1778 for the reversion of a Tellership of the Exchequer and a pension of £2,680 pending the enjoyment of the office. It was only the beginning of the trouble. Barré's pension of £3,200 also fell due, as did the pensions of £2,680 each for Lord Grantham and Sir Joseph Yorke, in reward for past ambassadorial service. Four compensating pensions — to Maurice Morgann for having gone out to America as Carleton's secretary in 1782, to George Rose for abandoning the security of the Tax Office to become Secretary of the Treasury, and two others finished off the surplus and left a deficit of £6,400.[3] Shelburne hoped that the future income from consolidated fee funds — which he reckoned at £5,000 — and savings from the regulation of incidents and stationery in the various offices and from the falling in of pensions held by old people, would soon cover the gap.

[1] Treasury Minutes August 13, 1782, January 2, 14, 1783, *ibid.*, vols. 162, 164.
[2] Estimated Savings by the Reform of 1782, Add. MSS 29,465, fos. 217–21.
[3] *Ibid.*, fo. 224; Treasury Minute March 14, 1783, *ibid.*, vol. 168, Part III, fo. 51; King to Shelburne, February 28, March 1, 6, Bowood MSS; Shelburne to King, March 1, 2, 1783, Fortescue, VI, nos. 4144–5, 4149.

If the Paymaster and Superintendent, the Inspector, the Master of the Household, and the Secretary to the Lord Chamberlain continue properly chosen [he wrote to the King], with a view to the performance of their respective Dutys, and without any political mixture, and are well supported, I am persuaded that Your Majesty's expences will come within the Estimate. I am confirm'd in thinking so by those who have been most conversant in what has pass'd concurring in the same opinion, and without taking into account Pensions and Compensations, which must fall in to a considerable amount. I take it for granted in saying so, that Your Majesty's gracious disposition continues the same and that those who hold the higher Offices of Government will be actuated by high principles of honour towards Your Majesty and the Publick. The Secret Service of the two Secretarys of State being unlimited will however always require Your Majesty's attention. . . .[1]

However much Shelburne might wrestle with the intractable economy of the Civil List, the danger of influence still haunted him. Yet this was now almost the least of the problems connected with the Civil List as contingent and incidental payments drove it once more into debt. Even in 1782 these payments had totalled nearly a quarter of a million pounds.[2] Under the circumstances, to follow Burke's plan of establishment in which payments were to be made in eight classes, beginning with the Royal Family and ending with the First Lord of the Treasury and the Chancellor of the Exchequer, however effective it might have been in curbing the extravagance of ministers, would have been the extreme of financial unreality. Shelburne submitted to the King on April 6, 1783, a copy of the Civil List establishment arranged according to Burke's classifications, but neither he nor any subsequent prime minister believed that it could be implemented.

Burke's Act failed in the necessary work of making the civil government cheaper and more efficient largely because Burke himself refused (and in this he was reflecting the attitude of two

[1] April 6, 1783, Fortescue, VI, no. 4287. At the time of the further application to pay off the Civil List debt in 1786, Shelburne, now Marquess of Lansdowne, boasted not only of having implemented the Civil List Act but also of having inspired the restrictions on the Civil List (apparently the passage of four years had been sufficient to allow him to forget Burke's authorship of the Act), and of having planned methods of maintaining a favourable balance in the Civil List, such as returning West Indies duties worth £30,000 from the control of Parliament to the Civil List and selling a number of houses no longer of any use to the Crown (*Parliamentary History*, XXV, 1348–61).

[2] Net Produce of the Aggregate Fund of the Civil List, T 1/576.

centuries of parliamentarians) to recognise that the Civil List was inadequate to meet the charges placed upon it. Even at £900,000 the annuity could not keep pace with the growth of incidental payments, let alone pay off past debts. Arrears continued to pile up, as Shelburne had warned they would if incidents were not regulated. The Civil List disbursements for 1782, far from being less, were £117,034 more than those for the preceding year, and slightly more than this sum — £118,626 — remained to be paid off on October 5, 1782, after the conversion of more than £322,000 of Civil List debt into Exchequer bills. Estimates for the Civil List, prepared in hurry and hopefulness by the Coalition at the beginning of April 1783 showed regular Civil List expenses at £745,459 10s. 8½d. and incidental payments at £104,292 18s. 10d., leaving just enough to meet the repayment instalment on the debt.[1] But this was much too optimistic. By the beginning of 1786 the expenditure was £135,876 10s. 6d. in excess of the Civil List annuity, and the new debt amounted to £279,278 17s. 6d. A further appeal was made to Parliament, this time with no stipulation of repayment; but the arrears grew again and by the end of the century had reached nearly a million. The process continued until the progressive reorganisation of the Civil List finances between 1817 and the 1840's.

[1] Add. MSS 29,470, fo. 49; Add. MSS 29,466, fos. 12–13.

Administrative Reform I:
Reform of Fees and Offices

Outside the Civil List structure Shelburne's efforts at reform were dispersed and uncoordinated. The principles governing Civil List reform — the reduction of influence and the promotion of economy — were principles which he had been accustomed to support in Opposition. When he turned to the national financial system he had no such guides. He wanted administrative efficiency; but only gradually, with the help of leading government servants in the financial offices, the reports of the Commissioners for Examining and his own studies of the Exchequer, did he see his way to achieving it.

His uncertainties were compounded by stringency in the government finances, conflicts of principle and his own ambitions, jealousies and anxieties. In 1782 the harvest, following several poor years, failed; food was scarce, the burden of the unfunded debt and of remittances abroad reached new peaks, and the sale of British securities on foreign markets rose rapidly toward the panic situation of February 1783. More immediately, the pressing necessity to make economies in administration forced on Shelburne by Burke's Act distorted his efforts at reform, compelled him to undertake them in an atmosphere of emergency, and without the necessary preliminary investigations of offices.[1] His anxiety to stand well with Parliament held him ostensibly faithful to the principle of popular control of financial administration through parliamentary appropriation, though with every week he spent at the Treasury he

[1] Ashton, *Economic Fluctuations in England 1700–1800*, 24, 130–1, 164. It was the enforced economy, for example, that directly inspired the Treasury Minute of August 29, 1782, ordering the regulation of incidental payments from the Civil List and an enquiry into fees in the principal administrative offices. It was also at the bottom of Shelburne's devices for transferring dormant funds, such as the Army Windows' Pensions Fund to General Revenue (State of the Widows' Pensions, December 24, 1782, Sir George Yonge to Thomas Orde, February 18, 1783, Shelburne Papers, vol. 136).

was becoming a more convinced upholder of Treasury control over
the executive offices. His conversion was hastened by his discovery
of how effectively common law sanctions similar to parliamentary
control were protecting administrative anomalies. The freehold
inviolability of patents permeated all offices of administration even
though, as Shelburne was to learn, the executive had the power to
cancel patents whose terms had been abused. Public accounting,
moreover, was still dominated by the principle of judicial audit that
required accountants to be personally responsible at law for the
probity of their conduct rather than by the principle of adminis-
trative audit, just coming into fashion, in which the accuracy and
promptness of the accounts were enforced by auditors under
Treasury authority. Both the freehold theory and judicial audit
stood in the way of reform. Only gradually were Shelburne's
doubts about them resolved, only gradually did he come to agree
unreservedly, as government and Parliament would later be forced
in the crisis of the French Revolutionary War to agree, with the
dictum of the Commissioners for Examining in their Eleventh
Report:

> It matters not what the duration or condition of the interest may be,
> whether for life or years, during good behaviour or pleasure; all are
> equally subject to that governing principle for the sake of which it
> was created: the good of the public.[1]

Having pledged his Ministry's shaky existence on reform, Shel-
burne wanted to be reckoned the one genuine reformer of the age
and could not tolerate competitors. Hence he gave as little credit
as possible to the Commissioners for Examining for inspiring the
reform of the Exchequer offices and claimed as much as possible
for himself. Hence, too, he was inclined to disregard the principles
of reform set out by the Commissioners until necessity and his
own advisers confirmed them. This anxiety and jealousy also
pushed him into a frenetic eclecticism, clouding and confusing the
objectives of his reforms. His enquiry into the Treasury began as a
proposal to reform the fee system, but as it progressed extended
itself into the associated offices of revenue and account, becoming a
measure to reform establishments and office procedures as well.
Its focus moved, that is to say, from the reduction of influence to
the promotion of efficiency. Restriction of fees was accomplished

[1] *Commons Journals*, vol. 39, p. 780.

in some offices and the clerical establishment of the Treasury was put on a coherent footing. But long before the reform of Exchequer offices could be carried further than general plans and a few specific recommendations, Shelburne was also planning reforms in accounting procedures and the government contracting system, the improvement and consolidation of the revenue and the improvement of the debt management. His frantic concern to attend to everything personally meant that public business was delayed in some offices while he was deep in the affairs of others. At the end of his administration he had a variety of proposals of varying quality and some acts in draft form, but not the great range of measures on which he had hoped to stake his own and his Ministry's reputation.

Nonetheless this haphazard grasping at all the parts of the administration brought an improvement in the understanding of the national financial system. The war had accelerated the process by which there slowly dawned on eighteenth-century governments the realisation, not only of the weaknesses of the financial system, but of what that system was, and of what it ought to be. Before Shelburne's Ministry the various parts were considered in isolation. Shelburne's attempts to correct defects in all parts of the system showed how complex that system was, how necessary it was to explain it carefully before making changes, and how interdependent those changes were likely to be.

Within the narrow circle of executive government by 1782 a change in tone and emphasis, rather than any sudden conversion to the cause of administrative reform, had become evident. North had responded to suggestions for improvement in particular offices when it seemed politically safe for him to do so, and his Commission for Examining the Public Accounts, in its first six reports, had considered the collection of the taxes, the accounts of the Paymaster-General and the Treasurer of the Navy and their irregular emoluments. It had recommended that the smaller revenue departments be consolidated; that public accountants be deprived of their balances and restricted to book-keeping; that the execution of public business be vested in salaried officials and not undertaken only in return for special fees and rewards; and that the most notorious of the patent sinecures in the Exchequer be suppressed. But for all that North deserves great credit for appointing and supporting the Commissioners, it cannot be said that he

made much effort to implement their recommendations. Only once, on May 10, 1781, did he bring those recommendations to Parliament's attention, and the only measures which he undertook in this connection were an ineffective Act of 1781 to require accountants to surrender their balances, and three unimplemented plans to consolidate separately the revenues of Customs, Excise and the Stamp Duties. The second Rockingham administration concentrated upon reducing influence and secondarily on securing a measure of economy in government. They had never liked the Commission for Examining Accounts and still hoped to change it into a parliamentary committee to be used against influence. Their enjoyment of power, however, was too brief, too vexed with quarrels and too crowded with the immediate campaign against influence for them to accomplish more than two measures of purely administrative reform: Shelburne's Act for the Regulation of West Indies Patents and Burke's Act to regulate the Paymaster-General's department. On June 17, 1782, the House addressed itself once more to the reports of the Commissioners and Lord John Cavendish presented eleven resolutions designed to begin the implementation of their later recommendations. But the Session was drawing to a close, the House was half empty, and the Commons contented themselves with supporting the reforms in principle. Until they could return to the question in the new Session, they authorised the Treasury to fill vacancies in office in accordance with the principles set out by the Commissioners.

There was, nevertheless, a growing sense of urgency about reform. The assurance that the funding system would see the nation through the crisis and that reforms could be undertaken at leisure had temporarily evaporated. Those who had taken a pessimistic view of the system and its operation — Charles Jenkinson (whose eclipse at the fall of North's Ministry could be only temporary), Sir William Musgrave, Stamp Brooksbank and Richard Price — were coming into their own. In Parliament the independents were sufficiently apprehensive of national bankruptcy to give a passive support to the reform of the financial system, though their ignorance of financial detail ensured that that support would be no more than passive. In particular they were not reluctant to see the Treasury reformed: unlike the Household it was not personal to the monarch; it had been encroaching for years on their preserve of local fiscal autonomy, the Land Tax

commissioners; and in the calculus of their sympathies it had far less respect than had the Commissioners for Examining Accounts who were planning its improvement.

Shelburne's reform of the financial structure began with the Treasury Minute of August 29, 1782, disapproving of accounts of incidental payments submitted by the Excise Commissioners and ordering more detailed ones. Almost as an afterthought the Treasury also ordered reports on the establishments and all fees and patents in the Excise and nineteen other offices of receipt and expenditure.

To the normal administrative objections to the fee system: that it reduced efficiency by dividing the allegiance of clerks, concentrating their attention on those parts of office business that paid the best fees and exaggerating those considerations of seniority by which establishments of office were rendered inflexible — had been added since 1776 the more obvious economic objection arising out of the enormous wartime increases in fee incomes made on the misfortunes of the nation. In Shelburne's own department of the Treasury accounts, warrants, patents, commissions, allowances, bills, Sign Manuals, King's Letters, Privy Seals, contracts, lotteries, pensions, salaries, taxes and grants paid fees to a variety of officers and clerks whose incomes, as the Commission on Fees noted in 1786, were nonetheless uncertain and whose duties were largely undefined.[1]

Shelburne's corrective was a comprehensive plan drafted by George Rose, junior Secretary of the Treasury, on principles which, as Shelburne explained later, it was hoped to apply in the other offices. Attendance of clerks was enforced, pluralism and the performance of clerical duties by deputy forbidden, and the Treasury Minute of February 22, 1776, recommending the advancement of clerks according to ability rather than seniority, implemented. All fees were henceforth to be collected according to an official schedule; they were to be paid only to a receiving clerk; and from the fund thus collected regular salaries were to be paid to the secretaries and allowances to the clerks. The immediate saving was not great — the statutory salaries of £3,000 and £800 for the secretaries and chief clerks respectively were hardly less than their previous fee incomes. The most notable feature of the

[1] *Reports of the Commissioners Appointed to Inquire into Fees, Gratuities, Perquisites and Emoluments which are or have been lately received in several Public Offices* (London, 1793), Report no. 2 (June 20, 1786), p. 29.

reform was the provision that in case of a deficiency in the fee fund, not the Civil List, but the salaries of the officers and clerks, should suffer.[1] It was inspired partly by Shelburne's anxiety to balance the Civil List accounts, partly by the same overrighteous desire to punish the beneficiaries of 'undue influence' that had been at the bottom of Burke's draconian treatment of ministers' salaries in the Civil List Act.

According to Shelburne, fee-funding was never intended to be anything but a temporary expedient to be employed while an impartial examination was made of the offices,[2] and until (though he did not specify this) the Civil List was in condition to bear the burden of the additional salaries made necessary by the suppression of fees. Pitt's Commission on Fees in 1786 approved of its use under these circumstances. But requiring official salaries to bear the burden of deficiencies in the fee fund was impractical and unjust since it would have ensured a chronic shortage in the salaries of the Treasury establishment. Fortunately Lord John Cavendish, in his Exchequer Regulation Bill of 1783, placed the burden on the Civil List and the unappropriated part of the sinking fund.

Regulation of the abuse of stationery at the Treasury was part of the reform of incidental payments. The abuse was clear enough. Stationery bills for 1781 had totalled more than £4,700 and included £2,387 15s. 5d. incurred on behalf of North and his secretary. Some of this was attributable to the usual wartime inflation of prices and the weakness of Treasury control over contractors, but some was due to the carelessness of North and the carelessness or calculation of William Brummell, the Treasury clerk responsible for ordering stationery.[3] Shelburne's Treasury ordered that the usual allowances for stationery be made to the Usher of the Receipt of the Exchequer (Horace Walpole) until his office was suppressed in compliance with the Commons' resolution of June 17, 1782. But they also ordered that no stationery, other than that on official schedules, be delivered to the Treasury except by written order of a Secretary or the Chief Clerk. Schedules were authorised strictly defining stationery, specifically excluding such items as the

[1] Treasury Minutes November 30, 1782, February 25, 1783, Shelburne Papers, vols. 163, 164.
[2] Fitzmaurice, op. cit., II, 226.
[3] Shelburne Papers, vol. 124. Some of the prices were apparently those of the early 18th century when paper and parchment were very expensive (cf. Fitzwilliam MSS, Rockingham 118–14, 16, 17).

supply of newspapers to Treasury officials, and limiting expenditure on legitimate stationery.[1]

Walpole, as Usher of the Receipt, had been the principal beneficiary of the old system and hence was the principal loser by the new. To do him justice he had been prepared to accept his loss philosophically. When the House resolved that the Ushership should be put on the road to extinction he had written to Shelburne that he would be content with whatever the regulation left him, insisting only that his deputy and clerk should be provided for. At this point he was willing to support Shelburne because Conway supported him, because Shelburne might secure peace, and because he hoped to preserve the Ushership intact for his own lifetime. But contemplation of the office in its unreformed luxuriance excited Shelburne's most puritanical sentiments.

> What can be so inconsistent with every principle of economy [he wrote in later life] as to have the right of supplying several offices with stationery for ever, sold at public auction, and bought like a freehold estate, to be let out afterwards by the owner to the highest bidder, or in other instances, granted for one, two, or three lives?[2]

The axe fell in January 1783 at a time when Conway had begun to drift uncertainly toward the Coalition. The cumulative effect of the reform and Conway's change of heart was that Walpole drifted with him and in his *Last Journals* wrote a classic villification of Shelburne that was the starting point of much of the retrospective propaganda against Shelburne's Ministry.[3]

The reform of the Lower Exchequer was characterised by a confusion of aims that was the product partly of the complexity of the offices concerned, and partly of the rivalries of successive reformers. The Commissioners for Examining Accounts discovered that the Lower Exchequer's obsolete paraphernalia for protecting its cash — notably the Tally Court — was still fully established and remunerated even though that cash was now deposited in the Bank. They recommended suppressing the offices of the Chamberlains, the Tally Court, the Usher and second clerks to the Tellers,

[1] Treasury Minute January 7, 1783, Shelburne Papers, vol. 124; cf. James Woodmason's Proposal for Saving Stationery, January 5, 1783, Chatham Papers, vol. 231. Shelburne recalled later that 'several articles of household furniture were had in many instances through the medium of patents; each article paying 40 per cent tax to the Usher of the Exchequer, besides the enormous profit of the patentee' (Fitzmaurice, *op. cit.*, II, 226). [2] *Ibid.*

[3] Walpole, *Letters*, XI, 236–9, XII, 308–9, 314–15, 321, 411, XIII, 420; *Last Journals*, II, 465–7.

and reducing the number of Tellers from four to one. They urged that if the Tellers were to be maintained in their offices then at least their profits should be reduced to a reasonable standard, and that in any case all fees and poundage collected in the Exchequer be abolished.[1] The House of Commons' resolutions of June 17, 1782 watered down these recommendations. Only the offices of Usher, Chamberlains and Tally Cutter were ordered abolished, and, since property rights must be respected, only after the death or removal of the persons in possession or with reversionary interests in the offices. As it happened this qualification (since it was adopted in subsequent regulations) was to postpone the over-due abolition of the Lower Exchequer until 1834. The House also agreed that the emoluments of the Auditor, Clerk of the Pells, Tellers and Usher of the Exchequer were excessive and ought to be regulated. Further reform, since it was the end of the Session, was postponed until the next Session. Meanwhile the Treasury, through its power to fill vacancies on the basis of fixed salaries rather than fee incomes, could extend the application of the Commissioners' principles.[2]

Shelburne's reforms, which he prefaced by ordering an outline prepared of the functions and course of office in the Treasury and Exchequer,[3] went further than the parliamentary resolutions. He proposed to replace the profits of the Auditor of the Receipt — which in 1780 had been more than £14,000 and in peacetime were at least £7,000 — with a salary of £3,000; the Clerk of the Pells was to be reduced from £7,600 to £2,000; and the Tellers from £6,700 each to £1,500, out of which they should pay whatever deputies they might need. The offices of the Chamberlains, Tally Cutter and Usher of the Exchequer were to be abolished after the deaths of the possessors and those with reversionary interests. In the case of the Usher the regulation of stationery had already seriously reduced the profits of the office. Only one category of fees — those on government loans — was to be abolished outright;

[1] *Commons Journals*, vol. 38, 702–14. For the reaction of Lord Hardwicke and his deputy Teller to the Commissioners' enquiry, see Add. MSS 35,402, fos. 240–3, 264–7, 281–4. For accounting procedure in the Exchequer, see Appendix I, *infra.*, p. 445. [2] *Parliamentary History*, XXIII, 120–1.

[3] In submitting his accounts to the King in April 1783 Shelburne wrote that he had hoped to have prepared a classification of the Treasury's business, but that it was not finished on time (Fortescue, VI, no. 4287). Two of the documents referred to are probably the booklet entitled 'The Business Done in the Treasury' (Chatham Papers, vol. 231) and 'The Business of the Receipt (or rather Cash) Office' (Shelburne Papers, vol. 124).

the rest were to be consolidated in a fund for the payment of salaries of clerks on the Exchequer establishment.

These reductions were too severe for either the Commissioners for Examining or the Coalition Ministry, and fee-funding went against the recommendations of the Commissioners. When Shelburne submitted his plan to them for comment they criticised him for failing to suppress the offices of the second clerks to the Tellers and to consolidate the Tellership, and for singling out for suppression the fees on government loans, apparently without considering that the major part of the income of the Lower Exchequer offices came from the issues of money rather than receipts.[1] In making these criticisms the Commissioners overlooked the financial pressures that were at the bottom of Shelburne's fee-funding, and failed to take account of the fact that he had specified the abolition of fees on government loans as part of his regulation, not of the Exchequer, but of the management of loans. In any case Shelburne's drastic reduction of the profits of office would have made it largely irrelevant whether fees on issues or on receipts were specified for suppression. But his plan was not implemented before his Ministry fell, and Cavendish, in his Exchequer Regulation Act, followed different principles.

Outside the Treasury structure, the enquiry revealed a bewildering variety of fees and patent offices and a wearisome similarity in their operation. Overburdened and underpaid clerks took a great many official and unofficial douceurs for doing after office hours such work as registering documents, cashing bills, checking accounts, telling money and calculating duties and taxes which should have been done by regularly-salaried full-time clerks during office hours. The large service departments, where the biggest money was to be made, had already been the object of reforming attention: Burke's Act had funded fees at the Pay Office and Barré's subsequent Act would soon abolish them altogether; and at the Admiralty, though pluralism had been increasing steadily since the beginning of the century, office incomes from salaries and fees had been considerably reduced.[2]

[1] Inspection into Certain Offices in the Exchequer; with Remarks on the Regulations Proposed Therein by the Commissioners of Accounts, Shelburne Papers, vol. 166.
[2] An Account of the Offices and Emoluments under the Crown in the Naval Service ... 25 October, 1705 ... and 15 February, 1779; An Account of the Amount of Fees which have been Received ... by the Secretary and Clerks of the Admiralty in the Years 1779, 1780 and 1781, Shelburne Papers, vol. 138.

Reform at the Navy Board was undertaken on the highly individual lines dictated by the Comptroller, Sir Charles Middleton. A fanatic for efficient administration whose professional sensibilities were supplemented by strong evangelical religious principles, Middleton had a profound conviction that no subject to do with the Navy or administration was outside his ambience. But he had no conception of achieving his purposes by the political arts, and his Roman virtue palled on Sandwich and Mulgrave whom he was constantly reproving for inattention to duty, pork-barrel politics, failure to keep service matters secret and professional incompetence. He particularly objected that the Admiralty lacked the necessary professional knowledge, and urged as the only and necessary corrective the appointment of the Comptroller to the Admiralty Board.[1] His opinion of Shelburne was even worse,[2] but he turned in desperation to him in the face of Keppel's stubborn resistance to reform. On September 9, 1782 he sent a long disorganised memorandum to Shelburne reviving his proposal to appoint the Comptroller to the Admiralty (more necessary than ever in view of Keppel's apparent incompetence) and included plans for reforming supply and strategy, replacing sinecure offices with pensions, perquisites with money grants and fees with salaries, drawn if necessary from fee funds.[3]

But when, a fortnight later, he received a Treasury order to submit accounts of fees and other irregular emoluments collected in his office preparatory to a Treasury reform of them, he balked, reporting with technical accuracy that no fees were collected. On closer examination the Treasury discovered a wide range of customary gifts, premiums on the appointment of clerks, perquisites such as houses, unwarranted allowances for attendance at payments in the Navy Office and the dockyards, and poundages collected by the Commissioners and their subordinates. The salaries of the clerks had been kept low in the expectation that they

[1] *Sandwich Papers* (London, 1938), III, 179–80, 369–75, IV, 374–80; *Letters of Barham* (London, 193), II, 3, 5–8, 11–36. In later life Middleton recalled: 'Lord Sandwich was no worse than those who followed him in my time and more zealous for the improvement of the service . . .' (*Letters of Barham*, II, 10).

[2] 'There appears to me to be no decision in the Cabinet; the members are too many for conducting the national business. The first minister, as far as I have seen, has not weight enough for his station, nor abilities to conduct it; as a man of business he wants method and application; as a minister, he wants knowledge of the line he had undertaken; and being without weight, can carry no plan into execution' (*ibid.*, II, 56).

[3] Shelburne Papers, vol. 151.

would receive such additional benefits. Shelburne now proposed to double the salaries and abolish the gratuities altogether.[1]

Both Middleton and his clerks objected. To do them justice they were not being merely obstructive. They had borne the main burden of work in the enormous wartime expansion of the Navy and in their view the unofficial gifts — at rates varying from 10s. 6d. to one guinea per £1,000 — though they had increased five-fold in wartime were barely adequate recompense for work which had increased a good deal more than five-fold. For the past four years, moreover, the Navy Board had managed the transport service for the Victualling and Ordnance Boards for which the Treasury made additional allowances to them. The service was the most difficult department in the Navy to manage and the most criticised. The clerks complained constantly of being overworked and underpaid, and the flame of incipient mutiny that ran among them was continuously fanned by the circumstance that the perquisites of the service, amounting to more than £20,000 annually, went to the functionaries of the Victualling Board, who no longer did the transport business.[2]

Middleton's objections to Shelburne's proposals were the practical administrative ones which had so far frustrated any reform of the fees. Only the senior clerks really profited by gratuities, he argued, but it would be unfair to abolish them when the junior clerks had served faithfully in expectation of succeeding to them. Raising salaries in compensation, however, would force a round of salary demands throughout the government offices and it was doubtful if fee funds could support the increases. To abolish the premiums received by Commissioners on the appointment of clerks would be only a moderate, and certainly a misguided, saving. The attention and probity of the Commissioners was a sufficient guarantee of the honesty of clerks, and the suppression of gratuities (directed against little people) should have been preceded by a

[1] Allowances made to the Clerks of the Pay and Navy Offices . . . , Thomas Davies to Middleton, October 5, Robert Gregson to Shelburne, September 22, 27, 'Candour and Propriety' to Shelburne, October 9, December 30, 1782, January 27, 1783, to Middleton, January 17, 1783, *ibid.*

[2] Davies to Middleton, October 5, 1782, *ibid.*; John Robinson to Commissioners of the Navy, March 13, 1779 (copy), Particulars of £3,250 in Allowances made to the Members of the Navy Board and their Clerks (copy), October 7, 1779, *ibid.*, vol. 145; An Account of all such Fees, Gratuities and Perquisites as have been received by the Officers and Clerks in the Several Departments under the Management of the Victualling Board, November 11, 1782, *ibid.*, vol. 129.

suppression of sinecure offices (directed against big people). The clerks were being 'singled out as a mark of reform' that would, he warned, make enemies for Shelburne without serving any useful purpose, 'and a defeat in the first instance will endanger the whole fabric'. The Navy Board clerks had been pacified thus far only by Middleton's promise that the various accounts of gratuities in office would be sent separately to the Treasury, that no attempt would be made to correlate them and that the Treasury would not publish them.[1] This may have been what Shelburne had in mind when he wrote in later years of the resistance to his reforms:

> The course was, first, to try to laugh it down; when that did not do, to call it personal revenge, then Republicanism; and in all events to gain time by retarding as much as possible.[2]

In spite of his doubts and the opposition of his clerks, Middleton nevertheless prepared a plan for fee-funding in the Navy Office. He proposed unduly harsh penalties and gave rather too large an incentive for informers. He also suggested including his proposals for the appointment of the Comptroller to the Admiralty and for centring patronage in his own hands among the parliamentary regulations of public offices to be announced in the King's Speech of December 1782, and was even ready with a draft of a public offices bill for Shelburne's approval.[3] Shelburne had no intention of adopting Middleton's schemes and the fall of his Ministry relieved him of the necessity of saying so. Pitt was not so lucky. Six years later the Commission on Fees, though they recommended the abolition of all perquisites at the Navy Office except the taking of odd pence, joined the perverse legion of those who did not appreciate Middleton's schemes. But Middleton did not know this, and when Pitt refused to publish the Commissioners' findings he finally carried out his repeated threat of resignation.

In the case of the revenue offices such conflicts with the Treasury were popularly supposed to have encouraged the growth of abuses, though in fact they were more apparent than substantial. The acknowledged corruption of Customs officers and the general failure to suppress smuggling were attributed by contemporaries

[1] Middleton to Shelburne, September 26, 1782, *ibid.*, vol. 151.
[2] Fitzmaurice, *op. cit.*, II, 225.
[3] Middleton to Shelburne, October 16, 17, 24, December 6, 19, 1782, January 7, 18, 27, 1783, Shelburne Papers, vol. 151.

(and by some later historians)[1] to the wide powers of patronage exercised by the Treasury which the Customs Board more or less unsuccessfully, and the Excise Board more or less successfully, strove to resist.[2] This fitted with the propaganda, associated with the passage of Crewe's Act, that pictured revenue officers as the agents of Treasury influence, and with the country gentry's hostility toward the Treasury for encroaching on the powers of the local Land Tax commisioners.

But Treasury influence was not nearly so corrupting nor so overwhelming as was supposed. Though Treasury patronage resulted in appointments to the revenue offices varying from political pensions and sinecures to the advancement of professional administrators, the professional administrators set the pattern at the larger boards, and such beneficiaries of patronage appointment as Sir William Musgrave at the Customs and John Pownall, William Stiles and Stamp Brooksbank at the Excise were Shelburne's most active coadjutors in reform. Despite the dark suspicions and outright accusations of political influence in the various departments made by a great many anonymous and pseudononymous correspondents (who almost invariably turned out to be dismissed revenue officers) the evidence of payment for political services was very small.

> Very few of the Employments (exceeding £200 per annum) [wrote Sir William Musgrave to Shelburne concerning the situation in the Customs] have been given to any persons for their support of Government, but have rather been bestowed upon Relations, Friends and Dependents of the Minister for the time being. . . .[3]

Far from securing the interests of government, many of the lesser appointees were seldom at their posts to exercise either influence or vote and in any case their influence, as Miss Kemp has shown, could hardly have been decisive.[4] Musgrave felt it necessary to advise Shelburne in 1782 to take the disposal of patronage even more out of private hands and into those of the Treasury 'to

[1] Cf. Elizabeth Hoon, *The Organization of the English Customs System, 1696–1786* (New York, 1938), 16–25, 45–55, 195–203; Edward Hughes, *Studies in Administration and Finance, 1558–1825* (Manchester, 1934), 266–316.

[2] Hoon, *op. cit.*, 45–55, 197–201; Commissioners of Excise to the Duke of Newcastle, October 13, 1757, November 25, 1761, to North, June 7, 1770, November 26, 1772, January 20, 1774, Shelburne Papers, vol. 119.

[3] Musgrave to [Shelburne], December 10, 1782, Fortescue, VI, no. 4016; cf. W. R. Ward, 'Some Eighteenth-Century Civil Servants: The English Revenue Commissioners, 1754–98', *E.H.R.*, vol. 70, 25–54.

[4] Betty Kemp, 'Crewe's Act, 1782', *E.H.R.*, vol. 68, 258–63.

P

strengthen and enlarge the proper influence that Government ought always to have'.[1]

At the larger boards the Commissioners possessed the ultimate sanction of dismissing officers for cause; they could exercise patronage by accepting or rejecting recommendations made by persons or agencies other than the Treasury; they could 'desire' or 'request' the Treasury to make appointments by patent, constitution or deputation. Their power to control subordinate officers was also not as inadequate as they sometimes complained it was. Their authority over the Bench Officers in the London offices of the Customs and Excise was established. In 1774 Thurlow, as Attorney-General, had reassured the Customs Commissioners that they had authority to regulate patentees and that patentees could be held responsible for the behaviour of their deputies on pain of revocation of their patents by process of *scire facias*. This interpretation was successfully tested only in 1782–3 when Attorney-General Kenyon, on Shelburne's instructions, threatened the Duke of Manchester, patent Collector of Customs Outwards for the Port of London, with revocation of his patent on the ground that it had been granted to his ancestor by Charles II only by dispensing with the acts of the reigns of Richard II, Henry IV and Henry VI forbidding the granting of any patent except during pleasure, and forbidding the conversion of any patent into a sinecure.[2] In 1778, moreover, the Treasury had agreed to require officers appointed by their constitution to render strict obedience to the various commissioners. Even granting that Treasury interference from time to time was inhibiting, the revenue Commissioners cannot be exonerated from the charge of neglecting to enforce their authority.

It was also unlikely that left to themselves the revenue Commissioners could have carried the reform of their offices very far. Their correspondence shows that, with a few honourable exceptions, their enterprise seldom went further than strictly departmental schemes, and that they had little appreciation of the fact that

[1] Musgrave to Shelburne, October 10, 1782, Shelburne Papers, vol. 114.

[2] Cf. 14 Richard II, c. 10; 17 Richard II, c. 25; 1 Henry IV, c. 13 and 31 Henry VI, c. 1; Memorandum of Grants made in 1762 and 1782 of the Office of Collector Outwards in the Port of London to the Duke of Manchester; Lloyd Kenyon to Shelburne, January 26, 1783, Musgrave to Shelburne, March 15, 1783, Shelburne Papers, vol. 114; Manchester to the Commissioners of Customs [January 1783], Chatham Papers, vol. 284; Treasury Minute, January 25, 1783, T 29/53, fo. 54; Thurlow to —— [probably Shelburne], January 4, 1783, H.M.C., *Kenyon MSS*, 512–13.

suppressing fee incomes meant an immediate increase in the cost of administration through compensating salaries and pensions. Suppression of fees, in fact, depended upon increasing the yield of the revenues under Treasury direction. Far from being wholly corrupt and pernicious, the steadily increasing influence of the Treasury clearly represented a necessary centralisation of authority over all financial administration without which no coherent reform could be accomplished.

It was equally clear that the establishments of both Customs and Excise needed reforming.

> Every person who has made the least enquiry about the Customs [wrote Musgrave to Shelburne] must have heard that there are many useless sinecure places which ought to be suppressed for the benefit of the revenue, and the First Lord of the Treasury who shall have virtue enough to adopt such a plan, will be the most meritorious of public approbation.[1]

He was determined that Shelburne should be thus distinguished. In his plan of reform, submitted to Shelburne in November 1782, he proposed to abolish sixty-four pure sinecures and the places of seventy-two sinecurists who held offices of business. He hoped that savings to the revenue of £15,858 7s. 4d. in salaries, and to the public of £36,807 in fees might thus be made. In addition he expected enormous savings in efficiency by the removal of absentee patentees who had hitherto controlled the appointment of their deputies, and of inadequately trained deputies hitherto protected by their principals.[2]

In their place he proposed the appointment of only six categories of officers — Collectors, Comptrollers, Landing Surveyors, Landing Waiters and Searchers, Coast Surveyors and Inspectors of Revenue, and Coast Waiters and Tide Surveyors. These would hold their places not by patent, but by warrant during pleasure, and would be subject to advancement from category to category by merit, thus ensuring that the highest posts were held by properly-trained officers. Hitherto the Commissioners had attempted to

[1] August 15, 1782, Shelburne Papers, vol. 114.
[2] Musgrave to Shelburne, October 6, 1782; List of 64 Useless and Obsolete Offices or Employments which are Proposed to be Abolished; List of 72 Employments in the Customs which have been converted into Sinecures by the Grantees . . . ; enclosed by Musgrave to Shelburne, November 20, 1782, ibid.; Same to same, December 10, 1782, Fortescue, VI, no. 4016; Hoon, op. cit., 221–7.

mitigate the fee system and its concommitant of low salaries by making additional allowances to the officers for good service and, since 1781, by sharing out among them the Crown's share of fines and forfeitures and the proceeds of the sale of seized goods. Musgrave proposed to replace these with regular salaries ranging from £800 for the Collector Inwards of London to £40 for Coast Surveyors and Waiters at the eighteen smallest outports.[1]

At the Excise the fees were apparently lower, though hardly less varied. In 1782 the Commissioners reported that they thought the bulk of them belonged to the category of unofficial gifts granted by stationers, brewers and other tradesmen without the knowledge of the Board. The legal fees were almost negligible, only those paid to the secretary's office for affidavits amounting to more than £100 a year. The number and variety of useless offices, too, were quite small. The Commissioners, Stamp Brooksbank and John Pownall, in separate representations to Shelburne, identified only the offices of the five Commissioners, Register, Doorkeeper and Messenger of the Appeals Office and the Solicitor of Excise as useless and fit for suppression; and only the Comptroller General, the Comptroller of Cash, Auditor of Excise, Auditor of Hides (the last two complete sinecurists, since the Commissioners of Excise did their own auditing),[2] Register to the Commissioners, Inspector of Inland Duties and one Housekeeper as patent or warrant offices of business where the principals ought to be removed as useless, at a total estimated saving to the public in salaries of £4,630 14s. In Scotland it was reckoned that £7,000 might be saved in salaries.[3]

It was one thing to plan such reforms but quite another to effect them. With the greatest goodwill in the world on the part of the Ministry — and Shelburne's appointment of the efficient

[1] Plan for Vacating Certain Unwarrantable Grants and for Abolishing Various Useless and Obsolete Offices in the Customs . . . , Musgrave to Shelburne, November 20, 1782, Shelburne Papers, vol. 114.
[2] The Auditorship of the Hides had been abolished already by Burke's Civil List Act and the deputy Auditor, who was also the efficient Auditor of Excise, continued for almost another twenty years to perform the functions of both offices (Binney, op. cit., 38, 41).
[3] An Account of all Fees, Perquisites and Gratuities taken by the Officers in the Department of the Public Service under the Management of the Commissioners of Excise . . . ; Commissioners to Rose, December 7, 1782; An Account of Such Places, Patent or Other, which are Sine-cures, or of so small Business as to require little or no Attendance; Schedule of Fees &c. . . . taken by Officers in the Department of the Public Service under the Management of the Commissioners of Excise . . . , Shelburne Papers, vol. 129; Brooksbank to Shelburne, December 28, 1782, ibid., vol. 119; Robt. Gordon to Shelburne, November 9, 1782, ibid., vol. 119.

William Stiles as Secretary of the Excise was certainly an earnest of that[1] — permanent reform of fees and establishments depended on being able to find the money to support it and on the co-operation of Parliament in passing the necessary legislation. Shelburne promised in the Speech from the Throne in December 1782 to present it; the Treasury, on the basis of the reports on fees and establishments, drafted an act for regulating them in the Treasury, Exchequer, Admiralty, Navy Office, Victualling Office, Ordnance, Excise, Stamp, Salt, Hackney Coach and Hawkers' and Pedlars' Offices;[2] Musgrave's draft was adopted for the Customs; and both were to be presented to Parliament, according to Shelburne's intention, in the wake of the victorious passage of the Peace Treaty. They might have been presented earlier, might have been ready, indeed, before the fatal vote on the peace came on. But they were not. 'For the want of a nail the shoe was lost.'

The flaw lay in the very comprehensiveness and interdependence of the reforms. In both the service and revenue departments the attention of the reformers had been diverted as, in each case, the fee enquiry merged into other enquiries for other reforms: in the service departments into the reform of accounting and expenditure; in the revenue departments into the reform and increase of revenue collections without which, it was certain, the costs of reforming establishments and of government itself could not be met.

[1] Brooksbank to Shelburne, January 28, 1783, *ibid.*, vol. 119.
[2] Treasury Minute, November 30, 1782, Shelburne Papers, vol. 163.

Administrative Reform II: Reform of Accounting, Expenditure and Revenue

Reform of accounting was already well advanced when Shelburne turned his attention to it. It had been before the public at least since 1776 when war, and its companion waste, had first enabled the Opposition to get a hook into the administrative leviathan. Since then they had enlivened every Session of Parliament with attacks on the Army Extraordinaries, the contracting system or the returns of the public accounts. But after 1780 these subjects had been dealt with by the Commissioners for Examining the Public Accounts in such an apparently comprehensive and competent manner as to deprive rival reformers of most of the political advantage that they might have expected to reap from their pioneering criticisms. In 1782 it might have seemed to Shelburne that it was left to him only to follow in the Commissioners' footsteps, correcting their mistakes and supplying their omissions.

In reforming the establishments in the Exchequer, he did, indeed, confine himself to the Lower (or administrative) branch where the Commissioners had been before him; but curiosity about the returns of the sheriffs aroused during his examination of the Crown Land revenue establishments soon carried him on to the Upper (or judicial) branch and to considering the fundamental conflict between the principles of judicial and administrative audit.

The sheriffs' accounts were a microcosm of that conflict. Sheriffs were personally accountable as the ultimate debt collectors for enforcing the writs of *distringas ad computandum*[1] and more

[1] This writ provided for the distraint of goods of the accountant pending the return of his accounts.

extreme processes culminating in the Long Writ of the Exchequer against defaulting collectors of the Land, Window and House Taxes and First Fruits and Tenths. They were direct collectors of the casual revenues of the Crown Lands, Issues of Green Wax,[1] Post Fines,[2] Goods and Chattels of Felons and Deodands.[3] They also made the formal Proffers[4] which provided the occasion for their being summoned to accounting. They were summoned, not by the King's Remembrancer like other accountants, but in conformity with their oath of office requiring them to make their Proffers in elaborate biennial oral examination, called the apposal, before the Barons of Exchequer.[5] By the Summons of the Pipe and the Summons of the Green Wax they were ordered to explain whether or not they had collected the debts scheduled in the summons and to pay what they had collected. They were not required, that is to say, to show that the accounts were correct as in the submission of 'Declared' or institutional accounts under administrative audit, but to show that they themselves were personally honest. If they failed to make their Proffers, failed to appear on the appointed day, or went away without leave, they were in contempt of court and liable to arrest under writ of *capias in manus nomine districtionis* which required the seizure of their persons by the Marshal of the Exchequer Court. Thus in theory the personal honesty of the sheriffs and the authority of the Courts were maintained, and the King's debtors forced to pay on pain of seizure of goods or, in extreme cases, of person.

In practice it was very different. The shortcomings of the system were vaguely known, and both Burke in his Speech on Economical Reform, and the Commissioners for Examining in their First Report, made passing reference to them. In the autumn of 1782 Shelburne appointed Francis Russell, Surveyor General of the Duchy of Lancaster, to study the whole office and its

[1] Forfeited recognizances, fines and issues of the Courts of Justice.
[2] Fines payable as the Crown's fees in the feigned litigation in the Court of Common Pleas, called the 'levying of final accord', by which title in real estate was anciently transferred.
[3] Personal chattels which having been the immediate occasion of the death of a person (e.g. a kicking horse) were forfeited to the Crown to be put to pious use. In the eighteenth century it was not a considerable item in sheriffs' accounts.
[4] Fixed immutable payments made by the sheriffs to the Exchequer and originating in the advance on taxes demanded by government before sheriffs' accounts could be passed. By the eighteenth century these were a formality and were automatically credited to the discharge side of the sheriffs' accounts.
[5] Sheriffs of Wales and the Palatines of Chester, Lancaster and Durham accounted before the Auditors of the Land Revenue.

revenues.[1] His report constitutes the most extensive study of the
sheriffs between Sir Matthew Hale's *Short Treatise on Sheriffs'
Accounts* of 1683 and George Price's *Treatise on the Law of the
Exchequer* of 1830.

Russell discovered that the sheriffs seldom undertook personally
to enforce collection, but delegated their authority to under-
sheriffs and they to bailiffs. The latter — unsworn, unqualified and
underpaid — were especially likely to succumb to temptation, and
with suspicious frequency certified that debtors had no goods to be
seized under *distringas*. Their certificates were eventually referred
by the sheriffs to the Barons of Exchequer in support of their
apposals. When it came to processes against debtors, few town
clerks sent in estreat rolls, few sheriffs enforced processes (pound-
age rates were too low to provide much incentive), and when they
did the effect of *capias* or the Long Writ was too often merely the
perpetual imprisonment of an insolvent debtor. Worse from the
point of view of efficient administration, the Receivers General of
the Land Tax who were supposed to act as a check on the sheriffs,
usually left their offices to be performed by deputies. In many cases
these deputies acted as sheriffs' deputies in performing the
apposals before the Exchequer. Even the writ of *capias* for the
sheriff's non-attendance was not enforced, but was usually com-
muted for a nominal fine of three shillings and fourpence. It
followed that the accounting of sheriffs was a farcical and, since it
required the statutory appropriation of £4,000 from the Civil List,
an expensive formality.

Russell pointed out in his report that the original purpose of the
accounting — securing the collection of the debts owed to the
King — was not being accomplished; nor was the somewhat
secondary aim of preventing the oppression of the subject by
prohibiting the attachment of the body of the debtor when seizure
of his goods was possible. The fault lay partly with the requirement
for the sheriffs to account directly for casual revenues. The com-
plexity and expense of the combined procedures, and the conse-
quent failure to enforce either, resulted in the laws and the dignity
of the courts and the Crown being flouted.

To correct this Russell proposed in a draft act to relieve the

[1] Shelburne also employed him to draft legislation to provide temporary relief
for the East India Company in 1783 (Treasury Minute, March 18, 1783,
Shelburne Papers, vol. 164; cf. Sutherland, *East India Company in Eighteenth-
Century Politics*, 374–5).

sheriffs of the necessity of passing an account by transferring the collection of the casual revenues to the four senior sworn attornies of the Pipe, the Surveyor of Green Wax and the Registrar of the Land Revenue under the general authority of the Land Tax Commissioners. The sheriff would henceforth be apposed only once a year and be bound in *propria persona* to give account of, and be charged with, all debts for which he had received process but for which he had not levied it. He would be regularly authorised to appoint a representative (so long as the representative was not already an officer of the revenue) to make his apposal; his poundage would be more generous than before; and the Barons of Exchequer would be empowered to change the date of apposal on reasonable excuse. The Barons, and in some cases the Justices on Assize, would be authorised to discharge small or hopeless debts and to release Crown debtors after six years' imprisonment. Procedure was also to be simplified. The Exchequer would no longer be obliged to suffer the delay of having to issue *capias* or Long Writ after *distringas* had failed in its effect. The new process would be by Long Writ only, authorising the sheriff to distrain, if necessary, successively the goods, the land and the person of the debtor. The functionaries whose offices would be suppressed as a result of such simplifications would be compensated out of the £4,000 voted for sheriffs' accounting.[1]

The most important effect of the proposed reform — which Russell noted had already been urged by Sir Matthew Hale — would have been to place the casual revenues in the category of declared accounts while concentrating the sheriffs' attention on the duty of debt collection where the principle of personal responsibility had some relevance. But Shelburne, though approving the report and its principles, was too preoccupied with the collapse of his administration to pursue the matter further and not until 1834, with the final abolition of judicial audit, were these vestiges of medieval accounting theory eliminated.

Shelburne was more immediately concerned with reforming the procedures of administrative audit. Here there was a sharp division

[1] Report Concerning the Revenues of the Crown in the Collection of Sheriffs in England and Wales and the Manner of their Accounting in the Exchequer, with Plans for the Increase of those Revenues, and Retrenchment of the Present Expences of Accounting for them, February 15, 1783 [by F. Russell]. Addressed to the Earl of Shelburne, Shelburne Papers, vol. 122; cf. A. L. Cross, *Eighteenth Century Documents Relating to the Royal Forests, the Sheriffs and Smuggling* (New York, 1928), 165–233.

of opinion. Officials in the accounting and auditing departments tended to maintain that existing regulations were adequate and what was required was to strengthen the enforcing process. The Board of Taxes in November 1782 blamed the slowness of their returns on the ineffectiveness of the existing process of *scire facias* (or requirement to show cause why payment should not be made) and recommended the use of *distringas* or the Long Writ.[1] Similarly Lord Mountstuart, the Auditor of Imprest, when first the Commissioners for Examining, and then Shelburne, drew attention to the slowness of his audit, blamed the sheriffs for their non-enforcement of *distringas*, *distringas* for being less effective than the Long Writ, the Treasury for not authorising the Long Writ — and in fact almost everyone and everything rather than accept blame himself. The Commissioners for Examining recommended that most of his auditing function could be suppressed with benefit to the nation.[2] Shelburne also decided against the Auditor. He suggested (nearly a year before the Commissioners for Examining did the same) that the office be gradually abolished as it became possible to copy in the other offices of government the internal administrative audit undertaken at the Navy, Ordnance and Excise Boards. Like the Commissioners later, Shelburne argued that patent rights of the Auditors should not be allowed to stand in the way of public interest.[3]

In the larger departments accounting faults were due more to the complexity and size of the operations than to conflicts of principle. The Excise was almost entirely free of such shortcomings and was frequently praised as the most efficient of the revenue departments. But its remittances and accounting were both made much simpler than in the other departments by the circumstances that the duties were easy to collect and hard to evade, and the accounting was made to the Commissioners of Excise rather than to the Auditors. The Customs, however, was divided into seventy-four widely varying accounts. Neglect on the part of patent sinecurists had allowed accounting in most of them to run into arrears for five or six years. Office regulations recently had shortened the arrears to two years,

[1] Report Respecting the Defects in the Laws at Present in Force for the Collection of the Revenue under the Management of the Board of Taxes, to the Treasury, November 16, 1782, T 1/577, fos. 198–9.

[2] Mountstuart to Shelburne, February 12, 1783, Shelburne Papers, vol. 168, Part I; *Commons Journals*, vol. 38, 1066–73, vol. 39, 45–57.

[3] Shelburne to Pitt, February 27, 1783, Bowood MSS; *Commons Journals*, vol. 39, 779–80.

and more recently still better practice had shortened it to one; but as the Finance Committee of 1782 had remarked, there could be no effective remedy until the various revenue accounts were consolidated.[1]

In the armed service departments the question of reforming accounts became merged with the more fundamental one of the control of expenditure. The Opposition and the independents frequently reminded the government that they must respect parliamentary appropriation, and were constantly casting about for ways of strengthening it. But Parliament's distrust of the government and its parsimoniousness in supplying the armed services, even in wartime, forced the services to extend their anticipations of supply by means of a variety of credit expedients. These were principally the 'In Course' and 'Ready Money' bills and debentures of the Navy and Ordnance Boards and the Extraordinaries of the Army. The unfunded debt of the Navy and Ordnance mounted rapidly, to be funded from time to time by Parliament. The Army Extraordinaries were voted by Parliament annually, and were invariably the occasion for a squabble between the Ministry and the independents. Over this situation the Treasurers of the Navy and Ordnance, who were merely accountants to their respective boards, had very little control.[2] The Paymaster-General of the Army, on the other hand, had absolute control over issues to meet the needs of the Army. Since he alone had any clear idea of those needs, his estimates were made independently even of the Treasury, and he could accumulate balances in his hands as he judged necessary for meeting them. Some of the unprovided services — Chelsea Hospital, Widows' Pensions, clothing funds and contingencies — were paid out of poundage on regular issues or by fictitiously increasing the establishments of companies and regiments. When they were in Opposition, Shelburne and his friends thought the cure was to be found in a more detailed parliamentary appropriation and bringing accountants to book before Parliament. After they came to power they slowly realised that the control might be most effectively exercised by auditors acting under the joint authority of the Treasury and Parliament.

[1] Report from the Committee of the House of Commons on the Account of Sums Raised by Annuities . . . 5th July, 1782, *Reports from Committees of the House of Commons* (London, 1803), XI, 5, 15–18.
[2] An attempt by the Navy Board in 1772 to rationalise its estimates and include what were now contingencies in regular accounts was blocked by the Admiralty (Navy Board to the Admiralty, November 24, 1772 (copy), Shelburne Papers, vol. 138).

Their slowness to arrive at this conclusion is explained by the fact that the Treasury possessed no control over the departmental estimates (except that of reviewing the regular, though not the Unprovided, estimates of the Ordnance), and by the fact that accounting procedures were very slow and complicated. Books of ships on foreign stations and of regiments on extended foreign service necessarily took years to make up and close; and the established principle of the personal responsibility of public accountants ensured that these officers took out of office with them the books and accounts, the balances and the responsibility for dispensing them, so that their terms of office were prolonged into retirement and even beyond the grave. The delay in securing the necessary *quietus* from the Exchequer was extended by leaving the preparation of back accounts to the overworked clerks in the various offices of account as a part-time or after-hours task. A further delay was created by the antiquated 'course of office' in the Auditors of the Imprest's department, whereby no books of any accountant could be audited until those of his predecessor were closed. Some accounting procedures appeared to be useless. The Commissioners for Examining discovered that the audit of the Treasurer of the Navy's accounts by the Auditors was a mere formality since the Treasurer was excused by Order-in-Council from submitting vouchers which had already been examined by the Navy Board whose verification the Auditors accepted.[1] Similarly they relied on the Ordnance Board to verify the Treasurer of the Ordnance's accounts.

Reform began with the first four reports of the Commissioners for Examining and North's act to require *inter alia* the armed service paymasters to pay specific balances into the Treasury within a space of three months from their determination. But the act was more honoured in the breach than in the observance, and when the Rockingham administration came into office in 1782 the accounting system was still substantially untouched.

The first effective attack on it was made by Lloyd Kenyon, the Attorney-General. A protégé of Thurlow, Kenyon had deserted to the Opposition in 1781 and was now carving out a place for himself in the new Ministry in alliance with Shelburne. Somewhat earlier

[1] In their Eighth Report the Commissioners recommended that since the real audit was done by the Navy Board it should be officially recognised and the submission of accounts to the Auditors abandoned. The recommendation was not implemented.

than most of the opportunists, he saw the political advantages to be
gained from reform and took a delight in outbidding the reluctant
Rockinghams. When the Commons reform resolutions were being
debated on June 17 he hinted that he might challenge in the courts
the right of accountants to the profits they had made with public
money, and threatened the Auditors of the Imprest with *quo
warranto* proceedings. A week later he moved a series of resolutions
requiring Richard Rigby and Welbore Ellis to declare forthwith an
account of their balances as they had stood when they went out of
office in March 1782; to deliver up the balances remaining in their
hands within fourteen days of the beginning of the new Session of
Parliament; and to pay the interest on those balances into the
Exchequer. The resolutions had the support of such leading
independents as Thomas Powys and James Martin, and the first
four — requiring accounts of the balances — were agreed to by the
House. But the united opposition of the Rockinghams, of Fox
(defending the family fortune) and the Northites (showing strength
for the first time since North's overthrow) defeated the resolutions
requiring the payment of interest on balances and their return into
the Exchequer by the beginning of the next Session.[1] The success-
ful resolutions noticeably accelerated the returns. Confusion reigned
for a time as old accountants were threatened with legal action and
old accounts for which, in many cases, the vouchers had been lost,
were disinterred. Requests to be exempted from having to produce
vouchers were frequent, and Richard Rigby, in particular,
attempted a variety of dodges to avoid immediate payment. Even
with the threat of legal action from the Treasury there was still
nearly £50,000 in balances due from Rigby and Ellis at the end of
February 1783 and nearly £87,000 from insupers dating from as far
back as the Seven Years War.[2]

More recent accountants were also brought to book. On July 15,
1782, the Treasury at Barré's suggestion ordered that every future
memorial for issues from a paymaster or treasurer be accompanied
by a statement of the balance in his hands at that time. The order
was intended to regulate the Treasurer of the Navy's balances,
rather than the Paymaster-General's which would be regulated at
the New Year when Burke's Paymaster-General's Act was due to

[1] *Parliamentary History*, XXIII, 115-19, 127-34.
[2] William Molleson to Shelburne, February 14, 1783, Shelburne Papers, vol.
166; Treasury Minutes, February 24, March 18, 1783, *ibid.*, vol. 164.

come into force.[1] But having issued the order to the Treasurer, the Treasury applied it to the Pay Office as well, and a statement was demanded from Burke himself. He affected to believe that he had been reproved by the Treasury for not submitting an account of his balances before applying for further issues, and refused to obey what he regarded as an unjust *ex post factum* regulation.[2]

Like the Civil List Act, Burke's reform of the Pay Office was a mixture of significant and overdue improvements stopped short by its author's reluctance to interfere with property rights. Its main provisions: for depositing in the Bank all cash issued for army services, preventing the accumulation of further large balances in the hands of the Paymaster, transferring balances and accounts from one paymaster to another, retaining accounts in the offices instead of allowing them to be taken home by retiring Paymasters, and funding the office fees, were all changes recommended and approved by the Commissioners for Examining. Burke also made a gesture in the direction of a more detailed regulation of sub-accountants by requiring returns from the Secretary at War of the effective establishment of the Army in Great Britain, accounts of musters from regimental agents, and the making out of debentures according to the numbers of men borne on the muster rolls. The sub-accountants, however, remained substantially free from regulation.

Barré's subsequent act was designed to supply this deficiency. Shelburne's preliminary enquiry into contingencies and extra-ordinaries in the Army and the Seventh Report of the Commissioners for Examining, coming at about the same time in the autumn of 1782, both drew attention to it, and Barré, convinced from his years in Opposition that the Pay Office was 'a labyrinth indeed, and . . . undergoes a perpetual sweat', was determined to correct it.[3] In addition to abolishing the office fees which Burke had merely funded, his act anticipated the Ninth Report of the Commissioners for Examining by replacing the variety of fictitious establishments and stoppages from pay with regular issues from the

[1] Treasury Minutes, July 15, 17, August 8, 1782, *ibid.*, vol. 162; Robert Gregson to Shelburne, September 13, 1782, *ibid.*, vol. 147; George Rose to Burke, July 19, 1782, *ibid.*, vol. 136.

[2] Burke to Rose, July 18, Rose to Burke, July 19, 1782, *ibid.*, vol. 136; Treasury Minutes, July 15, 16, 17, 18, 19, 1782, *ibid.*, vol. 162.

[3] Account of the Establishment of the Examiners of the Contingent Expenses of the Army, 1765 (copy); Sir George Yonge to Shelburne, August 22, 30, 1782, . Shelburne Papers, vol. 136; *Commons Journals*, vol. 38, 1066–72; Barré to Shelburne, January 1783, Bowood MSS.

Pay Office for the support of such incidentals as regimental agents, recruiting, hospitals, surgeons, paymasters, the cost of subsistence on the march, apprehending deserters and transport of new officers and horses. Henceforth estimates were to be based only on the muster rolls of effectives as reported twice a year to the Secretary at War, the Paymaster-General and the Comptroller of Army Accounts.[1] Two exceptions were made to this suppression of anomalous establishments: the profits of colonels and other commanding officers from the clothing of non-effectives were to be preserved out of respect for the property rights that were supposed to be inherent in them; and the Act was not made applicable to the Household Troops who continued exotically unreformed for another century.

Shelburne wrote later that apart from himself, the Duke of Richmond, Master General of the Ordnance, was the most earnest supporter of administrative reform in the Cabinet. Richmond had almost absolute powers over his office and there were no patent sinecures there to be reformed or abolished. Without encountering any serious difficulty, he was able to replace fees of office with salaries, and to order Ordnance contracts to be let on open tender. But in other respects his arrangements for economy were impracticable. He thought that by grouping hitherto unprovided services with Ordinary and Extraordinary estimates, funding the Ordnance debt and fees of office, consolidating Ordnance expenditure and establishments in a system of coast defence,[2] and always paying ready money he could bring Ordnance expenditures within existing estimates. But his notion of an estimate — as the total of expected liabilities for the year rather than the sums expected to be disbursed — perpetuated the lag in accounts. Though he admitted that unless he had at hand detailed accounts of expenditures related to appropriations he could not plan his savings, he made no attempt

[1] 23 George III, c. 50. The act was passed in the summer of 1783 under the Coalition and was much amended by them (cf. Commons Journals, vol. 39, 458). Neither Barré nor Shelburne apparently paid much attention to the recommendation of Sir John Dick, Comptroller of Army Accounts, that the original powers of his office be furbished up to relieve the Pay Office of the responsibility of managing Army expenditure (Dick to Shelburne, November 12, 1782, Shelburne Papers, vol. 136; Chatham Papers, vol. 231).

[2] It was over this scheme that Richmond and Shelburne quarrelled in 1787, Richmond claiming that Shelburne had approved the plan in 1783, Shelburne denying it. The evidence indicates that Shelburne gave verbal encouragement but no written committment (Richmond to Shelburne, January 30, 1783), Shelburne Papers, vol. 136; Parliamentary History, XXVI, 566–595).

to have these prepared.[1] In fact, though he reduced the expenses of administration and improved the day-to-day management of the Ordnance, he fell a long way short of achieving his goal of putting the department's payments on a complete ready money basis, and his misconception of the nature of estimates was perpetuated until the Select Committee of Finance of 1797 recommended correction.

★ · ★ · ★ · ★

One form of expenditure — the war contracts — was well within the powers of the Treasury to regulate and already marked down for reform. Shelburne and his friends in Opposition had been so particularly scathing in their denunciation of the Victualling service and so sure that the huge Extraordinaries of the Army were the product of corrupt bargains between the North Ministry and the contractors that it was incumbent upon them to show that they could do better.

This necessitated the double operation of excluding what they thought was undue political influence from the letting of contracts, and excluding the contractors from politics. Even before the passage of Clerke's Act, the Rockingham administration had called for an account of contracts held by Members of Parliament. The Ordnance Board had contracts with two M.P.'s — Anthony Bacon, cannon master, and Thomas Fitzherbert, horse dealer. Neither of the contracts was irregular and Fitzherbert had complained that his worked against his own best interests.[2] The Navy Victualling Board held a contract with only one Member — Christopher Atkinson, then on his odyssey through the courts.[3] The Navy Board on April 30 permitted four Members who held contracts with them — Sir John Henniker, Anthony Bacon, Thomas Fitzherbert and Gabriel Steward — to transfer them to associates or silent partners. The Crawley ironworks gave up their contract in order that their partner, Charles Boone, should not have to give up his seat.[4] In the Army's victualling service,

[1] Richmond's Report on the Estimates of the Ordnance for the year 1783; Colonel Barré's Observations on the Proposed Reduction of the Royal Regiment of Artillery; Richmond to Shelburne, January 30, 1783; Shelburne Papers, vol. 136; *Parliamentary History*, XXIII, 615–40.

[2] *Parliamentary History*, XXIII, 634–6.

[3] Report of the Committee of the House of Commons appointed to Examine into the Conduct of the Commissioners for Victualling . . . 1782 (printed copy), Shelburne Papers, vol. 151; Treasury Minute, November 1, 1782, T 29/52, fos. 222–3.

[4] Navy Board to Treasury, T 1/570 (68); Middleton to Shelburne, August 12, 1782, Robert Gregson to Shelburne, September 13, 1782, Shelburne Papers, vol. 147.

conducted by the Treasury, eleven Members held contracts.[1] All were supporters of North at the time they received the contracts, though Christopher Potter and John Stephenson were soon to desert to Shelburne and Abel Smith had a hedge against political adversity in the person of his son Robert, a supporter of Rockingham. John Durand, Sir William James and John Stephenson were allies of Sandwich in the East India Company. William Fitzhugh, Richard Peacocke, George Brown, Richard Atkinson and Anthony Richardson, who also held victualling contracts, were partners of Members of Parliament,[2] two of whom — Christopher Atkinson and Anthony Bacon — held contracts themselves. Though probably no parliamentary votes were actually bought by contracts,[3] the fact that at the Treasury at least contracts were not given on open tender and were given to known allies of the Ministry, gave an appearance of substance to the Opposition's charges of corruption.

The operation of Clerke's Act eventually would have removed these Members from active participation,[4] but it would not have corrected the uneconomic terms on which contracts were negotiated. Close enquiry showed that the method of victualling the Army in America at a set sum per ration had enabled the contractors to inflate the costs enormously. In the early years of the war contracts had been regulated on the plan of broker's rates — that is, fixing the price of each article separately. But for some years an allowance per ration had been made — varying from 5d. to 6d. The allowance was unduly high, giving a profit of from ten to fourteen per cent or a total of £118,179 on contracts to the value of £859,190.[5] Such arrangements were naturally attributed by Opposition to mismanagement or corruption. In fact they were

[1] Robert Mayne, Sir John Henniker, Lawrence Cox, Adam Drummond, John Nesbitt, John Durand, Christopher Potter, Edward Lewis, Sir William James, Abel Smith and John Stephenson.

[2] Respectively of: John Purling, John Halliday, Lord Newhaven, Christopher Atkinson and Anthony Bacon (Treasury Contracts made 6th February 1781, for Supplying the Troops Abroad with Provisions; Treasury Contracts just made for victualling the Troops Abroad [Spring, 1782]; A List of Sundry Contractors, Shelburne Papers, vol. 147.

[3] Cf. Christie, 'Economical Reform and the Influence of the Crown', *Cambridge Historical Journal*, XII, 144–54.

[4] But as the *Morning Chronicle* pointed out (October 2, 1782) Members who were also contractors could evade the operation of the Act by becoming contractors in Ireland. A similar difficulty was experienced with respect to bringing accountants to book who chose to retire to Ireland (cf. Binney, *op. cit.*, 206–7).

[5] Notes on Army Provisions and Victualling Estimates for Supplying 10,000 Men on Commission, September 1782, Shelburne Papers, vol. 147.

adopted because of their simplicity; and carelessness on the part of officials, wartime shortages, complicated trans-shipment arrangements and the uncertainty of harvests all helped to provide the opportunity for contractors to profiteer.

While they were in Opposition the members of the new government had been convinced that letting contracts on open tender would correct all this; in office they were not so sure. They now discovered that the large contracts, like that of Harley and Drummond for supplying the Army in America with money, were apparently satisfactory and could not be replaced in any case. The principal abuses seemed to arise where several contractors shared a contract, as in the Army victualling service. By the time Clerke's Act was debated in May 1782 Shelburne had come around to arguing that contracts should be given to the most solvent and 'unconnected', rather than merely to the lowest, bidder.[1]

Such suggestions and the operation of Clerke's Act demoralised existing contractors and encouraged new aspirants. By the time the contracts came due for renewal at midsummer the Treasury was being showered with offers to undertake the victualling contracts at commissions of as little as two or three per cent. Shelburne was guided by the advice of his friend Francis Baring, brother-in-law of Ashburton and partner in the banking house of John and Francis Baring. Baring suggested two ways of letting the contracts: to one contractor at a set sum per ration or, preferably, by commission.

> The Contractor must be an idiot [he wrote] to content himself upon calculation with so small a profit as a commissioner's; the latter therefore is undoubtedly the cheapest mode for the public.

Baring advised that since such a contractor would have great opportunity to defraud the public (the total price of the provisions not being fixed and the provision market being subject to great fluctuations) he must be a reliable person enjoying the confidence of the Minister, and with the facilities of government at his disposal.[2]

Shelburne took the hint. On October 11, in the teeth of Pitt's disapproval and the outcry of other contractors, all the overseas supply business except for Harley and Drummond's money contract was let to Baring on commission. To keep a check on his

[1] *Parliamentary History*, XXII, 1376–7.
[2] Memorandum Relative to the Provision Contracts, Baring to Shelburne, August 29, 1782 Shelburne Papers, vol. 147.

profits in case of a rise in the price of provisions, the Treasury set the commission at £75 16s. 8d. (about one per cent) for every thousand men victualled at the rate of 5d. per ration.[1] This consolidation would probably have effected a considerable saving. But Baring never completed his deliveries. He became entangled with the Navy Board in a quarrel over the appointment of inspectors of provisions at Waterford and Cork, and with the sub-contractors over the rising price of provisions in the closing months of the war. Before he could fulfil the contract Shelburne's government fell, leaving him to settle with his sub-contractors under a government which thoroughly disapproved of his arrangements. At least the principle of letting contracts at commission was established and Baring was to reap the reward of his pioneering under the Younger Pitt.

Shelburne planned a similar consolidation of contracts in the negotiation of government loans. For years in Opposition he had made one of the chorus who demanded open subscriptions, and as late as 1781 he had strongly supported Price's arguments that an open subscription would lure capital from Italy, Holland and other foreign countries, and tap the wartime prosperity of the middling and lower classes, which North's private bargains with the City could not do.[2] But in the spring of 1782 North tried the experiment of a closed subscription by a small syndicate of responsible financiers with the sum required being kept a secret until the moment of negotiation. Shelburne was converted by its success, and the loan which he and Pitt planned to bring in after the peace was approved was to be negotiated on this basis.[3]

Once in office, he also questioned Price's idea for the conversion of the debt to a higher rate of interest. This advocacy of upward conversion originated in Price's preoccupation, in common with most of his contemporaries,[4] with the rapidly growing capital of the debt rather than with the more significant figure of the interest charges. They took an unduly alarmist view, anticipating the imminent collapse of the national credit in contemplating a floating debt of twenty-three millions shared between Navy, Ordnance and

[1] Treasury Minutes, October 31, November 9, 1782, *ibid.*, vol. 163; Observations on Supply Contracts for America for 1783, *ibid.*, vol. 168, Part I; T 1/580.
[2] Richard Price, An Essay on a New System for Raising the Public Loan for 1782, May 27, 1782, Shelburne Papers, vol. 152.
[3] *Parliamentary History*, XXIII, 811–16, 824.
[4] Report from the Committee on the Account of Sums Raised by Annuities... *Reports of Committees*, XI, 5–9; Binney, *op. cit.*, 283–6.

Exchequer Bills and the unprovided services of the Army, and a funded debt of nearly two hundred million. They might, more realistically, have called attention to the debt charges of £7,335,543 — a heavy burden for a nation which had almost reached the limit of its readily exploitable tax resources. Instead, Price proposed to increase those charges by converting the entire debt to five per cent stock. He believed that this would supply to investors in the public debt a substitute incentive for that currently supplied by stock bonuses and lotteries. Pitt was convinced of the usefulness of the scheme, partly on the ground that it would provide the possibility later for a conversion back to lower interest with political advantage to the government, partly on the ground that it seemed to provide for securing money at the real market price. Shelburne, however, was of two minds on the matter. On the one hand, perhaps on Baring's advice, he questioned whether subscribers to loans could be persuaded to accept such terms. Even if they could be persuaded, he questioned whether upward conversion would have any other result than binding the nation to paying a higher rate of interest since the capital of the debt would continue to grow so long as the revenues of the state were inadequate. He believed that his own scheme for a closed subscription to loans would control the increase of the debt capital without any other device being used. Nevertheless he authorised Pitt to open negotiations for an upward conversion with Robert Dent of Child's Bank and John Harman, the principal agent for Dutch and other foreign investors in the City.[1] Later he was to justify upward conversion as strengthening the credit of the nation by demonstrating an intention to pay off the debt, and to claim credit for originating Pitt's somewhat sharp proposal of 1784 for converting Navy Bills to five per cent stock in apparent breach of the stockholders contract rights.[2]

Whatever doubts he may have had about Price's other ideas, Shelburne was wholly devoted to the inviolable sinking fund which he himself had originated and planned to institute it in his budget of 1783.[3] A rival plan, which he sent to Price for comment in the

[1] Price, An Essay on a New System . . . Shelburne Papers, vol. 152; Price, The State of the Public Debts and Finances . . . in January 1783, 20–3; Pitt to Shelburne, January 1, May 4 [March 4?], 1783, Bowood MSS.

[2] Parliamentary History, XXIII, 815–16; Fitzmaurice, op. cit., II, 229; cf. The Case of the Proprietors of Navy and Victualling Bills Now Proposed to be Funded (London, 1784).

[3] Cf. Price, The State of the Public Debts . . . , 32.

summer of 1782, proposed to make the fund dependent on the faith of Parliament, as Walpole's fund had been, rather than place it under the absolute control of independent commissioners. This plan proposed to further weaken the authority of the commissioners by leaving it to Parliament to specify the amount of debt to be redeemed annually. The principle of inviolability was to be further jeopardised by the measure of withdrawing more than twenty million for the first fifty years of the plan's operation, replacing it by thirty-seven million in the last twelve.[1] Unfortunately for the subsequent financial fortunes of the nation, Shelburne agreed with Price's criticisms of the plan and held firmly to the principle of inviolability. Pitt did the same, and embodied it in the sinking fund of 1786.

* * * *

The enquiry into the revenue departments' establishments had gone far enough to show that reform in establishments and expenditure depended upon improving the yield of the tax revenues. The failures of North's war taxes were not, as Price and other Opposition theorists had supposed, due to the general viciousness of the funding system under North's management, but rather to the particular miscalculations of 1777, when interest on the loan of that year anticipated taxes by six months and when most of those taxes failed to produce much, probably because they were imposed before the profits of war justified them. Though North quickly corrected the error in 1778 by imposing additional duties on wines and vinegar and a house duty and subsequent increases in Customs and Excises, the damage was done. The deficiencies thus created continued to accumulate throughout the war, to be covered in part by loans, in part by unfunded debt, in part by a gradual tightening up of the collections of revenues and by the abolition of bounties and discounts to merchants.[2]

But there was still no significant increase in revenue. The Land Tax was fixed at its maximum yield of £2,000,000 and wartime additions to Customs, Excise and luxury taxes tended to take away from the yield of existing taxes or barely compensated for the

[1] Observations on a Scheme for Paying off 200 Millions of the National Debt in 99 Years, August 6, 1782; Price to Shelburne, August 6, 1782, Chatham Papers, vol. 275, 169.
[2] Report from the Committee on the Account of Sums Raised by Annuities . . . Report of Committees, XI, 3–5.

decline in their yield.[1] In the last years of the war, moreover, there was an unprecedented increase of smuggling. It could hardly be suppressed by inadequately trained officers struggling to maintain their collections in the teeth of steadily increasing complications of the revenues. The seventy-four duties of the Customs and almost equal variety of the Excise, levied for the various purposes of regulating trade, plugging holes in existing regulations or wringing a little more out of the nation's taxpaying capacity, represented neither coherence nor concert on the part of the taxing authorities. In the way of reform stood the general administrative principles of individual responsibility of officers and the self-sufficiency of administrative units, as well as the separate appropriation of duties under the funding system to a variety of funds and purposes. To pay for the reform of establishments and secure efficiency of administration it would be necessary to collect a central fund; but as long as decentralisation of administration and the separate appropriation of duties continued, the revenue departments could not gather a large enough fund to eliminate decentralisation of administration and separate appropriation.

It was an apparently unbreakable circle, as the frustration of successive attempts to consolidate the various duties in the different departments seemed to demonstrate. Consolidation had been contemplated from time to time for more than thirty years,[2] and in 1777 the Treasury ordered the Commissioners of Customs to prepare a plan of consolidation for their revenue. But the Treasury were unwilling to face the disruption to the revenue that the plan's implementation would have caused. They put the report aside while smuggling and the complications of the Customs service continued to flourish in the congenial climate of war. Only in April 1781, in anticipation of parliamentary criticism, did the Ministry order the Commissioners to proceed with the proposal and invite the great monied companies to consult with them on releasing duties from the funding arrangements.[3] Meanwhile, in their Second Report, the Commissioners for Examining the Public Accounts had recommended the consolidation of the offices of the Land Tax, Stamp and Salt Duties and Hawkers and Hackney Coach Licenses. In response, the Treasury ordered the

[1] *Ibid.*; Comparative State of the Customs for 3 Years Last Past to 5 January 1782, Musgrave to Shelburne, August 7, 1782, Shelburne Papers, vol. 114.
[2] Hoon, *op. cit.*, 249.
[3] Treasury Minutes, March 27, April 27, 1781, T 29/50.

Commissioners of Excise and Stamps to prepare plans of consolidation. These recommended the simple expedient of repealing the various duties and passing a general consolidation act — a measure very much easier to effect in the Excise than in the Customs because the duties were fewer and less variously appropriated. Even so the preliminaries of analysing existing regulations were much more complicated than either the Treasury or the Commissioners at first supposed, and by November 1781 the Commissioners were warning that they could not have a plan ready for enactment before the spring of 1782. The Commons Select Committee on Finance in 1782 repeated the recommendation for consolidating the revenues, but matters had gone no further when Shelburne took office.[1]

By that time the pressures for economy in establishments and the huge burden of unfunded debt had made consolidation more urgent and also more difficult to accomplish than ever. Both Musgrave at the Customs and Brooksbank at the Excise were anxious that their respective plans should be hurried into legislation before another Session of Parliament went by and particularly before Shelburne, who was encouraging them, was overthrown. Musgrave sent Shelburne a copy of the 1777 plan for Customs consolidation together with reasons why it must be implemented, a plan for consolidating and equalising the coal duties as between London and the outports, and a clause in his plan for reforming Customs establishments proposing to substitute for the Alien Duty paid by foreign ships three simple tonnage duties on coastal, deep-sea and foreign shipping.[2] But Musgrave was too much taken up with his reform of offices to be able to give much attention to the drafting of a consolidation act which, as the experience of 1787 was to show, required long and careful preparation.[3]

More realistically, Brooksbank at the Excise suggested to Shelburne that in consolidating the Excise it would save time if, rather than being permitted to range over all the duties, the Commissioners were directed by the Treasury to concentrate at first on

[1] *Commons Journals*, vol. 38, 142; Copy of Report from the Commissioners of Customs to the Treasury, April 29, 1777; Secretary of the Customs to the Treasury, October 3, November 10, 1781, Shelburne Papers, vol. 114; Copy of the Commissioners' Report Respecting the Consolidation of the Several Stamp Duties, September 29, 1781, *ibid.*, vol. 119.
[2] A Plan for Equalizing the Duties on Coal, Musgrave to Shelburne, September 18, 1782; A Plan for Vacating Certain Unwarrantable Grants . . . Same to same, November 20, 1782, *ibid.*, vol. 114.
[3] Cf. Brooksbank to Shelburne, September 21, 1782, *ibid.*, vol. 119.

preparing a bill to consolidate the duties of only one branch — such
as the Spirit Duties — to provide a pattern for the rest.[1] Unfortun-
ately the Treasury paid no attention to this advice and directed the
Commissioners merely to the general tasks of consolidating the
duties and revising the Excise statutes. As Brooksbank anticipated,
in the absence of a strong directive, the Commissioners fell to
reviewing the statutes in a vague way, and Shelburne's Ministry
ended without anything further being accomplished.[2] The reform
was hardly something to be rushed through, as Shelburne hoped to
do, to bring credit to a tottering ministry.

Cheap administration and consolidation of duties could achieve
only a limited improvement in the revenue yield. What was needed,
if the tax resources of the nation were to be properly exploited, was
a change in tax policy and in particular in the economic and
fiscal theories on which it was based. Shelburne and his advisers
came to consider it in connection with the suppression of smuggling.

Most of the plans for suppression were still based on the
assumption that the enforcement of existing regulations must be
improved by making enforcement more effective or the regulations
more punitive.[3] Some included schemes for making enforcement
more attractive to the enforcing officers: both William Richardson
(a gauger in the Customs) and Brooksbank urged that the Crown's
share of the proceeds from the sale of condemned goods, as well as
of fines and forfeitures, be distributed among informers and
officers. They also suggested encouraging associations of fair
traders against smugglers, even to the extent of binding them by
statutory oath to regulate their own members and inform the
government of frauds.[4]

But there was also a growing awareness that permanent improve-
ment in the revenue required a new tax policy. Drawbacks and
allowances to merchants, which had been the subject of frauds in
both Customs and Excise, were progressively withdrawn after

[1] *Ibid.*
[2] Add. MSS 42,775, fo. 156; Treasury Minute, February 4, 1783, Shelburne
Papers, vol. 164.
[3] Cf. Robert Lisle to Shelburne, August 8, 1782, Brooksbank to Pitt, January
14, Report of the Commissioners of Excise on Smuggling, February 15, 1783,
Shelburne Papers, vol. 119; James Montgomery, Chief Baron of the Exchequer
for Scotland to Shelburne, September 21, 1782, *ibid.*, vol. 115.
[4] Richardson to Shelburne, July 30, 1782; Enclosure: Heads of an Act to
Prevent Smuggling in General, Proposed to Enact Early in the Session; Three
Motions Intended to have been Proposed in the House of Commons if a Change
of Ministers had not taken Place, *ibid.*, vol. 166.

1781, partly as an economy measure, partly, as Musgrave remarked in urging the abolition of bounties and prohibitions in the Customs, in response to a growing conviction that they were intolerable interferences with fair and open trade.[1] Shelburne's Treasury contributed notably to the change by abolishing compositions for the Excise duties by private brewers and maltsters.[2] At the same time brewers and distillers of the metropolis were demanding a reduction of the excises on their respective products on the ground that it was necessary to enable them to compete successfully with defrauders of the revenue. They had the authoritative support of Adam Smith who lent his name to a scheme to replace all excises on beer by one large one on malt, thus eliminating the inequitable exemption enjoyed by the home brewers and brewers in the cider counties. John Pownall, however, pointed out that such a change would reduce the revenue rather than increase it, since the gauging service was not as efficient in the malting industry as it was in the brewery. Instead he proposed the equalisation of the incidence of the beer duties on town and country brewers alike.[3]

But the Commissioners of Excise in their report on smuggling of February 15, 1783, came to the heart of the matter:

> The total abolition of those duties [they wrote] or even any reduction that could have the effect to remove the temptation is a proposition which we conceive, in the present situation of the Kingdom, is inadmissable, unless the revenue could be compensated, in some other shape. Such a compensation must not be sought for in any addition to the present duties on other exciseable commodites: but if any judgment could be formed of the consumption of families, or individuals, so as to impose a duty in another shape proportionate to that consumption, it may be made to appear that at the same time that the revenue would be considerably increased, the consumer himself would be eased of a large share of the burden he now bears, and the temptation to smuggling entirely removed.[4]

Already William Richardson had found the answer in the commutation tax. Some glimmerings of the principle of compen-

[1] Observations on Bounties and Prohibitions, with a Proposal for Repealing them . . . Musgrave to Shelburne, October 3, 1782, *ibid.*, vol. 114.
[2] 23 George III, c. 64; Treasury Minute, January 14, 1783, Shelburne Papers, vol. 164.
[3] Pownall to Shelburne, August 28, 1782 (endorsed 'to be copied afterwards and sent to Mr. Pitt, January 30, 1783'; Comments on the Proposal to Add 3 shillings per Barrel on Strong Beer, same to same [1783], *ibid.*, vol. 119.
[4] *Ibid.*

satory taxation had appeared in the adjustments of the Excise and House Duty by North in the later years of his administration,[1] but to Richardson belongs the credit for the first workable plan. In the original form, he proposed to replace Customs and Excise on tea with a tax on houses on a sliding scale based on the number of windows in each house as a general indication of ability to pay. Richardson calculated that customs and excises on tea (which he set at an annual gross of £700,000) provided such a temptation to smuggle that only 5,539,939 of 13,338,140 pounds of tea consumed in Britain (on an annual average for the years 1772-80) was legally imported in British ships. This involved a loss to foreigners and smugglers of the equivalent of the employment of twenty ships and 2,560 seamen. He reckoned that his window tax would bring in £735,342. To this he added the share (three-quarters above eight per cent of capital stock) to which the public would be entitled out of the expected increase in the business of the East India Company, the savings in the cost of collecting Customs and Excise on tea, and the increase in the yield of those taxes from the tea trade with Ireland and the colonies and from the licensing of tea dealers and public places selling tea. Anticipating the criticism that the incidence of the house duty would be inequitable, since the groups paying it would not be identical with those who had paid the old customs and excise, Richardson endeavoured to show that the consumption of tea in the various classifications of households was proportionate to the number of windows in their houses and hence to the tax to be paid by them; and that the inhabitants of all the taxed houses in England and Wales, not to speak of those in Scotland and in houses not at present taxed, would benefit to a total of £1,256,554 per annum.[2]

Even granting that Richardson's figures were exaggerated (John Pownall pointed out that Irish and American tea consumption would no longer be channelled through Britain and thus Richard-

[1] I do not here consider Sir Matthew Decker's suggestion of 1743 for a single tax on houses, or that for the replacement of the tea taxes with licences to be paid by all tea drinkers, since these were not planned as part of one integrated tax system ([Sir Matthew Decker] *Serious Considerations on the Several High Duties which the Nation in General (As well as its Trade in Particular) Labour Under* (London, 1743), *passim.*).

[2] A Plan to prevent Smuggling Tea by taking off all the present duties of Customs and Excise on Tea and Laying a small tax on such houses as pay the Window Tax ..., Shelburne Papers, vol. 119. Cf. Benefits to Arise from the Converting the Tea Duties to a Window Tax, Brooksbank to Shelburne, *ibid.*, in which the above calculations are referred to as 'Mr Richardson's'.

son's figure for the total consumption of tea must be reduced from thirteen to about eight million pounds), the advantages of the plan seemed impressive. Administratively the revenue departments would no longer have to waste time and money suppressing tea smuggling. Economically the nation and the subject would benefit by increased prosperity of commerce and shipping, by the abolition of the tea duties and by relief from the costs of administration to an extent outweighing the burden of the house duty. The principal objections to the new tax were those arising from its departure from the old system of separately administered, separately funded, non-compensatory taxes: it converted customs and excises into a land tax; it was taxing people in lieu of a tax which they might not have paid formerly since tea consumers and householders were not identical; it was inequitable in that tea consumers who were not householders, but tenants, escaped the tax altogether, and people who had several houses had to pay more than those with equal ability to pay who had only one. Pownall and Brooksbank, to whom Shelburne referred the plan for an opinion, replied to these criticisms by enunciating the fundamental justification of compensatory taxation — that the benefits were general to all classes of people, even to those who did not drink tea. There were also some fiscal objections: that the rate of the house tax was not sufficient to counterbalance what the yield of the tea duties would have been if smuggling had been suppressed, let alone what it might have been in future years had it not been surrendered by the public; and that the landed interest would ostensibly lose the benefits for which they accepted the tax if in the future the price of tea should be raised. To answer the first, Pownall proposed levying the window duty at a higher rate; and to the second, Brooksbank suggested that as often as the price of tea was raised the ports of the kingdom be opened to foreign teas. Finally there was the psychological objection of novelty:

> The difficulty [as Brooksbank put it] to persuade mankind in general ... that it is better to pay a small sum in advance, and thereby to save a much greater, which they pay but do not see ... when the commodity is itself taxed.[1]

Surprisingly, in the event it turned out to be not much of a hazard.

[1] Pownall to Shelburne, Observations Proposed Respecting the Tea Duty, January 26; Objections and Advantages to the Plan Offer'd for Commuting the duty on tea to a House Tax, Rec'd from Mr. Brooksbank, January 27, 1783, *ibid.*

Brooksbank adopted the proposal for his own,[1] and for the purposes of the budget which Pitt was expected to bring down in the spring of 1783 reduced Richardson's calculations to realistic proportions. He based the commutation on a tea consumption of five million rather than thirteen million pounds, and abolishing the excise, but not the customs, on tea. The yield of the window tax he calculated to be £696,933 and the savings in administration £70,000. To these he added the existing yield of the customs on tea (£182,387) and an identical sum representing the expected increase in the customs on account of the increased legal importation of tea. From the total of £1,493,607 thus secured he subtracted £479,454 — the yield of the tea excise — and £425,000 — representing the peacetime reduction of one shilling in the Land Tax rate on the houses concerned, leaving a net saving of £589,153 attributable to the commutation. More important to Brooksbank was the administrative advantage of freeing the Excise service to manage other duties.[2] For the shape of the 1785 Commutation Act to be complete it remained only for Pitt to add exemptions for the poorer houses and, by omission, to take credit for the scheme himself. Shelburne had intended to include it in the budget of 1783, but he received Brooksbank's finished proposal only on the eve of his defeat on the peace treaty,[3] and like most of his other intentions it remained to be implemented by other hands.

* * * *

[1] He recommended Richardson to Shelburne for the post of Secretary of the Excise Board but gave him no subsequent credit for the scheme. Richardson complained and produced an enlarged plan, including an improved land tax, a house tax, a poll tax on all persons over the age of nineteen, and a selection of sumptuary taxes, consolidated under the management of the Land Tax Commissioners, which he tried to persuade various politicians to sponsor (Brooksbank to Shelburne, January 28, 1783, *ibid.*; Outlines for a General Commutation Proposed by William Richardson to the Marquess of Lansdown when 1st Lord of his Majesty's Treasury (1782), Richardson to the Rt. Hon. Earl of Wycombe, n.d., *ibid.*, vol. 168, Part I).

[2] Benefits to Arise from Converting the Tea Duties to a Window Tax, *ibid.*, vol. 119.

[3] Brooksbank wrote to Shelburne on February 11, 1783: 'Your Lordship's ideas of revenue being formed on a large and liberal scale, I will venture a proposition when I have next the honour to wait upon your Lordship, for an arrangement of certain taxes, extremely simple in its operation, whereby I think I can make it appear that every individual concerned will be benefitted, the revenue considerably increased, smuggling suppressed without the aid of a single soldier, or without the necessity of enforcing any penal law, and if I should add that such a plan being adopted would enable your Lordship to abate 1s. in the pound of the Land Tax, I doubt you will think me rather qualified for admission into a lunatick hospital than to a corner in your Lordship's confidence. But I forbear saying more till I have your Lordship's permission to explain myself' (*ibid.*).

Later Shelburne, in self-exculpation, would attribute his failure to achieve his great measures to a variety of circumstances: to the hostility of the Court; the inexperience of the Ministry and their involvement in the peace negotiations; the unwillingness of the government servants to give up their profits of office, their fear of being detected in their crimes, their conviction that if they played for time the Ministry would collapse and the threat blow over; and the pressures of economy required by the war and Burke's Act.[1] This was all true enough. But his own anxiety to protect himself and his Ministry at all points was responsible in at least equal measure. Drawn down into the administrative vortex, into the coils of excessive detail where every office had a scheme for new-modelling, Shelburne nevertheless was maturing his own ideas and the general understanding of the financial system. His jeremiads in Opposition were behind him now, though they could still be echoed to advantage in the theme that the real guarantee of cheap and honest government was naked publicity.[2] He was questioning the principles of freehold tenure of public office and the personal responsibility of the office holder; and ineluctably this was leading him to accept the alternatives: the principles of the paramountcy of the public interest and of institutional responsibility. His anxieties deepened; his impatience with resistance grew; the circle of his interventions widened. He was struggling with almost the entire range of the administrative structure as the time approached for the meeting of Parliament and the testing of his administration.

[1] Fitzmaurice, *op. cit.*, II, 224–5.

[2] 'It has been found by experience that this is the grand principle of economy, and the only method of preventing abuses; far better than oaths or any other checks, which have been devised. Instead, therefore, of oaths of secrecy, there should be an obligation *to print* at the end of the year every expenditure and every contract, except in cases of Secret Service, which may be subject to checks of another nature' (*ibid.*, 226–7).

The Fall of Shelburne's Ministry

Shelburne's administration had to meet four conditions to survive the test of a vote in the House of Commons on the crucial issue of the peace: they had to be united among themselves and command the united support of their followers in the Commons; they needed the support of one or other of the great parties following North and Fox; they needed the support of a substantial proportion of the independents in the Commons; and above all they had to present a peace treaty which the majority of the House and the country could support or at least could not plausibly oppose. They fulfilled none of these conditions completely; but they fulfilled three of them to a sufficient degree to leave the issue of the contest in doubt until the very last moment.

On August 7, 1782, John Robinson sent Shelburne an analysis of the current sympathies of the House of Commons.

> Nothing [he wrote in preface] can be more difficult than to form a state of the political sentiments of the House of Commons in the present juncture. In a stable, permanent government to whom gentlemen have professed friendship, with whom they have in general acted, and from whom they have received favours, conjectures may be formed with a tolerable certainty of the opinions which gentlemen will entertain on particular questions, but in a state so rent as this has lately been, by intestine divisions, and split into different parties, with an administration to be established, after one has been overturned and another divided, it is the hardest task that can be to class them.[1]

All that could be certain in the summer of 1782 was that the Commons was made up of three large parties, grouped around the government, Fox and North,[2] and a large floating vote made up of

[1] Laprade, *Parliamentary Papers of John Robinson*, 42.
[2] In October William Eden estimated that 140 Members adhered to the Ministry, 120 to North and 90 to Fox (Edward Gibbon to Lord Sheffield, October 14, 1782, Add. MSS 34,884, fo. 275).

various private electoral interests and independents. The future belonged to the leader who could unite his own with another party and a sufficient proportion of the floating vote to command a majority on the first important division after the meeting of the new Session in the winter of 1782–3. There was a widespread conviction in the summer of 1782 that that leader would not be Shelburne.[1]

Robinson's analysis hardly refuted this conclusion. In the course of his long career as the principal parliamentary manager of the age, he had cultivated a fine judgment of the effectiveness of influence on those Members ordinarily receptive to it. Like all devotees of an art he was beginning to run to exaggerations of his own genre and neglect new and unfamiliar realities, with the result that his calculations inflated the number of court and government Members and underestimated the number of independents — whose sympathies he was not able to assess — on whom Shelburne would be able to depend. But even allowing for such errors, there was a gap, ominously unfavourable to Shelburne between his totals of 'Pros' and 'Hopefuls' and 'Cons' and 'Doubt-fuls'.[2]

Robinson's emphasis on court and government votes was sound in one respect; Shelburne had almost no following of his own, and to keep the Ministry in office must depend on the support of the King and upon the influence which his position at the Treasury gave him. Dependence was mutual between the monarch and his minister in the face of Fox's threat to storm the Closet and the need to end the war. The King maintained his position in the Council not by personally dominating the prime minister but by having a Cabinet drawn from diverse elements bound together only by loyalty to himself. By Shelburne's time the position of prime minister was much more established than the traditional denigration of it made apparent. Grenville and Chatham had performed the functions of prime minister; Grafton and North had acknowledged the need for such a function; and Rockingham had tried unsuccessfully to expand it by claiming the right to choose the Cabinet in 1782. But the traditional prejudice against the premier-

[1] Cf. Thomas Coutts's warning to Caleb Whitefoord in Paris: 'The Sun of Shne. may set upon you before you come home' (August 12 [1782], *Whitefoord Papers* (Oxford, 1898), 174).
[2] State of the House of Commons, Robinson to Shelburne, August 6, 1782, Bowood MSS.

ship was still strong enough for Richmond and Grafton to claim
with some — though not much — plausibility that the Cabinet
was a committee of equals with no head other than the King him-
self.

Shelburne, however, firmly asserted his primacy, channelling
all Cabinet business through his own hands and confining the
discussion of most matters to an inner cabinet consisting of Pitt,
Ashburton and the two Secretaries of State. Most of the routine
work of the peace negotiations was left to Grantham and Towns-
hend, but the essential discussions with de Rayneval and Heredia,
the French and Spanish envoys in London, and the direction of
Oswald, Strachey and Fitzherbert in Paris were handled by Shel-
burne. He consulted in a limited way with Pitt on reform policy,
and assigned him the responsibility for carrying the necessary
implementing legislation through the Commons. Certainly this
'marvellous boy' had to be consulted a good deal more than the
other members of the Cabinet, since he was the leader of an
independent party in the Commons, the link with the Duke of
Rutland and his following, the ally of Dundas and, quite obviously,
the coming man in the Commons. His high-vaulting influence
reduced Thomas Townshend's title to lead the Commons to a
barely-sustained fiction, and at the close of the administration was
strong enough to effect the appointment of the young and un-
talented Duke of Rutland to the Cabinet in the face of objections
from Richmond and Grafton.

The nature of his relations with Shelburne is hard to determine,
since barely a dozen letters between them survive in Shelburne's
papers and only three or four in Pitt's. That fact in itself indicates a
good deal, for Shelburne was down at Bowood in the early autumn
of 1782 and might have been expected to correspond regularly
about Treasury business with this most talented of his colleagues.
Perhaps he did, and the letters were later destroyed; but more
likely he kept as much as he could of the Treasury business to
himself, working through the Secretaries, Orde and Rose, and the
minor figures in the revenue offices. Pitt had very nearly joined the
Rockinghams in March 1782, and he might yet join Fox. More-
over, in spite of Shelburne's long association with Chatham, he was
not really a friend of the family, and his personal reaction to Pitt
may be judged from his remark to Barré when instructing him in
negotiations with Pitt in 1784: 'I know the coldness of the climate

you go into, and that it requires all your animation to produce a momentary thaw.'

Shelburne could not entirely ignore the rest of the Cabinet, though he did not suffer them gladly. Ashburton had to remind him how necessary it was to keep on civil terms with Thurlow, the King's representative, even though this meant having to bear with Thurlow's ridicule of parliamentary and Civil List reform.[1] Camden, Grafton, Conway, Keppel and Richmond had helped to draw the teeth from Fox's secession by continuing to represent the old Rockingham party in the Cabinet,[2] but they were a mixed blessing. Camden and Grafton were deadweight, living down past failures in present valetudinarianism and pursuit of patronage for relatives and friends, rarely attending Cabinet, and regularly complaining both of the pressure of business and of not being consulted.[3] The public service suffered from their sins of omission to an extent not justified by the voting strength they could bring to the government, but Camden was the legal symbol of resistance to 'influence' and Grafton the only peer of consequence with whom Shelburne was connected, and hence necessary to such a shaky administration.

Conway and Keppel were more competent and energetic, but almost equally troublesome. Respectively the Rockinghams' military and naval symbols of resistance to influence and the American War, neither had a strong grasp of strategy nor, in spite of Conway's penchant for candle-ends economy, of war administration. Keppel's slowness in making decisions very nearly lost the hazardous naval campaign of 1782, and probably only the absence of major military operations prevented Conway from adding to his equivocal laurels won at the Rochefort expedition of 1757. Keppel still looked to his old allies the Foxites, hoping to bring them into the Ministry at the first opportunity, and at the end of the campaigning season broke with Shelburne over the peace. Conway

[1] Ashburton to Shelburne, July 19, August 29, 1782, Bowood MSS.

[2] 'As long as such friends to liberty and the constitution as the Duke of Richmond, Lord Camden and Lord Keppel remain in office, some hopes will be entertained that the Premier will not espouse such measures as are directly contrary to the interests of the nation' (*English Chronicle*, October 8, 1782).

[3] Cf. Camden to Grafton, June 4, September 6, 9, 1782, Grafton MSS, 76, 85, 86. Grafton's correspondence with Rockingham and Shelburne during this crisis year is almost totally taken up with Grafton's demands for place or pension for Joseph Pennington, Lord Jersey, and Richard Stonehewer and translation for John Hinchliffe, Bishop of Peterborough (Grafton MSS 80, 109, 141, 143, 673, 678, 679, 681, 682, 687, 737, 749–54, 757, 760–2; *Grafton Autobiography*, 325–7, 329, 333–8, 357–9).

R

characteristically waited for the lead of his friends, Grafton (to whom he owed his seat) and Horace Walpole, before doing the same.

Richmond was competent and energetic and, as the most ardent supporter of parliamentary reform in the Cabinet, a valuable counterweight to Fox in appealing to the reformers. Like Keppel, however, he was very sensitive to the charges of apostasy showered on him by the Foxites and hoped for the reunion of the old Rockingham party in office. In his own estimation he should have succeeded Rockingham, was at least Shelburne's equal in the Cabinet, and ought to be treated as such. But for the moment he would work with Shelburne for reform and peace.

Beyond the ranks of the Cabinet Shelburne was even less sure of the loyalty of his quondam supporters. Barré could always be relied upon, but his influence was more restricted than Shelburne's and throughout most of the autumn he was troubled with an early manifestation of the blindness that eventually overcame him.[1] Dundas was more influential and great deference was paid to him, even to the extent of offering to purchase Gatton from Lord Newhaven in order to seat him after his appointment as Treasurer of the Navy in Shelburne's administration. He was supposed to be a great catch, not so much for his undoubted debating and administrative capacities, as for his apparent control of the Scottish Members. This last was not as great as was popularly supposed. His immediate following was only nine or ten of whom at least two, Sir John Henderson and Sir Adam Fergusson, stayed with North. His influence over the six followers of the Dukes of Buccleuch and Gordon was also not complete; three — Lord Adam Gordon, Adam Drummond and Francis Charteris — followed North. The Scottish Members were confused by this division in their accustomed allegiance and only twenty of the forty-five followed Dundas on the peace. Sixteen went with North and five with Fox.[2]

The Grenville interest was represented in the administration by Lord Temple as Lord Lieutenant of Ireland, William Grenville as his Chief Secretary and James Grenville at the Treasury. They had followed Shelburne partly as the price of Temple having a free hand in Ireland, partly out of distaste for Fox's courting of the mob, and partly out of anxiety to protect their electoral power in

[1] *English Chronicle*, October 8, 1782.
[2] Cf. Appendix II; Christie, *North Ministry*, 294.

Buckinghamshire by alliance with a prime minister .who was himself a power in the county.[1] This last consideration also persuaded Lord Verney, deep in debt and desperate to protect himself from his creditors by holding his seat, to part company with Burke and make his peace with Shelburne.[2]

Further afield Shelburne's friend Lord Abingdon brought to the Ministry's support his followers and clients, Lord Wenman, Peregrine Bertie, John Gardiner, Samuel Estwick (the two latter bound directly to Shelburne respectively by the grant of a baronetcy and by appointments as Secretary and Register of Chelsea Hospital and Searcher of Customs at Antigua), and Chaloner Arcedeckne. Shelburne's friend Lord Pembroke could answer for his son Lord Herbert, but not for his client, William Gerard Hamilton, despite Shelburne's offer to Hamilton of the Vice-Treasureship of Ireland.[3] Sir James Lowther, master of nine seats, had insisted that Shelburne and not some Rockinghamite be named prime minister in July and supported him to the end. The interest of another major patron, Edward Eliot, was about evenly divided: three Members followed Fox (including Shelburne's uncertain friend Wilbraham Tollemache), and four, including Edward Eliot the Younger at the Treasury and Edward Eliot himself, supported the government. The Duke of Northumberland, similarly, though he sympathised with Shelburne, let his seats for money to government and Opposition supporters alike. He seated Shelburne's friend Sir John Jervis at Launceston by agreement with the Treasury in the spring of 1783.[4]

Throughout the summer of 1782 rumours were current that either Shelburne or Fox would soon unite with the parties of the old Bedford connection. Rumour had made their principal leader, Lord Gower, a candidate for the premiership at every crisis since his resignation from the Presidency of the Council in 1779. He and the other leaders, Lord Weymouth and Richard Rigby, hoped in the Bedford tradition to intervene decisively to restore and control a broad-bottomed administration. They had an ambivalent attitude

[1] Duke of Buckingham, *Memoirs of the Court and Cabinets of George III* (London, 1853), I, 302–3; Temple to Thomas Grenville, January 7, 1783, Add. MSS 41,851, fos. 12–13.
[2] Verney to Shelburne, November 21, 1782, Lacaita-Shelburne Papers, vol. II.
[3] Bishop of Bath and Wells, ed., *Journal and Correspondence of William, Lord Auckland* (London, 1861), I, 22.
[4] Northumberland to Shelburne, December 21, 1782, Lacaita-Shelburne Papers, vol. II.

toward Shelburne. He was the King's minister and therefore worthy of their support; but he was also a poacher on other people's parties, a radical, and unpopular with their old allies of the North and Sandwich connections. Weymouth and Rigby eventually supported Shelburne, as did their followers — a total of eight Members. Gower, though his following of six voted for the peace, held back until after Shelburne fell when, like a number of other waverers, he rallied to the cause of the King and Pitt.[1]

Of somewhat similar sentiments was the Duke of Marlborough, for whose support Shelburne had gone to such lengths to secure the Vice-Treasureship for Lord Charles Spencer. It amounted to a great deal of effort for very little return. Lord Charles voted for the peace as did another of Marlborough's clients, Viscount Parker. But Lord Robert Spencer voted against it; and William Eden, though careful to keep the lines to Shelburne open,[2] was the principal agent with Lord Loughborough in persuading North into the Coalition.

★ ★ ★ ★

When all these associates and hesitaters were counted in, the government could command not much more than 120 votes in the Commons. Obviously Shelburne must negotiate an alliance with one of his rivals. It was perfectly clear what Fox's terms would be: surrender of the government into the hands of the Rockingham party. There might be some faint-hearted in the party who were appalled at the prospect of spending yet more decades in Opposition — in the event nine regular supporters of the Rockingham-Fox connection and sixteen Rockinghamite independents supported Shelburne on the peace[3] — but the majority were determined to maintain the battle against 'influence' and have nothing to do with the apostate Shelburne. For the moment the principal basis of their unity was a common determination to overthrow him. As early as the third week of July, moreover, Fox was sounding out the possibilities of an alliance with North. By the beginning of September he was in close communication with many of the

[1] Thomas Pelham the Younger of Stanmer to Thomas Pelham the Elder, July 14, 1782, Add. MSS 33,128, fo. 85; Walpole, *Last Journals*, II, 482; *General Advertizer*, July 23, 1782.

[2] Cf. Eden's thanks to Shelburne for preserving his wife's pension from the economical reformers (November 5, 1782, Lacaita-Shelburne Papers, vol. II; *Auckland Journal*, I, 3–4, 6, 8).

[3] Cf. Appendix II.

leaders of the party and waiting impatiently to hear North's terms. For the purposes of the alliance he would be willing to moderate, perhaps even suppress, his enthusiasm for parliamentary reform, but in return North must agree to take a subordinate position in the alliance, leaving the principal offices to the Foxites.[1]

North refused such terms. His was the best organised and most united party in the House, and he held the balance of power. But no more than his rivals did he enjoy liberty of action. His first necessity was to maintain his party.

> At present [Lord Sandwich had written him on their retirement from office in March] my parliamentary interest is very considerable ... but if I am reduced by my circumstances to live in absolute retirement, that interest will soon sink to nothing, and my means of doing any service to this distressed country be utterly annihilated.[2]

A fortiori this was true of North as well. He must return to office.

After the debacle of March he had temporarily lost the support of the gentry, but during the spring his party recovered gradually and on June 17 it was strong enough (with the help of Fox and Burke) to save Rigby and Welbore Ellis from having to pay interest on the balances in their hands. The split of the Ministry in July seemed to provide a golden opportunity for action. But what action? North was not sure. At first, because so few of the Rockingham Ministry had resigned, he suspected that Fox had not really broken away from the Ministry and would be won over by Shelburne.[3] When he realised that the split was real there remained to him the choice of one of three courses of action. The first of these was a policy of neutrality between the parties, giving just enough support to the Ministry to ensure that the war and the King's government could be carried on, reserving liberty of action for the future and waiting to receive deserters from the other parties until such time as he was strong enough to return to office on favourable terms. This line of conduct had the support of his own immediate following, of his former friends like Jenkinson, Robinson and Rigby who wanted to keep Shelburne in office, and

[1] Loughborough to Eden, July 24, 1782, *Auckland Journal*, I, 12; Same to same, August 2, 1782, Add. MSS 34,419, fos. 4–5.

[2] March 26, 1782, H.M.C., *10th Report, Appendix Part VI, Abergavenny MSS*, 53; cf. Loughborough to Eden, July 12, 14 [January 1783?], *Auckland Journal*, I, 7–8, 11–12, 42–3.

[3] North to John Robinson, July 16, 1782, *Abergavenny MSS*, 53.

of the country gentry. In the summer of 1782 North was inclined to stick to it out of constitutional inertia and the conviction that it was too early to make alliances. But the time was coming when the great issue of the peace would force him to take a stand, for or against; with Shelburne or with Fox.

An alliance with Shelburne for the purpose of ensuring a good peace and the maintenance of the King's government would have the support of the independents and of most of his own party. It should not be difficult for the Northites to accept the acknowledgement of American independence since North, as Robinson reminded him,[1] had already admitted that America had been lost during his administration, and that any peace that brought the nation out of war without much greater losses than the recognition of American independence was a good one. Some of his followers yearned to return to office, and Jenkinson and Robinson urged him to take the plunge. Both the King and his own father told him that it was his duty to support the King's government.

But there were obvious objections to this course of action. Joining the Ministry would mean North's strict subordination to Shelburne, a man for whom he had no liking and whose present followers would demand and get the bulk of the now sharply reduced fund of patronage.[2] Moreover in alliance with Shelburne he would have to take the principal blame for a humiliating peace treaty on the ground that his loss of the war had made it inevitable. When, in early August, the King through Robinson demanded his support, he replied that he could not speak for his party or the county gentry, but would endeavour to learn their sentiments before Parliament met.[3]

His loyalty had been strained to the limit by the King's cool refusal to pay the election account outstanding in 1782 (leaving him to settle the bill as best he might) and by the King's constant reminders that he had been rescued from bankruptcy by royal benevolence. He was determined not to enter that bondage again. But the alternative was entering office by the back door of formed opposition — by storming the Closet. The influence which loyalty to the King's government and abhorrence of formed opposition

[1] Robinson to North, February 1, 1783, *ibid.*, 56–7.

[2] 'I much doubt whether matters are ripe either for conquest or Coalition, and the havoc which Burke's Bill has made of places &c., increases the difficulties of a new arrangement' (Gibbon to Mrs. Holroyd, November 7, 1782, Add. MSS 34,884, fo. 277).

[3] Fortescue, VI, nos. 3870–3; *Abergavenny MSS*, 54–5.

had, or ought to have had, on North has been somewhat exaggerated.[1] Though there was a tradition against formed opposition among politicians in the middle years of the eighteenth century, that tradition was honoured more in the breach than in the observance by its very advocates — Pelham, Newcastle, Grenville and Chatham — all of whom took part in formed oppositions. By 1782, thanks to the work of the Rockinghams in organising resistance to the American War, opposition was much more acceptable than it had ever been before. North's willingness to go into Opposition, while it was a break with his established habits, was not as remarkable or unprecedented as has sometimes been supposed.

An alliance with Fox would have some of the same drawbacks as an alliance with Shelburne: it would be difficult to share patronage and agree on the peace to be made, and there would be the added disadvantage that attacks by either party on any moderate peace settlement made by Shelburne would be bound to be regarded as insincere by those who remembered North's admission of the national defeat and Fox's demands for the recognition of American independence. But there were counterbalancing advantages. The main target would be Shelburne's peace and not North's loss of the war. Moreover North had no personal antipathy to Fox and in an alliance with him could claim to be the senior partner, providing the largest parliamentary following and most of the experienced men of business. Majorities in both parties shared antipathies (which were not identical) for parliamentary and administrative reform. In the early stages of the negotiations North did not bother to consider these factors. But they were closely considered by Loughborough and William Eden who hung assiduously on North's coat-tails, solicited patronage from Shelburne, urged a coalition with Fox before Richmond deserted the Ministry and thus strengthened Fox beyond the necessity of coalescing, and, in fact, explored every avenue that might bring them back to power.

* * * *

Pending the formation of a firm party alliance, Shelburne might still appeal to those who had no connection with the large parties —

[1] Cf. I. R. Christie, 'The Political Allegiance of John Robinson', *Bulletin of the Institute of Historical Research*, vol. 29, 113-20.

to the small electoral interests and to the independents of the great floating vote. This meant first, a judicious use of patronage with those who might be bought; and second, the promotion and direction of his 'measures' — reform and the peace in particular — by which not only the floating vote, but the parties and their leaders as well, might be persuaded to give their support.

Subsequent claims of some of his friends to the contrary,[1] Shelburne did not disdain the use of patronage, but for a variety of reasons he had very little to distribute and he managed it badly. On the one hand, economical and administrative reform had eliminated a good deal of the conveniently disposable patronage in the Household and financial system; on the other, though the press repeated rumours of an impending creation of peers,[2] the King's prejudices against frequent creations stood in the way of this simple solution to the problem. He had made a creation in 1780 and there were still outstanding many promises of a personal and private nature which he was inclined to fulfil in accordance with his own highly specialised rules of obligation. But since 1780 only the creations demanded by Rockingham and Shelburne as conditions of taking office, and those — of Rodney, Howe and Elliot — necessary as rewards for distinguished service, were made. Had he been able to meet a few demands for peerages — such as that of Lord Lisburne[3] — Shelburne might have secured a few more votes in the Commons. But the promise of good things to come may have acted almost as powerfully to bind those who could be bound in this way, and few appear to have become heartsick merely from hope deferred.

If there was no opportunity to create lords temporal, the opportunities to create lords spiritual were very little better from Shelburne's point of view. Frederick Cornwallis, Archbishop of Canterbury, died in March 1783 and though Shelburne had resigned by that time, he urged the claims of Jonathan Shipley, the radical Bishop of St. Asaph's. The King had other intentions and eventually appointed John Moore, Bishop of Bangor. Earlier,

[1] Grantham to Sir James Harris, February 20, 1783, *Diaries and Correspondence of James Harris, First Earl of Malmesbury* (London, 1844), II, 31; Richard Watson, *Anecdotes of the Life of Richard Watson, Bishop of Llandaff* (London, 1817), 104; *Memoirs of Dr. Joseph Priestley* (London, 1806), 84–5 note.

[2] *London Packet*, July 22–4, *English Chronicle*, September 3–5, 1782. Almost all the names suggested were those of former supporters of Rockingham.

[3] George Jackson to Lisburne, July 23, 1782, Egerton MSS 2,136, fo. 204.

Shelburne had had only slightly better fortune in the case of the vacancy in the See of Salisbury. In spite of the vigorous importunings of Grafton and Camden on behalf of Hinchcliffe, Bishop of Peterborough, the King's promise to Shute Barrington, a supporter of North, had to be fulfilled. But this left the minor see of Llandaff vacant, and to secure the various purposes of throwing a sop to Grafton, currying favour with the Duke of Rutland, and placing an experienced reformist pamphleteer on the episcopal bench, Shelburne arranged the appointment of the egregious Richard Watson, whose protean career in the pursuit of patronage had already included the occupancy of the chairs of Chemistry and Divinity at Cambridge. According to Watson, Shelburne for a moment contemplated bringing him into the inner circle of his advisers. But this much-rewarded nepotist now expressed an eleventh-hour determination to follow his own judgment, independent of all parties. With unmeasured zeal he pressed on Shelburne his plan for equalising the incomes of the episcopal sees to eliminate the necessity for poorer bishops to hold deaneries *in commendam*, to put a stop to the trade in translations to richer sees, and to augment the stipends of the poorer clergy. Shelburne replied that the Church might more appropriately make a contribution to correcting the financial troubles of the nation, commiserated with the condition of the poor clergy, and suggested that perhaps in a year or two it might be possible to proceed with the reform, leaving its author to reflect smugly on the sad lack of principle among politicians.[1]

While Shelburne had no marked success in exercising patronage at the higher levels of politics, there is no evidence that his distribution or denial of patronage, by themselves, had much effect in deciding opinion at the lower levels. In the case of most placeholders, established loyalty to a party leader, to the King's government, or to a particular policy or measure was the deciding factor. Such contractors as Sir Robert Herries, Samuel Smith, Henry Drummond and Thomas Fitzherbert, though they deserted in the spring of 1782, followed North a year later because they were bound to do so by considerations of friendship and gratitude for past favours, and not simply because they resented being deprived of privileges by Shelburne's government. Some small place-

[1] *Anecdotes of the Life of Richard Watson*, 89–103, 155–8, 164, 207–8; Norman Sykes, *Church and State in England in the XVIII^th Century* (Cambridge, 1934), 60–1, 66–7, 375–6, 400–1, 406; Fortescue, VI, no. 4216.

holders: John Kenrick (Clerk of the Deliveries at the Ordnance),
Archibald Fraser, James Wemyss,. William Graves (a Master in
Chancery), Francis Eyre (Solicitor for Plantation Appeals) and
John Clevland (a Commissioner of Greenwich Hospital) may have
felt sufficiently alarmed at the prospect of losing their places or
annoyed that their friends had been dispossessed, or contemptuous
of reformers generally, to strike out against the government; but
they also had other, and much less self-interested motives for doing
so. Equally, such Members as Henry Strachey (late Clerk of the
Board of Green Cloth, late Undersecretary of State and present
negotiator in Paris) and William Masterman (Clerk of the Council
and Register of the Court of the Duchy of Cornwall) who had lost
sinecures, nonetheless voted with Shelburne for the peace.
Administrative reform may have had a more positive than negative
influence — many more were persuaded than alienated by it.
Thomas Pitt, Sir Robert Ladbroke, Charles Marsham, Noel Hill,
Thomas Powys, Sir George Cornewall, James Martin, William
Hussey, Sir Edward Astley and Ambrose Goddard, were all
prominent economical reformers who supported Shelburne and
the peace. But some were also disillusioned. The granting of
pensions to Barré and Ashburton at the beginning of the adminis-
tration, and to Thurlow and Grantham at the end, though within
the provisions of Burke's Act, shook the faith of Powys and Hussey.
Sir George Onesphorus Paul, county justice of Gloucestershire,
reported to Wyvill that 'the Whigs of this county' believed, on the
evidence of Barré's pension and Ashburton's sinecure of the
Duchy of Lancaster, that Shelburne had given up economical
reform,

> and however the reform of a few particular offices may be permitted,
> the unreformed list of great emoluments, and the eagerness for the
> power of disposal, are unequivocal proofs which mere protestation
> will not do away.[1]

One branch of influence — that to be secured from the expendi-
ture of secret service money — was now effectively restricted by
law. Only £2,670 was paid in pensions during the administration,
of which £2,550 was to be repaid from other funds and the rest was
accounted for in small secret service pensions to Father Hay and
Principal Gordon. Two electoral payments were made: £600 to

[1] *Wyvill Papers*, IV, 236–7.

Robert Waller, perhaps as part of an arrangement with Shelburne for their common control of Chipping Wycombe; and £2,300 to Sir Richard Worsley for his interest at Newtown, Isle of Wight, in the successive statutory re-elections of Henry Dundas and Pepper Arden, the Solicitor-General. In addition, the usual allowance of £870 was made for the support of the Treasury's electoral interest in its boroughs.

Barré, at the outset of the administration, had advised 'Extra-Parliamentary' measures to support the ministry, that is, an appeal to the opinion in the metropolis, and this should have meant drumming up support for the peace among the newspapers. Only £1,884 10s. 9d. was spent on this however.[1] The invective that poured from Stockdale's *London Courant*, Woodfall's *Public Advertiser*, the *London Chronicle* and the *Morning Herald* was only feebly answered by such government organs as Debrett's *General Advertiser* and the *Morning Post*, now edited by Isaac Jackman. In pamphleteering Shelburne was equally at a disadvantage. The initiative seized by Denis O'Bryen in his savage satire, *A Defence of the Earl of Shelburne* and by the author of *A Word at Parting to the Earl of Shelburne* was inadequately met by the ponderous *Vindication of the Earl of Shelburne, Monitory Hints on the Present State of the Nation, Reply to the Defence of the Earl of Shelburne*, and Andrew Kippis's plodding official defence of the peace, *Considerations on the Provisional Treaty with America*. In a mudslinging contest the government champions were at a serious disadvantage. They could refer to Fox's dissipation and financial irresponsibility; but though such vices might alarm sober gentry, they had no such effect with the public of London who found them rather attractive in the Man of the People. The Foxites, on the other hand, could ring the changes on the established theme of Shelburne's duplicity with particular effect among the parliamentary reformers, who expected much from the first avowed reformer to achieve the premiership and were not likely to appreciate the pressures which hampered him in fulfilling his promises.

Since the failure of Pitt's motion on reform, enthusiasm in Parliament had dwindled. But out of doors the split between Fox and the Ministry was reflected in the Quintuple Alliance, where the

[1] Fortescue, VI, no. 4287, Enclosure no. 2, 'Money Received for His Majesty's Secret Service by Thos. Orde, Esq. between 10th July 1782 and 15th April, 1783'; Barré to Shelburne (n.d.). Bowood MSS.

Westminster group put up Serjeant Adair against the Townsend group's candidate, Henry Thornton, in a by-election at Southwark in August. By the end of September there was open warfare between the two groups. On the one hand, the Westminster Association appealed to Fox, the memory of Rockingham and, less frequently, to Richmond; on the other, the City men urged that Shelburne had the power to institute reform and would do so. Wilkes and Lewes wavered unhappily and eventually came down in support of Shelburne. Worse was the case of the Earl of Surrey, Member for Carlisle under the joint sponsorship of Portland and Lowther, and a close friend of Fox. On the question of reform he was very close to Shelburne, a bond that was strengthened in the course of the summer and autumn by appointments as Deputy Earl Marshal and Lord Lieutenant of the West Riding. At meetings of the Quintuple Alliance and the Westminster Association he defended Shelburne's sincerity on the question of reform, but with steadily diminishing enthusiasm, until, at the last, it was doubtful who he would support.[1]

Would Shelburne institute reform? This was something that Wyvill, working feverishly to prepare another petition and instruction campaign against the next meeting of Parliament, would have liked to know. He and his friends, like the City men, hoped that their friends in the Cabinet would still prevail to commit the administration to a measure of reform. Shelburne once more asserted that he wanted a 'wise, prudent and effectual reform of Parliament', and in August sent a message to Wyvill that he meant to act nobly by the Associations. But the conviction carried by these assurances varied with the recipients: Jebb and the other Foxites questioned their sincerity; the London Committee, on the basis of them, decided to postpone instruction of Members until after the results of the investigations by a parliamentary committee and the effect of another petition campaign were known; while Cartwright and Wyvill hoped to use Shelburne's assurances and similar private encouragement by Pitt to persuade the Associations to agree on a petition and push it forward vigorously. But Shelburne was unwilling to be so publicly committed when the majority in the parliamentary parties he was trying to woo, whether Northite or Foxite, took alarm at the

[1] Fortescue, VI, nos. 3941–2; *Wyvill Papers*, IV, 195–6; *English Chronicle*, December 7, 1782; *London Courant*, September 4, 28, 1782.

suggestion of parliamentary reform. Wyvill, having published Shelburne's approval, had to withdraw it.[1]

Shelburne's credit among the reformers fell and the split in the Quintuple Alliance widened. At the audit dinner of the Society for Constitutional Information on December 7 Horne Tooke and Richmond wrangled with Sir Charles Turner, Sheridan and Richard Fitzpatrick over the former's support of Shelburne, while Lord Surrey vainly endeavoured to direct their attention to the common cause of reform, and urged that the Ministry must not be charged with duplicity until the fact was proven.[2] In the larger movement there was still no agreement on the sort of reform to be supported. The metropolitan and commercial interests objected to increasing the county representation as strengthening the landed interest; the closed boroughs supporting North or the Rocking-hams objected to reform generally. Wyvill therefore decided to get away from any specific proposal with the result that the Yorkshire petition — prototype for most of the others — spoke the un-impeachable sentiments of defending and preserving the con-stitution, giving the commons of England a voice in the choice of the House of Commons, and purifying the representation.[3]

In reply to a warning from Sandwich during the debate on the Address not to overturn the constitution, Shelburne repeated his pledge to work for 'a more equal representation'. But it was clear that he had already lost the friendship of Marlborough, Lisburne and the other hesitating Northites (if, indeed, he had ever had it) and North had pledged himself against reform and invited the gentry to rally on the issue. On the other hand, conservatives like Temple and Dundas who also objected to Shelburne's encourage-ment of the reformers, were now committed to support the Ministry on the peace.[4] Everything now depended upon the peace,

[1] *Wyvill Papers*, I, 333, 335, 337, II, 28–30, 156–174, 229–32, IV, 163–5 footnote, 189–90; Wyvill to Shelburne, October 12, 21, November 3, 1782, Bowood MSS; *Life of Cartwright*, 146–7; *A Reply to the Defence of the Earl of Shelburne*, 27; *London Courant*, December 3, 18, 1782; *Parliamentary History*, XXIII, 143–4.

[2] *English Chronicle*, December 7, 1782; *London Courant*, September 28, December 3, 23, 1782, February 27, 1783.

[3] *Wyvill Papers*, IV, 92–4, 202–5; G. S. Veitch, *The Genesis of Parliamentary Reform* (London, 1913), 89–92.

[4] *Parliamentary History*, XXIII, 214, 218, 220; Add. MSS 34,418, fo. 505; Add. MSS 34,419, fos. 2, 8–9; *Auckland Journal*, I, 41–2; Temple to W. W. Grenville, February 11, March 1, 1783, H.M.C., *13th Report, Appendix Part III, Fortescue MSS* (London, 1892), 192–3; Dundas to Alexander Gordon of Greenlaw, September 12, 1782, Melville MSS, vol. 578, no. 210; Fortescue, VI, no. 3972. Shelburne's old coadjutor, Dean Tucker, accused him, in a notable

and as if in recognition of this both the Quintuple Alliance and the Yorkshire Association arranged for the presentation of their petitions after the crucial debate. Meanwhile the cause of reform had helped to keep firm perhaps a dozen influential Members,[1] in the support of a Minister who at least promised much.

* * * *

> It is our determination [wrote Shelburne to Alleyne Fitzherbert in October] that it will be either War or Peace before we meet the Parliament, for I need not tell you that we shall be then to meet so many opinions and passions, supported by party and different Mercantile interests, that no negotiation can advance [thereafter] with credit to those employ'd or any reasonable prospect for the Publick.[2]

The effect of the peace negotiations upon the fate of his Ministry can be understood only by understanding what it was politically necessary for him to secure in the peace treaty and the extent to which he succeeded. For most Members of Parliament the primary desideratum of the treaties was the preservation of the empire from the 'traditional' Bourbon enemy. Unless favourable terms could be secured the war, which against America had been effectively terminated by the Commons Resolution of February 27, must still be pursued against France and Spain. Indeed, it necessarily was being pursued at sea, where even in the aftermath of the Saintes victory, Britain still had to protect her commerce from the Combined Fleets and prepare for the climactic attacks on Jamaica and Gibraltar. Later, the spectacular victory at Gibraltar appeared to justify larger British demands at the peace conference and, in the eyes of the public, a continuance of the war unless those demands were met.

Even before the victory, the tone of resistance to concessions had been set by the British proposal made by Alleyne Fitzherbert to Vergennes on July 27 to ground the negotiations on the recognition of American independence and the restoration of the *status quo*

pamphlet, of basing his hopes of power on humiliating the monarchy by economical reform while leaving untouched aristocratic corruption and playing up to the mob with impracticable schemes of popular suffrage (*Four Letters to the Earl of Shelburne* . . . (London, 1783), *passim*.).

[1] In this group I include the London Members, Bull and Lewes, Wilkes (Middlesex), Sir Joseph Mawbey (Surrey), Filmer Honeywood and Charles Marsham (Kent), and Sir Thomas Skipwith (Steyning). Beilby Thompson (Thirsk), Thomas Scott (Bridport), Charles Barrow and John Webb (Gloucester) and Lord Surrey (Carlisle) might be added to the list (cf. Appendix II).

[2] Shelburne Papers, vol. 71, fo. 299.

of 1763 between Britain and France.[1] Subsequent discussions revealed that there might be room for bargaining Gibraltar against the French and Spanish gains in the West Indies. But the British would resist French demands for enlarged fishing rights and sovereignty over a large part of the coast of Newfoundland and any concessions in the East Indies that might revive French power there or give advantage to France's ally Hyder Ali.

Only secondary, and to a great extent subordinated in the public mind to the resistance to Bourbon encroachments, were the negotiations with America. In spite of the emotional wrench that the final recognition of American independence was bound to bring, the inevitability of that recognition had been generally, though tacitly, acknowledged since the Commons' resolution of February 27. Independence, generous boundaries (including the Trans-Appalachian lands and the Great Lakes basin), continuation of former privileges of trading within the British empire, and the use of the Newfoundland and Maritime fisheries might all be conceded to America in exchange for the *sine qua non* of the British negotiators: the separation of America from France and reparation to the American Loyalists.

At Shelburne's accession to power the British government and negotiators still believed that America could be persuaded to break away from the French alliance and reunite with Britain in some sort of federal and commercial union. In spite of Franklin's efforts to keep this illusion alive to America's advantage, by the end of July Shelburne realised its hopelessness and shifted the emphasis of the negotiations to ensuring that in future America would not be the ally or satellite of France. In this endeavour, Oswald, on July 31, was authorised to state the British preference for some form of reunion or common naturalisation regulations, but if this was impossible to offer as an incentive to the separation from France the early recognition of independence. He was also to insist on a general amnesty and restoration of property for the American Loyalists (for which, if necessary, he was to concede the Trans-Appalachian lands), and to do his best to secure the payment of debts owed by Americans to British merchants before 1775 and the restoration to British residents of their confiscated

[1] The following account of the peace negotiations is based largely on the very full account of Professor V. T. Harlow in *The Founding of the Second British Empire, 1763–1793*. Vol. I. *Discovery and Revolution* (London, 1952), 263–407. I have indicated where I disagree with Professor Harlow's interpretations.

American property. The Loyalists, in defence of whose rights the Northites, the independents, and the Court were all united, must be supported at almost all costs; and second only to them, the merchants and property holders in America.

The Americans appeared quite as adamant as the British had been in their negotiations with France. As summer wore on the anxieties of defending the western trade from the Combined Fleets, the Baltic trade from the Dutch, the West Indies from the French and Gibraltar from the Spanish weakened Shelburne's resolution. On August 29 he persuaded the Cabinet to authorise Oswald to enlarge the offer to the Americans to include the recognition of independence in the first Article of the Preliminary Treaty. If that would not do, Oswald was to offer special legislation to acknowledge independence before the Treaty was made, in addition to surrendering Trans-Appalachia and the Great Lakes basin and perpetuating American trading and fishing privileges within the empire. But in return the Americans must agree to separation from France. A more significant measure of the Cabinet's desperation was their instruction to Oswald to surrender, if necessary, the stipulations concerning merchants' claims and even the Loyalist indemnity.

But already the tide had begun to turn. Vergennes' disadvantages in the negotiations had hitherto arisen from the fact that the principal triumph of the Allies in the war had been the winning of American independence and that elsewhere they had not done sufficiently well to justify large claims on the small fund of possible British concessions. If he was to secure the important gains which alone would justify the great sacrifices and near-bankruptcy suffered by France and Spain, he must bind their demands as closely as possible to the recognition of American independence which the British were prepared to concede. To conciliate the British and ensure that at least French demands should be met, he offered to return most of the captured British West Indies and help Britain resist American claims to fishing rights and the Western Lands. Unfortunately for him, the Americans got wind of his intentions. Thus, by the middle of August when the British plenipotentiaries had at last lost faith in the friendly intentions of the Americans, John Jay and John Adams, in revulsion from what they regarded as Vergennes' double-dealing, were urging separate negotiations with Britain. By the middle of September they were

ready to trade such a negotiation in return for a practical acknow-
ledgement of independence in the terms of Oswald's commission to
treat. Deep in confidential negotiations with Gerard de Rayneval,
Shelburne by this time had realised the weakness of the French pos-
ition and saw that the critical moment for separating Britain's enem-
ies had arrived. Soon the outcome of the struggle at Gibraltar would
be known. What must surely be a fleeting opportunity for bringing
over the Americans must be seized before the news of defeat
strengthened American demands or the news of victory turned
King, Cabinet and Parliament against any concessions whatever.

In spite of legal caveats from Thurlow and Ashburton that the
executive, without benefit of parliamentary statute, might not have
the right to acknowledge American independence, and in spite of
practical objections from the King and some members of the
Cabinet that the concession was inexpedient,[1] Shelburne was able
to secure authorisation for the new commission, enabling Oswald
to treat with the Commissioners of the 'Thirteen United States',
with the safeguarding clause: 'inasmuch as the Commissioners
have offered under that condition to accept the Independence of
America as the First Article of the Treaty.' The Knot was cut.

Henceforth, as British power and demands at home for a strong
peace grew, Shelburne endeavoured to recover the concessions
made to the Americans in the time of Britain's weakness, and to
harden the terms offered to the other allies. Oswald, now
strengthened (and to some extent controlled) by Henry Strachey,
was directed on October 17 to reserve the Western Lands —
originally a bait for luring the Americans out of the French
alliance — as a bargaining counter to ensure amnesty and indem-
nity for the Loyalists and indemnity to British merchants and
property holders. The Cabinet was conscious of the enormous
appeal of the Loyalist issue and rather than face the wrath of
Parliament were apparently willing to risk the renewal of war.[2]
Fitzherbert and Strachey were ordered to appeal for French
assistance, if necessary, to save the Loyalists, even though this

[1] To the King, Shelburne urged that though he personally was still against
independence the difficulty of mobilising the nation's resources, especially of
persuading admirals and generals to serve, the decayed state of the armed forces,
the disturbed state of Ireland and the uncertain temper of the House of
Commons, all obliged him to advise the King to recognise independence,
which, after all, was merely ratifying the decision of the Commons of February
27 (Fortescue, VI, no. 3922); cf. Ashburton to Shelburne, September 16, 1782
(copy), Clements Library, Sydney Papers, vol. 5, no. 7.
[2] Pitt to Shelburne, November 10, 1782, Bowood MSS.

S

might mean later concessions to the French in India. Strachey
secured an extension of the Canadian boundary south to the Great
Lakes, but the American boundaries were still sufficiently generous
(including as they did the Western Lands) to give room for
American concession on the Loyalist question. Unfortunately, the
predominance of highly-prejudiced state legislatures in the
American Confederation ensured that this was the one concession
that could not be made. But in Paris the Americans were isolated;
everyone, by the middle of November, wanted a quick settlement;
and as frequently happens in such circumstances, unauthorised
compromises were resorted to. Strachey secured a specific
promise in the draft treaty that prosecutions and confiscations at
the expense of the Loyalists would cease, and the weak formula
that Congress would 'earnestly recommend' indemnity to the state
legislatures was inserted in the Treaty. In view of the circum-
stances that independence had been practically thrown away as a
bargaining counter in the spring, and that Shelburne had been
forced to use the Western Lands as a bribe to break up the
Franco-American Alliance, it was the best that could be done. The
American Preliminaries were signed on November 30.

Shelburne, meanwhile, dominated the negotiations with France,
in which he played upon Gerard de Rayneval as Franklin had
played upon Oswald, and with similar results. In long colloquia at
Bowood far from the influence of the Cabinet, Shelburne drew out
of his guest the full extent of the Bourbon demands in the East and
West Indies and the Newfoundland fisheries, and how much
France was willing to concede in the plenitude of her power.
By the time Vergennes came to present the French demands
formally on October 6, that power was on the wane, as Spain sank
back exhausted from Gibraltar and the naval campaign of 1782
came to a close. Spain was still determined to have the fortress,
even if France had to pay the price for it. But the attitude of the
British Cabinet hardened in response to the popular enthusiasm
for this new symbol of British indomitability. Shelburne and the
King were willing to try to trade it for a suitable equivalent,[1] and

[1] Francis Baring submitted a memorandum to Shelburne arguing that
Gibraltar was commercially and militarily useless ('The Importance of Gibraltar
with regard to Commerce and Merchant Ships in time of Peace, from Mr.
Baring, 28 December, 1782', Shelburne Papers, vol. 72). Samuel Garbett, on the
other hand, argued that considerations of national prestige must forbid the
cession of Gibraltar ('Considerations for and against the Possession of Gibraltar,
from Mr. Garbett', ibid.; cf. *Parliamentary History*, XXIII, 299–305).

the glittering prospects of securing in exchange Puerto Rico, or Guadeloupe, Dominica, West Florida and Minorca, or Martinique, St. Lucia, West Florida and Minorca, passed in quick succession before the eyes of the British negotiators. But at last a combination of Cabinet reluctance to risk the odium of having surrendered Gibraltar and Shelburne's unwillingness to find the necessary *quid pro quo* in the East Indies for the French contribution of Martinique to the composite price of Guadeloupe, Dominica and St. Lucia decided him to keep the fortress after all. For the rest, the French gains in the fishery were confined to the inevitable restoration of St. Pierre and Miquelon, and the right (not exclusive) to dry fish on the north and west coasts of Newfoundland; and though they also secured Senegal and Tobago, and the Spanish the Floridas and Minorca, most of the conquered British West Indies were restored.

The French had intended the *sine qua non* of their negotiations to be in India, but here their weakness was most apparent. They were waiting to hear news of the success of their expeditionary force sent out to India at the end of 1781. Hence their rather ambiguous statement at the outset of the negotiations that they wanted no territorial empire in India, but merely the restoration of their trade as they had enjoyed it in 1754, the restoration of their comptoirs formerly dominating Orissa, Northern Circars, and the Coromandel and Malabar coasts, and the control of enough territorial revenue to support their trade. They were playing for time until the news of victory altered the circumstances in their favour. But they waited in vain, while Shelburne whittled away their demands, pointing out that for peaceful trade it was not necessary that they should have fortifications or territories, until at last the pressure of all the belligerents for peace drove them to agree to accept only the restoration of their freedom to trade, token districts around Pondicherry and Karikal, the restoration of their comptoirs (unfortified) and the exiguous gesture of a ditch around Chanderanagore. The Preliminaries with France and Spain were signed on January 20. Dutch intransigence was to postpone their treaty for another nine months.

In defending the treaties in the Lords, Shelburne's primary purpose was to save his Ministry. He designed his defence to emphasise what his hearers would regard as its strong points and pass over those that were weak or controversial such as the failure to secure indemnity for the Loyalists, the surrender of the Western

Lands, the grant to Americans of fishing rights and the intended grant of trading rights, the revival of French trade in India and the apparent loss of the gum trade by the surrender of Senegal to France. The Loyalist question he wanted to avoid at all costs; but the others might be defended on the ground that they were all in preparation for a great new liberal system of commercial and political harmony between nations. Here necessity and inclination went hand in hand.

Professor Harlow in his very thorough discussion of the negotiations and Shelburne's defence of them, came to the conclusion that Shelburne was directed by his free trade sympathies almost exclusively. He believed that Shelburne deliberately fashioned the treaties with a prevision of Anglo-American partnership in the exploitation of the North American continent, and that he conceded the Western Lands, the North Atlantic fisheries and the principal resources of the Canadian fur trade in conscious harmony with the ideas of Adam Smith and in opposition to 'the mercantilist idea of colonies, which threatened to denude the new factories for the sake of creating artificial and uneconomic markets overseas, thus hampering Britain in becoming the workshop of the world'.[1] In the case of the Western Lands, Shelburne did indeed revive the argument used to justify his policy of the 1760's: that America, preoccupied with expanding into the great continent, must continue to depend upon British manufactures for ages to come. Benjamin Vaughan prepared memoranda showing that access to the Mississippi gave Britain all that was worthwhile in the area in the form of a 'trading coast' that would enable her to dominate the trade there for decades, if not centuries, to come. Andrew Kippis defended the treaty in a subsequent pamphlet with somewhat similar arguments. In the treaties themselves provision was made for future commercial agreements between the powers.

But this argument that liberalism made the treaty can be carried too far. Setting aside the fantasy about mercantilism and the 'workshop of the world', there were definite limits to how far Shelburne could press his enthusiasm for free trade, dictated by national advantage and the need to save his Ministry. He was reluctant to close with Rayneval's proposal for an Anglo-French commercial treaty during their discussions at Bowood, and refused to include the Armed Neutrality's code of neutral rights in the

[1] Harlow, op. cit., 306.

treaty. In his speech defending the treaty, he halted his liberal defence half-way through, as though realising how egregious it was sounding. After defending the Canadian boundaries and the concessions of the North Atlantic fisheries and Tobago on the free trade argument, he reverted to the much more forceful justification that the exhausted state of the nation demanded peace and that it was the best that could be got. His colleagues in both Houses similarly emphasised the incapacity of Britain to continue the war.[1]

Almost to the day of the debate, Shelburne had been uncertain whether or not the Coalition would materialise. On the eve of the Speech from the Throne in December North was disturbed by rumours that large territories had been surrendered in America, but he was still determined to give the Ministry enough support to enable them to continue the war.[2] On the government side, Shelburne mobilised his supporters in both Houses to hear the Speech and the Address read, and tried to discount the absence from the meeting of Richmond, who was now thoroughly disgruntled from not being regularly consulted on the peace negotiations and criticised the employment of Oswald as negotiator, the cessions to the United States and the suggestion of exchanging Gibraltar.[3]

In the debate on the Speech, the Northites attacked the granting of independence to America before the negotiations were complete, and took credit for the success of the recent naval campaign. Fox claimed credit for having been ready to grant independence before the negotiations started and demanded a more vigorous prosecution of the war. It was apparent that the Opposition had not yet coalesced. The government might have taken advantage of their disagreements had not Pitt incautiously permitted himself to be pushed by Fox into stating that the recognition of American independence was unconditional. Shelburne and the rest of the Ministry had already announced that it was conditional on a general peace settlement being arrived at. When taxed with this

[1] Vaughan to Shelburne, October 17, 29, December 7, 1782, January 5, 1783, 'Vaughan Letters', *Proc. Mass. Hist. Soc.*, 2nd Ser., XVII, 400, 414–20, 425, 430; Shelburne Papers, vol. 87, fos. 209–14; Pitt to Shelburne, September 24, 1782, Bowood MSS.

[2] *Auckland Journal*, I, 38–9; H.M.C., *Abergavenny MSS*, 56.

[3] Fortescue, VI, nos. 4008–9, 4011–12, 4017, 4021; *London Courant*, December 3, 1782; List of Peers Written to for Hearing the Speech read at Shelburne House, December 4, 1782, Shelburne Papers, vol. 166.

discrepancy in the Lords, Shelburne, with unexpected help from Richmond, fell back on the formula that the delicate state of the negotiations did not permit a public discussion of the point. The Opposition supported the Address, ostensibly as their contribution to patriotic unanimity, actually because they did not yet know the full terms and could not decide the ground for uniting among themselves until they did.[1]

By January 27, when the Preliminaries were laid before Parliament, it was obvious that Shelburne must soon complete arrangements for an alliance with one or other of the parties or be defeated. At first sight it seems surprising that the negotiations begun through Robinson and Jenkinson with North in the summer had not yet been pressed forward vigorously, or that, alternatively, no encouragement had been given to Richmond's proposal to come to an agreement with Fox. Grantham, indeed, subsequently complained that Shelburne trusted too much to his measures, and Temple blamed him for 'the affectation of holding the ostensible language of Mr. Pitt in 1759', professing 'to know nothing of the management of the House of Commons, and to throw himself upon the people alone for support'.[2]

The explanation is that Shelburne was apparently quite confident that the peace would be a good one, that on the basis of Robinson's analysis, the court and government groups would support him, and that North, as shown by his moderate attitude in the debate on the Address (and as Loughborough in a white fury was predicting) might criticise the peace in detail, but would yield at last to the pressure of the King and come to the support of the government.[3] Schooled during a decade and a half in Opposition in the legend of royal influence, particularly of royal influence exercised over North, he could not believe that North would not be directed by it to support the government and risk taking a share — the largest share — of the odium for the peace, without receiving any offer of sharing even in a subordinate way, the good things of

[1] *Parliamentary History*, XXIII, 205–8, 210–20, 223–92, 305–22; Fortescue, VI, nos. 4014–15, 4023, 4025; *London Courant*, December 23, 1782.
[2] Jenkinson to William Adam, November 21, 1782, Add. MSS 38,128, fo. 154; Adam to Jenkinson, January 3, Jenkinson to Adam, January 4, 1783, Add. MSS 38,309, fos. 77–8; Grantham to Sir James Harris, February 20, 1783, *Diaries and Correspondence of James Harris, First Earl of Malmesbury* (London, 1844), II, 31; *Memoirs of the Court and Cabinets of George III*, I, 302; *Leeds Memoranda*, 89.
[3] Richard Fitzpatrick to Lord Ossory, December 2, 1782, *Memorials of Fox*, II, 10; *Auckland Journal*, I, 11–12, 40–5.

office.[1] On this question he was also badly served by the person who should have been his principal political adviser. Thomas Orde was still too inexperienced to be a reliable guide to the shifting loyalties of the House of Commons (hence the request to Robinson for a state of the Commons) and he too believed in the omni-potence of the royal command where North was concerned.

The resignation of Richmond and Keppel at the New Year seems to have decided Shelburne to press the negotiations forward. Dundas gave dinners to bring Northites and Shelburnites together, and Jenkinson assured the Northites that a reform of Parliament would not be carried in that Session. Pitt, on the other hand, urged that the approach be made to Fox. Shelburne hesitated for more than a week at the beginning of February, while the government seemed to disintegrate around him, and the struggle for North's soul and votes grew more furious than ever. Then Pitt was permitted to ask Fox for terms; Fox stipulated Shelburne's resignation as the first term; and the negotiation was broken off.[2]

Shelburne then suggested that North be tried again, hinting for the first time that he might resign to facilitate arrangements. But there might still be a play or two that he could make. What followed is somewhat obscure. Apparently Shelburne informed Dundas of his intention to resign and predicted that he would be succeeded by a Pitt-Fox coalition. As he probably hoped, Dundas rushed off in alarm to William Adam to urge him to persuade North to support the peace and save the country from such a radical combination. But it was just a little too late for such cleverness. North had already learned of Pitt's approach to Fox and could see the danger of isolation. On the evening of February 13 Dundas struggled to nail North down to supporting the peace, Fox to have him oppose it; but whereas the government was still demanding North's support unconditionally, Fox agreed that there should, in the first instance, be an alliance of equals to defeat the peace, and later an agreement on forming a Ministry and dividing the spoils.

[1] Cf. W. W. Grenville to Temple, February 19, 1783, *Memoirs of Court and Cabinets*, I, 158. Shelburne was not the only one who assumed that North would be content to be a silent partner. At the same time Portland was congratulating himself and the party that Fox had insisted in negotiations with North that the Coalition must be founded upon the suppression of royal influence and the subordination of North (to Burke, January 11, 1783, Fitzwilliam MSS, Burke 1214).

[2] Loughborough to Eden [January 1783?]; *Auckland Journal*, I, 41-2; Jenkinson to Sir G. Cooper, January 4, 1783, Add. MSS 38,309, fo. 78; *Abergavenny MSS*, 56-7; Pitt to Shelburne, February 1, 1783, Bowood MSS.

On these latter terms the agreement was made.[1] Now it remained only to administer the *coup de grâce* to Shelburne.

It very nearly failed to be administered at all. In the Lords, Shelburne's desperate and ingenious defence of the peace carried the Address on the Peace by the narrow margin of 72 to 59 in the face of rather feeble Northite attacks on the desertion of the Loyalists and the cession of the Western Lands. In the Commons, however, against Fox's attack on the terms given to France in India, and North's denunciations of the desertion of the Loyalists and the surrender of the Middle West, Townshend made very heavy going and Pitt laid himself open to a classic snub by Sheridan. At half past seven on the morning of February 18 Cavendish's ingeniously-worded amendment to leave out of the Address expressions to the effect that the House had taken into their consideration and approved the peace, and to substitute a declaration of intention to take it into consideration was carried by 224 to 208. On such a deliberately ambiguous proposition the new union had managed a majority of only sixteen. If they were to drive the defeat home they must come out more openly against the peace. During the next four days Fox and Cavendish worked feverishly to draft a formula that would be acceptable to their allies. On February 21 they proposed to the House a series of resolutions grudgingly accepting the peace as necessary, approving the granting of independence to the United States as in conformity with the wishes of Parliament, but condemning the concessions to the enemy, as being greater than they were entitled to considering the comparative strength and situation of the belligerents. After another all-night debate, the censure was carried by the margin of 207 to 190. A further resolution protesting the abandonment of the Loyalists was then dropped by Cavendish.[2] The job was done, and there was no reason for the Foxites to lament the fate of the Loyalists, a group whom they had been condemning for years as renegades. Two days later Shelburne resigned.

Why did he resign? Comparisons are naturally drawn with Pitt's superior determination a year later in the face of a similar hostility from the House. At the time rumours, inspired perhaps

[1] Shelburne to the King [February 10, 1783], King to Shelburne, February 11, 1783, Fortescue, VI, nos. 4109–10; Fitzmaurice, *op. cit.*, II, 234–5; *Memorials of Fox*, II, 37–8.

[2] *Parliamentary History*, XXIII, 373–571.

by a favourable Address on the peace from the City and the presentation of parliamentary reform petitions, were current that Shelburne intended to hold on and secure a dissolution. At a conference of the Ministry on February 23 this possibility, together with those of a coalition with the Bedfords or with Fox and an appeal to the landed and commercial interests, appear to have been explored, but without much enthusiasm.[1] Later commentators, wise after the event, condemned Shelburne for not having anticipated Pitt's action of 1783-4. The King and most of the Commons men who supported Pitt in December supported Shelburne in February. But rumour mongers and commentators overlooked the different circumstances of the two crises. The young Achilles is a more inspiring captain than the wronged Menelaus; Pitt on the floor of the House of Commons fighting for King and Constitution was a more attractive figure than the Jesuit in Berkeley Square. Shelburne, however, made no attempt to carry on, but threw in his hand almost immediately following the defeat of February 21. Later Wraxall suggested that it was due to his lack of fortitude.[2] But that was not one of Shelburne's failings. An analysis of the vote in the Commons on the peace, taken together with Shelburne's contemporary and subsequent comments on the subject, provides the explanation.

From an interpretation of the available material on the state of the Commons,[3] it appears that Shelburne secured a much larger proportion of the independent vote than was expected. Out of 208 or 210 Members listed as supporting him on the division of February 18, eighty-seven could be regarded as independents. Their support for Shelburne was probably due to varying convictions that Shelburne was actually carrying out economical reform, that he had secured an acceptable peace, or that he stood between the King and the 'unprincipled' Coalition's attempt to storm the Closet. Only 38 independents voted with North (whose supporters

[1] *Leeds Memoranda*, 23-4; *Parliamentary History*, XXIII, 571-2; Address to the City of London to His Majesty on the Peace with America, Shelburne Papers, vol. 130; *London Courant*, February 22, 25, 27, 1783.
[2] *Historical and Posthumous Memoirs*, V, 238.
[3] A division list of the vote on February 18 was published in the *Morning Post* of February 27, 1783, and a 'State of Parties', dated March 10, 1783, in the Melville Papers (vol. 63A) was drawn up, perhaps by John Robinson, for Henry Dundas for the purpose of discovering if a Ministry could be formed to exclude Fox. Neither is wholly reliable in the designation of party loyalties, but with corrections from other sources, they provide a general indication of party loyalties in February and March of 1783. Such a corrected 'State' is to be found in Appendix II.

totalled about 133) and only 9 with Fox (whose total strength was
78). On the other hand, outside the ranks of the holders of minis-
terial office, only twenty of those in the category of the court,
placeholders and serving officers voted with Shelburne, though to
these perhaps should be added another thirty-four who belonged
to small followings customarily associated with the court. But
North secured twenty-nine court votes, as well as those of five
holders of contracts or other financial patronage, and of two naval
officers who followed Sandwich. Thus the Ministry, which,
according to the best eighteenth-century precedents, ought to have
been able to rely upon most of the court vote, lost forty per cent of
it to the Opposition, while securing, somewhat unexpectedly,
almost sixty-five per cent of the voting strength of the independents.

Thomas Townshend boasted in the House of this latter gratify-
ing development, and the *Morning Post* drew attention to it in
publishing the division list; but Shelburne overlooked it in his
chagrin at the loss of votes he ought to have been able to rely on.
His naturally suspicious mind turned back to the question of royal
influence. Almost to the last he had luxuriated in the false
assurance that North would be brought over by royal command.
Now, disregarding in his rage the real considerations of friendship,
respect and obligation that still held a good many of North's
peripheral followers loyal, it seemed to him that a royal con-
spiracy, such as that to which Opposition myth still attributed the
fall of Rockingham's Ministry in 1766, had directed the Court
phalanx to overthrow him. The King had never intended to order
North to save the government.

Brooding over this apparent betrayal, he remained inactive after
the defeat of February 18, an embarrassment to his followers who
had their own careers to consider. On February 20 Pitt got him to
agree that if the second attack of the Coalition looked like succeed-
ing, Pitt should announce Shelburne's resignation. The next day,
perhaps in an attempt to push him to a decision by confirming his
worst suspicions, Orde reported to Shelburne the opinion (which
was also his own) of James Hatsell, Clerk of the House of Commons
that since the survival of the Ministry depended absolutely on the
King's command over North's loyalty, he should be urged to take
action before the coming debate if he wanted the Ministry to
stand. It would not answer for Shelburne to make the approach to
North himself, 'for experience had formerly shown, that nothing

less than the King's earnest co-operation and immediate address could do'. If the King declined, it should be taken as evidence of his indifference to the Ministry's fate, and Shelburne should consider whether it would be 'comfortable, creditable, or safe, to continue efforts in his service under such disadvantage'.[1]

There is no record that Shelburne made such a representation, and it is doubtful if it would have made much difference if he had. Others, notably Grantham and Carmarthen, believed that Shelburne's fate was being decided by royal influence;[2] probably, too, the King's small fund of enthusiasm for his Minister had evaporated in face of the recent demonstrations of Shelburne's political incapacity. But he had no considered plan to replace Shelburne with North. He would accept North, or Pitt, or Gower, or 'Mr. Thomas Pitt or Mr. Thomas anybody',[3] rather than accept the Coalition or the Foxites. But, as his later unsuccessful struggles demonstrated, it was now too late to recover North from the Coalition, and probably had been since the Coalition agreement of February 14.

The subsequent manoeuvres to avert the Coalition's accession to office confirmed Shelburne more firmly in his convictions. In the debate of February 22 Pitt excoriated the Coalition as a combination designed solely to remove Shelburne from the Treasury, and in announcing the achievement of that purpose, delivered a glowing panegyric on his leader. To the sensitive or suspicious ear the combination was not a happy one. The prediction that the public would come to appreciate Shelburne's great qualities and achievements when, stripped of power and emoluments, he returned to private life, sounded remarkably like an epitaph; and was it very tactful for Pitt to take the high line that notwithstanding his close ties with Shelburne, he would not wish him to remain in power against the wishes of the public? Shelburne had been urging Pitt not to resign since the crisis began on February 10. At his own resignation he told the King, Weymouth and Dundas that Pitt must succeed him. But was it kind of Pitt to have insisted upon Shelburne's explicit renunciation before he took up the succession? Was it necessary that Pitt, Dundas, Thurlow and (worst of all) Ashburton should have accepted the succession with such alacrity, ignored him, and with Jenkinson as *deus ex Machina* closeted

[1] Fitzmaurice, *op. cit.*, II, 245–8. [2] *Leeds Memoranda*, 82–3.
[3] Fitzmaurice, *op. cit.*, II, 256.

together on the new arrangements, in apparent disregard of the line agreed upon by the Cabinet on February 22 that they could not carry on major business any longer?[1]

He informed Pitt that he should have no difficulty securing a majority in the Commons if he had the confidence of the King, because with that confidence went the support of North and his followers. But Pitt, too, discovered that North would not budge, and perhaps apprehensive that Shelburne's suspicions of the King might be correct after all, surrendered his mandate. 'This resolution [he wrote to Shelburne] will I am afraid both surprise and dissappoint you.'[2] If it did, Shelburne managed to control his feelings admirably. The fires of jealousy and suspicion raged on, fed by Ashburton's dislike for Thurlow and the King's refusal to grant Shelburne's post-resignation requests for patronage. By the time the Coalition came to office the King and Shelburne were each convinced that he had been deserted by the other.

In fact, the Ministry fitted Charles Townshend's description of the first Rockingham administration — 'a lutestring administration, fit only for summer wear' — and it did so because Shelburne had gambled for power against the political realities of the age and lost. He had lost by a much narrower margin than anyone would have predicted. But in a sense, the fact that he made the attempt at all demonstrated his misunderstanding of the situation. In later life he was to describe government by the House of Commons as 'converting the Legislature into a false Executive', and laying the foundation for parties and factions.[3] He was blind to the changes in the nature of Parliament and the party system, and he hardly had time to study them in office. Hence he made the mistake of despising Lord North, who did understand the nature of parliamentary loyalties; and by that mistake he fell.

[1] *Parliamentary History*, XXIII, 550–3; Fortescue, VI, nos. 4130–1, 4142; Dundas to Shelburne, February 24, 1783, Clements Library, Melville Correspondence, 1780–1830, fo. 105; Fitzmaurice, *op. cit.*, II, 252.
[2] Pitt to Shelburne, February 27, 1783, Melville Correspondence, fo. 106.
[3] Fitzmaurice, *op. cit.*, I, 80.

The Sylvan Sage: Conclusion

After 1783 Shelburne's career dwindled into a long diminuendo. He was still in the prime of life, and knew more about the workings of the executive government than did any of his contemporaries. But after the debacle of February 1783, the leadership of his party — and, as it turned out, his ministry had created a party — passed completely into Pitt's hands. Without power, and without even the hopes and excitements of active opposition that made a lifetime in the political wilderness tolerable to Charles James Fox, he sank into the semi-retirement of the *Rolliad's*

'. . . sylvan sage,
Whom Bowood guards to rule a purer age'.

His judgments of men and past events grew sharper and shrewder as the years carried him away from the centre of affairs. But he nursed his grievances. He was by turns pococurantist and boastful concerning his career. He considered himself an unappreciated martyr to the cause of reform, but patronising the utilitarians in anticipation of their and his future triumph was poor consolation. He had the inside knowledge to be able to cut to the weaknesses of Pitt's reforms, which he regarded as pale imitations of his own intentions. But he could never persuade men to follow him again to correct the mistakes of the Ministry. As the years went by even his technical knowledge went out of date. He lost touch with events, and in desperation fell to repeating the old slogans about Revolution principles, influence, the dangers to the rights of property, the evils of corruption and the salutary effects of publicity. These acquired a new topicality in the age of the French Revolution and Pitt's conservatism, and he ended his career in odd alliance with Fox, as one of the little band who, according to Victorian radical tradition, kept the light of reform burning in the darkest days of Tory reaction.

His eclipse was not immediate, because at first he refused to accept it. In the spring of 1783 he stayed in town to defend his Ministry and defy the Coalition in the debate on the loan bill. Certainly the Coalition was not following his lead in negotiating the loan of 1783. They had had to undertake this task within two weeks of taking office because Shelburne's government had failed to do it in the previous month. Market conditions were very bad, and they had made the sort of arrangement that the monied men in the City wanted — closely resembling North's wartime loans, with stock bonuses that increased the capital of the debt by £16,500,000 for a cash return of £12,000,000. Because they were short of patronage, the Ministry also kept a reserve of stock for distribution among their friends.[1]

Shelburne drove the point home that the Coalition were irresponsible, improvident and corrupt in their financing. Their Lordships ought to protest, as the Opposition Lords had in the case of the loan of 1781, against the improvidence and corruption of the bargain and the use of those 'splendid instruments of ruin and distress', lotteries. Ideally, he said, there should have been a closed subscription such as he had used in the provision contracts, distributed only to contractors who met the secret price determined on by the government. The smaller the number of contractors, the lower their price was likely to be. He accused Lord John Cavendish, the Chancellor of the Exchequer, of having refused the offer of such an arrangement with the result that the public, to secure twelve millions, would have to add sixteen and a half millions to the already enormous burden of the debt. All this was done for the sake of influence which the Ministry wanted to exercise by distributing the reserved part of the subscription among a set of men without a shilling to their names. He proposed (unsuccessfully) to amend the loan bill to require that all future loans be negotiated in a manner best suited not to hinder the reduction of the national debt, and to ensure that in closed subscriptions there should be no reserve at the disposal of the Minister.[2]

In a subsequent wrangle he flung back the accusations of having accomplished nothing in office. He had been able to fulfil his promises of essential reforms — a Customs House Bill and a regulation of fees were prepared, as anyone who took the trouble

[1] H.M.C., *Abergavenny MSS*, 60; Laprade, *op. cit.*, 49.
[2] *Parliamentary History*, XXIII, 767–95.

to enquire at the Treasury could learn; only at the Admiralty had reform been held up, and he left no doubt that he thought Keppel's reluctance was the stumbling block here. The House might accept his amendments or reject them (they rejected them) — it was all one to him — but he was content to have set the record straight and stood out for better practices.[1]

From anxiety bred of their lack of patronage, the new government was led into ways that seemed to confirm Shelburne's accusations of nepotism. The royal fountain of honour obstinately refused to play; forty places ordinarily available had been eliminated by economical reform; and the surviving places at the revenue boards were not compatible with a seat in Parliament. In the circumstances the grasping for available plums was particularly ruthless. Fox endeavoured unsuccessfully to persuade Conway to open the army to party patronage, and almost as soon as Ashburton and Sir John Shelley were in their graves, their places were transferred to deserving Coalitionists in defiance of the protests by economical reformers.[2]

The Coalition's difficulties were increased by the belated appearance of Shelburne's reform measures in the House and the passage of Cavendish's Exchequer Regulation Act during the spring. Orde attributed the appearance of the measures to the Coalition's inability to resist the reform tide,[3] but in fact there was no agreed opinion on reform among them. In the debates, Fox's deliberate, almost insouciant, defiance of the economical reform sentiment was counterbalanced by the concern of Cavendish and North that the Ministry should have a reputation for financial responsibility. Fox dominated the attack on Pitt's Custom House Bill (designed to implement Musgrave's plan) and Mahon's Bribery Bill, warmly defending patents on the ground that 'it was impossible for the government of a great Kingdom to go on, unless it had certain lucrative and honourable situations to bestow on its officers', and seconding the more cogent criticism that Customs reform would cost more in compensations than it would save. The measure was defeated, however, for the good political reason that it came from the Opposition. Pitt's Public Offices Regulation

[1] *Ibid.*, 806, 931–45; Fortescue, VI, no. 4335.
[2] Burke to J. Bullock, March 3, 1783, Fitzwilliam MSS, Burke 1272; Gibbon to Lady Sheffield, July 26, 1783, Add. MSS 34,884, fo. 308; Add. MSS 47,579, fos. 21–2, 23–4, 27, 118; Add. MSS 47,561, fos. 1–2, 56, 62, 64; Add. MSS 47,568, fos. 144–7, 148–51, 156.
[3] To Shelburne, July 17, 1783, Bowood MSS.

Bill for the reform of fees inspired Fox, North, Burke, Stormont and Portland to denounce Shelburne's reforms as impractical, insincere and ungenerous. Cavendish, however, was inclined to take a leaf out of Shelburne's book and ground his argument on the necessity of leaving it up to the Treasury to make the necessary reforms. These differences came out more clearly in the debates on Cavendish's successful Exchequer Regulation Bill. The Treasury proposed to implement the recommendations both of the Commissioners for Examining the Public Accounts and Shelburne's Ministry to put the great sinecures of the Exchequer on the road to extinction; Pitt, Kenyon, Powys, and Hussey urged immediate abolition; while Fox, Courtenay and Dempster deplored the terrorising of public accountants by the threat of wholesale reform.[1]

Shelburne had no concern with these, nor with the subsequent, battles with the Coalition. Having delivered his defiance, he cut his ties with his party after an awkward interview with Pitt, and before Parliament rose slipped away to Spa. There he took the waters and ministered to his *amour propre* with Morellet's praises and the reflected admiration of Vergennes. Even here he was not quite beyond the reach of English affairs, since Fox and Manchester (now Ambassador at Paris) had his mail opened under the suspicion that he was conspiring to lead Britain into an Anglo-French alliance and away from the will-o'-the-wisp Anglo-Russian agreement to which Fox had devoted himself.[2] For years to come they were to suppose that Shelburne was the secret inspiration of Pitt's policy of good understanding with France.[3]

Pitt, however, had no intention of consulting him. When in December 1783 the King's appeal went out to the Lords to rescue him from Fox and the India Bill, Shelburne was not informed, though Rutland and a few others thought he should have been. Pitt may have been embarrassed at treating his benefactor in this way, but he was apparently more embarrassed at the thought of consulting Shelburne and deciding what part he should play in the new arrangements. For once consulted, he must obviously play a part. He was easily the most capable and distinguished figure in Pitt's camp, and still in the prime of his vigour and political know-

[1] *Parliamentary History*, XXIII, 926–31, 946–59, 993–5, 1049–50, 1060–96, 1106–21; Fortescue, VI, nos. 4402–3.
[2] *Malmesbury Diaries*, II, 50; H.M.C., *8th Report, Pt. II*, Manchester MSS, 128–31; Add. MSS 47,561, fo. 58, Add. MSS 47,579, fos. 23–4.
[3] Fox to Fitzpatrick [November 1785], Add. MSS 47,580, fos. 128–9; James Cunningham to Eden, August 28, 1787, Add. MSS 34,426, 48.

ledge. He was also willing to join, as seems clear from his hints to Orde about having definite views about the India Bill (including freeing the East India trade from the Company's control), and offering unreserved support to the King in the crisis. The new Ministry might have been very much stronger than it turned out to be if Shelburne could have been called to manage Indian or foreign affairs as a secretary of state. And perhaps by the beginning of 1784 he had reconciled himself to serving under Pitt.

But the King believed that Shelburne had deserted him; and Pitt could remember how barely eighteen months ago Shelburne, as Secretary of State, had gathered the power of the Rockingham Ministry into his own hands, and also how grudgingly he had surrendered the lead in February. Neither of them had any intention of providing the means for restoring the Shelburne Ministry to power. Even a cabinet of Carmarthens and Sydneys was preferrable to that. In the event Shelburne was awkwardly ignored (when everyone else was being called on to rally to the King) until after the arrangements were made. Then the first explanations were made through Jenkinson and Dundas, whom Shelburne had now convinced himself were the real authors of the 'conspiracy' which had defeated him in the previous February. Later Sydney, with even less sensitivity, explained to Orde that Shelburne's intense unpopularity would make him impossible as a cabinet member — 'it would not be much more alarming to many to bring Lord Bute forward'.[1] The result produced was doubtless what Pitt intended. Shelburne was frozen out.

Of Shelburne's close supporters, only Orde was offered a place — his old one as Secretary of the Treasury, which he refused on the ground that Shelburne had not been properly treated. Orde still corresponded loyally with Shelburne, but there may have been an element of political calculation in his refusal of office, since in the winter of 1783–4 he appears to have expected that Pitt would not last and Shelburne would come back stronger than ever.[2] After the election of 1784, however, he became Chief Secretary to Rutland, now appointed Lord Lieutenant of Ireland.

These two remaining friends of Shelburne in the Ministry were responsible for acknowledging the debt of honour owing to him for

[1] Orde to Shelburne, December 25, 1783, Bowood MSS.
[2] Same to same, December 9, 12, 16, 18, 20, 23, 25, 1783, January 4, 1784, Shelburne to Orde, December 20, 1783, Bowood MSS; Fitzmaurice, *op. cit.*, II, 270–85.

T

the peace. In the summer of 1784 Rutland wrote to Pitt urging him that in the various arrangements and promotions that were being made, Shelburne be offered a step in the peerage. He reminded Pitt that:

> The government (in which my principal object is completed by seeing you placed at the head of it) was first formed under his auspices, and by the quiet manner in which he has quitted his pretensions to any share of it, certainly owes him some compensation.[1]

Apparently Pitt was not so sure that Shelburne had flung away ambition and waited until October before making the offer. It was for a marquisate, and Pitt assured him that it would have been a dukedom had not the King decided to reserve that rank for the Royal family. Later the gilt was rubbed off the prize by the news that Temple's intrigues at the fall of the Coalition were considered worthy of a similar reward. But Pitt's purposely ambiguous explanation that he wanted his government to 'receive the most public marks of your Lordship's approbation', excited Shelburne's curiosity and perhaps his hopes. The Privy Seal was vacant, and a rumour went the rounds that Shelburne was to be offered it. From Bowood Shelburne wrote anxiously to Barré to discover what was behind the offer of this peerage. He was inclined to accept and to give his support to Pitt.

> You are to tell Mr. Pitt in regard to the present system of government [he wrote], if he means his being at the head of the Treasury, I have no objection to it. I detest the situation for myself, and I shall certainly enter into no cabal against him, neither with any part of the Opposition. Further I suppose he cannot mean.

He went on to explain that he would take no office unless the King specifically desired it, and unless he had a conversation with Pitt about measures. He would handle the negotiations with Chatham's son with Chathamite reserve. But he assured Barré that he had no intention of being touchy, and wanted his relationship with the Ministry to be settled as clearly and frankly as possible.[2] Barré thought this was protesting too much, and on his advice Shelburne wrote accepting the offer and expressing pleasure at Pitt's anxiety to have his approbation. It seems probable that he hoped at least to be consulted in the role of elder statesman. Nearly a month went

[1] June 16, 1784, Fitzmaurice, *op. cit.*, II, 289.
[2] October 25, 1784, *ibid.*, 290–2.

by, and Shelburne began to worry about not hearing further, suspecting that Jenkinson and the Court interest were trying to keep Pitt from consulting him on measures. But at the end of November Pitt wrote apologising for the delay and informing him that the patent of creation was ready.[1] Shelburne disappeared into the new dignity of Marquess of Lansdowne, but with his relationship to the Ministry as ambiguous as ever.

He still yearned to be in the secret, 'in some confidential line without office', and it became increasingly evident, as he complained to Morellet in 1786, that he was 'growing very insignificant, very fast in the political world'.[2] His personal party was gone. Ashburton died in the summer of 1783; Barré was blind, and though he attended Parliament from time to time, he was no longer the Opposition bulldog as of old. He fell out with Lansdowne over what he considered the latter's unnecessarily radical tendencies, and at the election of 1790 he was replaced by Joseph Jekyll as Member for Calne. James Townsend lost his standing in the City in the spring of 1783 when the Westminster group at the time of the defeat of the peace treaty overcame the moderates from the City to control the Quintuple Alliance. He died in 1787 before the turn of the political wheel in the City and the excitements of the French Revolutionary era could bring him back to power. Horne Tooke continued on his own independent way, remaining on good, but not cordial, terms with Lansdowne. The independents still annually exorcised the demon of government extravagance, but their quondam allies, the professional politicians of the Shelburne-Pitt party and the administrators, now held to a party allegiance which was soon transformed into an allegiance to the most stable government of the century. Pitt, with a clearer (though narrower) perspective of the ways and means of change than Shelburne had possessed, channelled reform of the financial structure out of parliamentary debate and into the machinery of departmental administration. The belief in reform as the embodiment of economy, virtue and liberty, had never been widely shared and now dwindled to an evanescent existence in the nostalgia of a few out-of-place politicians, of whom Lansdowne was the most notable. Out-of-doors support for parliamentary reform remained active for some time longer, kept alive by Pitt's

[1] *Ibid.*, II, 270–94; H.M.C., *Rutland MSS*, III, 102, 112, 114, 121, 129–32, 151, 153–4.
[2] November 7, 1786, Bowood MSS.

two attempts in 1783 and 1785 and by the efforts of the Society for Constitutional Information, until these merged with those of the natural rights and class movement of Place's London Corresponding Society in the 1790's.

But Lansdowne was drifting away from radical politics and the cause of parliamentary reform. He could hardly disapprove of Pitt's motions of 1783 and 1785, and gave Wyvill his good wishes in 1792 and 1795, but he had no stomach for the further unpopularity that active support of the cause would entail. Though he defended the right of the reform associations to agitate against Pitt's repressive legislation, he urged that administrative reform was the one change that would conciliate public opinion and quiet the clamour for parliamentary reform.[1]

Early in 1792, as a by-product of the negotiations between Ministry and Opposition that promoted Loughborough to the Woolsack in place of Thurlow, the King was persuaded to ask Lansdowne for his views on a new administration. Lansdowne suggested that the King might once more endeavour to break up the party system. Against such a proposal it might be urged that since the 1760's, and even since Pitt's accession to power, circumstances had changed. The party leaders had more popular support than before, the King's sons were active in party politics, America had been lost, and the Court had been held captive by the parties since 1783. On the other hand, the King's popularity was still greater than that of any Minister or leader of Opposition, and he could still appeal over their heads to the public, as he had done in 1784. Any such move, however, ought to be proceeded with slowly, first by gaining over small groups in the House of Commons and securing a leader there — Lansdowne suggested Sheridan. It would also be necessary to undertake large and generous measures of reform, lay them early and clearly before the public, and guard against misunderstanding, disappointment or anything being left to the leaders of either party to take credit for.[2] Lansdowne had obviously learned a good deal from pondering over his own defeat; but nothing came of the overture, and he sank back into semi-opposition again.

[1] Lansdowne to Wyvill, April 30, 1792, Wyvill to Lansdowne, May 11, December 6, 31, 1795, Bowood MSS; Lansdowne to —— [Horne Tooke?], November 19, 1792, B.M., Lansdowne MSS 1228, fo. 57; *Parliamentary History*, XXIX, 1569-70.
[2] Fitzmaurice, *op. cit.*, II, 384-7.

Increasingly, now, he compensated for his exclusion from active politics by encouraging those who planned perfection in the future. His *salon* was even more brilliant than before the war. From the Continent Morellet wrote regularly, and since the peace treaty Lansdowne House had become one of the recognised stopping places for *philosophes* on tour. By a series of odd chances the politics of Switzerland made a brilliant contribution to his circle. In 1782 the young Francois d'Ivernois, exiled from Geneva which was then under the rule of the pro-French aristocratic party, came to Shelburne with a plan for reviving democratic Geneva, complete with watchmaking industry, in England. Shelburne already had enough refugees from America on his hands and suggested that he try Ireland. Both the Irish government and the Irish Volunteers gave enthusiastic support to the idea of an industrious, libertarian, and especially Protestant, New Geneva being established just outside Waterford. But the Coalition came in, the emigrants disagreed among themselves, and Vergennes put pressure on the Swiss government to forbid the migration. D'Ivernois kept up his connection with Lansdowne and introduced him to his fellow utopians — Duroveray, Clavière and the young Pierre Etienne Dumont. Dumont became tutor to young Lord Henry Petty and amanuesis to Bentham. When 1789 revived the prospects of Genevese democracy, Dumont, Duroveray and Clavière went off to Paris to persuade Mirabeau, whom they had met at Lansdowne House, to free their city. Instead, he set them to work writing for him, and in 1790 they produced the Declaration of the Rights of Man.[1]

They were accompanied to Paris by young Samuel Romilly, since 1787 Lansdowne's adviser on public law. Interest in the subject at Shelburne House in the old days had run to the partisan protection of what Chatham and Dunning had thought was the pure common law against Mansfield's new-fangled interpretations. Now it centred on scientific reform, with Bentham supplying philosophic justifications and Romilly, later joined by Brougham, providing specific measures to ameliorate the ferocity of the common law.

In later life Bentham, in recalling his relationship with Lansdowne, inflated his own role and deflated Lansdowne's:

[1] Otto Karmin, *Sir Francis D'Ivernois, 1757–1842* (Genève, 1920), 115–67; Etienne Dumont, *Souvenirs de Mirabeau* (Paris, 1818), I, xx–xxiii.

His manner was very imposing, very dignified, and he talked his vague generalities in the House of Lords in a very emphatic way, as if something grand were at the bottom, when, in fact, there was nothing at all. . . . He was afraid of me, so there was not much intimate communication.[1]

But Bentham owed almost all his knowledge of the world of affairs to Lansdowne. His early innocence of that world, apparent in *The Rationale of Punishments and Rewards* and the early drafts of *The Fragment on Government* produced in the 1770's, gave place to a greater sophistication of thought (if not of expression) in the later drafts of the *Introduction to the Principles of Morals and Legislation* and his attacks on Pitt's Poor Law proposals of 1797, under Lansdowne's influence. The Marquess was constantly urging reality on him, persuading him that scientific legislation was not a cause to be fought for on the hustings, but to be won only by patient lobbying, and instructing him in how to go about it. He would not himself take on a public campaign on the subject and doubted if anyone else could. When Bentham, relying on a vague promise, demanded to succeed Barré as Member for Calne in 1790, Lansdowne explained as gently as he could that Bentham was not suited to play the philosopher-king.[2]

As Lansdowne's humiliation of 1783 receded in time and in the memory of his contemporaries, he spoke with increasing frequency on questions of trade. Inevitably he weighed Pitt's attempts at trade liberalisation in the balance of his own intentions. He attributed the indefinite postponement of a commercial agreement with America to the influence of the Coalitionists 'who either from prejudice or unpopularity are for calling out the Navigation Act on this and all other occasions', rather than to merchant opinion which he was convinced was enlightened.[3] Garbett's opposition to the American agreement, the rise of the General Chamber of Manufactures, and their attitude on Pitt's propositions of 1785 to give Ireland reciprocal trade advantages with Britain, largely disillusioned him. He defended the propositions as a hopeful

[1] *Works*, X, 116.
[2] Lansdowne to Bentham, August 27, 1790, Bowood MSS; Add. MSS 33,533, fos. 28–37; Add. MSS 33,541, fos. 5–7, 53, 70; U.C.L., Bentham MSS, Box IX, fo. 92, Box CLXIX, fos. 153–8; cf. *Parliamentary History*, XXVIII, 939–48, XXX, 147–52, 329–31, XXXV, 1198–9.
[3] Shelburne to Sydney [June 1783], Shelburne Papers, Misc.; Samuel Garbett to Shelburne, October 2, 5, 1784, September 21, 1786, Lansdowne to Morellet, May 22, 1785, Bowood MSS.

beginning for the refashioning of the trade systems of the world. He rejoiced at the negotiation of the Eden Treaty, describing it as the beginning of the end for monopoly in Europe, and exchanged mutual congratulations with Morellet and Price on the advancement of the cause of freer trade. But he could not resist criticising the delays in negotiation and the relative narrowness of the reciprocity secured.[1]

The suggestion that Britain acknowledge a code of neutral rights set him off on another tack in enthusiastic pursuit of simple, universal principles of law. In 1783 he had refused to embody the code prepared by the Armed Neutrality in the Treaty of Versailles because he said that the principle of free ships, free goods went too far — under free trade in time of war Britain, as the greatest trading nation, was likely to lose much of her commerce to neutral flags — and not far enough — because, as he pointed out in criticising the Eden Treaty, what was wanted to make the principle feasible for British commerce was the exemption of merchant ships of belligerents from capture, as had been provided in the recent Prussian-American treaty.[2] Now he laid plans with Bentham and Morellet for preaching an amended neutral code in a newspaper, to be called the *Neutralist*. In pursuit of the cause, he defended even the freedom of the slave trade against the attacks of Wilberforce and Pitt.[3] But the campaign for international law foundered. Bentham went off to Russia and later quarrelled with him over Lansdowne's refusal to seat him in Parliament; and under Pitt's apparently unshakeable administration, the nation embarked on foreign adventures, culminating in war with France.

This march of events brought into focus Lansdowne's vague irritations with Pitt's other measures to reform the financial system. The foundation of their differences was Lansdowne's ever-present sense of grievance, sharpened, if that was possible, by his awareness that in endeavouring to restore public credit, stimulate prosperity and revenue, and reduce the national debt, Pitt was carrying out Lansdowne's own proposals. But there was also a

[1] *Parliamentary History*, XXV, 855–64, XXVI, 554–66; Garbett to Lansdowne, November 6, 1784, February 15, 26, March 11, 1785, Lansdowne to Morellet, July, October 17, November 7, to Garbett, July 31, 1786, Bowood MSS; Lansdowne to Price, November 22, 29, 1786, 'Price Letters', *op. cit.*, 357–60.
[2] Fitzmaurice, *op. cit.*, II, 307–8.
[3] Lansdowne to Wycombe [1789], Clements Library, Shelburne's Letters to his Son, 1780–9.

clash of temperaments and through it a clash of principles. Lansdowne always was ready to suggest risky expedients. By contrast, Pitt was the model of political circumspection. His commissions of enquiry into financial problems served the double function of demonstrating the financial difficulties in the way of reform (so little appreciated by Lansdowne), and of pigeon-holing the awkward subject for a number of years. Lansdowne's attacks on Pitt's measures were almost always directed against their caution, their narrowness, or their failure to abide by the principles he had endeavoured to introduce in his ministry.

Pitt's proposals for increasing the revenues for the sinking fund were a case in point. Price criticised Pitt's failure to provide new taxes to support the sinking fund, and his reliance on what Price considered to be a temporary boom in trade to provide, by way of improved yield from Customs and Excise, for the additional revenue required.[1] Lansdowne pushed it a stage further. On kissing hands for his marquisate he found Pitt rejoicing at the improvement of the yield in revenues, preparing to institute Richardson's scheme for commuting the tea duty, and contemplating consolidating the Customs as Musgrave had recommended. But he apparently paid very little attention to Lansdowne's alternative suggestion of 'a tax upon incomes, which would go to the root of the evil, and lay the foundation for an entire change of system', restore public credit by raising supplies within the year, and tax manufactures and commerce effectively for the first time.[2] It would be an unpopular tax; and Pitt's success in the 1780's was built on foreseeing and avoiding unpopularities.

On questions of administration the disagreement gravitated around the problem of where the control should lie: with the executive, with the legislature as it had exercised its prerogatives in the negative libertarian tradition of the Revolution Settlement, or with the executive and legislature together under what was coming to be the new arrangement of parliamentary enquiries prescribing the detailed regulation of the public money throughout its course from the pocket of the taxpayer to its disbursement and accounting in the public service. In the solution of the problem, neither Pitt nor Lansdowne, in the transitional and emergency circumstances of the 1790's, adopted a clear or consistent line.

[1] Discussion of the Proposal of the Sinking Fund, Shelburne Papers, vol. 135.
[2] Fitzmaurice, *op. cit.*, II, 296–7.

Pitt's political prudence prevented him, even in the midst of the war emergency, from supporting a straightforward policy of executive or Treasury control over all administrative affairs that could be kept out of Parliament's hands. On the other hand, he had little appreciation for the growing awareness of, and interest in, financial affairs by Parliament. Lansdowne was hampered by his uneven grasp of the issues. Where his interest as an administrator was particularly engaged and where he clearly understood the question, as in the case of the suppression of sinecures, fees, or useless offices, he came out strongly for Treasury control and blamed the difficulties in reforming on Pitt's slackness in this respect. But where he had little interest in, or understanding of, the question, or where he relied on advisers like Price who usually took an ideal or libertarian view of political institutions, he was inclined to fall back on the whiggish dictum that 'that government is best which governs least'.

This ambivalence can be seen in his penetrating reflections on government, written in 1801:

> Our constitution, at least as it has been administered for the last ninety years, is admirably calculated to resist grievances, but the moment that is done it degenerates. I am sorry to say upon an experience of forty years, that the publick is incapable of embracing two objects at a time, or of extending their views beyond the object immediately before them. . . . They consider men more than things . . . and in that they are repeatedly deceived. Yet it operates together with the freedom of the Press as a considerable check upon absolute power. It promotes emulation among the candidates for power, and though not so well-calculated to build as to destroy, yet it keeps the publick awake and operates as a powerful negative, which in fact is the great requisite in all government; for Providence has so constituted the world, that very little government is necessary. . . .[1]

Like many other eighteenth-century magnates, he was alarmed at the social· changes which war and revolution had brought. He believed that taxes had weakened the nobility and gentry, and commensurately their capacity to patronise and protect the lower orders; while war and the rise of industry had raised up new classes who would prey on both. The agricultural poor were:

> . . . the strength and wealth and glory of England, who must be the best means of saving the country, when the misers of farmers have

[1] Fitzmaurice, *op. cit.*, I, 80–1.

sold it (as they will anything for the sake of lucre), and of restoring the race of men after the manufacturers have debased it. While the hoggish farmer grudges bread to everything around him, and while the manufacturer abounds in wealth (from the upstart master, who finds himself possessed of a fortune, for which he was not educated, and consequently considers it as a means of insolence, down to the wretched weaver, who knows no other use of high wages except to be idle two or three days in the week, or to ruin his constitution and that of his family by debauchery and spirits), the agricultural poor are dying through want, the prey of every disorder which results from poverty, filth, cold, and hunger, with laws intended for their relief, but so ill-adapted to the present state of things and so shamefully executed, that they only serve to multiply their numbers, to lower the few feelings they have left, and to stifle every exertion on their part.[1]

He proposed to relieve their wants by closing alehouses, abolishing the poor law and giving their children,

... two or three years *daily* education and eight or ten years *Sunday* education, which would consist in nothing more than in inculcating the simplest of the simple principles of the Gospel, namely, public obedience, the duties and affections of domestic life, and contentment, under the doctrine of future rewards and punishments.[2]

Except that he would keep the clergy out of the arrangements, Hannah More could have had no more faithful disciple.

Politically he was also anxious for his class. If the nabobs and *nouveaux riches* had seemed to threaten the landed gentry in the possession of their borough interests in the 1760's, how much more did this seem to be the case in the 1790's. Lansdowne urged them to protect themselves, not by trying to outspend their rivals, but by throwing themselves on the sympathy of their constituents by adopting the anti-corruption and reform cause.

Nothing is more easy, as you are acting all the time upon the defensive, in support of what you possess, and of rights which are generally presumed to belong to your property; besides, that power lost in one sense is power gained in another, for the moment you are unhampered with particular personal managements, everything becomes reversed, and you become the terror of evil doers, and your influence bears a just proportion to the extent of your property and the integrity of your conduct. It may be observed, here, that towns will always be found the most open to conviction, and among them, the

[1] *Ibid.*, II, 351.　　　[2] *Ibid.*, II, 305–6.

tradesmen and middling class of men. Next to them are the manufacturers, after which but at a great distance, comes the mercantile interest, for in fact they belong to no country, their wealth is moveable, and they seek to gain by all, which they are in the habit of doing at the expense of every principle; but last of all come the country gentlemen and farmers, for the former have had both their fortunes and their understandings at a stand while everything else has been in motion, and are obliged in consequence to sell their estates, and retire into towns, where they become different men, and better subjects, but leave the country unhappily not to great proprietors, for they reside only a few months in the year on it, but to the professions who plunder it; particularly the country attorneys, the scourage of all that is honest or good, and the farmers, who uneducated and centred in their never ceasing pursuit of gain, are incapable of comprehending anything beyond it.[1]

There is no evidence, however, that the elections at Calne and High Wycombe were conducted on this unorthodox basis.

He did not share to the full the Opposition's enthusiasm for Revolutionary France. He had strongly condemned the Birmingham Riots against Priestley, defended the right of the Associations to agitate for parliamentary reform, and offered to be a character witness for Horne Tooke in the sedition trials of 1794. But there were clear limits to his opposition. He refused to join Fox in formal secession from Parliament, or to defend the London Corresponding Society in their 'nonsense of universal suffrage'. Rather, he preferred to base his opposition in a revival of the old whiggish idea of the balanced constitution. In this the royal veto would be restored in order that King George might play King Richard to the ministerial Wat Tyler, in alliance with an amorphous 'public opinion' of the middling class of people in town and country. This alliance, avoiding the extremes of enlightened despotism and the levelling tendencies of the reform Associations, would transcend the prejudices of class and neighbourhood and pursue reform in the interests of *national* economy, *national* virtue and *national* liberty.[2] It was very close to what in fifty years' time would be recognised as Victorian Radicalism, but it was largely irrelevant to the political issues of the 1790's.

[1] *Ibid.*, 357–9.
[2] Garbett to Lansdowne, July 31, September 12, 1791, February 17, 1792, Romilly to Lansdowne, October 6, December 13, 1792, November 18, 1794, Bowood MSS; Lansdowne to Coutts, November 26, 1793, July 3, November 5, 25, 1794, November 16, 1796, Clements Library, Letters to Coutts; Lansdowne to

He was still effective on the subject of administrative reform. Rewarding the political faithful had presented almost as many difficulties under Pitt as under the Coalition. For those who were not eligible for or did not want a peerage, there remained only a limited number of established sinecures. Pitt could appear to be virtuously saving money by giving Barré the Clerkship of the Pells in lieu of a pension, and a Tellership of the Exchequer to the importunate William Eden as a reward for his commercial treaty. It was this sort of assiduity in the public service (soon to be described by Cobbett as: 'Methodists in the morning and jobbers in the afternoon') on the part of the Minister and his coadjutor, George Rose, that most irritated Lansdowne. Even in the evening of his career, the suggestion that Rose's sinecure tenure of the Clerkship of the House of Lords was as justifiable as the freehold right of the Duke of Bedford in his estate could fire him to thunders of invective.[1]

The war made the shortcoming more obvious, made Lansdowne discover the old dragon 'influence' in every increase in government activity, in every new office or board, regiment or fund.[2] In the spring of 1796 his attacks culminated in what was intended to be a duplication of the Economical Reform campaign. As the Seventeenth Parliament drew to its close, Opposition concerted a series of blows, of which the centre piece, as in 1779, was to be a motion for reform from Lansdowne. On May 2 he moved unsuccessfully to censure the Ministry for failing to realise the reforms to which they had been pledged since 1783, and for ignoring those recommended by the Commissioners for Examining Accounts and the Commission on Fees. Parliament was asked to enquire whether any new offices had been created or salaries granted or continued without good reason, and whether expenses had increased beyond

Bentham, July 3, 21, 1791, Add. MSS 33,541, fos. 272, 274, to Warren Hastings, August 29, 1799, Add. MSS 39,871, fo. 71; Lansdowne to Romilly, October 8, 1792, *Romilly Memoirs*, II, 14; Fitzmaurice, *op. cit.*, I, 18, 24-5, II, 336-8, 353-9, 376-82, 385-6, 391-2, 397, 425-6; *Parliamentary History*, XXVII, 874-882, XXVIII, 939-48, XXIX, 441-8, 1524-7, XXX, 164-6, 732-6, 1391-1424, XXXI, 598-601, 683-5, 979, XXXII, 154-5, 195-6, 434-9, 551-2, XXXIII, 176-7, 191-4, 755-62, 873-9, 1352-3, 1538-9, XXXV, 165-9.

[1] 'Was any man in office to presume to put a sinecure, the child of gross abuse, an office held as a means of income for service not performed, in competition with the hereditary property of a noble duke, of himself, or of any man of hereditary estate in the kingdom? The idea was monstrous' (*Parliamentary History*, XXXIII, 171-2).

[2] *Parliamentary History*, XXVII, 227-33, XXIX, 154-8, 1569-70, XXXI, 233-234, XXXII, 1041-9, 1566, XXXV, 1198-9.

the supplies granted by Parliament in time of war, of unexampled waste, of declining trade and tax resources. Parliament was also urged to intervene as the protector of the constitution against the encroachments of the executive.

This time, at long last, Lansdowne was willing to surrender at least part of the credit for having originated administrative reform to the Commissioners for Examining Accounts, and took their recommendations seriatum as his brief. This was partly to borrow the Commissioners' reputation with Parliament which was better than his own, partly as a symbolic gesture of disdain for Pitt's commissions of enquiry, who had declared the difficulty of implementing Lansdowne's proposals for reform.

According to Lansdowne, though the Fourteenth Report of the Commissioners had recommended the suppression of the great sinecures in the Customs — sixty-one of them worth £26,000 a year in the Port of London and one hundred and fifty-seven worth £140,000 in the Outports — the Ministry had left them undisturbed. Pitt had done more than Lansdowne was prepared to give him credit for, but political caution and financial realism had stood in the way of a thoroughgoing reform. After the defeat of his Public Offices Regulation and Customs House Bills in 1783, he apparently decided that Kenyon's opinion that patents converted into sinecures were suppressible, however sound it might be in law, was bad politics. This was especially true in the case of the patents held by the politically great in the London Customs House, whose deprivation demanded a degree of hardihood not to be expected from the Treasury under Pitt's chairmanship. But Musgrave's warnings, supplemented by those of the Commission on Fees, that compensated suppression of Customs patents was likely to be an expensive affair, also weighed on Pitt's mind. In 1789 he appointed a further commission to investigate the Customs fees, which confirmed his fears. The reform would cost the Treasury an additional £127,247 annually in salaries and compensating pensions. The out-of-doors sinecures might be suppressed for only about £45,000 and a bill was prepared for this purpose in 1792. But the war came, and even this modest proposal remained unrealised. Hence in 1796 Lansdowne could remind his hearers that the sinecures had been recommended for suppression by Musgrave during his own administration, and again by the Commissioners for Examining more than ten years previously, and

still flourished in the midst of the emergency and privations of war.

Similarly the consolidation of the minor revenue boards, recommended by the Commissioners in their Second Report, attempted by North in a blighted measure of 1781, and approved by resolution of the House of Commons in 1782, had not yet been effected. In fact, Pitt contemplated abolishing the Hackney Coach and Hawkers and Pedlars' Boards in 1785,[1] but changed his mind under circumstances that gave substance to Lansdowne's remark in 1796 that as each of the fifteen places that would have been abolished 'may be supposed capable of gaining a Member of Parliament, if he is to be so gained', the economy effected would have been as nothing compared to the suppression of influence involved.

The Commissioners' Ninth Report (and, Lansdowne might have added, Barré's Act of 1783) had attempted with only limited success to reduce the elaborate system of payments to, and deductions from, soldiers' pay to the two items of subsistence and arrears. Why was the system continued? Lansdowne enquired. It was impossible to guess, unless for the purposes of fraud and concealment, 'as a pretext of supporting a number of idle clerks, at the expense of a deserving soldiery, and to enable ministers without detection, to apply public money to purposes different from those it was voted by Parliament'. If not, why had not the simple plan suggested by the Commissioners been adopted?

The reason in this case, as also in those of the perpetuation of the Navy's archaic system of estimates and the lack of satisfactory management for the transport service, was the failure of Treasury control. Patent offices individually, and boards of administration collectively, according to Lansdowne, were bastions of privilege in resistance to reform which only the strongest Treasury action with the utmost power of the law could force. Arguments that members of a board served as a check on one another were beside the point. An active man or men under the immediate direction of the Treasury (as Baring had been under Shelburne in 1783) was much more effective, and certainly less likely to misuse his place.

The public money [he concluded, in echo of the Commissioners for Examining] ought to flow directly from the Treasury; and instead of giving the first lord a staff, which is the present badge of office, I

[1] Ibid., XXV, 307.

would give him a knife to cut off every man's fingers that dared thrust his hand into the public purse.[1]

When he turned to discuss the national finances, he was much less effective. The drain of war expenditure had dangerously over-burdened the nation's still meagre tax resources, and apparently justified Lansdowne's advice concerning the income tax. Pitt's political caution, so obviously a virtue in the 1780's, was now shown to be misplaced. But instead of sticking to the income tax and being proven right in the event, Lansdowne warned that the existing taxes would bankrupt the gentry and the nation, and would in any case destroy the social order. Like most of the Opposition, he admired the financing of the French Revolutionary governments until the collapse of the *assignats*, after which he warned against Pitt's drift toward a paper currency as a repetition of the French mistake. When war brought prosperity to manu-facturing and increased tax revenues, he insisted that these would collapse as soon as peace brought a revival of smuggling and foreign competition.[2]

He had the prejudices of his generation and class against the expansion of credit, and, like Tom Paine and Napoleon, freely predicted the failure of Pitt's system of financing. But on both economic and social grounds he was hostile to the development of internal and local credit as well. His natural caution in financial matters and his distrust of agents and lawyers after his experience with Macleane,[3] was intensified by a justifiable distrust of banks and banking in the depression of the 1770's and by the prejudices of Samuel Garbett who had suffered in the Ayr Bank failure of 1772-3 and who maintained in his correspondence with Lans-downe and in his report on the Mint in 1783 that credit problems of industry and the nation could be solved by a large-scale coinage of gold.[4] At the turn of the century Lansdowne complained that more than ever agents and tenants now kept their money as long as possible before paying it in to the landlord,

... on account of the number of country banks, which corrupt the whole country, by soliciting the custody of ever so small a sum, if it

[1] *Ibid.*, XXXII, 1041-62.
[2] Lansdowne to Coutts, January 14, 28, September 12, 1794, February 17, 1796, Clements Library, Letters to Coutts; *Parliamentary History*, XXIX, 49-50, 441-8, XXX, 330-1, XXXI, 1272, 1445-9, XXXII, 196-7, XXXV, 1197-9.
[3] Fitzmaurice, *op. cit.*, II, 347. [4] Bowood MSS, *passim.*

be but for a day, and by having recourse to this and a variety of other methods to circulate their notes, which must end in some great public calamity. To obviate this so far as regards your particular interest, it will be prudent on no account to receive or pay the notes of any country bank, but both to receive and pay in current coin.[1]

On one issue he might have taken a lead and allied himself with the trend of the future. Sooner than most men he identified the essential improvement yet to be made in the public accounting, and which Pitt had not made when he replaced the Auditors of the Imprest with his Audit Commission in 1785. This was to give to some authority the power to ensure that expenditures were made only according to the public interest. Lansdowne perceived the inadequacy of the estimates and never failed to denounce, as he had done in the old days, the system of extraordinary payments as negating parliamentary appropriation and hence parliamentary control over the objects of expenditure. Eventually the solution was found administratively — that is, by giving the auditors and their successor the Comptroller General the power to enquire whether the objects of expenditure in particular accounts were in the public interest, and to withhold approval from those items that did not meet the test. But because of his preoccupation in these later years with the slogans of the early part of his career, Lansdowne looked for the cure in an extension of parliamentary appropriation to the minor details of expenditure. Moreover, the successive enquiries into the nation's finances following Economical Reform had been marked by a progressive quickening of interest on the part of Parliament, and an increasing sophistication in the discussion of these questions, as more and more bankers and merchants with experience in government affairs came to sit in Parliament. The climax of the change came in the work of the great Select Committee of 1797 — the first comprehensive parliamentary survey of the nation's finances. But the significance of it was lost on Lansdowne. No more than Pitt did he have a prevision of the parliamentary committees of the nineteenth century in which Parliament would provide the information upon which the executive would fashion policy.

For years he had been delivering jeremiads on the wrath to be expected from a combination of the inflation of credit, the Treasury's domination of the Bank and the weakening of parlia-

[1] Fitzmaurice, *op. cit.*, II, 341–2.

mentary control over the financial system. But when the crisis of 1797 came, his assurance deserted him. He blamed the crisis on the old chimeras, beloved of successive oppositions through the century: the drain of money to foreigners through payments of interest on the debt, and the improvidence of government. He could suggest as correctives only that there should be no interference with the private rights of the Bank and above all that its notes must not be made legal tender, or credit would perish, and speculation and bankruptcy ensue. A month later he was urging that this apparently disastrous measure be implemented for fear that anything less drastic would not be effective.[1] The familiar landmarks of peacetime financing were all but obliterated, and Lansdowne had lost his bearings. When his allies in Opposition came to him during the crisis to plan their strategy he could only mumble cryptically, in the tradition of Chatham, that he had always been in favour of publicity and simplicity,[2] and thereafter dwindled away into bewildered silence.

So it was that his career ebbed out in hopeless opposition, patronising increasingly eccentric schemers who might perhaps contrive to bring him back to power. From time to time in political crises — in 1797, in 1801 and in 1805 — he was spoken of for the Home Office or the Foreign Office, but death saved him from the Ministry of All the Talents. He spoke his last in the Lords in 1803, against the drift to war with the French Empire. Then he fell ill and gave up Parliament. But he continued 'perpetually doing and undoing', predicted the imminent collapse of 'Christianism', dropped dark hints about his contemporaries (in the spring of 1805 he undertook to reveal the identity of Junius) and still hoped for the regeneration of mankind and English politics, until one May morning in 1805 when, as Bentham wrote to Dumont, there was 'no longer any information to be asked'.

*　　*　　*　　*

In recent years the historians within the brilliant orbit of Sir Lewis Namier have told us so often, and with reference to so many different epochs in the eighteenth century, that politics was moved by the concrete realities of influence and patronage and not by the

[1] *Parliamentary History*, XXXII, 1048–9, 1562–8, XXXIII, 176–7.
[2] *Journal of Lady Holland*, I, 210.

abstractions of political theory, party loyalty and public opinion, that we are in danger of accepting their generalisations as stereotypes true for the whole century and, indeed, for all time. We may overlook the often impalpable, but nonetheless enormous changes which came about during the century in the political and administrative system.

The orthodox politics of party and interest alone, superficially so static, were in fact changing steadily. The roles played by patronage and influence and by the Court as an independent entity were diminishing as party loyalties became established around government and Opposition during the long administration of Lord North and the supreme crisis of the century, the loss of the American colonies. As one of the leaders of the Opposition Shelburne contributed to this development, but by temperament and character he was completely unsuited to play effective politics under the new dispensation. He did not approve of government by patronage; his own idea was the fanciful one of rallying political opinion to his support by the excellence of his measures. But neither this apolitical administrative approach, nor reliance upon a patronage system, by themselves could be employed effectively in the face of organised political parties and the new weight which ideology was coming to have in politics. Shelburne's failure to appreciate this brought his career to a close. But his emphasis upon a platform to appeal to political opinion was to have a future in the party politics of the next age.

He was dimly aware of the change in the class structure of politics that was bringing these other changes about. The balance of political power was shifting in the second half of the century from the neighbourhoods — where the activity of the gentry during and since the Revolution had drawn it — back to the metropolis dominated now, not by an inefficient despotism, but by an efficient modern executive in partnership with a rapidly maturing Parliament. The new responsibility of Parliament itself reflected the same changes; in 1750 the most important single parliamentary group had been the country party, in 1800 it was the merchant group of the metropolis in close and knowledgeable alliance with the executive.

This change encouraged a profound alteration in the administration of the country's finances. Shelburne's generation was the first to become fully aware of the machinery of that administration.

When he was in Opposition, he had agreed with the traditional belief that administration was above all an agency of royal and government influence. After he came to know that administration he wanted to correct its anomalies and inefficiencies. Philosophically, his career from 1768 to 1783 was a transition from whiggish contractual libertarianism to utilitarianism.

Much earlier than his contemporaries, he understood and encouraged the changes by which the immediate object of control in financial administration ceased to be the money to be distributed and became the officers distributing it; and by which the personal accountability of administrative officers by judicial audit was replaced by the perpetual accountability of the offices in which the officers served, under administrative audit. He contributed essentially to ending the acceptance in government circles of the diffusion of administrative power among a variety of private and semi-private interests, and to establishing instead the paramountcy of the public interest.

But he did not like the magnification of the executive power which these changes brought. Specifically, he did not appreciate the change in the means of control of expenditure, from the broad unsophisticated sanction of parliamentary appropriation (implicitly hostile to the executive government and sanctified by Revolution tradition), to the more specific and harmonious authorisation of expenditure by auditors or a Comptroller General, responsible to Parliament. As his fortunes ebbed, he reverted increasingly to his older parliamentary prejudices.

His achievements were limited because he badly missed the temper of his times. But perhaps he would have been odd man out in any age. His treacheries were not as heinous as contemporary party passions drew them; no more than Fox and North in their coalition, nor Pitt and the Court in theirs, did his political privateering fly cold-bloodedly in the face of principle. Yet none of the others excited the distrust and hatred that Shelburne inspired. His radicalism was not unique either; Richmond and Fox were more violent, Pitt and Middleton were more self-righteous. To picture him as a latter-day Prometheus, defying the established gods of politics to bring down the fire of radical reform from heaven and ending his days chained to the rock of political oblivion, is to give him a singleness of purpose which he disastrously lacked. In all probability this was the key to his character. He was perpetu-

ally striving to reconcile the conflicts between his liberalism and his ambitions, his righteousness and his treachery, his enterprise and uncertainties, behind the impressive façade of the Jesuit in Berkeley Square.

Treasury and Exchequer — Plan of Accounting

TREASURY BOARD

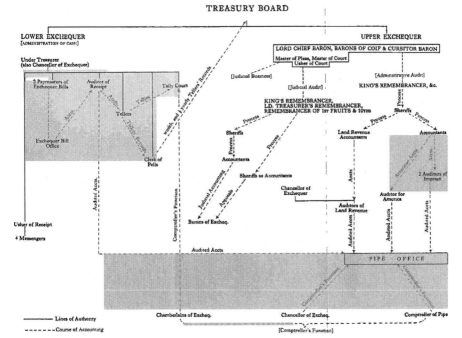

LOWER EXCHEQUER
[ADMINISTRATION OF CASH]

UPPER EXCHEQUER

LORD CHIEF BARON, BARONS OF COIF & CURSITOR BARON

Master of Pleas, Master of Court
Usher of Court

Under Treasurer
(also Chancellor of Exchequer)

[Judicial Business]

[Administrative Audit]

KING'S REMEMBRANCER, &c.

2 Paymasters of
Exchequer Bills

Auditor of
Receipt

Tally Court

[Judicial Audit]

Tellers

Tellers

KING'S REMEMBRANCER,
LD. TREASURER'S REMEMBRANCER,
REMEMBRANCER OF 1ST FRUITS & 10THS

Sheriffs

Exchequer Bill
Office

Clerk of
Pells

Sheriffs

Land Revenue
Accountants

Accountants

Accountants

2 Auditors of
Imprest

Accountants

Sheriffs as Accountants

Chancellor of
Exchequer

Auditor for
America

Usher of Receipt

Judicial Accounting

Appeals

Barons of Excheq.

Auditors of
Land Revenue

4 Messengers

Audited Accts

PIPE OFFICE

Audited Accts

Chamberlains of Excheq.

Chancellor of Excheq.

Comptroller of Pipe

——————— Lines of Authority

– – – – – Course of Accounting

[Comptroller's Function]

The Vote on the Peace, February 18, 1783

THE following lists are based on two sources: a list of the crucial division on the peace of February 18, 1783, published in the *Morning Post* of February 27, 1783, and a 'State [of Parties in Parliament]' as of March 10, 1783, apparently prepared for Henry Dundas and to be found among the Melville Papers (vol. 63A) in the National Library of Scotland. Neither is entirely satisfactory as a record of how Members voted. The *Morning Post* list adds two to each of the totals on the division of February 18, making them 210 to 226 instead of 208 to 224. One of these additions may be accounted for by the inclusion in the list of John Fenton who was not a Member of the Parliament of 1780. The Dundas 'State' is unsatisfactory for analysing the vote of February 18 because it was designed to indicate what support a Pitt-Dundas Ministry might be able to muster in the second week of March. Apart from the fact that some who had voted against Shelburne might support Pitt, and some who had supported the peace would not support a Pitt-Dundas Ministry, the 'State' gives only a fragmentary indication of who supported the peace and who did not, does not indicate whether this support was given on February 18 or February 21, and makes some obvious errors in attributing sympathies. It seems the most satisfactory arrangement to list the Members as the *Morning Post* did, admitting the obvious errors and the possibility of greater hidden ones, subdividing the two sides into categories indicated by previous allegiances and the Dundas 'State'. Special categories have been created where the two lists disagree or where the voting records of Members have been especially erratic.

Some comments are appropriate concerning the results. The most remarkable support for Shelburne came from the independents — 81 voted with him, to which may be added Richard Hill (listed as absent on March 10), Matthew Brickdale, Thomas Bramston and George Daubeny (listed as supporting North on March 10), and Sir William Codrington and John Hanbury (listed as supporting Fox on March 10) — a total of 87. In the same category North had the support of only 38 (32 plus 6 listed as Doubtful on March 10) and Fox only 9 (8 plus Thomas Staunton listed as absent on March 10).

The distribution of the support of Court, Placeholders and Serving Officer Members is also interesting. Only 20 (19 plus Captain Eliab

Harvey listed on March 10 as against the peace and supporting North) voted with Shelburne on February 18, whereas 29 (27 plus George Onslow — listed as absent on March 10 — and Captain John Luttrell — listed as supporting the peace on March 10) voted with North.

Absences in eighteenth-century politics were often as significant as votes. Some Members — George Augustus Selwyn, Sir Charles Turner, Sir George Savile, Lord Nugent, Lord Verney, Lord Fairfield, G. B. Brudenell, Frederick Bull and Henry Thornton — probably abstained from voting to avoid the inevitable clash of loyalties which it would have entailed. By contrast, Barré's absence from such an important division can only be accounted for by ill-health. Thirty who might have supported Shelburne stayed away; thirty-seven who might have supported North and twenty-four who might have supported Fox were also absent.

The hypothetical full House would thus only have ensured that Shelburne's defeat would have been more decisive than it was in fact. On February 18 he did remarkably well. Another leader might have recovered the position, as the leaders of the Coalition, surprised at Shelburne's strength on February 18, expected Pitt to do in the anxious month that ensued before they were safely installed in office.

I. THOSE WHO VOTED WITH THE MINISTRY ON THE PEACE — FEBRUARY 18, 1783 — ACCORDING TO THE *Morning Post*.

1. Shelburne's Party:

Lord Mahon	Sir George Yonge
James Townsend	John Aubrey
Sir John Jervis	John Baring
Richard Jackson	John Wilmot
William Clayton	John Parker
	George Rodney 11

2. Holders of Ministerial Offices:

Thomas Townshend	W. W. Grenville
William Pitt	Thomas Orde
Henry Seymour Conway	James Grenville
Lloyd Kenyon	Edward Eliot Jr.
Pepper Arden	Richard Hopkins
	Henry Dundas 11

3. Court, Placeholders and Serving Officers:

Philip Stephens	Gen. Richard Philipson
Thomas Johnes	Col. James W. Adeane
John Ord	Capt. W. Cornwallis
Gabriel Steward	Hugh Boscawen

Henry Strachey · Sir Sampson Gideon
Charles Jenkinson · Henry Pelham
Sir James Marriott · Thomas Pelham
William Masterman · John Boyd
William Ewer · Viscount Fielding
Lawrence Cox · 19

4. Small Groupings Around the Court:
 Marlborough:
 Viscount Parker · Lord Charles Spencer
 R. Jackson:
 Barne Barne · Sir Edward Dering
 Brudenell (Earl of Ailesbury):
 William Woodley · Lord Courtown
 Lisburne:
 Robert Shaftoe
 Gower:
 Richard Vernon · Thomas Gilbert
 Commodore Keith Stewart · Sir John Wrottesley
 Rigby:
 Richard Rigby · Francis Hale
 Robert Mackreth
 Weymouth:
 John Calvert · John Calvert Jr.
 John St. Leger Douglas
 Hardwicke:
 George Anson · J. Somers Cocks
 Frederick Robinson · Philip Yorke
 Advocate (H. Dundas):
 Sir Robert Laurie · James Murray
 Hew Dalrymple · Alexander Garden
 Marquess of Graham · Peter Johnston
 John Pringle · John Sinclair
 Andrew Stuart
 Duke of Gordon:
 Staats Long Morris
 Earl of Pembroke:
 Lord George Herbert
 Lord Bulkeley:
 Lord Bulkeley · John Parry · 34

5. Parties Not Connected with the Court:
 Pitt:
 Henry Bankes · John J. Pratt
 Robert Smith

Rutland:
 Lord George Sutton George Sutton
 Earl of Tyrconnell Sir Henry Peyton
 William Pochin
Abingdon:
 Peregrine Bertie Lord Wenman
 Samuel Estwick J. W. Gardiner
Lowther:
 Sir James Lowther Sir M. Le Fleming
 J. B. Garforth James Lowther
 William Lowther John Lowther
 Edward Norton Walter S. Stanhope
Lord Howe:
 Charles Brett Arthur Holdsworth
Duke of Bolton:
 Sir Philip Jennings Clerke
Duke of Richmond:
 Thomas Steele
Earl of Bristol:
 Sir Charles Davers 25

6. City:
 John Wilkes Sir Watkin Lewes
 Sir Joseph Mawbey 3

7. East India:
 Sir Robert Palk T. B. Rous
 C. W. Boughton-Rouse 3

8. Former Adherents of the Rockingham Interest:
 Earl Ludlow Charles Barrow
 John Webb Thomas Lucas 4

9. Independents:
 Formerly Inclined to North:
 Charles Boone Lord Frederick Campbell
 James Campbell Sir Archibald Edmonstone
 Earl of Fife Samuel Blackwell
 John Hunter Blair John Fuller
 Thomas Grosvenor Sir H. Houghton
 Noel Hill Benjamin Keene
 Lord Kensington Edwin Lascelles
 Benjamin Lethieullier Francis Fownes Luttrell
 John Fownes Luttrell Sir Herbert Mackworth
 R. A. Nevill John Peachey

George Philips

Anne Poulet

Henry Rawlinson

George Pitt

Abraham Rawlinson

Robert Thistlethwayte

Robert Waller

Formerly Inclined to Opposition to the American War:

Henry Duncombe

R. P. Knight

Sir Robert Ladbroke

William Morton Pitt

Filmer Honeywood

Thomas Powys

Edward Eliot Sr.

Sir John Griffin

Thomas Pitt

William Wilberforce

John Pennington

Sir John Rous

Usually Unconnected:

John Lambton

Sir Robert S. Cotton

Baron Dimsdale

William Drake Sr.

George Gipps

Henry Howarth

John Hussey Montagu

James Phipps

Clement Taylor

Ambrose Goddard

Thomas Halsey

William Hussey

Lucy Knightley

Sir Charlton Leighton

Sir William Lemon

John Morgan

Sir James Pennyman

Evan Lloyd Vaughan

Francis Annesley

Sir George Cornewall

Archibald Douglas

William Drake Jr.

Benjamin Hamnett

James Martin

Edward Morant

Charles Robinson

John Trevanion

Sir Edward Astley

Sir William Guise

George Hunt

Thomas Kemp

Sir Robert Lawley

Sir William Middleton

Sir Roger Mostyn

Sir John Rushout

Watkin Williams 75

10. Independents voting for the Peace on February 18, but listed as Supporting North on March 10:

Matthew Brickdale Thomas Bramston

George Daubeny 3

11. Independents voting for the Peace on February 18, but listed as Supporting Fox on March 10:

Sir William Codrington

Charles Marsham

John Hanbury

Sir Thomas Skipwith

John Tempest 5

12. Independents voting for the Peace on February 18, but listed as Doubtful on March 10:

Charles Morgan John Rolle

John Vaughan 3

13. Independent voting for the Peace on February 18, but listed as Absent on March 10:

<div align="center">

Richard Hill 1 87

</div>

14. Members voting for the Peace on February 18, but listed as Supporting North on March 10:

Captain Eliab Harvey	Sir Walter Rawlinson 2

15. Members voting for the Peace on February 18, but listed as Supporting Fox on March 10:

George Dempster	Lord Euston
Sir Harbord Harbord	Viscount Middleton
Thomas Scott	Beilby Thompson.

<div align="center">

Sir Gerard Van Neck 7

</div>

16. Members voting for the Peace on February 18, and listed as part of the Shelburne Connection on March 10, but supporting the Coalition later:

John Crewe	Earl of Surrey 2

17. Members voting for the Peace on February 18, but listed as Absent on March 10:

Chaloner Arcedeckne	Francis Burton 2

Total: 210

II. Those Who Voted Against the Ministry on the Peace — February 18, 1783 — According to the *Morning Post*

A. North's Party and Connections:

1. North's Personal Following:

Lord North	George North
Lord Lewisham	Whitshed Keene
William Graves	Sir George Osborne

<div align="center">

Sir R. Sutton 7

</div>

2. Supporters of North's Ministry Who Remained Loyal to Him:

William Adam	John Buller
Sir Grey Cooper	Henry Fane
M. Fonnereau	Edward Gibbon
Charles Grenville	T. S. Jolliffe
William Jolliffe	James Mansfield
Lord Melbourne	D. R. Mitchell
Abel Moysey	Lord Palmerston
Henry Penton	John Robinson
Hans Sloane	Charles Townshend

<div align="center">

James Wallace 19

</div>

3. Court, Placeholders and Serving Officers:

Christopher Atkinson	Anthony Bacon
Sir Peter Burrell	John Clevland
Sir James Cockburne	Nathaniel Curzon
Welbore Ellis	George Keith Elphinstone
Francis Eyre	Archibald Fraser
Sir Charles Frederick	John Frederick
Bamber Gascoyne Sr.	Bamber Gascoyne Jr.
John Halliday	John Henniker
Sir George Howard	John Kenrick
Edward Lewis	James Macpherson
P. P. Powney	Sir F. L. Rogers
Lovell Stanhope	William Strahan
James Wemyss	Sir Richard Worsley

Nathaniel Wraxall 27

4. Parties Supporting North:

Sandwich:

Admiral George Darby	John Durand
Sir William Gordon	Lord Hinchinbrooke
Sir William James	John Morshead
Lord Mulgrave	John Pardoe
John Purling	George Stratton
John Stephenson	John Townson

Lord Hertford:

Lord Beauchamp Henry S. Conway

Robert S. Conway

Duke of Newcastle:

Sir Henry Clinton A. Eyre

C. Mellish

Sir Francis Bassett:

Sir Francis Bassett Francis Bassett

Poole Carew

Duke of Bridgewater:

Timothy Caswall J. W. Egerton

Earl of Carlisle:

Peter Delmé Anthony Storer

Lord Sackville:

George Damer Hon. A. Herbert

Lord Lisburne:

Lord Lisburne Hon. J. Vaughan

Lord Bathurst:

James Whitshed

Earl of Bute:
 James Stuart
Duke of Gordon:
 Lord Adam Gordon
Lord Loughborough:
 Sir J. Erskine
Lord Newhaven:
 Lord Newhaven 34

5. Bankers and Contractors not Part of the Court Group:
 Adam Drummond Henry Drummond
 Thomas Fitzherbert Sir Robert Herries
 Samuel Smith 5

6. Independents:
 Richard Barwell John Bond
 John Campbell Francis Charteris
 William Clive Sir William Cunnynghame
 Sir Thomas Davenport Sir John Delaval
 William Dickenson Sir William Dolben
 Sir John Eden William Eden
 Sir Thomas Egerton William Evelyn
 Sir Charles Farnaby William Hanger
 George Hatton Sir John Henderson
 George Johnstone Sir James Long
 Hugh Owen Francis Page
 Henry Rosewarne George Ross
 Hugh Scott Lord Sheffield
 Humphrey Sibthorpe John Strutt
 Sir Francis Sykes Sir Richard Symons
 Robert Vyner William Ward 32

7. Independents Voting with North on February 18, but Listed as
 Doubtful Supporters on March 10:
 John Darker Thomas Farrar
 Sir H. Gough John Hungerford
 Philip Rashlegh Samuel Whitbread 6

8. Voted with North on February 18 and Listed as Supporting
 North on March 10, but also Listed on March 10 as having Sup-
 ported the Peace:
 Captain John Luttrell 1

9. Voted with North on February 18, but Against the Coalition Later:
 C. G. Perceval 1

10. Voted with North on February 18, but Listed as Absent on
 March 10:

<div align="center">George Onslow 1</div>

Total of North's Party and Connections: 133

B. Fox's Party and Connections:

 1. Fox's Personal Following:

Edward Coke	Thomas W. Coke
Richard Fitzpatrick	Charles James Fox
Thomas Grenville	Lord Maitland
Edward Monckton	George St. John
St. Andrew St. John	Richard B. Sheridan
Lord Robert Spencer	John Shaw Stewart

<div align="center">John Townshend 13</div>

 2. Inherited from the Rockingham Connection:

Edmund Burke	Sir Robert Clayton
David Hartley	W. H. Hartley
Sir Richard Hotham	John Lee
Thomas Lister	Sir John Ramsden 8

 3. Parties Supporting Fox:

Portland:

Lord Edward Bentinck	Sir Henry Bridgeman
George Byng	John Cotes

Cavendish:

William Baker	R. W. Bootle
Wilson Bradyll	Lord G. A. H. Cavendish
Lord George Cavendish	Lord John Cavendish
Viscount Duncannon	James Hare
Dudley Long	Frederick Montagu
William Plumer	William Weddell

Spencer:

Lord Althorpe	Viscount Lucan
Henry Minchin	John Radcliffe
W. C. Sloper	W. W. Tollemache

Dundas:

Sir Thomas Dundas	Charles Dundas

Walpole:

Richard Walpole	Horatio Walpole

Fitzwilliam:

Richard Benyon	George Fitzwilliam

Anderson-Pelham:

F. E. Anderson	Charles Anderson Pelham

<div align="center">John Harrison</div>

Foley:

Hon. Andrew Foley	Hon. Edward Foley

Edward Winnington

Richmond:

Hon. F. Stanhope	P. C. Wyndham

Aislabie:

William Lawrence

Derby:

Thomas Stanley

Warren:

Sir George Warren 39

4. East India Supporters:

John Smith	General Richard Smith	2

5. City:

Richard Beckford	John Sawbridge	
Sir Watkin Williams Wynn		3

6. Former Adherents of North:

John Courtenay	John Craufurd	
John Nesbitt	Sir Horace Mann	4

7. Independents:

W. P. A. A'Court	Sir C. W. Bampfylde	
Sir H. Fethersonehaugh	George Forrester	
H. W. Mortimer	William Nedham	
Jacob Wilkinson	Humphrey Sturt	8

8. Independent who Voted with Fox on February 18, but was Listed as Absent on March 10:

Thomas Staunton 1

Total of Fox's Party and Connections: 78

C. Former Rockinghams who Voted Against the Peace on February 18, but were Listed as Shelburne Supporters on March 10:

Sir Matthew White Ridley	Samuel Salt	2

D. Independents who Voted Against the Peace on February 18, but on March 10 were Listed as:

Shelburne Supporters:

Charles Ross	Daniel Parker Coke

John Curtis

Supporters of a Possible Pitt-Dundas Ministry:

Andrew Boyntun	Charles D'Oyly	
Charles Penruddock	Lord Trentham	7

E. Independent who Voted Against the Peace on February 18, Listed as Doubtful on March 10, and eventually supported Pitt:

<div align="center">William Pulteney 1</div>

F. Adherents of Various Parties who Voted Against the Peace on February 18, but according to the *Morning Post* voted for the Ministry on February 21 and Against the Coalition:

Listed on March 10 as Favouring a Possible Pitt-Dundas Ministry:

<div align="center">Archibald MacDonald</div>

Listed on March 10 as Supporting North:

<div align="center">Lord Hyde</div>

Listed on March 10 as Supporting Fox:

John Elwes Sir Cecil Wray 4

Total Voting Against the Peace: 225
 ——

III. THOSE WHO DID NOT VOTE ON FEBRUARY 18:

A. Listed on March 10 as Supporters of Shelburne, His Ministry, and the Peace:

Isaac Barré	John Barrington
W. H. Bouverie	Frederick Bull
Frederick Cornewall	John Dawes
Sir Charles Gould	Earl Nugent
Sir Robert Smythe	Henry Thornton
Clement Tudway	Earl Verney
Sir William Wake·	Sir John B. Warren
	P. Wilkinson 15

B. Party Supporters and Independents Listed on March 10 as Favourable to Pitt-Dundas:

Lord William Gordon	Lord George Lennox
John Luther	James Luttrell
Crisp Molyneaux	Richard Skeene
	Glyn Wynn 7

C. Listed as Favourable to Pitt-Dundas on March 10, but Doubtful:

<div align="center">Francis Cust 1</div>

D. Party Supporters and Independents Listed on March 10 as Hopeful with Respect to Pitt-Dundas:

A. R. Bowes	Sir C. Cocks
Sir J. Coghill	Alexander Murray
Lord Percy	John Yorke 6

E. Listed on March 10 as Supporters of North:

Sir J. Anstruther	Viscount Bateman
Sir Cecil Bisshop	G. B. Brudenell
John W. Cawthorne	William Chaytor
Sir Thomas Clavering	P. C. Crespigny
Peregrine Cust	Sir John Duntze
Lord Fairfield	Sir A. Fergusson
George Graham	Thomas Harley
Maurice Lloyd	George A. Selwyn
Abel Smith	Sir Ralph Payne

Lord Westcote 19

F. Party Supporters and Independents Listed on March 10 as Favourable to North:

Charles Ambler	Wharton Amcotts
Lancelot Brown	William S. Conway
Earl of Lincoln	Henry L. Luttrell
Thomas Onslow	Sir H. Owen
Sir Hugh Palliser	Charles Phipps
William Praed	Lord Shuldam 12

G. Listed on March 10 as Supporters of Fox:

Peter Baker	John Bullock
Sir Charles Bunbury	Richard Hippsley Coxe
Henry Dawkins	Sir H. Fletcher
Sir S. B. Fludyer	Sir Thomas Gascoigne
Hon. Booth Grey	William Gerard Hamilton
Henry Peirse	Henry St. John
John St. John	Sir George Shuckborough

John Scudamore 15

H. Party Supporters and Independents Listed on March 10 as Favourable to Fox:

General Philip Honeywood	Jervoise Jervoise
C. Meadows	Nathaniel Newnham
William Norton	William Owen
Sir George Savile	Sir Charles Turner 8

I. Listed on March 10 as Ill or Can't Attend:

Favourable to Pitt-Dundas:

Sir M. Burrell	Sir P. Blake

Favourable to North:

E. Bacon	H. Cecil
Joseph Gulston	Sir J. Irwin

Henry Jones

Favourable to Fox:

R. Gregory 8

J. Listed on March 10 as Doubtful:

John Acland	Charles Edwin
George Fludyer	Thomas P. Legh
William Lygon	Paul C. Methuen
Richard Myddleton	Thomas Noel
Sir Thomas Rumbold	Thomas Rumbold
Sir John Thorold	Sir John Trevelyan
Earl of Upper Ossory	Thomas Whitmore 14

K. Those who were Abroad:

Sir Edmund Affleck	Paul Benfield
John Burgoyne	Henry Burrard
Lord Clive	Isaac Dutton
Sir Gilbert Elliot	Sir James Harris
Lord MacLeod	Viscount Maldon
Sir Hector Munro	Hugh Pigot
Sir John Stepney	Charles Stewart
Thomas Walpole	William Wollaston 16

L. One Seat — at Pontefract — was Vacant while the Returns were being Contested: 1

M. One Speaker:

Charles Woolfran Cornwall 1

Total of Those Who Did Not Vote: 123

Summary:

For the Ministry (*sic*)	210
Against the Ministry (*sic*)	225
Not Voting (*sic*)	123
Total	558

Corrected Summary:

For the Ministry	208
Against the Ministry	224
Not Voting	126
	558

x

MANUSCRIPT BIBLIOGRAPHY

BODLEIAN LIBRARY, OXFORD
 North Manuscripts
 Price Letters
BOWOOD PARK, WILTSHIRE
 Shelburne Manuscripts in the Possession of the Most Honourable
 the Marquess of Lansdowne
BRITISH MUSEUM
 Additional Manuscripts
 Egerton Manuscripts
 Lansdowne Manuscripts
BURY ST. EDMUNDS, WEST SUFFOLK COUNTY RECORD OFFICE
 Papers of Augustus Fitzroy, 3rd Duke of Grafton
NATIONAL LIBRARY OF SCOTLAND, EDINBURGH
 Papers of Henry Dundas, 1st Viscount Melville
PUBLIC RECORD OFFICE
 Admiralty Papers
 Board of Trade Papers
 Colonial Office Papers
 Foreign Office Papers
 Home Office Papers
 Chatham Papers
 State Papers, Domestic
 Treasury Papers
CENTRAL LIBRARY, SHEFFIELD
 Wentworth Woodhouse Muniments [Fitzwilliam Manuscripts]
 Burke Papers
 Rockingham Papers
UNIVERSITY COLLEGE, UNIVERSITY OF LONDON
 Bentham Papers
WILLIAM L. CLEMENTS LIBRARY, ANN ARBOR, MICHIGAN
 Dowdeswell Papers
 Correspondence of King George III, 1783-1810 [Fortescue
 Transcripts]
 Lacaita-Shelburne Papers
 Lee Papers
 Melville Correspondence
 North Papers

Pitt Papers
Sackville Papers [Photostats]
Gage Papers, English Series
Shelburne Papers
Sydney Papers

INDEX

PRINTED IN GREAT BRITAIN
BY ROBERT MACLEHOSE AND CO. LTD
THE UNIVERSITY PRESS, GLASGOW

Date Due

Printed in the USA
CPSIA information can be obtained
at www.ICGtesting.com
LVHW022102190124
769127LV00003B/76